Basics of Perception in Architecture

Jörg Kurt Grütter

Basics of Perception in Architecture

 Springer Vieweg

Jörg Kurt Grütter
Bern, Switzerland

ISBN 978-3-658-31158-2 ISBN 978-3-658-31156-8 (eBook)
https://doi.org/10.1007/978-3-658-31156-8

Based on the German version of the book "Grundlagen der Architektur-Wahrnehmung", Jörg Kurt Grütter, 1st edition 2015, Springer Vieweg.

© Springer Fachmedien Wiesbaden GmbH, part of Springer Nature 2020
This work is subject to copyright. All rights are reserved by the Publisher, whether the whole or part of the material is concerned, specifically the rights of translation, reprinting, reuse of illustrations, recitation, broadcasting, reproduction on microfilms or in any other physical way, and transmission or information storage and retrieval, electronic adaptation, computer software, or by similar or dissimilar methodology now known or hereafter developed.
The use of general descriptive names, registered names, trademarks, service marks, etc. in this publication does not imply, even in the absence of a specific statement, that such names are exempt from the relevant protective laws and regulations and therefore free for general use.
The publisher, the authors and the editors are safe to assume that the advice and information in this book are believed to be true and accurate at the date of publication. Neither the publisher nor the authors or the editors give a warranty, expressed or implied, with respect to the material contained herein or for any errors or omissions that may have been made. The publisher remains neutral with regard to jurisdictional claims in published maps and institutional affiliations.

Publishing Editor: Dipl.-Ing. Ralf Harms
This Springer Vieweg imprint is published by the registered company Springer Fachmedien Wiesbaden GmbH part of Springer Nature.
The registered company address is: Abraham-Lincoln-Str. 46, 65189 Wiesbaden, Germany

Foreword

Architecture, the art of building, has both scientific and artistic facets. Its more rational aspects, such as economics, structural analysis and building physics, are today precisely definable and quantifiable. Their concerns are for the most part logical and can be dealt with using scientific methods. The more irrational, emotional aspects of building, which concern the realm of aesthetics, are neither precisely definable nor measurable. This may be one reason why today there is so much uncertainty associated with the aesthetic aspects of building.

The experience of architecture, the perception of it, is quantifiable only to a very limited extent, since its subjective component is always greater than its objectively measurable aspects. Architecture as an object is measurable and determinable; it can be expressed in numerals. By contrast, the observer, the human being as subject, cannot be generalized as a type.

The process of perception, the experience of our environment takes place via our sensory organs. Many of the factors making up this process are explainable; many of the physical, chemical and biological mechanisms involved can even be measured.

The processing of the information absorbed via the sensory organs is extremely complex and differs from person to person. Even when we observe the same thing, we perceive it in a different way.

Today we are also aware of how peripheral phenomena such as physical state, previous knowledge, experience etc. can affect perception. However, these components differ from person to person to such a degree that a generalization of the perceptual process covering all possible types of states during reception is practically impossible.

For these reasons the development of an integral theory of the perception of architecture is not possible. Even a general prognosis of how to plan and build in order to maintain "good" architecture can only be formulated to a limited extent.

This book does not aim to provide any recipes. My intention is rather to render the complex process of architectural perception somewhat more transparent and thereby perhaps to help simplify certain individual decisions. This book is therefore intended not only for professionals but also for all those with a general interest in the expression and design of a built environment.

The first chapter is devoted to a brief discussion of the general principles of perception which serve to explain many aspects of architecture and its perception in the following chapters. The analysis of these aspects forms the major part of the book. However, has been necessary to simplify the presentation of certain processes in order to emphasize their essential characteristics. This book therefore does not claim to be comprehensive. The examples used come from different epochs and different cultures. The intention here is to underscore the fact that certain architectural principles are independent of epochs, culture, ideology and climate. The quotations included here have been chosen to present certain opinions expressed by some of the most important representatives of their respective fields.

My thanks to all those who provided me with assistance and advice in the course of completing this book and to Springer Vieweg, above all to Ralf Harms und Pamela Frank.

Bern, Switzerland Jörg Kurt Grütter
April 2014

Contents

1 Introduction—The Foundations of Perception 1
 1.1 The Principle of Information Transmission 2
 1.2 The Message .. 2
 1.2.1 Structuring the Message 2
 1.2.2 Active and Passive Messages 4
 1.2.3 Originality .. 4
 1.2.4 Aesthetic and Semantic Information 5
 1.2.5 Amount of Information 6
 1.2.6 Information and Repertoire 8
 1.2.7 Message Disruption and Perceptual Illusion 10
 1.3 The Receiver ... 12
 1.3.1 The Sensory Organs 12
 1.3.2 The Process of Seeing 14
 1.3.3 Reception Capacity and Memory Storage 16
 1.3.4 Gestalt Theory and Deduction Theory 18
 1.3.5 Constancy .. 29
 1.3.6 Depth Perception 30
 1.3.7 Perceptual Orientation in Space 33
 1.4 Socio-Psychological Aspects 36
 References .. 37

2 Part and Whole ... 39
 2.1 Parts and the Expression of the Whole 39
 2.1.1 Number of Parts 40
 2.1.2 Type of Parts 42
 2.1.3 Relationship Between Parts—Arrangement System 45
 2.2 Relationships Between Type, Number and Possible Arrangement
 of Parts .. 54
 2.2.1 The Relationship Between Type of Parts and Number
 of Parts ... 55

		2.2.2	The Relationship Between Number of Parts and Arrangement System	55
		2.2.3	The Relationship Between Type of Parts and Arrangement System	60
	2.3	Connection Between Type, Number and Relationship of Parts		65
	2.4	Assemblage of Parts ...		68
	2.5	Prefabrication of Parts ..		69
	2.6	Industrial Construction ..		74
	References ...			76

3 Culture and Style

				79
	3.1	Architecture as a Cultural Medium		79
	3.2	The Origins of Culture ...		84
		3.2.1	Art and Science ...	84
		3.2.2	The Beginnings of Art	84
	3.3	Style and the Type of Information		86
	3.4	Order and the Complexity of Styles		89
	3.5	Style and the Type, Number and Arrangement of Parts		92
	3.6	Style and the Personality Structure of the Beholder		94
	3.7	Changes in Style ...		95
	3.8	Acceptance of Styles ...		99
	References ...			104

4 Site and Surroundings

				105
	4.1	Influence of Surroundings on the Perception of Architecture		105
	4.2	Site ...		108
	4.3	Type of Surroundings and Choice of Site		110
	4.4	The Relationship of Human Beings to Nature and Their Surroundings ...		112
	4.5	The Relationship of Buildings to Their Surroundings		116
		4.5.1	Adaptation—Contrast—Confrontation	116
		4.5.2	The Relationship to the Ground	119
		4.5.3	The Relationship Between Interior and Exterior	122
	4.6	Streets and Squares ..		130
	References ...			131

5 Space

				133
	5.1	On the History of Space ..		133
		5.1.1	The Three Conceptions of Space in Western Culture	135
	5.2	Types of Space ...		150
		5.2.1	Mathematical Space and Experienced Space	150
		5.2.2	Daytime Space and Night-Time Space	151
		5.2.3	Private Space and Public Space	151

Contents

		5.2.4	Experienced Space	152
		5.2.5	Intermediate Space	154
		5.2.6	Emptiness	157
	5.3	Elements of Space		159
		5.3.1	Material and Surface	161
		5.3.2	Openings	163
	5.4	Spatial Organisation		165
		5.4.1	The Relationship Between Different Spaces	165
		5.4.2	Spatial Flexibility and Spatial Polyvalence	169
		5.4.3	Culturally Determined Types of Orientation in Space	174
	References			178
6	**Form**			**181**
	6.1	Form and Culture		181
	6.2	Choice of Form		182
	6.3	Form and Shape		190
	6.4	Form and Structure		190
	6.5	Regular Forms		193
		6.5.1	Horizontal and Vertical	194
		6.5.2	The Line	194
		6.5.3	The Flat Surface	197
		6.5.4	The Curved Surface	199
		6.5.5	The Circle	202
		6.5.6	The Ellipse	206
		6.5.7	The Sphere	208
		6.5.8	The Square and the Cube	211
		6.5.9	The Rectangle	212
		6.5.10	The Triangle and the Pyramid	212
		6.5.11	The Hexagon and the Octagon	214
	6.6	Irregular Forms		216
	6.7	Formal Contradiction		216
	References			218
7	**Harmony**			**221**
	7.1	Harmony and Balance		221
	7.2	Tension		223
	7.3	Proportion and Scale		226
	7.4	Symmetry and Rhythm		232
		7.4.1	Bilateral Symmetry	233
		7.4.2	Translational Symmetry	238
		7.4.3	Rhythm	240
	7.5	Hierarchy		240
	References			245

8	**Aesthetics and Beauty**		247
	8.1	Aesthetics and Architecture	247
	8.2	Beauty Through the Ages	250
	8.3	The Point of Beauty	254
	8.4	What is Beautiful? – the Sensation of Beauty	254
	8.5	Fashion and Taste	259
	8.6	The Measurability of Beauty	261
	References		268
9	**Movement and Path**		269
	9.1	Movement	269
	9.2	Time	273
	9.3	On the History of Movement in Art and Architecture	275
	9.4	Dynamism	278
	9.5	Rhythm	286
	9.6	Path	288
	9.7	Axis and Direction	297
	References		299
10	**Light and Colour**		301
	10.1	Light and Its Effects	301
	10.2	Directed Light and Openings	306
	10.3	View and the Natural Illumination of Interior Space	308
	10.4	Light Intensity	315
	10.5	Shadow	318
	10.6	Colour	319
		10.6.1 Why Do We See in Colour?	321
		10.6.2 The Psychological Aspect of Colours	323
		10.6.3 Colour and Space	324
		10.6.4 Colour in Architecture	325
	References		328
11	**Signs**		331
	11.1	Semiotics	331
	11.2	Semantics	332
	11.3	Adornment	334
	11.4	Symbols	335
	11.5	The Significance of the Sign in the History of Architecture	343
	References		352

Name index 355

Subject index 359

Introduction—The Foundations of Perception

The comprehension of space is instinctive, it is a corporeal experience: before we think and define it we feel it. Space is not outside us, it is not extension, it is that in which exist. Space is a where. It surrounds and sustains us; at the same time, we sustain and surround it. We are the support of that which supports us and the limit of what limits us. We are the space in which we are.

(*Octavio Paz* 2001, p.73)

Contents

1.1	The Principle of Information Transmission	2
1.2	The Message	2
	1.2.1 Structuring the Message	2
	1.2.2 Active and Passive Messages	4
	1.2.3 Originality	4
	1.2.4 Aesthetic and Semantic Information	5
	1.2.5 Amount of Information	6
	1.2.6 Information and Repertoire	8
	1.2.7 Message Disruption and Perceptual Illusion	10
1.3	The Receiver	12
	1.3.1 The Sensory Organs	12
	1.3.2 The Process of Seeing	14
	1.3.3 Reception Capacity and Memory Storage	16
	1.3.4 Gestalt Theory and Deduction Theory	18
	1.3.5 Constancy	29
	1.3.6 Depth Perception	30
	1.3.7 Perceptual Orientation in Space	33
1.4	Socio-Psychological Aspects	36
References		37

© Springer Fachmedien Wiesbaden GmbH, part of Springer Nature 2020
J. K. Grütter, *Basics of Perception in Architecture*,
https://doi.org/10.1007/978-3-658-31156-8_1

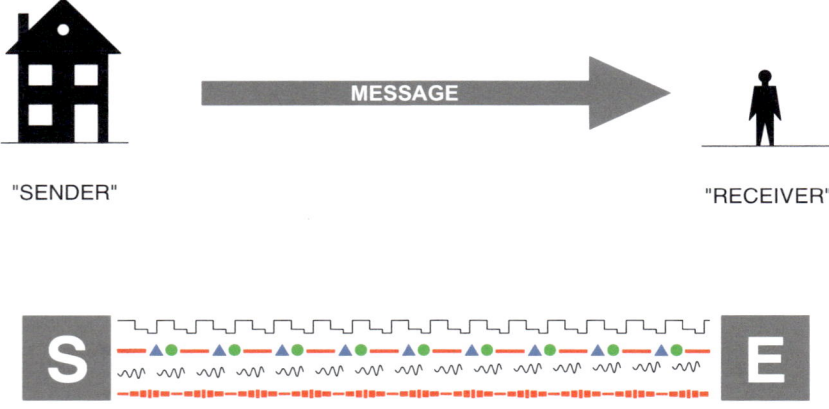

Fig. 1.1 Environment as message- "sender", the human being as message- "receiver". Different types of messages are transmitted via different channels, i.e., senses

1.1 The Principle of Information Transmission

We human beings need communication, information exchange with our environment. Without it we cannot survive. Our environment can be seen as the "sender" and the human being as the "receiver". As "receivers" we perceive the messages of the "sender" via different "channels", i.e. via our different sensory organs (Fig. 1.1). The signals we receive via our five sensory organs are further processed in the brain (see Sect. 1.3.1). The way in which these organs are utilized depends on the type of message they receive. In spite of their individual specialization, these sensory organs work in concert even at a very low level of perception. The choice of information that we consciously absorb is culturally shaped. It is also heavily dependent on our individual life stories and our psychological state at any one moment. A Central European negotiates his environment very differently to an Eskimo. The former orientates himself primarily with his eyes, a strategy that would hardly serve the latter well amidst a desert of ice. He therefore relies more on his senses of smell and touch. He can smell different types of wind and uses his feet to determine the properties of snow and ice.

1.2 The Message

1.2.1 Structuring the Message

What happens when we, for example, stand at an intersection in Paris (Fig. 1.2)? We receive an incredible amount of information: the partly sunlit grey façade of the building

1.2 The Message

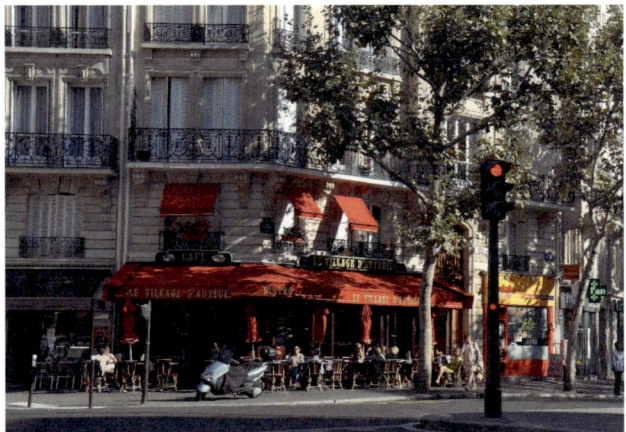

Fig. 1.2 Street cafe, Paris, France

Fig. 1.3 The formula for the calculation of originality (based on Abraham Moles)

$$\text{Originality} = -M \sum_{i=1}^{n} P_i \log_2 P_i$$

M = total number of message elements
P_i = their probability

on the other side of the road, the trees swaying in the wind, the traffic light that has changed to red, the squealing of a braking car, the scent of spring, and the people waiting next to us speaking a foreign language.

In order to understand what is happening in this moment, we have to attempt to order the array of messages we are receiving. Human beings rely on their capacity to find regularities in their surroundings so that they can structure the information they receive (Schuster und Beisl 1978, p. 50). Regularities allow us to summarize messages and thereby to reduce their informational content. We form so-called super-signs (see Sect. 1.3.3), which make it easier for us to perceive our environment.

When we look at the grey flickering on a defective television screen, we see "nothing." For us this message has only minor informational content, namely that the device is not functioning properly. But as soon as a form or even just a contour appears we begin to see "something." On the other hand, the flickering could contain a coded message, one that is not intelligible to us. It is only interesting for us if we are able to decode it, i.e., when it contains information for us. Decoding entails the recognition of a structure that facilitates the organization of the message. Such messages can only be decoded and understood with the help of special knowledge.

Let us return to the intersection in Paris. In this moment we are not interested in the façade of the building; our attention is directed at the people sitting the café. Do we

know them? Later, in another context, the façade may be of interest to us, its geometric layout, or we may be interested in the light and shadow in the trees. Perhaps the traffic light will change to green and we will concentrate on crossing the street.

Depending on the point in time and what we are interested in, we will select a particular message spectrum from everything available to us. Each level of perception corresponds to a different type of message, (Moles 1971, p. 59) and each of these levels has its own repertoire of signs that is different from those associated with other levels. In the formation of super-signs we change our level of perception: as soon as we see an opening in the wall no longer as an individual window but as a perforated facade, we have formed a super-sign. The messages of the individual windows have been combined into the concept of a perforated facade and in the process we have changed our level of perception (see Sect. 1.3.3).

At the moment we are interested in the person on the other side of the street, the smell of spring and the conversation of the people standing next to us. We perceive these events via different channels: we see, smell and hear. The perception of these messages occurs simultaneous via several channels. We therefore refer to them as multiple messages (Moles 1971, p. 234).

When we receive multiple messages we divide out attention between different channels. In the case of a theatre play, an opera or a film we can concentrate more on seeing and hearing, but in order to understand the whole we cannot completely exclude any of the messages. Our perception of architecture is also in part dependent on multiple messages.

1.2.2 Active and Passive Messages

In principle, a distinction can be made between active and passive messages. At the moment the person on the other side of the street interests us, and we would like to know more about her. The messages that reach us in this context are referred to as active messages. The motorbike on the opposite sidewalk does not interest us at the moment but we nevertheless perceive it; this is a passive message.

Another concept that is important in connection with active and passive messages is that of sensation. The American psychologist E.G. Boring argued that, although sensation is effectuated by influence on a sensory organ, it is a mental rather than a physical phenomenon (Boring 1942, p. 13).Sensation is based on active and passive perceptions but is not precisely definable. When we perceive the car coming to a stop, perhaps we feel fear or happiness without knowing exactly why. Sensations are fractions of perceptions; they do not provide an overall picture.

1.2.3 Originality

The measurable aspect of a message is its information content, although only the syntactic level of the message can be measured in information-theoretical terms. An email with fifty

words probably contains more information than one with ten words. However, the information content of a message is not always proportional to its length. The quantity of information always needs to be considered in relation to the value of that information. If we want to walk through a door, information about its material and colour does not help us much. In this situation it is only the information telling us how the door can be opened that is of value to us. When a message serves to influence our behaviour, then its informational value is greater the more it influences that behaviour. The influence of a message on our behaviour is greater the more new information it contains. If it contains nothing new, no information, it will not influence our behaviour and is thus worthless to us. The information content of a message is thus closely connected with its unexpected, original quality. The more original it is the more value it has for us. However, there must be a certain degree of coherence between the unexpected aspect of the information and what has preceded its reception, for if this is not the case the result is a sensation of chaos. Total originality is thus just as undesirable as no originality at all. What is therefore decisive for the value of a message is not its length but its originality. An email of fifty words is of little use if does not contain anything new for us. If it is composed of only ten words but has a high degree of originality, its information content is greater. The originality of a message can be calculated with the help of the concept of probability in the sense that originality is a function of a message's improbability. This can be quantified using a formula developed by the physicist and philosopher Abraham Moles (see Sect. 1.3) (Schuster and Beisl 1978, p. 57).

Originality is not and has not always been desirable. For example, in medieval architecture originality had a very low status. In the thirteenth century, people were convinced that the meaning and genesis of all creation could only be found in God. For such people the search for the new was thus largely alien. The authoritative model was decisive. The medieval architect relied for the most part on his sample book: on sketches of completed buildings he had made during his time as an apprentice and journeyman. And today, too, originality is not generally regarded as desirable.

1.2.4 Aesthetic and Semantic Information

When we consider the content of a piece of information, a further distinction suggests itself. The trees swaying in the wind are nothing new to us yet we can enjoy the sight of them: the gentle movement of the leaves, the illumination of the different shades of green.

This message has aesthetic informational value; it contains aesthetic information. This type of information speaks to our feelings; it awakens emotions. It is influenced by socio-psychological aspects and is therefore strongly dependent on the recipient. It is channel-specific and therefore difficult to translate. That is to say that the feeling we experience when we see leaves fluttering in the wind is difficult to translate into a verbal description or a drawing. Aesthetic information has no immediate, direct use.

By contrast, when we concentrate on a passing car, we may be interested in its make, what type of wheels it has, or when it was made. We have questions that we would like

to have answers to. Messages that answer concrete questions contain semantic information. They have no immediate aesthetic value, but they communicate a meaning; they teach us something. We draw certain conclusions from this type of information, and these in turn steer our behaviour. This information has a specific purpose; it is logical and comprehensible.

The terms "semantic" and "aesthetic" information come from Abraham Moles (Moles 1971, p. 165) and are a little misleading because the meaning of "semantic" here is not the same as that we associate with the concept of semantics.

The distinction between perceptions that relate predominantly to the intellect and those relating predominantly to emotion is one that existed long before the establishment of information theory. However, rather than aesthetic and semantic information it was framed in terms of "picturesque" and "rigorous" or "romantic" and "classical."

A message can simultaneously convey both aesthetic and semantic information. Let us take, for example, a door: its semantic information tells us how it can be opened, how large it is and whether we need to pull or push when opening it. Its form, proportion and color convey aesthetic information. In order to be able to open the door we need semantic information. However, this does not mean that the aesthetic information is useless.

A message always contains a certain ratio of aesthetic and semantic information. While the semantic information is easy to determine and measure, the value of the aesthetic information is dependent on the recipient and the prevailing external conditions (see Sect. 1.4).

Measuring aesthetic information and its subsequent transmission is more difficult and only possible to a limited extent. Conveying semantic information is easier. The plans drawn up by an architect can include all the information about the way a door functions, which is derived from empirical values and technical factors.

Even though at first glance aesthetic information has no immediate use, it is nevertheless important. It strongly influences our sense of well-being and our behaviour. The question of how a door should be designed in a way that conveys an optimal amount of aesthetic information is one that cannot be definitively answered but is of primary importance.

1.2.5 Amount of Information

Human beings require a certain measure of information. Experiments have shown the complete absence of information can lead to hallucinations and high levels of anxiety (Schuster and Beisl 1978, p. 47). On the other hand, the human being is not able to absorb just any amount of information. When looking out of the window of a high-speed train we are not able to absorb all the information coming at us. If we are exposed to such a situation for too long, we begin to feel uncomfortable.

So how great is the optimal amount of information? Information transmission takes place via different channels defined by our sensory organs. Each of these channels has

1.2 The Message

a certain maximum capacity and the amount of information it can absorb within a fixed unit of time is limited.

The amount of information can be measured. The unit of measurement is the "bit" (binary digit). The number of bits indicates how many "yes/no" decisions, so-called binary decisions, are necessary for the transmission of a quantity of information. The informational value of each message can therefore be expressed as a bit number. For example, 6 bits suffices to characterize a certain field in a chessboard. The first question could be: Is the field in the left-hand part of the board, yes or no? If the answer is no, then the second question could be: Is the field in the lower section of the right-hand part, yes or no? And so on.

The informational content of a message does not have to be proportional to its length. The answer to a yes/no question consists of one word. Despite its brevity this expression contains a great deal of information. A conversation conducted in a language that we are not familiar with contains little or no information for us, even if the message, in this case the conversation, lasts for a long time. Every message is transmitted with the help of signs. The relative "waste" of signs in the transmission of a quantity of information can be measured and is termed redundancy. The redundancy value lies between 0 (or 0%), indicating zero waste, and 1 (or 100%), indicating maximum waste and thus no information. The informational content of a message depends on the originality of its signs, which in turn is inversely proportional to the probability of the occurrence of a sign. The more original a message is, the less is its redundancy. For example, in the French language the occurrence of the letter W is 40 times less probable than the occurrence of the letter E (Moles 1971, p. 63).This means that the redundancy of W is less than that of E. Redundancy can be used to measure the efficiency of a message. Experiments have shown that the redundancy of the French language is 0.55, or 55%. (Moles 1971, 70). When writing a text, around half the signs are conditioned by the structure of the language, while other half are individually chosen. The redundancy of 55% does not make the French language boring. The degree of originality can decline still further: given sufficient complexity a message can even have 70–80% redundancy and still be interesting (Kiemle 1967, p. 109). Redundancy and originality are inversely proportional. Through learning originality can be decreased and redundancy increased (see Fig. 1.6).

The concept of redundancy is closely connected to so-called predictability. A message can be structured in such a way that, based on the signs already transmitted, the signs that have not yet been transmitted can be predicted and the missing elements reconstructed.

In Fig. 1.4a we see a red stripe lying across a black circle. In our perception the two segments of the circle are automatically integrated into a whole. The form of the circle has a certain redundancy, i.e., a portion of the signs that enable us to recognize its form is unnecessary and therefore "waste." A portion of these signs can be left out without preventing us from recognizing the form of a circle, i.e., the missing parts are predictable. The more regular a form is the greater is its predictability because its regularity triggers expectations.

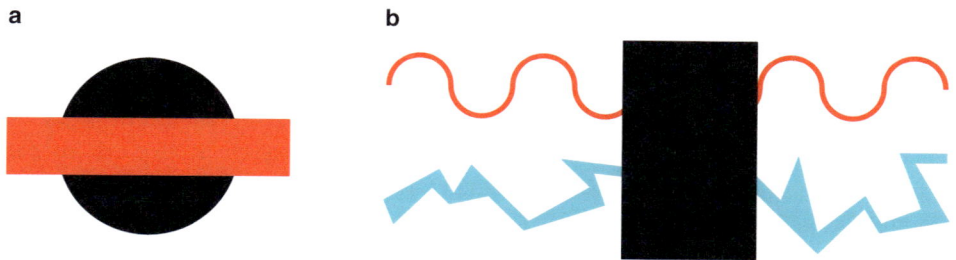

Fig. 1.4 Predictability: The more regular a message, the more predictable its signs (see Fig. 1.17)

In Fig. 1.4b we see two lines that are partly obscured by a rectangle. The upper, evenly curving line exhibits a regular form, its course is predictable, and the section obscured by the black rectangle can be easily reconstructed. No regularity is evident in the case of the lower line, its form cannot be predicted, and it is therefore not reconstructable. Even the three- or fourfold repetition of form triggers an expectation of a further repetition, of periodicity (Moles 1971, p. 103).

And in the present context it is also the case that the more regular a message is then the more predictable are its signs, the less original they are, the more their informational content decreases, and the greater is their redundancy.

The effect is similar when, for example, we look at different facades. When we look at the building in New York (Fig. 1.5b) we find little originality, a lot of redundancy and thereby a high level of predictability; it appears rather boring. The other façade (Fig. 1.5a) has the opposite effect. Although the different elements such as balconies and windows exhibit similar forms, their arrangement and different colours make for a lot of originality and thereby little redundancy.

1.2.6 Information and Repertoire

Every message consists of signs. When a message contains information for the recipient, this means that the recipient is able to understand the signs because he recognizes them as part of his repertoire.

We can comprehend a text because we can read and understand the language. The letters, the words and the language belong to our repertoire and we can therefore understand the information in the message.

The message transmitted by the sender can only be understood by the recipient if the signs making up the message are part of the recipient's repertoire. With the help of predictability, our experience, intelligence and statistical-learning ability we human beings are able to slowly extend our repertoires (see. Figure 1.6) (Moles 1971, p. 22). Over time we will come to understand the meaning of words that we were initially not familiar

1.2 The Message

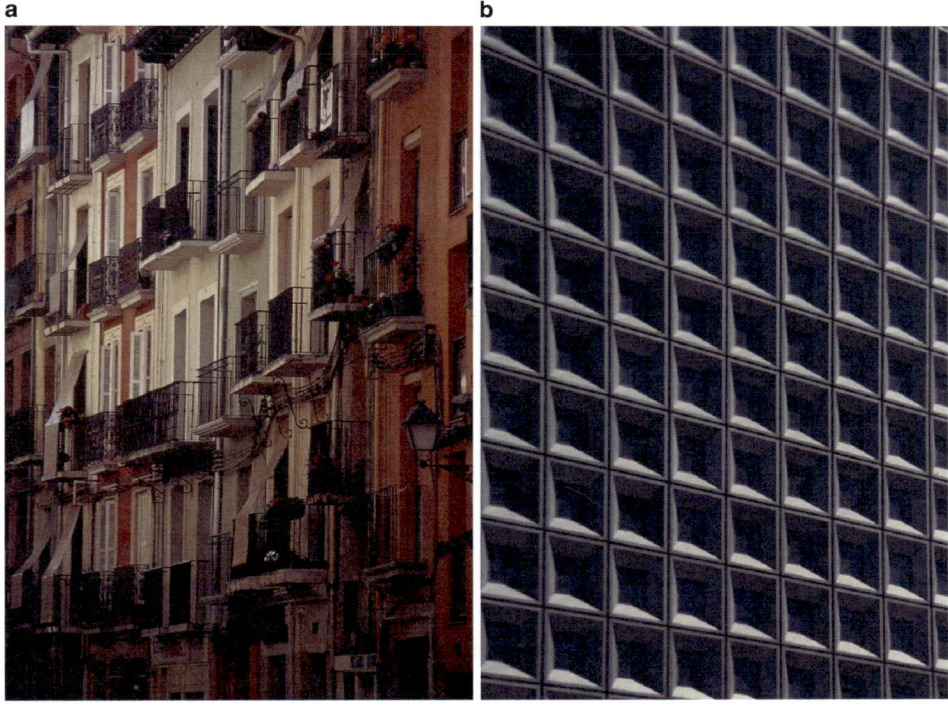

Fig. 1.5 The connection between redundancy and predictability (**a** Pamplona, Spain, **b** New York, USA)

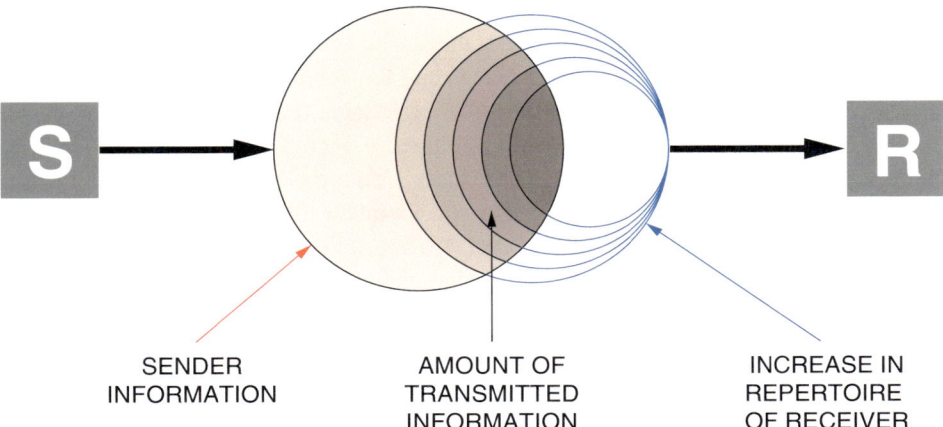

Fig. 1.6 The learning process: adaptation of recipient repertoire to the information from the sender

with. When we have learnt something, our repertoire has been expanded. However, as we have already seen, understanding a text does not necessarily require all the signs in this text to be part of the reader's repertoire. Since the transmission of a message usually produces redundancy, meaning that a portion of the signs used are "waste", we do not rely on all the signs to understand the message (see Fig. 1.4).

1.2.7 Message Disruption and Perceptual Illusion

The message does not always reach the recipient in the exact form in which it was sent. Disturbances to the transmission of a message are termed "noise", regardless of whether they are acoustic or other types of disturbance. When looking at a modern painting it is sometimes unclear which stroke or point is an intentional part of the painting and what constitutes an unintended mark, i.e., noise. It is not always possible to distinguish noise from the actual message, since there is no absolute structural difference between them (Moles 1971, p. 115). The only substantive distinguishing criterion is the intention of the sender. Only the painter of the picture can decide whether something is an element of the artwork or an unintended mark, or noise. However, it is not always possible to ask the artist about his intention. In most cases of perception there is no artist.

Noise is a part of a message that one does not want to receive. This means that it is ultimately the recipient who decides whether part of the message is noise or not. What is perceived as noise and therefore has a disturbing effect cannot be determined in terms of perception theory. In this context psychological and sociological aspects play a decisive role.

In many cases the signals belonging to the message have a higher degree of order than the noise. A single sloping element in a rigorously orthogonal façade can be a disturbance, a noise, for one observer, while another finds this break with the structural system original.

The human organism has several mechanisms for compensating for noise (Stadler et al. 1975, p. 187). One consists of the so-called reflexes. For example, we "automatically" screw up our eyes when confronted with intense light. Another possibility involves the organism, when confronted with disturbances, seeking other ways to obtain equivalent information and then only taking into consideration the information that tends to guarantee a lack of disturbance. (Stadler et al. 1975, p. 133).

Apart from noise there is a second phenomenon that prevents a message being received in the form it was transmitted: the perceptual illusion. In principle, perceptual illusions can be generated under three different conditions (Stadler et al. 1975, p. 136):

a) Contradictory stimulus information:

The two pairs of diverging lines in Fig. 1.7 suggest depth. According to the law of size constancy (Sect. 1.3.5), if the real size of the vertical bars is the same they should actually be drawn in different sizes. Since this is not the case we perceive the left-hand bar as larger than the right-hand one, despite the fact that both have been

1.2 The Message

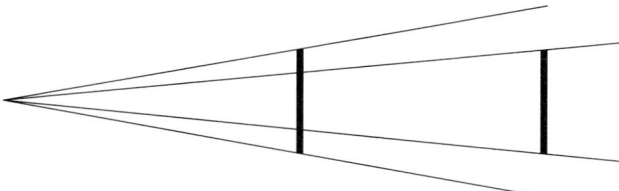

Fig. 1.7 Ponzo illusion

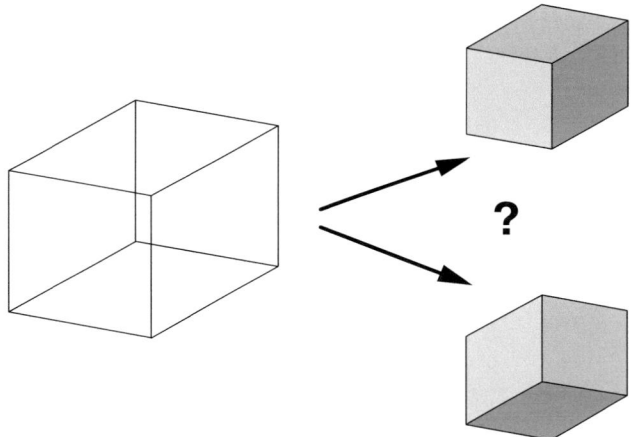

Fig. 1.8 Necker cube

drawn in the same size. Most so-called geometric-optical illusions are based on the principle of contradictory stimulus information (Stadler et al. 1975, p. 139). The so-called Necker cube (Fig. 1.8 left) does not permit stable perception. We see the cube from above or below. Since both interpretations are equally valid, a decision is not possible and the picture changes every few seconds. Such figures are therefore also referred to as ambiguous figures. This effect is often used in art.

b) The second condition under which perceptual illusions are manifested involves overloading the perceptual system. Such illusions are generated when the stimulus configuration is uniform yet complex. The image in figure Fig. 1.9 is structured from only a few elements, which are slightly different in different positions. The result is an overload of the perceptual system.

c) The third aspect that can lead to an illusion is the underloading of the perceptual system. Human beings depend on perceptual stimuli. As mentioned above, the absence of these perceptual stimuli for a long period can lead to hallucinations and other disturbances. What is important here is not the intensity but the complexity of the stimuli.

Fig. 1.9 "flashes", Clarc Benton, 2010: an illusion caused by overloading the perceptual system

It is not weakness but monotony that leads to the illusion. The phenomenon of the mirage can in part be traced back to this effect.

1.3 The Receiver

The message receiver, in our case the human being, must be equipped for the reception of messages. The instruments designed for this reception, the sensory organs, translate the physical, chemical and mechanical movement patterns of the material into biochemical and biotechnical potential (Stadler et al. 1975, p. 76). A further transformation takes place in the transition of the message through the receptor, the actual "reception antenna", to the nerve cords. Here, the message is translated into impulses similar to the binary system of a computer (see Fig. 1.11).

1.3.1 The Sensory Organs

Aristotle was the first to classify the human sensory organs and distinguished between the senses of sight, hearing, smell, taste and sound (Stadler et al. 1975, p. 79).

1.3 The Receiver

Today we distinguish between several other senses as well, such as the temperature sense (thermoception) and the pain sense (nociception). These can be seen as subcategories of the five main senses. The senses can be divided into two main groups: those that function at a distance, such as seeing, hearing and smelling, and those that require direct contact, such as the senses of touch and taste.

In terms of developmental history the oldest sense is the sense of smell. Smells awaken much deeper memories than, for instance, visual and auditory impressions. The role of the sense of smell in the experience of architecture is underestimated. For instance, we often do not feel at ease in a room that smells unpleasant.

The role of our sense of hearing in the perception of architecture is also underestimated. Auditory perception also provides information about architectural space: characteristics of surfaces and materials, the size of a space, whether the space is empty or furnished, etc. When eyes and ears receive contradictory information, for instance, about the location of a source of sound, we usually trust our eyes. Almost 3500 times more sensory cells are available for seeing as for hearing.

Our sense of hearing enables us to perceive the direction and distance of a sound source. The direction of a sound source is identified by comparing the stimuli registered by both ears (Linder 1967, p. 189). A sound coming from the left first reaches the left ear and then the right one. The marginal time difference between these two events suffices to determine the direction of the sound source. Human beings can distinguish between two sound sources separated by an angular distance of less than ten degrees (Linder 1967, p. 189). The determination of the distance from the hearer of a sound source is based on experience (Linder 1967, p. 189). The frequency spectrum seems to play a role here. Along with direction and distance we can also perceive the movement of a sound source (e.g., a passing car). Movement involves a combination of direction and distance. Finally, hearing is the key to one of the most important means of communication: language.

In contrast to seeing and hearing, our sense of touch requires movement. Haptic perception therefore usually takes place successively in accordance with the course of a movement. Our sense of touch enables us in the first place to perceive surface structures, and only then to comprehend shapes. For very young children the sense of touch is more important than visual perception.

The sense of taste is irrelevant when it comes to the perception of space, and it therefore has at most an indirect influence on the experience of architecture. For instance, we probably tend to experience a space in which we eat well in positive terms.

Seeing became increasingly important over the course of evolution, and today the sense of sight is certainly the most important sense when it comes to experiencing our environment. In the beginning human beings probably relied more on their senses of smell and hearing, as many animals do. Based on their visual perception, human beings subsequently created writing as an additional system of communication. Writing can be characterized as an "extension" of memory.

In the following, we will be concentrating above all on the sense of sight, since this is the most important sense for the perception of architecture.

1.3.2 The Process of Seeing

The term "perceive" comes from the Latin "percipere", meaning "to receive, understand." "Percipere" is based on the prefix "per", meaning "thoroughly", and "capere", which means "to seize, take". This implies that when we perceive something, we grasp it in its totality. What we see is regarded as true. But is this the case?

At the beginning of the seventeenth century Johannes Keppler concluded that it was not. He knew that the evening sun did not "sink" below the horizon because the Earth revolves around the sun. There is no objective reality. What we register in our environment is not simply a copy but an independent image. Our experiential world does not correspond to the physical world. We experience our environment only within the boundaries of our senses and even in this context there are differences from person to person. We do not have direct access to our environment. The information we register is filtered by our sensory organs. As early as the first century AD, Pliny the Elder, in his work "Naturalis Historia", argued that human beings do not really see with their eyes but with their mind. Seeing is translation, the transmission of an externally existing world to our perceptual world. This process is conditioned by different "filters", such as our personal experiences, our character and our prevailing state of mind.

The range of information that we consciously absorb is cultural conditioned. It is closely dependent in our particular life story (see Sect. 1.4). In order to be able to act and react appropriately and reliably we need to be able to reliably register our environment.

Figure 1.10 shows that we sometimes to see things in a way that does not correspond to their objective reality. Conversely, we sometimes fail to see things that do indeed exist, or we only see them after precise observation. For example, cigarette advertising shows us an idealized world of enjoyment and relaxation. However, when we observe this advertising more closely, we are able to read that smoking can be deadly. These days we are subjected to a deluge of optical information. And we know that much of the information transmitted in films and advertising simply cannot be true.

"Seeing" begins with the light energy either radiated or reflected by an object (Fig. 1.11). The energy of the image is projected through the ocular lens inversely onto the light-sensitive retina. We direct our gaze such that the projection of the focal point, the most interesting segment of the visual field, falls on the most sensitive part of the retina. Differentiated perception takes place within this relatively small area, which extends over only 2–5° of the angle of vision (Stadler et al. 1975, p. 90).

The retina's receptor cells are divided into two types: so-called rods and cones (Linder 1967, p. 182). Rods outnumber cones by a factor of eighteen and are responsible for the perception of light and dark. Cones are responsible for the perception of colours. Cones and rods are not equally distributed over the retina. The peripheral areas of

1.3 The Receiver

Fig. 1.10 Herzog & De Meuron, 1999, Institute for Hospital Pharmaceuticals, Basel, Switzerland

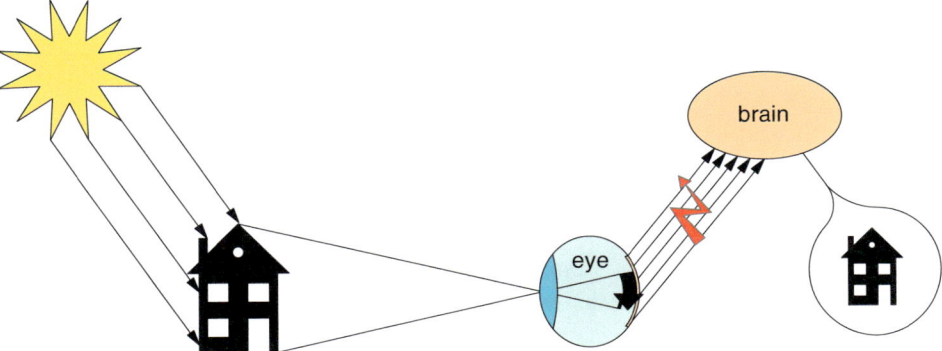

Fig. 1.11 The process of seeing, from the eye to the brain

the retina contain only rods, which are far more light-sensitive than cones and are therefore responsible above all for mesopic vision. Due to the irregular distribution of rods and cones, visual acuity is different in daylight and half-light (Stadler et al. 1975, p. 90).

In half-light acuity is consistently high around the periphery of the visual field but rather low in the central area. In daylight the situation is reversed, with visual acuity at its highest at the centre of the visual field.

Electrical signals are transmitted from the receptor cells, the light-sensitive cells on the retina, to the optic tract, which transmits the message directly to the brain. Here the signals are in turn processed into images. How this conversion of the nerve impulse into the visually perceived image takes place is still not completely understood (see Sect. 1.3.4).

1.3.3 Reception Capacity and Memory Storage

The eye and the other sensory organs transform perceptual stimuli into impulses. These in turn enter the central nervous system in the brain. Like a computer, the brain has a certain maximum intake capacity, which means that the amount of information it can take in per unit of time is limited. As we have seen, the informational value of a message is closely connected with its unexpected, its original elements. Reception capacity is conditioned by the degree of originality, by the part of the message that is unexpected and therefore interesting for us. The choice of optical, acoustic and haptic signals on offer is far greater than the maximum intake capacity.

Different experiments have shown that the maximum intake capacity is 16 bits per second (Gunzenhäuser 1975, p. 107). The smallest unit of time that can be registered by the human eye is 1/16 of a second, i.e., 16 optical signals can be received per second, a phenomenon that is exploited in film-making. If the number of signals is greater than this, we experience the individual signals not as individual units but as a "moving" image. Experiments have shown that this intake capacity of 16 bits per second also applies to acoustic perception (Schuster and Beisl 1978, p. 48).

We utilize only a very small fraction of the signs we receive. From the multitude of signals available to us we select only those that enable us to monitor our environment at a particular time. The number of signals required to be effective in this respect also depends on the recipient's knowledge of the message structure, which is in turn conditioned by the recipient's socio-psychological milieu. For example, when we are standing at a traffic light and want to cross the street, the information "green" or "red" suffices for us to monitor our environment. Someone who does not know the meaning of the traffic light needs much more information in order to monitor the situation. Before he can proceed he needs to ensure that no car is approaching from any direction.

Perception is not a passive process. The available amount of stimuli can be summarized and reduced through organization. This process is known as the "formation of super-signs" (Schuster and Beisl 1978, p. 49). The first step entails the automatic "summarization" of similar signs or organizational structures into a super-sign, in which the essential elements are emphasized. This means that at first glance the observer does not perceive all details. He sees, for example, only the form of a wall with the most

1.3 The Receiver

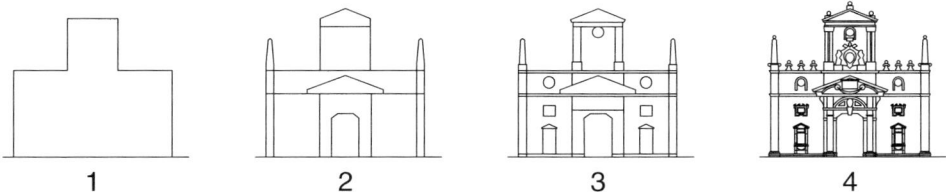

Fig. 1.12 Formation of super-signs: multiple summarization of similar signs or organizational structures (Michelangelo, 1564, Porta Pia, Rome, based on the original design). Fig. 1.13 shows the building today

important openings but without any details (Fig. 1.12). This reduces the quantity of information available for reception. The work of information storage is diminished and we can thus better perceive and monitor our environment. Regularities within a stimulus configuration are summarized and the essential aspects are accentuated. The next step takes place on another level of perception and involves the registration of additional elements. This process can be repeated multiple times until what is being seen is sufficiently identified.

Whereas the formation of super-signs constitutes a simplification, architectural design is the opposite. An idea is a vast simplification of a future project. The idea gives rise to a concept and ultimately the plans for the realization of a building. This process leads from a vast simplification to complexity (Fig. 1.14 and 1.15). The first sketches for a residential building on a narrow plot on a slope illustrate the idea. In order to allow a view of the valley to be enjoyed from all rooms, the cube is recessed on both of its long sides. This idea was developed and integrated into the concrete construction plans for the building.

The received information is absorbed by the brain, where it is evaluated and stored. There are two types of storage available for this purpose: short-term memory and long-term memory (Schuster and Beisl 1978, p. 48). The short-term memory can absorb information at an average rate of 16 bits per second. However, the units of information can only be stored for around ten seconds. After this relatively short period the information is passed onto the long-term memory or dumped, meaning forgotten (Gunzenhäuser 1975, p. 108). The quantity of information passed from the short-term memory onto the long-term memory is relatively small and amounts to an average of 1 bit per second, or between one fifteenth and one twentieth of the amount that reaches the short-term memory (Schuster and Beisl 1978, p. 48). A telephone number is stored in the short-term memory until it is dialled immediately afterwards and then forgotten. The maximum storage capacity of the short-term memory is 160 bits, i.e., ten seconds for every 16 bits. This capacity is also dependent on the age of the person concerned and can vary. The highest capacity is reached when a person is approximately 20 years old (Gunzenhäuser 1975, p. 108). The maximum storage capacity is seldom fully utilized. The larger the degree of redundancy, the smaller is the amount of information stored in the short-term memory. At between 40 and 60 bits of information, consciousness is already operating

at near full capacity (Kiemle 1967, p. 109), i.e., the message is registered as interesting. The amount of information reaching the sensory organs is 10^9 to 10^{11} bits per second (see Fig. 1.16). If the quantity of information passed on to the short-term memory is represented as a cube with a side length of one centimetre, then the information reaching the sensory organs corresponds to a cube with a side length of 17 m. This comparison indicates the amount of information we are deluged with. As a redundancy process, the formation of super-signs is not only a way of surmounting the large amount of available information but also an essential prerequisite for experiencing the sensation of beauty (see Chapter 8). Every perception therefore should be able to take place on at least two perceptual levels (see Sect. 8.3).

1.3.4 Gestalt Theory and Deduction Theory

Precisely how signals are directed from the retina into the brain is still not fully understood and different approaches have been developed to explain this process. The two most important of these approaches are gestalt theory and deduction theory (Moles 1971, p. 21).

1.3.4.1 Gestalt Theory

The foundations of gestalt theory derive from the work of René Descartes (1596–1650)and Immanuel Kant (1724–1804). Descartes argued that at birth the human brain is not a "blank page." The human being has innate information about the perception of space, form, etc. The information absorbed via the sensory organs is compared with this innate information, organized meaningfully and then processed. Images are generated by the appropriate organization of sensory impressions, not only through their interconnection. The whole is thus more than the sum of its parts. The principles of perception developed by gestalt theory are formulated in the gestalt laws. These laws are based on the fact that every stimulus pattern is organized by the perceptual process such that the resulting structure is as simple as possible (Arnheim 1978, p. 223). The following provides a brief summary of the laws that are most important for architectural perception.

Law of *Prägnanz* or law of good gestalt In the perception of segments of forms or incomplete figures, there is a tendency to turn them into complete figures, i.e. forms with "good gestalt". Incomplete aspects are supplemented with the aim of achieving the highest possible degree of orderliness or regularity (symmetry, right angle, etc.), and the figure is matched with forms that are already familiar (see redundancy and predictability). When we observe an interrupted circle for a brief moment, we do not perceive the interruptions but instead see a closed figure (Fig. 1.17a). In Fig. 1.17b we "see" lines that do not exist and, as a result, the figure is supplemented to form a cross. This means that what is drawn is supplemented in the perceptual process to produce a simpler figure with a higher degree of regularity. According to the law of "good gestalt" the simplest and

most stable possibility is selected from a range of different possible geometric organizational patterns.

This can result in misinterpretations. The drawing to the left in Fig. 1.18 allows for two different interpretations. Based on the figure-ground phenomenon the lower interpretation would seem to be the correct one, but the upper interpretation is also possible.

Law of proximity When an individual perceives a large number of the same or similar elements, those that are close to one another are linked together to form a larger unitary figure (see Sect. 1.3.3). In the case of the facade of an apartment block designed by Bruno Taut (1927) in Berlin (Fig. 1.19) the many small windows on the outside of the stairwell are grouped together into a vertical strip. A similar process occurs in our perception of the small windows under the roof (see Fig. 1.20).

Law of closure While according to the law of proximity elements close to one another are grouped together, according to the law of closure elements are combined into a figure when, as a group, they give rise to a closed form. Perceiving the four small squares in Fig. 1.21 as one large square decreases the storage capacity required for this perceptual information.

Law of similarity We also perceptually group similar elements together to form a single figure. We see the red strip-shaped facade elements on the building by Peter Eisenmann in Berlin (Fig. 1.22) as a continuous element, even though the strips are interrupted in places. We perceive the dark grey elements in a similar way (see Fig. 1.28).

According to gestalt theory the perceptual mechanism not only organizes the stimuli registered by the retina but orders them in a way that simplifies the recognition of objects (Stadler et al. 1975, p. 117). In this process incomplete stimulus patterns are supplemented. This mechanism is expressed in part by the laws of gestalt theory discussed above.

This process of supplementation is most obvious in the case of the so-called blind spot: the position on the retina where the nerve cords lead to the brain. There are no photoreceptors in this small area of the retina, and as a result this part of the eye only registers a black spot. However, this is compensated for by an automatic supplementation of our perception.

1.3.4.2 Sampling Theory

According to gestalt theory the observer first gains an overall impression of what is perceived and then works out the details of what is being perceived in a step-by-step process. The observer forms a super-sign, which is then divided into further super-signs (see Fig. 1.12 and 1.13). However, perception does not always follow this pattern.

When we read, our eye follows the lines; we register word after word, sampling the book page. According to so-called sampling theory the overall impression arises from many small pieces of information; the whole emerges from its individual parts. Sampling theory is a product of the study of psychophysiology. The fact that the field of greatest visual acuity (focal point) is relatively small, namely 2–5°, seems to support this theory.

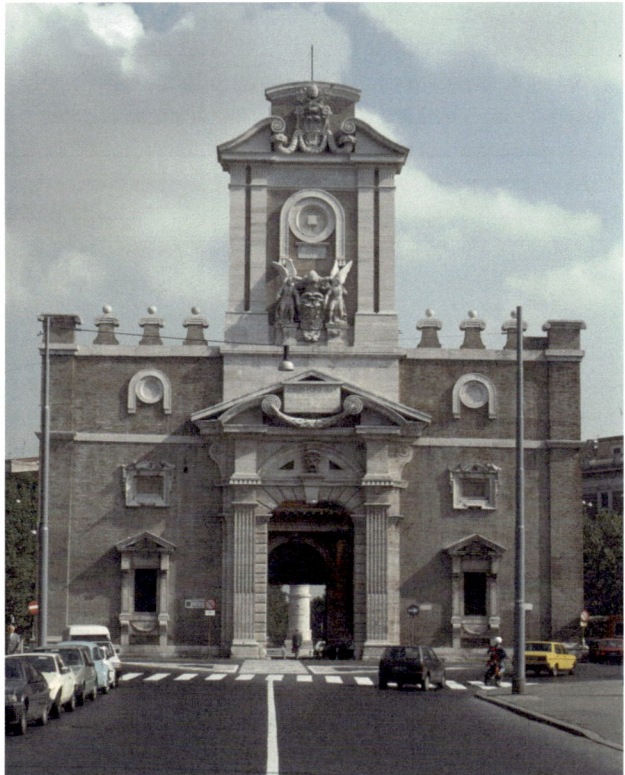

Fig. 1.13 Michelangelo 1564, Porta Pia, Rome

At first glance it might seem that the methods of seeing whole forms and sampling exclude one another. But this is not so; sampling and gestalt theory complement one another, although one of these two types of perception takes precedence in each particular case (Moles 1971, p. 110). The maximum amount of informational units a human recipient is capable of absorbing in a holistic fashion, i.e., as a gestalt, within a given unit of time is limited. If the number of such units making up a message exceeds this limit, the recipient will disregard some of these elements or sample them. We first recognize a house in terms of its contours, its gestalt. In a further perceptual step we then register open and closed elements. The more detailed our observation, the more probable it becomes that we will switch to the sampling method, namely when we observe things exhaustively and in a way that makes them memorable (see Fig. 1.13).

1.3.4.3 Deduction Theory

Deduction theory was systematically developed in the nineteenth century by the German physiologist and physicist Hermann von Helmholtz. In contrast to gestalt theory, which

1.3 The Receiver

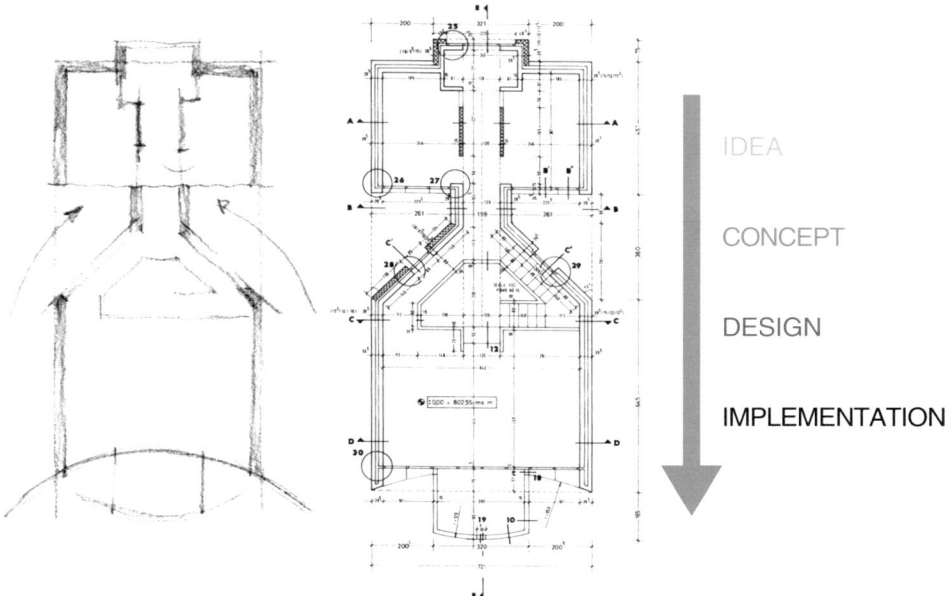

Fig. 1.14 The process of design as the converse of the formation of super-signs (Jörg Kurt Grütter 1988, residential building, Arosio, Switzerland)

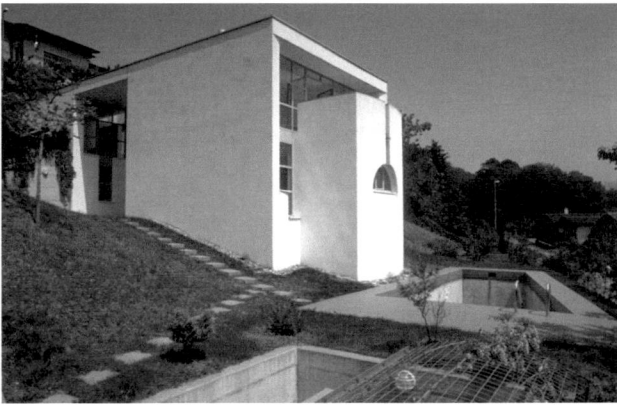

Fig. 1.15 Jörg Kurt Grütter 1988, residential building, Arosio, Switzerland

is based on the idea that the human being is already equipped with specific information at birth, deduction theory argues the opposite, namely that the human mind is initially a "blank page." It is experience that enables the individual to interpret subsequent perceptions. New experiences are compared with those already stored in memory. Based on this

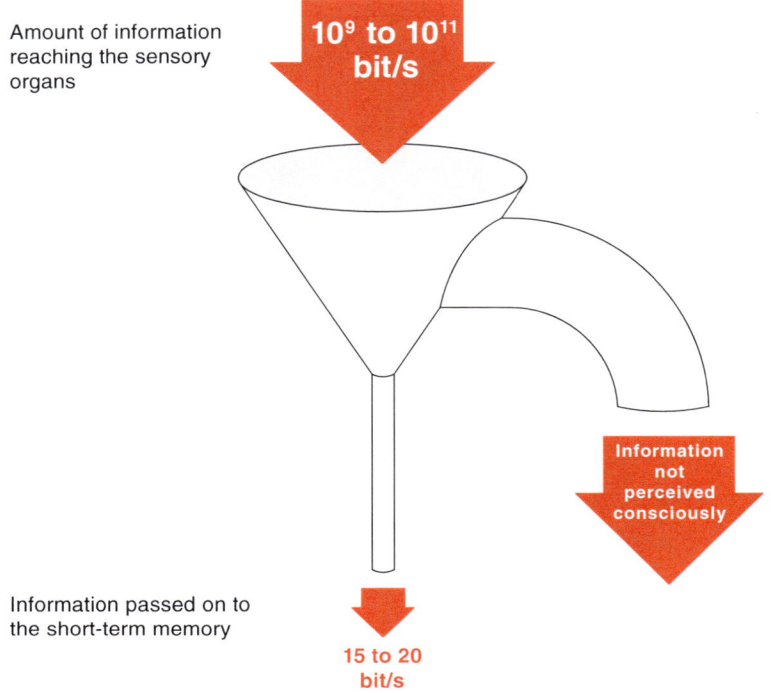

Fig. 1.16 The flow of information. The amount of information reaching the sensory organs is many times greater than the amount of information stored in the short-term memory and partially transferred to the long-term memory

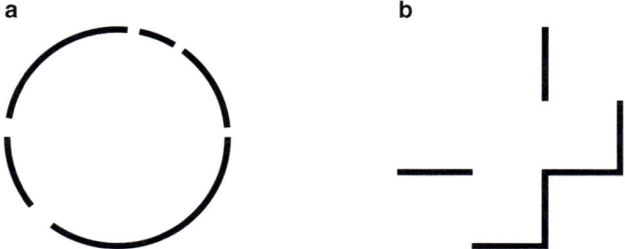

Fig. 1.17 In the process of perception the incomplete figure is automatically completed. We automatically extend the segments of the circle (**a**) to form a closed figure. In **b** we see a cross rather than three parts

comparison a hypothesis is formulated, which is in turn tested. Understanding is thus only possible due to experience.

Based on a comparison with the information stored in memory, the circle in Fig. 1.23 1) can represent many things: a ring, a coin, the Sun, etc. Drawing 2 limits this range of

1.3 The Receiver

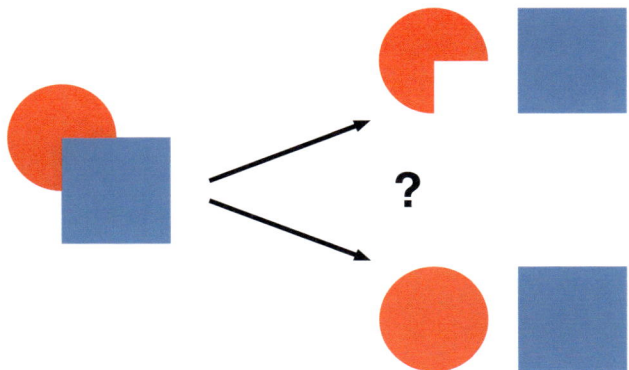

Fig. 1.18 Different interpretative possibilities

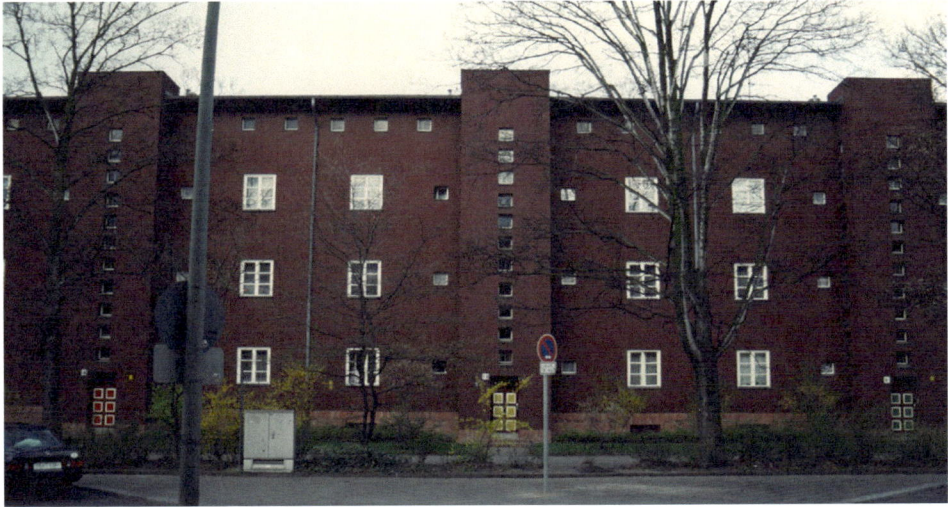

Fig. 1.19 Bruno Taut 1927, apartment block, Berlin (Germany)

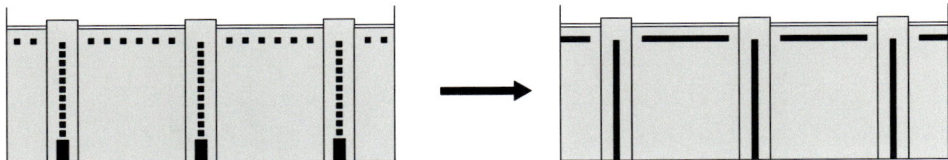

Fig. 1.20 Based in the law of proximity the rows of windows are perceived as units

possibilities: two overlapping coins of different sizes? Drawing 3 could represent an animal, but which animal? Drawing 4 obviously represents a cat.

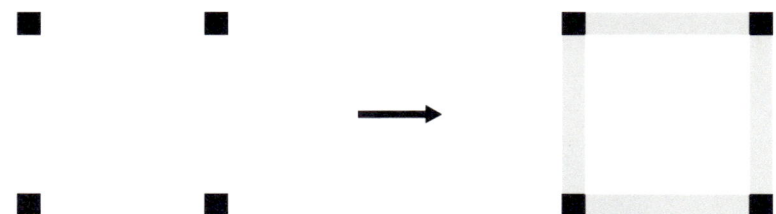

Fig. 1.21 According to the law of closure elements are combined into a figure when, as a group, they give rise to a closed form

Fig. 1.22 Peter Eisenmann, 1986, residential and office building, Berlin, Germany

Architects often consciously utilize the effect of familiar perceptual patterns. This approach varies depending on the style in question. The photo in Fig. 1.24a evokes

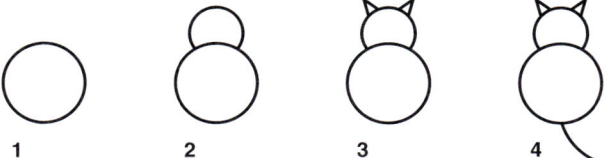

Fig. 1.23 Comparing what is seen with stored experiences

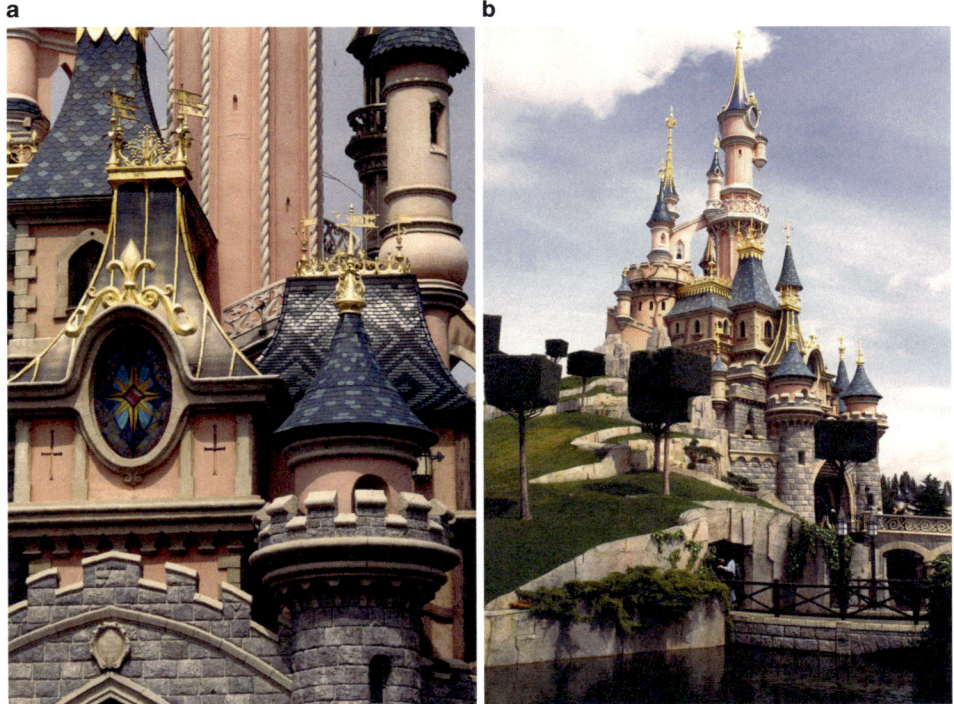

Fig. 1.24 Cinderella Castle, Disney Land Los Angeles, USA **a** detail **b** overall view

different memories for the beholder: Middle Ages, castle, fairytale, etc. This building in Disneyland in Los Angeles (Fig. 1.24b) was modelled on Neuschwanstein Castle, which was built in Bavaria, Germany, in the latter half of the nineteenth century. Such models can also be adopted as "quotations." For example, Richard Meier's museum built in Barcelona in 1995 (Fig. 1.25b) features slit windows almost identical to those designed by Le Corbusier for the La Tourette monastery in 1957 (Fig. 1.25a).

In the case of certain instances of perception, different ways of processing experience can lead to conflicts. For instance, when a pattern is observed that does not fit with the experiential repertoire of the beholder, the result is an optical illusion. This is an effect that architecture in part quite consciously works with.

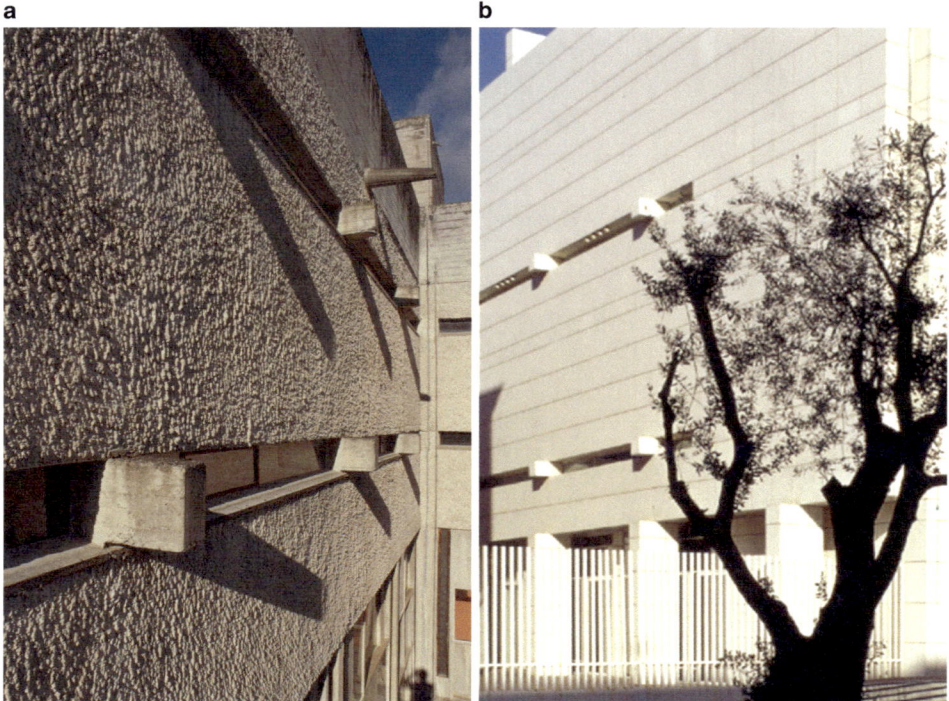

Fig. 1.25 Working with similar patterns: architectural quotations, **a** Le Corbusier 1957, La Tourette monastery, France, **b** Richard Meier 1995, museum, Barcelona, Spain

When looking up into the dome in a shopping centre in Singapore (Fig. 1.26) built by Philip Johnson in 1996, the beholder is confounded because he expects to see a square or at least a rectangular form. This expectation is reinforced by the orthogonally arranged staves on all sides of the dome. In fact the dome has the form of a rhombus. This confusion is intended: tension is created by distorting the banal motif of the square.

The modes of perception posited by gestalt theory and deduction theory do not exclude one another. Depending on the situation, one or the other comes into play, or both of them are utilized simultaneously.

Another important aspect of the process by which we understand and interpret the information we receive concerns the figure-ground phenomenon.

The figure-ground phenomenon Every differentiated perceptual pattern incorporates depth, i.e., we see a figure against a background. Even a black letter on a white page is perceived as a figure against a white ground. In Fig. 1.27a the dark green strips are narrower than the light green ones. We see the light green surfaces as a continuous background on which the darker strips are laid. In Fig. 1.27b the small dark green squares

1.3 The Receiver

Fig. 1.26 Philip Johnson 1996, cupola in the "Millenia Walk" shopping centre, Singapore

Fig. 1.27 Figure and ground, **a** dark strips on a light background, **b** a dark strip behind light rectangles

are positioned along a horizontal line. Their spatial organization causes us to read them as connected, as a continuous strip that is positioned behind the light green rectangles. This type of perception also involves information reduction: we register a horizontal strip rather than six small rectangles.

On the facade of the building by Peter Eisenman in Berlin (Fig. 1.22) we can perceptually distinguish between several overlapping levels (Fig. 1.28). The number and type of these levels can differ individually.

An observer of the facade of the Santa Maria Novella church by Alberti in Florence (the church was built around 1300 but the facade not until 1470) sees different dark figures against a light background (Fig. 1.29).

The manner in which the figure-ground phenomenon functions is subject to several rules. The closed areas appear in most cases as a figure, the open ones as ground. In the case of the facade in Florence, the observer reads the smaller dark parts as figures and the lighter areas as continuous background. The segments belonging to the ground area thus tend towards the formation of a connected background.

Fig. 1.28 Different perceived levels. Facade of the residential and office building by Peter Eisenmann in Berlin, Germany (see Fig. 1.22)

Fig. 1.29 Alberti 1470, facade, Santa Maria Novella church, Florence, Italy

1.3.5 Constancy

So-called variable constancy is one the most important organizational principles of visual perception (Stadler et al. 1975, p. 131). The correspondence between reality and perception is relatively high despite the significant difference between the real object and its two-dimensional projection on the retina. In Fig. 1.30 we can see two rows of pillars. We see those in the background as far smaller than those in the foreground. The lightness of the colours of the individual arch constructions and the pillars differs, i.e., they appeared differently coloured. Nevertheless, we know that all the pillars are all the same size, that the gap between them remains constant toward the back, and that the form and colour of all the arches is the same.

What would things be like if this were not the case? Every building, every object, indeed our whole environment would present itself as a moving monstrosity every time

Fig. 1.30 Portico di San Luca, 1674–1739, Bologna, Italy

we moved in relation to it. The smaller the gap between the observer and the object, the greater would be the size of the object and the more the form of a building would change. A walk along a busy street would become a horror trip. We would be inundated with far too much information.

The way in which information from the retina is processed in the brain allows objects to appear to us in a form similar to how they are in reality. Experiments have shown that even infants only a few weeks old are able to recognize objects correctly (Bower 1966, pp. 80–92). It follows that visual constancy is not a learned capacity. However, the correction of a stimulus pattern does not always occur automatically; the human being reacts differently depending on the situation. So-called optical illusions occur when an appropriate correction is not possible. The most important aspect of perceptual constancy is the stimuli coming from the environment. These provide the standard values according to which perception is relativized.

Size constancy The size of an object projected onto the retina is "corrected" in the brain in accordance with the distance between the eye and the object, i.e. we perceive objects such as the pillars in Fig. 1.30 as of the same size regardless of their distance from us. Stimuli in the surroundings provide reference points for determining the distance between the observer and the object, and these reference points enable us to perceive size correctly.

Shape constancy In perceptual terms, the arches and pillar capitals in Fig. 1.30 retain their form even if we move in relation to them and see them from different directions. The projection of a round arch is oval on the retina and yet we perceive the arch as round.

Law of invariant formation The law of invariant formation derives from size constancy and shape constancy. In the perception of different objects it is not only their sizes and shapes that remain constant but also their positions relative to one another and to the observer. Despite the observer's eye and body movements the objects remain "in one spot" and retain their size and shape.

Colour and lightness constancy Colour and lightness perception is constant within certain limits. The colours of the arches in Fig. 1.30 change from light to almost black. However, even though we perceive very different colour tones and degrees of lightness, it remains clear to us that the colour tone and lightness are constant (see Fig. 10.18). The irregularities are levelled out in the brain, i.e., a mean value forms the reference system for all areas of the object.

1.3.6 Depth Perception

In the case of size constancy and shape constancy and visual perception in general the distance between observer and object and between objects relative to one another plays a decisive role. The three-dimensional Euclidean space is projected onto both concave surfaces of the retina in both eyes and must be transferred from there into

1.3 The Receiver

a three-dimensional perceptual space in the brain. In this process the third dimension, i.e. depth, plays a key role.

How is distance perceived? Important reference points are provided by our surroundings. But these are not the only ones. The eye – considered as a mechanical apparatus – provides additional information.

Depth perception is actually based on the differences in the perspective imaging of an object that is horizontally elongated (in Fig. 1.31 defined by points A and B). The retinal projection of the length AB is not the same size (X and Y) in both eyes. Depth perception based on unequal retinal projections only functions up to a distance of about 100 m. At greater distances the size difference on the retinas in both eyes (X and Y) is too small.

This mechanism functions so precisely that length differences between retinal projections by only one photoreceptor cell (=1/600 of a mm) are already registered as depth differences (Metzger 1975, p. 349). However, this method of measurement does not provide us with absolute depth values, such as the distance from point A to the eye, but only relative values, such as the depth difference between A and B. On the other hand, this has the advantage that not every point needs to be measured and allows for the simultaneous perception of the depth distribution of very complex forms. Depth perception requires a certain width. As a result it is very difficult, for example, to determine how far away a vertical line is without a reference point in the surroundings.

Certain types of depth perception, however, do not necessarily require both eyes. As we have seen, every gestalt has a background: there is no purely two-dimensional perception (see "The figure-ground phenomenon" and Fig. 1.27). However, the size of the gap between the two layers remains unclear.

In the case of smaller distances (up to two meters) the ocular lenses adapt, a process known as accommodation in which the information provided by the shape of the lens enables the brain to "calculate" the distance in question.

Identical segments positioned at different distances, such as the wall and ceiling cladding segments in Fig. 1.32, are imaged on the retina in different sizes. Nevertheless, we perceive them as equal in size. When seeing similar objects of different sizes, the larger

Fig. 1.31 Different retinal imaging in both eyes (X and Y)

Fig. 1.32 Norman Foster 1996, subway station, Bilbao, Spain

ones appear closer, the smaller ones further away. Here, three-dimensional perception is supported by the lines converging at their vanishing point, so-called texture gradients.

Given the same conditions, yellow and red objects appear closer than blue and green ones. This difference can play a role in the perception of interior spaces. For instance, the perceived depth of a space can be increased or decreased by the use of colour (see Sect. 10.6.3).

Figures with a greater difference in brightness from their background appear further forward than those with a lesser degree of difference. In Fig. 1.33a the dark, middle strips appear further forward, while those at the side appear to be further back. This effect can be used to represent the form of a cylinder in a two-dimensional drawing (Fig. 1.33b).

As discussed in Sect. 1.3.2 the so-called receptor cells are located on the retina. When light hits these cells they emit impulses that are then directed into the brain. The individual receptor cells do not function independently of one another but are interconnected.

Fig. 1.33 Depth perception based on different degrees of brightness: **a** The lighter the strips, the further back they appear, **b** in the case of flowing colour transitions in a closed form we see a three-dimensional cylinder

1.3 The Receiver

Fig. 1.34 Perceived brightness difference

When an impulse flows through a nerve tract, the tracts in the neighbouring receptors emit a negative impulse, which means that the neighbouring tracts are "inhibited." A nerve tract lying in the midst of a brightness field receives negative impulses from its two neighbouring tracts and as a result is almost neutralized.

A nerve tract on the edge of a brightness field receives negative electrical currents only from one side and is thus still capable of transmitting messages. As a result, higher, or positive, electrical currents are manifested on the edges of a brightness stimulus. Inside the field of the brightness stimulus the positive currents are almost neutralized and as a result no message is transmitted from this region (Schuster and Beisl 1978, p. 21) (Fig. 1.34). The interconnection of the nerve tracts on the one hand leads to better perception of contrast in an image (brightness difference) and, on the other, to a weakening of the message inside the brightness field. This means that we perceive contrasts in an image as more intensive than they actually are in reality.

1.3.7 Perceptual Orientation in Space

In order to orientate themselves in space, human beings rely on two different perceptual systems: the visual reference system and kinaesthetic sensation. The kinaesthetic reference system is based on the equilibrium organ in the ear and muscle sensations.

The effect of gravity leads to kinaesthetic sensation, and as a result it is possible to distinguish up from down without the help of visual orientation. Whatever position our body is in we are aware of gravity and therefore are constantly aware of where up and down are. In the absence of gravity kinaesthetic perception is impossible and we are therefore forced to rely exclusively on our visual reference system. Visual orientation requires reference objects. In an empty, unlimited space the visual identification of up/down and forwards/backwards is not possible. Defined space serves as a reference system. The American psychologist Hermann Witkin showed in experiments that, depending on their personality, human beings rely more on one system than the other: the introverted type relies more on the kinaesthetic system, the extroverted type more on orientation based on the visual reference system (Arnheim 1978, p. 223).

These two orientation systems provide our perceptual capacity with a structural framework, a grid that facilitates measurement and orientation. The main axes of this system are the horizontal and the vertical. The horizontal separates "heaven" and "earth", it forms a horizon. The vertical links the solidity, the palpable of the earth with the unreal void of the sky, the realm of humans with the sphere of the divine and therefore plays a decisive role in all sacred architecture.

The human eye prefers horizontal-vertical seeing over a diagonal plane of reference. The explanation for this is provided by the fundamental principle of gestalt psychology: every stimulus pattern tends to be seen such that the resulting structure is as simple as possible. In the vertical we move with or against gravity depending on whether we are moving downwards or upwards. In the horizontal, at least at first glance, every direction is neutral. A horizontally orientated environment facilitates free movement and interpersonal contact, whereas a vertically organized environment tends to stimulate hierarchical and competitive thinking. In the case of a building the intersection between horizontal and vertical is usually located where the building touches the natural ground. The design and form of this point of contact determine the perceived relationship of the object to its surroundings. For example, we perceive a building as standing on the ground, as protruding from the underground, as threatening to "sink", etc. (see Fig. 7.11).

A horizontally accentuated object "lies" on its ground area. For the visual sense vertical elongation is more important than horizontal elongation (Arnheim 1980, p. 52). A square only appears as an equilateral four-sided figure when its width is in reality somewhat greater than its height. This is probably due to the fact that a horizontal eye movement uses only half the muscles employed in a vertical movement (Gunzenhäuser 1975, p. 67). As a result, the perception of horizontal elongation is less demanding than that of vertically accentuated elements. In this context it is worth noting Otto Bollnow's observation that lying and standing involve fundamental differences that go far beyond the physical sphere and ultimately co-determine the entire relationship between human beings and their surroundings. (Bollnow 1980, p. 170).

Whereas visual perception is more orientated to the vertical and thus height differences are perceived much more readily than width differences, human behaviour is paradoxically orientated more to the horizontal plane, which is perceived as neutral.

1.3 The Receiver

The conceptual pairs above/below and right/left are closely linked with the oppositions between vertical and horizontal, with the former relating to the vertical and the latter to the horizontal. Going upwards entails moving against gravity and it follows that resistance to this movement is greater than that experienced when going downwards. The potential mass energy of a more elevated object is higher than that of a less elevated one, and the perceived "weight" of an object is greater higher up on an object than the perceived weight lower down (Arnheim 1978, p. 32). There is a hierarchy between above and below. Left and right seem of equal value but they are not. The similarity of the left and right side of the individual is limited to the outside, whereas the arrangement of many inner organs is asymmetric. Most people write with their right hand. A clumsy person has "two left hands." People also perceive distinct differences between these two directions in psychological terms. Right is also a concept associated with "correct" and "just." The right-hand side is often the preferred one: a woman may walk on a man's right, a guest of honour sits to the right of the host, etc. In short, right and left are not equivalent. In the perception of an object using the sampling method (see Sect. 1.3.4.2), sampling proceeds from left to right. An object positioned to the left in the visual field appears "lighter" and smaller to us than the same object when positioned to the right in the visual field. If we have many objects in our visual field, those at the lower left appear to us as the "lightest" and smallest and those to the upper right as the "heaviest" and largest (Arnheim 1978, p. 35) (Fig. 1.35).

An observer identifies more with the left-hand side than the right-hand side, something that is exploited in theatre and film. The left-hand side of a stage is regarded as the more important one and the main character in a performance should be positioned to the left whenever possible, which results in a tendency in the audience to identify with the character and see the action from his or her point of view (Arnheim 1978, 36). It is also for this reason that the good character in a film often comes from the left, whereas the evil character, who is also the viewer's adversary, comes from the right.

This phenomenon also plays a role in our perception of speed. A car travelling from left to right appears to us to be moving faster than the same car travelling at the same

Fig. 1.35 Perceptual change in the size of four equally sized squares according to their position in the visual field

speed in the opposite direction. The reasons for this are not known but it is probably connected with the dominance of the left side of the cerebral cortex (Arnheim 1978, p. 36).

1.4 Socio-Psychological Aspects

Up until now our discussion has focused on the information-theoretical and technical aspects of human perception. These mechanisms often function automatically, like machines. This can create the impression that human perception is also completely quantifiable and reproducible.

The fact that we experience a church space during a wedding in a completely different way to how we experience it during a funeral indicates that this in fact is not the case. In the perception and processing of complex situations it is not only the stimuli impacting on the sensory organs that play a decisive role but also the individual's prevailing psychological state, personality structure formed by different experiences and circumstances in the past, hereditary disposition and socio-cultural background. As already discussed, a selection is made from the large quantity of signs available; super-signs are formed. It also has to be determined which information should be transmitted from the short-term memory to the long-term memory and which information should be immediately forgotten. This process of selection and decision-making is also significantly influenced by socio-psychological aspects.

Since the factors shaping decisions are never identical in the case of two or more people, an identical perception of the same event by two or more people is not possible (Moles 1971, p. 15). Each individual has a unique repertoire of such factors and individual decision criteria.

Bruner and Goodman showed that even simple perceptions are influenced by aspects other than sensory stimuli (Bruner and Goodman 1947, pp. 33–44). They had children estimate the size of different coins and equal-sized cardboard discs. The result was that the size of the coins, in contrast to that of the cardboard discs, was estimated to be bigger than it actually was. Bruner and Goodman interpreted the result as follows: "First off, coins, socially valued objects, are judged larger in size than gray discs. Secondly, the greater the value of the coin, the greater is the deviation of *apparent* size from *actual* size" (Bruner and Goodman 1947, p. 38). In another experiment two groups of children had to estimate the sizes of the coins. One group was made up of children from socially disadvantaged backgrounds, while another group came from more prosperous circumstances. The poorer children overestimated the size of the coins by far more than the wealthier children. The children's visual perception, influenced by their social background, thus led to different results.

Estimates of distances within a city differ depending on whether the estimated route leads into or out of the city (Lee 1973, p. 55). Experiments have shown that in almost all cases the length of a route leading out of the city is over estimated by a far greater degree than the length of a route leading into the city. This apparently has to do with the fact

that the route leading towards the centre is more complex and thus more interesting than the route leading out of the city. In his book *The Hidden Dimension*, Edward Hall demonstrates that perception is significantly conditioned by culture and, indeed, that culture is one of the main factors influencing every perception. People from different cultures apply their senses in different ways and thus live in different sensorsy worlds, which in turn means that they perceive their surroundings differently (Hall 1976, p. 88).

References

Arnheim, Rudolf: Die Dynamik der architektonischen Form, Cologne, 1980 (original title: The Dynamics of Architectural Form, Los Angeles, 1977)
Arnheim, Rudolf: Kunst und Sehen, Berlin, 1978 (original title: Art and Visual Perception, Berkeley,1954)
Bollnow, Otto F.: Mensch und Raum, Stuttgart, 1980 (1963)
Boring, E. G.: Sensation and Perception in the History of experimental Psychology, New York, 1942
Bower, T.G.R.: The visual world of infants (in: Scientific American, 12/1966)
Bruner, J. S. and Goodman, C. C.: Value and need as organizing factors in perception (in: Social Psychology, 42/1947)
Gunzenhäuser, Rui: Maß und Information als ästhetische Kategorien, Baden-Baden, 1975 (1962)
Hall, Edward T.: Die Sprache des Raumes, Düsseldorf, 1976 (original title: The Hidden Dimension, 1966)
Kiemle, Manfred: Ästhetische Probleme der Architektur unter dem Aspekt der Informationsästhetik, Quickborn, 1967
Lee, Terence R.: Brauchen wir eine Theorie?, in: Architekturpsychologie, Düsseldorf, 1973 (original title: Architectural Psychology, London, 1970)
Linder, Hermann: Biologie, Stuttgart, 1967 (1948)
Metzger, Wolfgang: Gesetze des Sehens, Frankfurt am Main, 1975 (1936)
Moles, Abraham A.: Informationstheorie und ästhetische Wahrnehmung, Cologne, 1971 (1958)
Paz, Octavio: Das Vorrecht des Auges, Frankfurt am Main, 2001
Schuster, Martin und Beisl, Horst: Kunstpsychologie – wodurch Kunstwerke wirken, Cologne, 1978
Stadler,Michael with Seeger, Falkaund Raeithei, Arne: Psychologie der Wahrnehmung, Munich, 1975

Part and Whole

Contents

2.1 Parts and the Expression of the Whole ... 39
 2.1.1 Number of Parts ... 40
 2.1.2 Type of Parts ... 42
 2.1.3 Relationship Between Parts—Arrangement System 45
2.2 Relationships Between Type, Number and Possible Arrangement of Parts. 54
 2.2.1 The Relationship Between Type of Parts and Number of Parts 55
 2.2.2 The Relationship Between Number of Parts and Arrangement System 55
 2.2.3 The Relationship Between Type of Parts and Arrangement System 60
2.3 Connection Between Type, Number and Relationship of Parts 65
2.4 Assemblage of Parts ... 68
2.5 Prefabrication of Parts .. 69
2.6 Industrial Construction ... 74
References .. 76

2.1 Parts and the Expression of the Whole

Our built environment consists of parts or components that are assembled in accordance with particular rules: on the small scale these parts are individual structural components, on the medium scale they are building sections, and on the large scale they comprise entire buildings or urban quarters (Fig. 2.1). Each whole is in turn a part of a still more comprehensive whole. For example, a screw can be a component of a steel girder, which in turn can be a component of a building canopy. The whole is in each case more than the sum of all the parts involved.

© Springer Fachmedien Wiesbaden GmbH, part of Springer Nature 2020
J. K. Grütter, *Basics of Perception in Architecture*,
https://doi.org/10.1007/978-3-658-31156-8_2

In order to understand and classify the overall appearance of a building—its expression of a whole—we need to proceed in three steps (Fig. 2.2). The **first step** entails focusing on three aspects of a building's components: their visible number on the whole structure, their type and how they can be arranged in relation to one another. After examining these three aspects independently, the **second step** involves investigating the connections between any two of these aspects: for example, the relationship between the type and number of components. The **third step** entails examining the possible relationships between all three aspects.

The way these three aspects—the type and number of components and their relationship to one another—are manifested on a building tells us something about its style (see Sect. 3.5).

2.1.1 Number of Parts

When considering the appearance of architecture we need to distinguish between the discernible and absolute number of parts. Every building consists of a large number of components: windows, doors, reinforcing rods, sand and gravel in reinforced concrete, screws, brackets, etc. However, many of these components are not visible to the observer (as in the case of the spherical section of the Parc de la Vilette museum—Fig. 2.6). When we speak here of the number of components, we are referring to the visible number of components. For example, we may see a monolithic concrete building as a "single piece" even though we know that it consists of many single parts. The autonomy of the individual components is no longer evident here. We see a sand dune as a whole although we

Fig. 2.1 Our built environment consists of parts or components which are discernible in small, medium and large ranges: **a** components in the small range (I. M. Pei, 1989, Louvre extension, Paris) (see Fig. 2.31 and 6.32), **b** components in the medium range (F. O. Gehry, 1997, Guggenheim Museum, Bilbao), **c** buildings or urban quarters in the large range (Cefalù in Sicily)

2.1 Parts and the Expression of the Whole

Fig. 2.2 The expression of the whole depends primarily on three factors: the type and number of involved parts and their relationship to one another

know that it consists of innumerable grains of sand, which are no longer discernible as individual parts.

Discerning the number of components is closely connected with their arrangement (see Sect. 2.1.3) (Fig. 2.3). When faced with an aggregation of more than six or seven components, we are no longer able directly to discern their precise number; we have to count them or divide them into groups. In other words, we form super-signs (see Sect. 1.3.3). In this case, however, the type and arrangement of components strongly influence our perception (Fig. 2.3). The more similar the components are and the stricter their arrangement is, the greater the number of components that is perceived at a glance.

The bipartite whole represents a special case. The expression of the whole depends on the type of and relationship between the two parts. Two identical parts juxtaposed with one another generate a bilateral symmetry (see Sect. 7.4). If the two parts are not identical, the result is a hierarchy and disequilibrium. Such duality can generate tension.

Fig. 2.3 Although in **A** the parts are the same, they are not ordered and it is therefore difficult to discern their number at first glance, which contrasts with **B**, where the parts are ordered

2.1.2 Type of Parts

The type of individual, visible component parts has a major impact on the expression of the whole. A component's type is determined by different factors, the most important of which are: form, dimension, material, colour and function.

Depending on their type, components can be more or less seen as a group, or whole. The less self-contained and more fragmentary components are, the simpler the formation of a whole (Fig. 2.4a). The more self-contained the components are, the more the whole tends to appear as an agglomeration of individual parts (Fig. 2.4b). In order for us to perceive two or more parts as a whole, they must be similar to one another to at least a minimal degree. And this similarity must be based on at least one of the following factors: form, material, dimension and colour.

Fig. 2.4 A whole composed of parts that are not self-contained (**a**) and a whole made of self-contained parts (**b**)

2.1 Parts and the Expression of the Whole

In medieval towns the individual buildings often differ only in terms of details. The structure of their facades and the materials used to build them are similar. As a result, the building rows along the streets have the appearance of single units (Fig. 2.36). The whole is more important than its individual parts, the buildings. The homogeneity of the whole is usually only interrupted by buildings with a special function, such as churches or town halls. These are distinguished from the other buildings in terms of dimension and form.

The form as well as the type of parts can be such that a number of identical parts can be combined simply into a unitary, homogeneous whole (Fig. 2.5a). Such parts tend to be rather fragmentary, non-self-contained and completely or partly subordinate to the whole. They are elements that can only exist as part of a whole. When observing a brick arch we tend to see the whole structure rather than the individual bricks. As parts they are subordinated to the whole, and only closer observation makes them discernible as individual components. Although when looking at the wooden structure of a Japanese temple we perceive the individual beams as single components, it is only in association with the other components that they form a whole (Fig. 2.5b). However, individual components can be also be structured in such a way that they appear as whole in themselves, and it is therefore difficult to combine them with other comparable components into a superordinate whole. The statues in the Erechtheion on the Acropolis in Athens are parts of the temple but can also be seen as autonomous components, as independent statues (Fig. 2.5c).

The extent to which a whole or its parts predominate in our perception of a building is also a question of style (see Sect. 3.5). For example, particular buildings, such as the spherical component of the Parc de la Vilette museum designed by Adrien Fainsilber in Paris (Fig. 2.6) or the pavilion for Expo 2002 by Jean Nouvel in Murten, Switzerland, are perceived as monolithic wholes whose components are difficult to discern and are only meaningful in the context of the other individual components.

Ludwig Mies van der Rohe's early buildings can be seen as representative of the middle type in Fig. 2.5. In his design for a brick country house from 1923 (Fig. 5.16) and the pavilion built in 1929 for the International Exposition in Barcelona (Fig. 2.7) the shear walls are clearly discernible as individual components. They are partly integrated into the whole as bearing elements and partly constitute an autonomous entity.

The third type (Fig. 2.5c) can be seen as exemplified by several of the buildings designed by Le Corbusier and Louis I. Kahn (Fig. 2.8 and 2.13). The 1931 competition brief for the Palace of the Soviets in Moscow called for spaces with multiple uses: different-sized auditoriums for 15,000, 6500, 500 and 200 people, administration facilities, several libraries and restaurants. As in his previous projects for the League of Nations building in Geneva (1927) and the Centrosoyuz Building in Moscow (1929), Le Corbusier first designed the individual building parts and combined them in different preliminary design studies in different ways (Fig. 2.8). These building parts could exist autonomously, as self-contained entities. However, this would decrease the expressive

Fig. 2.5 Type of parts: **a** non-self-contained, fragmentary parts: Ali Qapu palace, seventeenth century, Isfahan, Iran, **b** roof structure of a temple in Kyoto, Japan, **c** self-contained parts: Erechtheion, Acropolis, Athens.

power that they achieve only in connection with the other structural components. The whole is here more than sum of all sub-wholes.

A similar approach was taken by Louis I. Kahn in 1983 in his design for the National Assembly Building of Bangladesh in Dhaka. The different buildings around the central assembly space for the parliamentarians could almost exist independently (Fig. 2.13).

In this connection it is interesting to observe the development of children as expressed in drawings. In one of the early stages of life a child draws an object as something whole: a human figure, for instance, is rendered as an undifferentiated roundish shape (Fig. 2.9). In a later phase the individual elements such the head, legs and arms are treated as self-contained parts from which the whole is composed. Finally the figure

2.1 Parts and the Expression of the Whole

Fig. 2.6 Adrien Fainsilber, 1986, Parc de la Villette museum, Paris

Fig. 2.7 Ludwig Mies van der Rohe, 1929, "Barcelona-Pavilion", Barcelona, Spain (see Fig. 10.26).

is seen as a differentiated form with the individual limbs becoming components of the whole and linked into a unit (Arnheim 1978, p. 187).

2.1.3 Relationship Between Parts—Arrangement System

When building, the combination of parts into a whole must proceed according to particular rules. The final appearance is determined by different factors, whereby the

Fig. 2.8 Le Corbusier: Competition for the Palace of the Soviets, 1931, Moscow. Different design stages (from upper left to lower right)

Fig. 2.9 Development of a child's ability to draw a human figure, from left to right

arrangement of the components, the predominant organizational system, is one of the most important.

The rules for combining parts differ according to the type of components involved. In some cases these rules are constructional, in others aesthetic and stylistic requirements have to be taken into account.

If the emphasis is on uniformity when combining components, the resulting structure will tend to appear as a monolith, as an integral whole. Here uniformity is a key feature of the whole and the component parts are subordinated to this whole (Fig. 2.6 and 2.29).

When, conversely, the diversity of the parts is important, the observer of a building will tend to see it as an organized collection of different component parts. Nevertheless, the unity of the whole is preserved (Fig. 2.31).

A minimal perceptual connection between the parts, a certain degree of order, is always required. Otherwise we speak of chaos. On the other hand, too much order can lead to monotony (see Sect. 1.2.5 and Fig. 1.5).One and the same building task can be

2.1 Parts and the Expression of the Whole

solved in different ways. Where precisely between these two extremes a design should lie is ultimately a question of style.

The Swiss art historian Heinrich Wölfflin calls the first extreme the "tectonic (closed) style" and the second extreme the "atectonic (open) style". In his view this division applies not only to architecture but to art in general: "… a depiction which, by more or less tectonic means, makes the image into a phenomenon that is confined within itself, which everywhere points back to itself, just as, conversely, the open-form style everywhere points beyond itself, aims to appear unconfined, although a covert boundary is always there which makes possible a cohesive character in the aesthetic sense" (Wölfflin 1984, p. 147). And applied in particular to architecture: "In the first instance the tectonic style is the style of bound order and clear regularity; the atectonic style by contrast is the style of more or less reticent regularity and unbound order" (Wölfflin 1984, p. 175).

The way in which components, spaces and buildings are arranged says something about their functional, hierarchical or symbolic status within the group or the whole. A basic distinction can be made between three arrangement systems: central, linear and free arrangement (Fig. 2.10).

These arrangement systems apply on both small and large scales to the combination of component parts, buildings and building groups. Arrangements that correspond precisely to the three types referred to above are exceptions. In most cases we find variations or combinations.

2.1.3.1 Central Arrangement System

In a central arrangement the elements are ordered around a centre, which can be open space, a courtyard, a square or a particular building.

This centre dominates the parts around it, which are connected with one another via this central element. The central element is the point of departure, endpoint and focus. All trajectories are either arranged concentrically around or converge radially at this centre. A structure with a central arrangement system can grow concentrically, with new "rings" with larger radii continuing to form around the centre. Such a structure has a unifying effect and implies a hierarchy.

Fig. 2.10 Three different arrangement systems: **a** central, **b** linear and **c** free arrangement of parts

The central arrangement is the basic type found in courtyard and atrium buildings. As far back as 4000 years ago the rooms in town houses in Ur were arranged around a central courtyard (Fig. 2.11).

The Greeks and Romans adopted this building type. In places where a lot of people lived in a relatively small area, as was the case in cities, the courtyard house became the standard type. The courtyard formed a private, enclosed, exterior space and at the same time providing illumination and ventilation for the rooms around it. In China the courtyard house already appeared during the Han dynasty (third century BCE to third century CE) and remains a widespread dwelling type today (Blaser 1979, p. 7). The size of houses varied depending on the size and social status of the families living in them and they had one or more courtyards. The courtyard house can be found in all epochs prior to and including the modern era.

The central grouping of rooms does not have to be based on a courtyard or open space. For a long time the centre of the dwelling was formed by the fireplace and the chimney, which functioned as a heating source, cooking area and a place where the occupants could gather together.

From the twelfth century onwards, the Hakka people in southeast China built round fortified villages. The diameter of the circle formed by the outer clay walls, which can be up to 2 m thick and 13 m high, measures between 20 and 30 m but can extend to up to 60 m. The houses, which are oriented inwards, are arranged in 2 to 3 concentric circles around a courtyard and their number of stories reduces towards the centre. For strategic reasons such structures usually have only one entrance and only a few windows looking outwards on the upper part of the external wall (Fig. 2.12).

The centre of the National Assembly Building in Dhaka built in 1983 by Louis Kahn is formed by the assembly chamber for the parliamentarians. This space is surrounded by eight annexes arranged symmetrically around the chamber. The symmetry is only interrupted by the angled position of the prayer hall, which must be oriented towards Mecca (Fig. 2.13).

The central arrangement system often serves as a basis for the design of utopian ideal cities (Fig. 2.14).

Fig. 2.11 Courtyard house in Ur, Mesopotamia, ca. 2000 BCE

2.1 Parts and the Expression of the Whole 49

Fig. 2.12 Round house, Yongding, China (ground-floor layout)

The centre does not necessarily have to be circular or quadratic. However, the surrounding elements, buildings or urban quarters must be oriented towards this centre. This arrangement often symbolizes a cosmic or ideological order. In the centre stands a symbol of worldly or spiritual power, such as a palace or a church to which all paths lead (Fig. 2.15). Many organically developed cities from the Middle Ages are structured according to this system.

2.1.3.2 Linear Arrangement System

Elements arranged according to a linear arrangement system lie along an axis. In the urban sphere this axis is usually formed by a street. In terms of form, size and function the linearly arranged parts can be identical, similar or different. A linear arrangement has a beginning and an end but no centre. The positioning of the parts themselves does not produce a hierarchy (Fig. 2.16).

The linear concept can be extended to form a network in which several linear arrangements lie on top of and intersect with one another. This creates an orthogonal system, which can be extended at will on all sides. In contrast to the central arrangement system, the linear concept does not necessarily have a midpoint or centre.

The first orthogonal urban complex was probably built in Babylon in 680 BCE. Roman colonial towns built following conquests had orthogonal layouts modelled on the army camp and the garrison town (Fig. 2.17). They reflected the strict authoritarian order of the Roman system of power (see Sect. 4.3).

Fig. 2.13 Louis Kahn, National Assembly Building, 1983, Dhaka, Bangladesh

Fig. 2.14 The round city of Baghdad based on astronomical principles commissioned by the caliph al-Mansur in 762 BCE

2.1 Parts and the Expression of the Whole 51

Fig. 2.15 Structure of the medieval town of Brive, France

Fig. 2.16 Bazaar, Isfahan, Iran, in the sixteenth century (section)

In North America the orthogonal city layout was first introduced at the beginning of the eighteenth century (Moholy-Nagy 1970, p. 193). The reasons for this were economic. Surrounded by vast tracts of land, immigrants saw potential for a commercial capital on land that would be purchased, divided into plots and sold on (Fig. 2.18).

In ancient China, cities were built on orthogonal grids for other reasons. The basic architectural element here was not the individual building but the building group, the

Fig. 2.17 a Plan of a Roman garrison town, b Roman city foundation, ca. 100 CE, Timgad, now Algeria (see Fig. 4.5)

Fig. 2.18 Section of the layout of Manhattan, New York, USA

2.1 Parts and the Expression of the Whole

courtyard building consisting of several rooms arranged around a courtyard according to a central arrangement system, which served as living space for an extended family.

The stringing together of such groups produces a rectangular street pattern. In the "Book of Diverse Crafts" (Kao Gong Ji) from the third century BCE we find the following description: "Craftsmen lay out the square city measuring 9 li by 9 li with three gates on each side. In the city there are nine main streets (the north–south streets) and nine cross streets" (Thilo 1978, p. 171). This ideal type was not realized in any city but the basic idea of the chessboard-like structure became the archetype referenced by many city layouts. The orthogonal grid city was exported from China to the east and the west, including to Japan. It provided the model for the design of the new Japanese capital, Kyoto, founded in 792 (Fig. 2.19).

Around 2000 years ago, the orthogonal city layout was also adopted in India and influenced city planning based on the Hindu symbolism of the mandala. The "Mansara", an Indian handbook for urban planners and architects from the Middle Ages, contains

Fig. 2.19 Plan for the Japanese capital of Kyoto at the time of its founding in 792 CE

Fig. 2.20 Three ideal plans from the Indian "Mansara" handbook

Fig. 2.21 Luigi Snozzi, residential building, upper floor (project), 1973, Celerina, Switzerland

many ideal plans for cities structured as a right-angled grid, which in turn exerted an influence on the urban planners of the Renaissance (Volwahsen 1968, p. 45) (Fig. 2.20).

In the modern era the orthogonal city plan was advocated above all by the CIAM group under Le Corbusier, who was able to realize one of his projects in Chandigarh, the capital of the Punjab.

The linear and orthogonal organization systems are not only used in the urban sphere. The serial arrangement of identical elements can also be found on a smaller scale, for example, on buildings or parts of buildings (Fig. 2.21).

2.1.3.3 Free Arrangement

In the case of a free arrangement of parts no overall order is discernible. In most cases, such structures have developed more or less arbitrarily over the course of time. Many large cities, when observed as a whole, seem to have no discernible arrangement system and to be made up of chaotically juxtaposed individual parts.

2.2 Relationships Between Type, Number and Possible Arrangement of Parts

In a second step (Fig. 2.2) we will now examine the relationship between any two of the three aspects under discussion.

2.2 Relationships Between Type, Number and Possible Arrangement of Parts

What is the relationship between the type and number of parts? How do the arrangement system and the number of parts influence one another? What influence does the type of parts have on the arrangement system and vice versa?

2.2.1 The Relationship Between Type of Parts and Number of Parts

In Sect. 2.1.2 we saw that the type of a component part can depend on different factors: form, dimension, material, colour and function. All these factors influence the relationship of a part to the whole. They determine the extent to which the part is integrated into the whole. The type of a component part can therefore also be understood as referring to its capacity to integrate itself into a whole. The more fragmentary and less self-contained a part is, the easier it will be to integrate it into a whole. A self-contained part seeks to assert its completeness even in association with other parts and therefore has more difficulty integrating itself into a group (see Fig. 2.4). As we will see in Sect. 2.2.3, this connection is in part also dependent on the arrangement system used.

The entrance to a Frankurt subway station consists of a section of an old streetcar, creating the impression that the rest of the vehicle has been submerged in the ground leaving only part of it visible (Fig. 2.23). It is difficult to achieve a whole with this fragmentary, non-self-contained part (case A in Fig. 2.22). This "missing" part of the streetcar refers to the area below ground, thereby leading the traveller into the underground station.

The individual stones making up the Egyptian pyramids (Fig. 2.24) are fragmentary, non-self-contained parts. It is only in connection with other, identical parts that they form a whole. It is easier to form a whole with many fragmentary component parts (case C in Fig. 2.22 and 2.24) than with many self-contained parts (case I in Fig. 2.22 and 2.26), since the fragmentary parts surrender their autonomy to the benefit of the whole and integrate themselves within it.

The Column of Marcus Aurelius in Rome (Fig. 2.25) is a self-contained component which is perceived as a whole and cannot be supplemented by other components (case G in Fig. 2.22).

The three buildings on the Piazza Sant'Ignazio in Rome (Fig. 2.26) are self-contained structures which could also stand alone. However, their form and arrangement are such that they have a spatial relationship to one another and therefore together form a whole (case I in Fig. 2.22).

2.2.2 The Relationship Between Number of Parts and Arrangement System

The spatial relationship between parts and their surroundings is governed by a shared arrangement system, which can range from simple to highly complex (Fig. 2.27). This

56 2 Part and Whole

Fig. 2.22 Relationship between type of parts and number of parts (in a simple arrangement system). Highly simplified, schematic representation

Fig. 2.23 Subway station in Frankfurt am Main, Germany (case A in Fig. 2.22)

2.2 Relationships Between Type, Number and Possible Arrangement of Parts 57

Fig. 2.24 Pyramid of Giza, Egypt, 2600–2500 BCE (case C in Fig. 2.22)

organization system has a pronounced influence on the character of the whole and therefore the style of a structure.

The many ceramic fragments on a bench in Antonio Gaudi's Park Güell in Barcelona (Fig. 2.28) are subordinate to the whole and are not immediately discernible as individual parts. Their positioning appears rather random and is based on a complex arrangement system. In a complex arrangement system a larger number of parts tends to produce the appearance of a whole more than a limited number does, since in the latter case the parts are still discernible in terms of their number and thus aspire to appear autonomous.

The type of parts also plays a role. In a complex arrangement system the tendency for a structure to appear whole is greater when the parts have a fragmentary character, for example, in the case of the ceramic fragments on the bench (Fig. 2.28), than when they are self-contained.

Jean Nouvel's monolithic block pavilion built for EXPO 2002 in Murten, Switzerland, (Fig. 2.29) was located on a somewhat random site near the shore of a lake.

Fig. 2.25 Column of Marcus Aurelius, 180, Rome (case G in Fig. 2.22)

Fig. 2.26 Piazza Sant'Ignazio, Rome (case I in Fig. 2.22)

A spatial reference to the surroundings is difficult to discern. The arrangement system is thus highly complex. The constellation corresponds to case A in Fig. 2.27.

2.2 Relationships Between Type, Number and Possible Arrangement of Parts 59

Fig. 2.27 The relationship between the number of parts and the arrangement system (in the case of self-contained parts). Highly simplified, schematic representation

Fig. 2.28 Antonio Gaudi, 1900–1914, Park Güell, Barcelona, Spain (case C in Fig. 2.27)

Fig. 2.29 Jean Nouvel, EXPO 2002 pavilion, Murten, Switzerland (case A in Fig. 2.27)

The obelisk in St. Peter's Square in Rome (Fig. 2.30) is, like the pavilion by Jean Nouvel (Fig. 2.29), a self-contained component. However, in contrast to the pavilion, the obelisk in the centre of the square is integrated into a strict arrangement system (case G in Fig. 2.27). The component stands in a prominent position, which emphasizes its importance.

The glass pyramid by I. M. Pei over the entrance to the Louvre in Paris is composed of prefabricated elements (Fig. 2.31). The many identical parts are combined into a whole using a simple arrangement system (case I in Fig. 2.27). Although the individual parts are discernible they are subordinate to the whole, which dominates in perceptual terms.

2.2.3 The Relationship Between Type of Parts and Arrangement System

Figure 2.32 shows possible relationships between different arrangement systems and different types of component parts. The nine possibilities shown here are in part extreme

2.2 Relationships Between Type, Number and Possible Arrangement of Parts

Fig. 2.30 Bernini, 1667, St. Peter's Square, Rome (case G in Fig. 2.27) (see Fig. 9.22)

cases, and there are innumerable intermediate possibilities. The way parts are put together can be investigated on different scales (see Sect. 2.1): on the small scale of structural components, on the medium scale of building sections, or on the large scale of the residential estate and urban quarter. This section focuses on the relationship between the arrangement system and the type of parts on the scale of the latter.

Wholeness can be achieved in different ways. For example, a number of fragmentary parts can be arranged according to a complex system (case C in Fig. 2.32, 2.33) or a number of self-contained parts can be structured according a strict, simple system (case G in Fig. 2.32, 2.34).

It is difficult to imagine the individual buildings in Ho Chi Minh City (Fig. 2.33) existing as independent structures. They are fragmentary, non-self-contained, built against one another and interlinked in a complex arrangement. It is only in association

Fig. 2.31 I. M. Pei, 1989, Louvre, Paris (see Fig. 2.1a and 6.32) (case I in Fig. 2.27)

62 2 Part and Whole

Fig. 2.32 The relationship between type of parts and arrangement system (in the case of many parts). Highly simplified, schematic representation

Fig. 2.33 Ho Chi Minh City, Vietnam (case C in Fig. 2.32)

2.2 Relationships Between Type, Number and Possible Arrangement of Parts

Fig. 2.34 Le Corbusier, 1922, Ville contemporaine (project) (case G in Fig. 2.32)

with one another that these non-self-contained buildings form a whole. Since the individual buildings are different, a complex arrangement system is required to combine them into a unitary whole. Many organically developed cities correspond to this model (case C in Fig. 2.32).

Le Corbusier's "Ville contemporaine," an unrealized project for a new quarter in Paris designed in 1922, consists of an assemblage of independent objects which appear to claim a great deal of space and thus to contradict the basic idea of the traditional (or medieval) city (Fig. 2.34). One of Le Corbusier's concerns was to enable—in contrast to the medieval city—as much light and fresh air as possible to reach the dwellings. To achieve this it was necessary to position the quarter's skyscrapers, which measure over fifty stories, wide apart from one another. All buildings, all parts, are identical in terms of size and form, self-contained "sculptures" that are arranged on an open area according to a strict system. Despite this strict arrangement, the large gaps between the buildings and their self-contained character prevent them being experienced as a large unit, as a city. This constellation corresponds most readily to case G in Fig. 2.32.

Case C is more original and accordingly has a greater information density. In case G the repetition of an element two or three times already creates the expectation of more repetitions, of periodicity. As a result redundancy in this case is relatively high and originality correspondingly low.

Heinrich Wölfflin describes the difference between cases C and G as follows: "Only where the individual element appears as a necessary part of the whole can we speak of organic connection, and only where the individual element, while integrated in the whole, is perceived as an independently functioning entity does the concept of freedom and independence have meaning" (Wölfflin 1984, p. 189).

Fig. 2.35 Hong Kong (case A in Fig. 2.32)

Individual buildings in Hong Kong (Fig. 2.35) also create a sculptural and self-contained impression, designed as they are to stand out from surrounding structures (case A in Fig. 2.32). The individual buildings make little reference to those around them and no clear arrangement system is discernible.

The image projected by many medieval cities (Fig. 2.36) corresponds to case I in Fig. 2.32. As in case G, a strict arrangement system dominates here. The buildings are built against one another along the street line, are predominantly of the same height and exhibit similar forms and colours. The street front is perceived by the beholder as a homogenous whole. Due to the various small differences in terms of proportion and arrangement of openings the individual buildings attain a certain degree of autonomy; they become variations on a theme. Separated from the whole the individual buildings

Fig. 2.36 Old town of Bern, Switzerland (case I in Fig. 2.32)

would lose their character. Here the individual building is not a sculpture as in the case of Le Corbusier but rather a "filling" which shifts visual primacy to the adjacent space, the street, and away from the object itself.

In Chapter 1 we saw that visual perception in principle entails different possibilities for the reception of information. According to so-called sampling theory (Sect. 1.3.4.2) the overall impression arises from many small pieces of information, the whole from individual parts. The gestalt theory of seeing (Sect. 1.3.4.1), on the other hand, argues that seeing proceeds from the whole and individual parts are only registered step by step. The way we visually perceive something also depends on the type of object we are seeing.

If the individual parts are independent and self-contained, such as the buildings in Hong Kong (Fig. 2.35), and arranged according to a complex system (case A in Fig. 2.32), then perception tends to proceed according to the sampling model; we first register the individual parts and form an overall impression step by step.

Non-self-contained and fragmentary component parts, such as the buildings in Fig. 2.33, which are arranged according to a complex system (case C in Fig. 2.32), force the beholder first to register the whole and then its individual parts.

2.3 Connection Between Type, Number and Relationship of Parts

In the first part of this chapter we focused on three aspects of a building's components: their number, type and the possible relationships between them (Sect. 2.1). We then looked at the relationships between any two of these three aspects (Sect. 2.2). We will now examine the relationships between all three aspects (see Fig. 2.2).

For the Palace of the Soviets project in Moscow (1931) (Fig. 2.8) different building parts, such as halls and auditoriums, were designed separately and then combined in different ways into an entire building complex in several design studies (see Sect. 2.1.2). The individual parts, at least in the different studies, are arranged in rather complex systems. The type of these parts is self-contained, i.e. the structures could in part exist autonomously as self-contained buildings. A formal similarity and the various intermediate structures help to connect them into a whole.

The number and type of parts and their arrangement in the different design studies are represented in Fig. 2.37. The ultimate solution (below right in Fig. 2.8) exhibits a clear symmetry that subjects the whole to a stricter arrangement system than the design studies. Interestingly, this solution no longer takes into account the location of the structure on an elongated plot on the bank of the Moskva River.

The parliament building in Chandigarh (Fig. 2.38 und 2.39), which Le Corbusier completed in 1961, 30 years after the design for the Palace of the Soviets in Moscow, comprises two assembly halls for the upper and lower houses, a large foyer, offices for

Fig. 2.37 Connection between type, number and relationship of parts

parliamentarians and a large awning that serves as an entrance portal. The spaces differ not only in terms of their use but also their form and structural systems. The two assembly halls are enclosed by solid concrete walls, in one case forming a pyramid and in the other an obliquely truncated cylinder. The free-standing, curved portal roof rests on shear walls, which emphasize the direction of entrance. The office section is composed of a supporting skeleton and non-bearing walls which separate the individual office spaces.

2.3 Connection Between Type, Number and Relationship of Parts 67

Fig. 2.38 Le Corbusier, 1961, parliament building in Chandigarh, India

Fig. 2.39 Le Corbusier, 1961, parliament building in Chandigarh, India. **a** Layout, **b** The parts of the building: U-formed office area, assembly halls, entrance area and foyer.

The foyer, which features a "forest" of pillars that support the roof, recalls the grove found in many Indian villages that is used as a meeting place by the inhabitants.

The building consists of a number of different parts which could also exist in another combination or even autonomously. The arrangement system determining the relationships between the individual parts is rather complex: The offices are arranged in a U to form the "container," which is "filled" with the pillars in the foyer and holds the two free-standing assembly halls. The frontal conclusion to the building is formed by the large portal section, which marks the entrance (Fig. 2.39).

Le Corbusier used the same method when designing many of his buildings, composing a whole out of different, more or less self-contained parts using a similar arrangement system. This gave rise to buildings exhibiting a similar style (see Sect. 3.5).

2.4 Assemblage of Parts

The verb "construct" derives from Latin and means to assemble. To construct means to assemble component parts according to particular rules: mathematic-logical, technical-scientific, economic and aesthetic. Le Corbusier accordingly defined building construction as "the purposeful and consequential connection of building components" (Le Corbusier 1969, p. 94). Connection and composition take place at every level: A city consists of numerous buildings, a building of numerous components, these components of many parts, and these finally themselves of other components. In principle the same rules apply to all levels, although there are differences in terms of focus. Design can also be characterized as assemblage, the assemblage of walls, rooms and building components according to particular rules. In building, construction and design are one and the same action, although perhaps taking place at different levels.

Construction is a part of the design and cannot be separated from it. The design of a detail is just as important as the design of individual building parts or the design of an entire house. Aesthetic aspects are important whether in terms of the way a handrail is attached or the relationship between two building parts. The issue of heat management in a building is not only a structural-physical issue. It begins with the orientation of the building in its surroundings, followed by the question of the type of apertures required and is ultimately also a structural-physical issue. Decisions regarding technical execution are already made in the first design phase. The character of a building defined at this stage already significantly limits the spectrum of possible technical execution methods.

The Eiffel Tower could not have been built of brick (see Fig. 4.1). Steel was the only type of material that could be used for this type of structure and as a result the type of connections that could be used was highly circumscribed from the beginning. Certain forms are shaped by special structural systems. For example, in the case of an arch compressive forces are generated that require specific types of construction. Structural details cannot be arbitrarily changed. Or, as Louis I. Kahn puts it: "Form emerges out of a system of construction" (Kahn 1960, p. 162). Construction thus helps indirectly to demonstrate the intellectual content of a building. In highly constructivist architecture it even becomes the primary means of expression.

As already discussed, the assemblage of parts takes place according to a particular arrangement system. Statics and economics support this requirement. For example, placing vertical supports at equal intervals in a skeleton frame-structure allows the use of equally dimensioned horizontal beams, which in turn has a positive economic effect. The regularity of such a skeleton grid will in turn have a decisive influence on the expressive character of a building.

In the past building methods were empirically tested. The master builder knew precisely what the intellectual content was to which he was to give formal expression as well as the technical qualities of the materials available to him. The creator of the form was also the creator of the construction. The building components had to be assembled according to both aesthetic and technical rules. There was no separation between aesthetics and technique, as is so often the case today.

Parallel to the development of new building materials in the form of steel and concrete in the eighteenth and nineteenth centuries, scientific methods were developed to monitor the statics of these materials: the profession of the structural engineer was born. Large-scale construction of bridges and halls saw the structural engineer join the architect as a leading protagonist in the building process. From now on, the skills required to create the built environment no longer lay exclusively in the hands of the master builder. Over the course of time the team of participants in the planning of a building became ever larger. Indeed, today there is a risk that the different specialists working on a building, such as the architect, structural engineer, building physicist, construction manager, the different specialist engineers, etc., may fail to coordinate their planning effectively and produce a final result that is no longer a unified whole.

Today building is more multilayered and complex that earlier; universal knowledge covering all areas is no longer possible. For this reason an intensive dialogue, at the least, is required between the individual disciplines; all participating specialists need to aspire to a shared goal: to create a building as a homogenous whole that gives formal expression to intellectual content. In this context all disciplines are only means of reaching a common goal.

2.5 Prefabrication of Parts

Architecture has always been a whole composed of parts. At the beginning of the history of building these parts were rough, unprocessed pieces taken from the natural environment: branches, leaves, stones, etc. Then people began to process these parts: stones were worked so that they could be more effectively layered on top of one another; bulky pieces of wood were cut into pieces to create more functional building materials.

Later, each individual piece was no longer customized at its point of use but was processed beforehand and then mounted on the structure. This meant that the size and form of the individual components had to be coordinated. A common measure was introduced and different sizes were standardized. In situ construction was partly supplemented by prefabrication.

Standardized building with prefabricated parts is old. Traditional Japanese architecture, for instance, was based on the modular dimensions of the Tatami mat, a floor mat made of rice straw measuring approximately 90 cm by 180 cm. Most buildings were based on this modular unit, were standardized and could accordingly be prefabricated (Fig. 3.13a and Fig. 5.43). A similar form of standardization in China can be traced back to the eleventh

century (Thilo 1978, p. 62). It allowed not only for fabrication independently of individual building projects but also rapid replacement in the case of damage. As early as the seventeenth century prefabricated houses could be purchased in Moscow "off the shelf" (Vogt 1974, p. 133). A special market was located outside the city where the houses could be viewed. Once purchased, they were mounted at their new location within two days.

The Gothic cathedral is also an example of pre-industrial prefabrication (Fig. 2.40). The number of different parts on such a building is relatively small but a large number of these standard components were produced and used repetitively in the façade and support structure: manual prefabrication based on a standardized model in situ following by assemblage.

Fig. 2.40 **a** The components of the masonry of a Gothic cathedral (based on a drawing by Violet-le-Duc), **b** Cathedral in Strasbourg, 1176–1439

2.5 Prefabrication of Parts

With industrialization in the nineteenth century hand tools were replaced by machines. The manually produced component part was replaced by the industrially manufactured standardized mass product.

The advantages of industrial building were first recognized by engineers and utilized for the construction of bridges and halls (Fig. 2.41). Gustave Eiffel, who is today renowned above all for his spectacular tower in Paris, developed components that could be manufactured in series and used in multiple ways. In this way he developed a construction system consisting of eight different standard components. These could be used to assemble large bridges of different sizes with a maximum width of 5 m and a maximum length of 27 m. This bridge-building system was already exported as far as India in the nineteenth century (Birkner 1980, p. 50).

The Crystal Palace constructed for the World Exhibition in 1851 was the first building to be made primarily out of industrially prefabricated parts and assembled using the methods of modern industrialized building. Only in this way was it possible to

Fig. 2.41 Burton and Turner, 1884, Palm House, Kew, London, England (see Fig. 6.3)

complete the building within the extremely short timeframe of six months. Joseph Paxton was less interested in the aesthetic effect than in the economic advantages of prefabrication. He was faced with the almost insurmountable problem of erecting a hall over 560 m long with an exhibition area of more than 92,000 m^2 within six months. The entire building was constructed on a grid of square modules measuring 24 ft (7.32 m) and all its components were standardized so that they could be prefabricated. Over a thousand cast-iron vertical supports were used. The girders spanning 24 ft and numbering around 2800 all had a height of three feet, which allowed for a standardized connection to the vertical supports. The different weights on the girders were compensated for by using different strengths of material. The amount of glass used to cover the roof and the façade corresponded to the third of annual glass production in England. More than 325 kms of glazing bar were used to fix the glass in place (Werner 1970, p. 29).

Such a building volume could only be achieved in such a short time because manufacture and assembly were two separate fields of work, because the number of types of component was reduced to a minimum, and because assemblage was designed to be simple and rational.

Such industrially prefabricated buildings illustrate how new forms of expression emerged from new ways of producing components and assembling them into a whole. The constructors, who were for the most part engineers, were less concerned with style and aesthetics than with economic questions. For them, formal changes were a logical result of this development and thus a secondary phenomenon. On the other hand, it was precisely the formal expression of these buildings, as well as the beauty, rigor and simplicity of industrially manufactured products like cars and airplanes, which were admired by many architects and regarded as an ideal for the aesthetics of architecture (see Sect. 8.2). The possibilities offered by the manufacturing process of industrial mass production, which formed the foundation for this aesthetics, were, however, initially paid little regard by architects. Jean Prouvé, a pioneer of industrial prefabrication in the building industry, wrote: "Since the age of mechanization it is only the building industry that stands apart from the industrial miracle in which quality improvements have gone hand in hand with price reductions" (Prouvé 1964, p. 23).

Le Corbusier not only recognized the aesthetic advantages of industrial production: "After seeing the production of so many factory-assembled cannons, airplanes, trucks and railway cars, one has to ask oneself: Would it not also be ultimately possible to produce factory-assembled houses as well? Such an approach would be very much in keeping with the times" (Le Corbusier 1969, p. 99). He coined the term "engineer's aesthetic," referring to his belief that "if houses were produced in series by industry like chassis, we would very soon see surprising yet sound, reasonable forms emerge and the corresponding aesthetic would also formulate itself with astounding precision" (Le Corbusier 1969, p. 105). He also recognized the economic aspects of such building methods. CIAM's La Sarraz Declaration of 1928, which bears Le Corbusier's signature,

2.5 Prefabrication of Parts

includes the following statement: "The most efficient method of production is that which arises from rationalization and standardization. They exercise a decisive influence on work in the modern building industry" (Le Corbusier 1981, p. 104). "Architecture is type formation" (Le Corbusier 1969, p. 104): Industrial prefabrication demands standardization of types. The "Domino House" (Fig. 5.39), which he designed in 1914, was inspired by what he saw as the necessity of type standardization, although the house was neither prefabricated nor industrially produced. His wish to be able to manufacture houses industrially and in series was not realized. The closest he came was with his last house, the "Maison de l'homme" built in Zürich in 1963. Parts of the building were prefabricated industrially and assembled in situ (Fig. 2.42).

Walter Gropius was also interested in prefabrication and standardization. He laid out his ideas in his "Program for the establishment of a building society on an artistically unified foundation." Two points were particularly important for him, which could not be allowed to exclude one another: industrial mass production of components and types of components that permitted variable combinations and thus individual design. In 1923 Gropius developed house types of different sizes that could be assembled from standardized parts. In 1927 he erected two completely standardized and industrially prefabricated single-family dwellings on the Weissenhof Estate in Stuttgart (Fig. 2.43). The floor plans are based on a square grid. The primary structure is a steel frame and the non-bearing walls consist of insulating cork plates clad on the outside with fibre cement sheets and on the inside with wood.

The "engineer's aesthetic" became a foundation of Modernism, although a transition from traditional building methods to a progressive form of industrial construction was still in its beginnings.

Fig. 2.42 Le Corbusier, 1963, "Maison de l'homme", Zürich, Switzerland

Fig. 2.43 Walter Gropius, 1923, prefabricated house type made of modular components. **a** Building in Dessau, Germany, **b** 2 Different floor-plan variants

2.6 Industrial Construction

A basic distinction is made between two types of building system: closed and the open systems. In closed systems the whole building, including all detachable parts, is standardized and prefabricated. Adapting such a structure to a specific situation is difficult in this case. In the case of so-called open systems, only a part of the building originates from this particular building system, for example, the load-bearing system. Detachable parts may in this case be provided by different producers, or they may be produced in situ. Such systems are usually more flexible and more adaptable to specific situations.

Prefabrication, even of only a few building components, also means rationalization. The proportion of prefabricated parts is today larger than generally assumed. One only has to consider prefabricated kitchens, windows, doors and installations.

In comparison to conventional in situ on-site construction methods, standardized and industrialized prefabrication has advantages but also disadvantages. Industrial production means the manufacture of parts independent of the building's location and protected from the weather. Several work processes can be carried out simultaneously and the building time is reduced to the time needed for assemblage.

For economic reasons, planning for construction with prefabricated elements must involve as few different components as possible and a rigorous arrangement system. This

2.6 Industrial Construction

often leads to the criticism that a low level of variability between the components limits the spectrum of formal and spatial variation possibilities and creates a monotonous impression.

A high density of people means more building activity on a small area and thus shorter transport routes and costs. This is, for example, the case in Japan. Here, building processes are partly automated and can even include the use of construction robots. Firms such as Toyota Home and Sekishui offer architects a range of some two million modular parts from which to design and assemble a building to the specifications of the client. The firm of the future manufacturer is already involved at the design stage. In a showroom the client is able to examine and select the components of his future building on a 1:1 scale. These are then consecutively processed with a special computer program, enabling the client to take a virtual tour of his future building. The precise costs involved are also shown consecutively (Bock 2006, p. 756–762).

The assumption that industrial prefabrication entails a large number of components is only partially true today. The ship-building industry manufactures individual vessels with industrially prefabricated components. The processes employed here could provide models for industrial prefabrication in the wider building industry. Today the methods of industrial prefabrication can be used to produce small series and individual components. Frank Gehry, for instance, builds analogical models of his designs, which are then scanned three-dimensionally into a computer, where they are reworked to produce the blueprints required for realization. The computer program used here was devised for the mechanical engineering field (CATIA) (Böhm 2001, p. 76–83).

Extremely light-weight construction makes transport and assemblage easier. Such construction can be achieved for the most part with new, light building materials and special structural systems. Cement and brick could be increasingly replaced by building materials such as light metals and plastics or newly developed ultra-light materials. This would increase the need for structural systems that allow for material-efficient building: systems with less pressure and bending but with more tensile forces.

In contrast to other industries it is difficult for new materials to gain acceptance among architects and developers. Over fifty years ago Buckminster Fuller already suggested that in the case of new materials the greatest optimization potential lay in the construction industry. The fact that his prognosis was correct is illustrated by the successful use of new materials in the aircraft industry. In some cases the use of novel materials in architecture dates back many years. In the mid-1940s, for instance, Jean Prouvé used folded steel sheets as bearing and stabilizing elements, constructing houses that could be transported by plane, were freely extendable and could be fully assembled and disassembled by four people in one day without a crane.

Industrialization in the nineteenth century also provided architecture with quite new forms of expression and was indeed partly responsible for a new conception of space (see Sect. 5.1.1.3).

Similarly, a completely new industrialized way of building would radically change our built environment and thereby probably the way we use it. Such a way of building

Fig. 2.44 Kisho Kurokawa, 1972, Nakagin Capsule Tower, Tokyo, Japan

requires a change in thinking. Space is becoming a consumer good that can be produced as required, changed and disassembled again.

Instances of such a visionary architecture could already be observed over fifty years ago among 's Metabolists. Although most of their designs were never realized they have left their mark. One of their few realized designs is the Nakagin Capsule Tower built by Kisho Kurokawa in Tokyo in 1972 (Fig. 2.44). The structure comprises lightweight prefabricated capsule dwellings suspended on a central access and utility core.

This rethinking must proceed step by step. Traditional ideas need to be reconsidered and current standards examined.

Jean Prouvé once said: "The only industry that does not function is the building industry" (Prouvé 1964, p. 8). If one day it is made functional, namely when the built environment no longer consists of manually produced components but has become primarily a matter of industrial mass production, we will have reached a "turning point in building."

References

Arnheim, Rudolf : Kunst und Sehen, Berlin, 1978 (original title: Art and Visual Perception, Berkeley, 1954)
Birkner, Othmar: Eiffelturm (in: Archithese 4/1980)

References

Blaser, Werner: Hofhaus in China, Basel, 1979

Bock, Thomas: Leichtbau und System in: DETAIL, vol. no. 7/8, 2006

Böhm, Florian: Zum Stand der Kunst des industriellen Bauens. in: arch+, vol. no.. 158, 2001

Kahn, Louis: Ordnung ist, 1960 (in: Programme und Manifeste zur Architektur des 20. Jahrhunderts, Braunschweig, 1981)

Le Corbusier: Ausblick auf eine Architektur, Berlin, 1969 (original title: Vers une architecture, Paris, 1923)

Le Corbusier: CIAM-Erklärung von La Sarraz, 1928 (in: Programme und Manifeste zur Architektur des 20. Jahrhunderts, Braunschweig, 1981)

Moholy-Nagy, Sibyl: Die Stadt als Schicksal, Munich, 1970 (original title: Matrix of Man – An Illustrated History of Urban Environment, New York, 1968)

Prouvé, Jean: Vortrag am Kongress der U.I.A., Delft, 1964 (in: Huber Benedikt, Jean Prouvé, Zürich, 1971)

Thilo, Thomas: Klassische chinesische Baukunst, Zürich, 1978 (1977)

Vogt, Adolf Max: Revolutionsarchitektur, Cologne, 1974

Volwahsen, Andreas: Indien, Fribourg, 1968

Werner, Ernst: Der Kristallpalast zu London 1851, Düsseldorf, 1970

Wölfflin, Heinrich: Kunstgeschichtliche Grundbegriffe, Basel, 1984 (1915)

Culture and Style

3

Contents

3.1	Architecture as a Cultural Medium	79
3.2	The Origins of Culture	84
	3.2.1 Art and Science	84
	3.2.2 The Beginnings of Art	84
3.3	Style and the Type of Information	86
3.4	Order and the Complexity of Styles	89
3.5	Style and the Type, Number and Arrangement of Parts	92
3.6	Style and the Personality Structure of the Beholder	94
3.7	Changes in Style	95
3.8	Acceptance of Styles	99
References		104

3.1 Architecture as a Cultural Medium

Every society, whatever its organizational form and ideological character, has certain ideals and goals. The overriding task of a culture consists in illustrating these abstract ideas with concrete forms. Architecture plays a primary role in this process of transformation. As Hermann Muthesius, one of the early programmatic thinkers in the Deutscher Werkbund, wrote in 1911: "For its architectonic culture remains the trues index of a nation's culture as a whole. If a nation produces good furniture and good light fittings, but daily erects the worst possible buildings, this can only a sign of heterogeneous, non-clarified conditions, conditions whose very inconsistency is proof of the lack of discipline and organization" (Muthesius 1981, p. 24).

© Springer Fachmedien Wiesbaden GmbH, part of Springer Nature 2020
J. K. Grütter, *Basics of Perception in Architecture*,
https://doi.org/10.1007/978-3-658-31156-8_3

As part of an architectonic culture, every building has the task of making an abstract idea visible and is, in this sense, an index of this culture. As Hans Hollein puts it: "Architecture is an intellectual order realized through building" (Hollein 1981, p. 174). The frequent attempt to evade this responsibility is evident in the characterization of a building as purely "functional." But every building has a function; architecture does not exist for its own sake. Every building thus bears witness to its own culture, for better or for worse.

Sigmund Freud characterized culture as "the sum total of those achievements and institutions that distinguish our life from that of our animal ancestors and serve the dual purpose of protecting human beings against nature and regulating their mutual relations" (Freud 1970, p. 85). Along with the use of tools and taming of fire, Freud regards the building of dwellings as one of the first cultural acts (Freud 1970, p. 86). Culture is not merely based on utility, as illustrated, for example, by the pursuit of beauty. The development of cultures gives rise to an order that attempts to find a balance between the claims of the individual and those of the community. According to Freud, this order is based on a repression of basic drives and thereby on a necessary limitation of the freedom of the individual. The sublimation of these repressed drives is one of the most important aspects of cultural development. It is also the trigger for every religious-ideological, scientific and artistic activity. For a long time, these three factors were in balance and provided a certain degree of harmony. Religion and ideology form the structure of the all-encompassing order of things; science and technology appeal more to the intellect, art to the emotions.

This order regulates the relationship between human beings and shapes their culture and is based on particular value systems, which change over the course of time. What we commonly refer to as architectural style is the constructional expression of this order and thereby of the dominant value system.

A simple example can be used to illustrate this phenomenon. Over the course of centuries the conception of the relationship between the individual and God inside a church and what the interior of a church should represent has changed. The different conceptions were also part of the dominant value system, and as the value system changed so too did the design of church interiors. Whereas during the early Christian phase church ceilings were simple wooden constructions, during the Romanesque period rounded vaults enclosed the space from above. During the Gothic period peaked vaults were used (see Fig. 3.1).

Put very simply, these three types of ceiling corresponded to the three different conception of the relationship of the human being to God. In the early Christian period people in the church prayed to God in Heaven. The church was a space of assembly derived from the Roman basilica.

In the Romanesque period the use of a rounded vault creates a unified, enclosed space. The individual is no longer merely a marvelling spectator; he is included and, unified with God, is supposed to become part of the system (Norberg-Schulz 1975, p. 180). During the Gothic period the aim is to build a part of Heaven on Earth. The spaces

3.1 Architecture as a Cultural Medium

Fig. 3.1 Spatial relationship of the human being to God in the church interior: **a** Santa Maria Maggiore, from fourth/fifth century, Rome, Italy, **b** cathedral, eleventh century. Speyer, Germany, **c** cathedral, 1388–1573, Batalha, Portugal

become extremely high, peaked arches point upwards, walls and ceiling direct the gaze upwards; the walls and ceiling are dematerialized, and the supporting structure becomes a skeleton. The lateral incident light actually creates the illusion of a detached firmament (Norberg-Schulz 1975, p. 185) (see Fig. 10.2).

Drawing on the work of Erwin Panofsky, we can distinguish between three levels in the identification and understanding of architecture. The first level (which he refers to as phenomenal meaning) has to do with the physical space, with structures, dimensions and materials. The second level (the level of meaning dependent on content) has to do with the function of a building. The third level (intrinsic meaning) has to do with the expression of a mindset, a value system. The first two levels deal with concrete things, the third deals with the intellectual statement. In architecture this statement is visualized with concrete forms and materials. Its expression corresponds to the architectural style (Panofsky 1978, p. 38).

The technological achievements of the nineteenth century, the epoch of industrialization, were widely admired, with the result that rational thought tended to be given precedence over the world of feelings. As Siegfried Giedion writes, "The arts were exiled into an isolated realism of their own, completely insulated from everyday realities. As a result, life lost unity and balance; science and industry made steady advances, but in the now detached realm of feeling there was nothing but a vacillation from one extreme to the other" (Giedion 1978, p. 278). In contrast to painting, architecture is not a pure art. It includes aspects of technology as well as art. It has its rational and irrational sides; it calls for reason and emotion. Depending on the dominant ideology the pendulum swings to one side or the other, thereby changing the prevailing architectural style.

The nineteenth century, for all that its major technological advances, was largely a time of stagnation for architecture. Designers resorted to the tried and true; it was the era of the neo-style. Then, at the beginning of the twentieth century, Le Corbusier, influenced by the technological achievements and the aesthetic qualities of the automobile and shipping industries of the period, began to promote a new architectural style: "Architecture is choking on antiquated customs" (Le Corbusier 1969, p. 76). "All cars are in essence constructed in the same way. Due to the unceasing competition between innumerable car companies, every one of them has to be committed to triumphing over its rivals. As a result the standard solution adopted is the aspiration to perfection, to the achievement of a harmony that goes beyond basic practical considerations. This has produced not only perfection and harmony but also beauty, which gives rise to style, that is, those unanimously recognized accomplishment of a unanimously perceived perfection" (Le Corbusier 1969, p. 108).

The 1960s was a period that saw a rejection of technology and belief in the sciences. The upheavals at the end of the decade were also a protest against the hegemony of the rational and the suppression of the emotional. Slogans such as "flower power" and "make love not war" are indicative of the common thread that ran through the entire movement; the desire for more value to be placed on the irrational, emotional and symbolic. This change in the predominant value system brought with it a change in architectural style. Modernism was in part replaced by Postmodernism and other currents.

Culture as an expression of the dominant value system also strongly influences human perception, the way we experience our built environment and our environment in general

Fig. 3.2 **a** residential district in Los Angeles, USA, **b** historic centre of Damascus, Syria

and therefore how we behave within it. The significance of this is commonly underestimated. Behaviour in urban living space is, for instance, very different in the Anglo-Saxon and Arab cultural spheres. The American middle class lives in single-family dwellings with a front garden and would find the idea of living in a standard neighbourhood of Cairo or Damascus, where living space is limited and population density very high, barely conceivable (Fig. 3.2).

The different needs are culturally conditioned and are connected with the different conceptions of the relationship between body and ego (Hall 1976, p. 159). The ego of the American extends beyond his body. His immediate environment is also part of his ego and any physical contact is perceived as intimate. This is not the case for the Arab. His ego is in the body; basic physical contact does not immediately have an impact on his ego and is thus not perceived as intimate. Cohabitation in a restricted space, as is the case in most Arab cities, is not interpreted as a limitation on one's personality (see Sect. 5.2.4).

This differentiation can extend much further. Individual sensory organs are utilized in different ways in different cultures, thereby effectuating specific impressions. In the Western world the sense of smell is largely neutralized. The situation is quite different in an oriental bazaar, where perception is codetermined by smell to a large extent.

Linguists have shown that even language can have a decisive influence on perception. Edward Hall, drawing on the work of the American linguist Benjamin Lee Whorf, writes: "Furthermore … man's very perception of the world about him is programmed by the language he speaks, just as a computer is programmed. Like the computer, man's mind will register and structure external reality only in accordance with the program (Hall 1976, p. 15). For example, the language of the Hopi in Arizona has no word for the concept of "time" (Hall 1976, p. 99), which implies that for them space has no temporal dimension. They experience space only in the present and therefore are not aware of abstract space.

3.2 The Origins of Culture

3.2.1 Art and Science

Every culture reflects the value system of a particular social order. This occurs in the broadest sense through the arts and sciences.

Whereas science operates in a strictly rational manner and appeals above all to our faculty of reason, art appeals to the emotions and the irrational. With the help of "science" human beings attempt to improve their position in their struggle against the forces of nature: the taming of fire allows for its use to provide protection against the cold and to better prepare food, the wheel serves as a means of better locomotion, etc. For a long time the development of art and science proceeded in parallel.

Until well into the nineteenth century most people were able to comprehend what technology had achieved. Inventions such as the wheel or Gutenberg's printing press were and are universally comprehensible. Universal geniuses such as Leonardo da Vinci were both artists and "scientists". In the fifteenth century Leonardo created not only outstanding works of art but also designs for apparatus such as submarines and flying machines. Today scientific knowledge and the products based on it are too complicated for non-specialists to understand. We know how to use a computer but do not understand why it functions as it does.

Siegfried Giedion has shown that well into the Baroque period even abstract and mathematical scientific discoveries had parallels in the emotional sphere and were translated into art. However, he argues, in the nineteenth century science and art went separate ways: "the connection between the methods of thinking and the methods of feeling was broken" (Giedion 1978, p. 139). Gideon emphasizes the role of feelings, arguing that their strength and influence are too often underestimated today. In his view, feelings permeate all activities; thoughts are never completely 'pure' just as actions are never purely practical. Large parts of our emotional life are determined by circumstances over which we have no control because we are individuals living in a certain era. A truly integral culture, he concludes, yields a certain unity of feeling" (Giedion 1978, p. 278).

3.2.2 The Beginnings of Art

Where do the origins of art as our second cultural medium lie?

Some three million years ago, human beings began to think consciously, thereby creating an intellectual world. They began to think about the past and future. This process gave rise to the first 'intellectual products', which can be seen as the beginning of a cultural development. Around 600,000 years ago, human beings began to organize themselves in social groups. Interpersonal relationships led to the development of language.

As they evolved, human beings attempted to represent the invisible life of the mind in concrete terms. Around 50,000 years ago, when the human brain reached its full

3.2 The Origins of Culture

development, spirituality and mysticism emerged. Using ceremonies and rites—which were representative of concrete actions—humans attempted to combat the unpredictability of nature. Objects that supported these actions became cult objects, which gradually supplanted magical rituals and came to symbolize them (Kris 1977, p. 42).

These cult objects can be seen as the origins of art. They represented something and thereby formed a kind of language. As Theodor W. Adorno puts it: "With human means art wants to realize the language of what is not human" (Adorno 1974, p. 121). Louis I. Kahn even argues that art is the only true human language because it aspires to communicate in a way that allows for the recognition of what it is to be human (Giurgola 1979, p. 34).

The very first creative works we are aware of are thus not art in the contemporary sense. Even Palaeolithic cave paintings are certainly stages in a process that had begun a long time before (Adorno 1974, p. 480). For human beings at the time nature was something incomprehensible, threatening. The hunting scenes represented in these paintings were a first attempt to master nature and thus the Palaeolithic environment, at least within the image. The depictions did not have a decorative function; they were a surrogate for an ideal that could not be achieved (Hall 1976, p. 90). In this sense we now see some things as art that were primarily cult objects when they were created.

The first architectural entities that did not serve exclusively as protection were also probably cult sites, the structure and form of which was shaped above all by their cultic function (see Fig. 3.3).

Hans Hollein argues that building today retains a cultic element: "Building is a fundamental human need. It does not first manifest itself in the erection of protective roofs but in the construction of sacral structures, in the marking of focal points of human activity—the beginning of the city. All building is cultic (Hollein 1981, p. 174).

The replacement of an action by an alternative experience, which the American art historian and psychoanalyst Ernst Kris refers to as an "aesthetic illusion", is also, as already discussed, the origin of culture for Sigmund Freud. Art was thus originally, and in a certain sense still is, a sublimation of cultic actions with symbolic weight. Art was not an independent entity but was closely tied to the prevailing social and moral structure

Fig. 3.3 Sun temple, seventeenth century BCE, Stonehenge, England (reconstruction)

and was, indeed, part of it. As Theodor W. Adorno puts it: "Prior to the emancipation of the subject, art was undoubtedly in a certain sense more immediately social than it was afterward. Its autonomy, its growing independence from society, was a function of the bourgeois consciousness of freedom that was itself bound up with the social structure" (Adorno 1974, p. 334). As long as art exclusively served cultic purposes, its creators remained anonymous. Only when artistic production gained a certain level of intrinsic value and became an autonomous activity did the artist as such make his appearance. The uncoupling of the work of art from its cultic content took place in stages and to different degrees. In occidental culture it took place twice: first in Greek culture before the Current Era and later from the Renaissance onwards. In a few cases we know the names of the architects of ancient Egyptian buildings; by contrast the creators of medieval masterpieces have remained anonymous (Kris 1977, p. 54).

Representative art, and thus also architecture, are something tangible, something material, but also something intellectual, something that represents intellectual content, a value system. To quote Adorno again: "Artworks are things that tend to slough off their reity. However, in artworks the aesthetic is not superimposed on the thing in such a fashion that, given a solid foundation, their spirit could emerge. Essential to artworks is that their thingly structure, by virtue of its constitution, makes them into what is not a thing; their reity is the medium of their own transcendence. The two are mediated in each other: The spirit of artworks is constituted in their reity, and their reity, the existence of works, originates in their spirit" (Adorno 1974, p. 412). Since the Renaissance the artwork has not necessary also been a cult object. Whereas up until this time the authentic, the genuine character of art was guaranteed by the cultic, the divine that it represented, today it is the authorship of the genius, the artist.

Today, what we understand by the term art is something very new. If we were to represent the three million years since human beings have been capable of conscious thought on a twelve-hour clock, the 600,000 years we have lived in social structures would be represented by a little less than two hours and 24 min. The 50,000 years since human beings first developed spirituality and mysticism would constitute 12 min, and the 500 years since the Renaissance, i.e. since art as we know it began, would correspond to some 7.2 s.

3.3 Style and the Type of Information

In Sect. 1.2.4 we distinguished between aesthetic and semantic information. While the intellect, and thus also scholarship, are based above all on semantic information, in the emotional sphere, and thus the realm of art, it is aesthetic information that plays the primary role.

We also saw that an exchange of information can only take place when the signs making up this information are part of the repertoire of both the sender and the recipient (see

3.3 Style and the Type of Information

Fig. 1.6). The repertoire of semantic information consists of signs with concrete content. For example, a chemical process can be explained with the help of a formula. The content of this formula is precisely defined information that does not permit personal interpretation. The repertoire of aesthetic information consists of signs that can express symbolic as well as concrete content and thereby leave scope for personal interpretation.

The greater the probability is that a certain sign or a certain combination of signs appears in a message, the less original this message is and the more it corresponds to the established norm. This norm corresponds to the prevailing style in a given situation.

It follows that an artwork—and thus also a building—that is supposed to correspond to a style should have as little originality as possible. Architecture that is regarded as stylistically correct should be nothing more than a good copy of an original. For centuries this was the prevailing concept of art; there was little demand for originality. This meant that there was correspondence between the semantic information conveyed by different artworks in a stylistic period, which in the case of visually perceived art was expressed above all in terms of form, colour and material. As a result the scope for aesthetic information was significantly restricted.

However, an artwork that conforms to a style does not simply have to be a copy of an original; otherwise we would no longer describe it as art. Its semantic information will conform approximately to the norm and thus the style. But the aesthetic information conveyed by this artwork can be such that its symbolic content permits a personal interpretation, thereby lending the work, despite its stylistic fidelity, an individual character that actually makes it an artwork. In terms of information theory, affiliation with a style means a certain level of redundancy and thus a reduction of originality. Redundancy as message waste or message repetition facilitates the recognition of certain stylistically specific features. At the same time, redundancy effectuates a loss of aesthetic information and thus less scope for individual interpretations.

The style of a building determines the proportions of semantic and aesthetic information registered by the beholder.

Whereas at the beginning of Modernism architects aimed to create unambiguous and functional architecture very much in line with Louis Sullivan's maxim "form follows function", the emergence of Postmodernism reintroduced ambiguity. Modernism delivers predominantly semantic information which leaves little scope for interpretation; its appeal lies in its clarity. In relation to the repertoire of the entire built environment, the first works of Modernism constituted something new; they were original and had a low level of redundancy. However, in absolute terms, the information they presented was limited and was further lessened by the dissemination of the style. This also decreased the possibility of the formation of super-signs. In addition, the informational content consisted above all of syntactic signs, thereby leaving little scope for personal interpretation and offering little to meet emotional needs. Postmodernism consciously creates ambiguities, leaves questions open and thus creates greater scope for personal reflection. Modernism appeals more to the intellect, Postmodernism to feelings (Fig. 3.4).

Fig. 3.4 a Le Corbusier, 1929, Villa Savoye, Poissy, France, **b** M. Graves, 1991, Team Disney Building, Burbank, Los Angeles, USA

Changes to cultural ideals over the course of history have also led to changes in prevailing building styles. Today the products of past stylistic epochs in part appear to us as contradictory extremes (see Fig. 3.5).

Style arises from the search for the form that best corresponds to the dominant value system. As Philip Johnson put it, "A style is not a set of rules or shackles, as some of my

Fig. 3.5 Different building styles juxtaposed. Melbourne, Australia. *Right*: LAB architecture studio, 2003, Federation Square (see Fig. 6.13b)

colleagues seem to think. A style is a climate in which to operate, a springboard to leap further into the air. The onus of designing a new style anytime one designs a new building is hardly freedom; it is too heavy a load except for the greatest of Michelangelos or Wrights. Strict style discipline hindered not in the slightest the creators of the Parthenon, not did the pointed arch confine the designers of Amiens.—A style is also not a series of rules that can be applied by critics. It is rather the entirety of all observed aesthetic standards, some of which can be expressed verbally even by laypeople and critics" (Johnson 1982, p. 46).

3.4 Order and the Complexity of Styles

As we saw in Chapter 2, the elements making up a building are ordered, or arranged, according to a system. This arrangement system can be very simple and clear but also very complex.

Max Bense, one of the founders of information aesthetics, distinguished between three levels of order: chaos, structure (being structured) and gestalt (being shaped). Total chaos exists when no ordering principles can be identified in the relationship of elements to one another. The level of predictability is zero and there is maximum originality. Structure, or being structured, denotes a "regular" order. The structural framework plays an important role in the recognition of regular forms. As we shall see, the same structure can give rise to different forms (see Sect. 6.4). Bense terms the third type of order "irregular" order. This is found when the arrangement of elements is subject to a single main rule (Bense 1969, p. 36). The more the degree of order increases, the more complex it becomes and the more its informational content decreases. However, a high level of complexity does not automatically equate with disorder in the conventional sense. In such cases, the order is no longer readily recognizable and perhaps even includes ambiguities. A gain in order means a loss of originality. In the case of total chaos the probability of the appearance of all elements is equally great, redundancy is zero and thus the possibility of new combinations or innovations is maximal.

The continuity of style is dependent on order and redundancy and less on originality. The difference between styles is based on different elements and different arrangement systems. These aspects make them more or less complex and determine their particular relationship to their beholders and users.

An arrangement system automatically imposes constraints on design. The more extensive and rigid this order is, the smaller the scope for variations and the more the individual parts must be subordinated to the overall system. Buildings with very strict arrangement systems offer a very limited degree of freedom, i.e., it is very difficult to make changes within the system. As a result the statement made by such buildings is clear and interpretations are only possible to a very limited degree. Such buildings often appear monolithic to the beholder.

Fig. 3.6 System of ordering as exemplified by the ground plan of the Taj Mahal, 1630–52, Agra, India (based on Henri Stierlin, Islamisches Indien)

Conversely, a complex arrangement system allows for a relatively high degree of freedom; the scope for the individual elements is greater, and ambiguities and personal interpretations are possible. Such buildings demand activity; their order must be fathomed, the system researched (see Sect. 3.6).

Both strict order and complex order allow for exceptions; however, it is important that the structurally intrinsic parts of the system remain unchanged.

What is important for all styles is that the type and number of parts accord with the respective arrangement system (see Sect. 2.3). If this rule is maintained, it is not possible to evaluate the different styles in relation to one another: no particular style can become an absolute architectural highpoint.

What or who determines whether the prevailing order should be simple or complex? The American philosopher of aesthetics Thomas Munro argues that the complexity of an arrangement system in art constantly increases to the point where orientation becomes difficult, with the result that there is a relapse into a simpler system of arrangement system (Munro 1963).

This development diagnosed by Munro is confirmed by information theory. The redundancy of every appearance increases with the frequency of its perception. That is to say that the more often we see a building and are confronted with its style, the more redundancy increases and originality decreases. As we shall see, one of the most important preconditions for the experience of beauty is the possibility of forming super-signs. However, when redundancy increases, it is precisely this possibility that is reduced: it takes longer to reach 160 bits of information, i.e. until we are compelled to combine signs into a super-sign. In order to counter this trend the semiotic range is increased with a greater diversity of forms. This increase in the complexity of appearance also requires a more complex arrangement system. Peter F. Smith argues that a three-stage cycle can be identified that is repeated several times over the course of architectural history. This cycle, he argues, begins again as soon as the principle of rationality revolts against the inconsistency and uncertainty of the polymorphous value system (Smith 1981, p. 257) (Fig. 3.7). The first stage is dominated by strict order, simplicity and harmony. The architecture of the Greeks and that of the Renaissance belong to this category. The second stage is marked by tension. Michelangelo's vestibule in the Biblioteca Laurenziana in Florence (Fig. 3.8, middle), an example of Mannerism, is regarded by

3.4 Order and the Complexity of Styles

Fig. 3.7 The complexity of the respective arrangement system increased in the course of the development of a style up to a highpoint and then decreased again (based on T. Munro and Peter F. Smith)

Fig. 3.8 The increase in complexity during the period from the Renaissance to the Baroque, *1* Brunelleschi, 1445, Foundling Hospital, Florence, Italy, *2* Michelangelo, 1560, vestibule, Biblioteca Laurenziana, Florence, Italy, *3* Abbey Library St. Gallen, 1767, Switzerland

Smith as a masterpiece of this phase. The main features of the third stage are ambiguity and illusion, which are characteristic of all facets of the Baroque. Arrangement is so complex here that we come up against the limits of our ability to absorb information.

The boundaries between architecture and art and sculpture are often blurred in this context.

The cycles (Fig. 3.7) are not precise repetitions of what has gone before. Different, time-delayed variations are possible within the one cycle. For example, in ancient Greece the predominant conception of space was quite different from that found in the Renaissance (see Sect. 5.1). This classification is highly simplified and applies up to the mid-twentieth century at the latest. Since then, architecture in Western cultures has no longer exhibited an overall cohesion (Fig. 3.10).

3.5 Style and the Type, Number and Arrangement of Parts

In Chapter 2 we saw that the way in which the expression of a building is perceived by the beholder essentially depends on three factors: the type and number of visible parts and the relationship of these parts to one another, or the way in which they are arranged. When a new style establishes itself these three factors change.

When the arrangement system becomes more complex, the type of parts becomes less self-contained and their number increases. This development reaches a high point and then reverts to a simpler arrangement system, with less different parts, which are more self-contained (see Fig. 3.8 and 3.9).

All this applies to the development of Western culture but not, for example, to traditional Chinese architecture. The approach of the Chinese was different to that in Europe. Traditional Chinese architecture also had to represent a value system, which was inherent to the world view of Chinese culture. This world view was constructed according to precise rules and delineated a strict order that architecture was supposed to render visible.

At the centre of this order were Heaven and the Lord of Heaven, who was represented on Earth by the emperor. The emperor was the mediator between society and Heaven and he had to ensure that changes in the society were realized in harmony with the "Tao", meaning the way or course of Heaven.

In this system the four cardinal points correspond to the four seasons, and time turns in a clockwise direction around a centre. This centre is also the centre of power, the centre of the empire, the centre of which is in turn constituted by the capital and ultimately the emperor's palace. In ancient Chinese cosmology the sky is round and the earth quadratic. The circle is a non-directional form; it has neither a beginning nor an end and can thus stand for infinity or eternity. By contrast, the square is a form with four sides and four directions (see Fig. 3.11).

The two forms have something in common: the centre, the middle. The circle and the square are both basic forms in Chinese architecture. In architecture, terrestrial space tends to be designed as a square, hierarchically ordered around a centre, namely the imperial palace. On the one hand, architecture was a frame or vessel for a highly

3.5 Style and the Type, Number and Arrangement of Parts OK

Fig. 3.9 Relationship between arrangement system and type and number of parts in the development of styles (see Fig. 3.8)

organized social system. On the other, it had to provide a symbolic depiction of the universe. The arrangement, form and colour of buildings were precisely defined based on their function. Around 2500 years ago, this order found structural expression in a "Hall of Light", a square structure in the centre of a round platform. It provided a site for seasonal rituals, stargazing and ceremonial audiences with the emperor.

In old China the task of architecture, namely to represent a predefined world view, remained the same over centuries up to the modern era. The style, the way of building, accordingly changed little. Even for an expert is therefore difficult to assign a traditional Chinese building precisely to a particular epoch (Grütter 1997, p. 140).

Building styles are elements of traditions. Traditions are norms and rules that promote feelings of solidarity within groups and communities. Traditions can change. Based on the way they came into being and by whom their behavioural rules were established, traditions have a greater or lesser degree of durability and are correspondingly difficult or easy to change. If behavioural rules have been determined by a higher or even divine authority, as in the case of China, changes in architecture take place only very slowly.

Fig. 3.10 From the mid-twentieth century onwards different styles proliferated. *1* Le Corbusier, 1929, Villa Savoye, Poissy, France, *2* M. Graves, 1991, Team Disney Building, Burbank, Los Angeles, USA, *3* P. Behnisch, 1987, University Library, Eichstätt, Germany

3.6 Style and the Personality Structure of the Beholder

There is a direct connection between the degree of complexity and the proportions of semantic and aesthetic information. The clearer an arrangement or order is, the greater the proportion of semantic information and the greater the influence of the intellect as compared with emotion. Conversely, in the case of a large proportion of aesthetic information, i.e. in the case of a very complex order, emotion has a greater influence as compared with intellect. Personality structure also has an influence on the value attached to the three stages of the cultural cycle (see Fig. 3.7). An introverted person, who tends to react intellectually, will prefer clear arrangements and thus favour architectural styles associated with the first stage. An extroverted person tends to react emotionally and thus attaches more value to more complex arrangements and thus architecture associated with the third stage (Eysenck 1947) (see Fig. 3.12).

3.7 Changes in Style

Fig. 3.11 The Chinese world view as a paradigm for traditional Chinese architecture

3.7 Changes in Style

The type of dominant style has changed periodically in Western culture. The arrangement system has developed from simple to complex and, after reaching a point of oversaturation, returned to simplicity. Frequent and in part extreme changes in the dominant style are a phenomenon only found in the Western cultural sphere (see Fig. 3.7).

In old Japan styles changed far more slowly. In Japanese architecture we also find extremes but not of the breadth found, for example, in European architecture. Surprisingly, these extremes are not found at the beginning and end of a long period of development but are in part found coexisting in the same period. Good examples are the

Fig. 3.12 The connection between degree of complexity, type of information and personality structure

Toshogu Shrine in Nikko, north of Tokyo, and the Katsura Imperial Villa near Kyoto (see Fig. 3.13).

Both buildings were constructed at the beginning of the seventeenth century, the first as a mausoleum for Tokugawa Ieyasu, the first shogun of the Tokugawa dynasty, and the second as a residence for a prince from the imperial family. In Nikko we find

Fig. 3.13 **a** Katsura Imperial Villa, seventeenth century, Kyoto, Japan (see Fig. 5.43), **b** gate of the Toshogu Shrine, seventeenth century, Nikko, Japan

3.7 Changes in Style

an architecture overloaded with ornaments and decorations and a colour palette that includes gold, red, green, blue, black and white, and for this reason it is often referred to as Japanese Baroque. However, the supporting structure and even the constructional details of the site are thoroughly in keeping with Buddhist temples from this period and do not offer anything fundamentally new in formal or constructional terms.

The Katsura Imperial Villa is located in the midst of a large garden complex. Captivating due to its simplicity and harmony, the villa has no type of decoration at all. The strict geometry of the wooden supporting structure stands out against the sliding panels covered in white paper.

Both buildings are constructed in what was at the time the widespread shoin style, one of them as a sepulchre and temple, the other as a residence. The main difference between them is in their external appearance; one them is pompous and overloaded, while the other is plain and simple. In order to understand this difference one has to be familiar with the political situation at the time. The emperor, as the head of state and chief Shinto priest, resided in Kyoto and had no governmental power. Prince Toshihito, who commissioned the construction of Katsura, was one of the most influential members of the imperial court, a renowned poet and a master of the tea ceremony. Leadership of religious and cultural life was in the hands of the imperial family in Kyoto, while secular power was exercised by the shogun 500 kms away in Tokyo. This division of powers is one of major reasons for the very different types of expression found in Nikko and Katsura. Whereas the shogun wanted to demonstrate his power with radiance and colour, the Katsura Imperial Villa is embedded in the landscape of the great garden and harmonizes with it. The imperial court and its members had nothing to represent and devoted themselves to spiritual and cultural matters.

One of the buildings is designed to represent prestige and power; it therefore aims to address and manipulate above all the emotions with a great deal of aesthetic information. The Katsura Imperial Villa with its clear order demonstrates simplicity and harmony, is close to nature and introverted. The two buildings make different statements. They represent two basic intellectual attitudes that existed alongside one another in seventeenth-century Japan.

Political and economic changes can also lead to changes in the prevailing value system and thereby a change in style. Adolf Max Vogt has shown that architectural styles before and after the revolutions in France (1789) and Russia (1917) developed in very similar ways. Prior to the revolution we see a tendency toward geometric, constructivist architecture, which during the revolution, or in Russia's case shortly thereafter, changes to a more Classical style (Vogt 1974, p. 100) (see Fig. 3.14).

What is astounding at first glance is the fact that the development of the prevailing architectural style clearly proceeded contrary to political developments, namely from a more revolutionary to a conservative style. Vogt describes the revolutionary direction with the adjectives "cold", "hard" and "light" and the Classical direction as "warm", "soft" and "heavy" (Vogt 1974, p. 104). Revolutionary architecture such as the rather late project for a Lenin Institute in Moscow (see. Fig. 3.14c lower left) is described as

Fig. 3.14 Style development before (left) and after (right) the revolutions in France (above) and Russia (below) (based on A. M.Vogt). **a** Etienne-Louis Boullee, Cenotaph for Newton (project), 1784, **b** Pierre Vignon, La Madeleine, 1807, Paris, France, **c** Ivan IlichLeonidov, Lenin Institute (project), 1927, Moscow, Russia, **d** Ivan Zholtovsky, residential building, 1933, Moscow, Russia

light because the sphere appears to float and the contact surfaces are relatively small in relation to the volumes. The prerevolutionary buildings that Vogt refers to as revolution architecture for the most part never got past the project stage, either in France or in Russia.

Post-revolutionary architecture, such as a residential building by Zholtovsky in the Classical style (see Fig. 3.14d), is firmly fixed to the ground and has "weight". After the new political regime had consolidated itself in the wake of the revolution, it required visible signs of its power. In terms of architecture this could only be achieved with a style that had "weight" and buildings that did not appear to float. The Classical style was able to create the impression that everything was the same as it ever was. The façade of the building by Zholtovsky (Fig. 3.14d) is more or less an exact copy of the façade of the Palazzo Porto Breganze built by Palladio in Vicenza (1570–1580) (see Fig. 3.15).

Traditions provide orientation. When new traditions are imposed on a society, such as after a political revolution, people are deprived of the past so that they will look exclusively to the future. In such a new, undefined situation people do not have familiar orientation points they can build on. They therefore look for something solid and familiar, such as building in the old style.

A comparison with the previously discussed buildings from Japan reveals certain parallels. In Japan there was a discrepancy between the type of information that a building

Fig. 3.15 Palladio, 1570–1580, Palazzo Porto Breganze, Vicenza, Italy

conveyed and the function of its users. The function of the shogun is a matter of the intellect, but his building tends to speak to the emotions. The prince deals with religion and art, with spiritual, irrational themes, yet his villa conveys above all semantic information.

3.8 Acceptance of Styles

Building styles are manifested in the important public and representative buildings of an epoch, such as churches, palaces and stately homes. Many secular buildings that did not endure for long were not built in the style prevailing at the time.

The first buildings of the so-called modernist period, which began around the beginning of the twentieth century, represented a radical break with convention and what had gone before. Fostering and promoting the new and the modern are also always a critique of the old. The inventors of the new are peripheral groups, minorities. With the new they

change the rules of the game, creating new traditions. However, this is not accepted automatically by the majority, which must be confronted with the new and be able to engage with it. The most obvious way of engaging with the new is by comparing it to the old, to what already exists. Or as José Ortega y Gasset puts it, "The past is the only arsenal that provides us with the means to shape our future" (cited in Kägi 1997). Modernism's break with what had gone before was too radical and as a result the new style was not accepted by broad segments of the population.

A number of buildings by Le Corbusier from the 1920s provide good examples. The buildings were designed in strict accordance with the rules of Modernism and equipped with the latest technology. However, it soon became clear that the inhabitants were not satisfied with this type of house and they began to modify the buildings (Fig. 3.16).

The form of the roof often caused the greatest difficulty. The discussion about the different merits of flat and pitched roofs continues today; it is mainly an emotional question. The first "houses" had a purely protective function and consisted above all of a large protective roof.

The dwelling as a staging area between birth and death has always had a special symbolic meaning, with the roof playing a primary role (Rykwert 1983, p. 149) (see Fig. 3.17). A simplified form of the gable roof is used in different Chinese and Japanese written characters. The ideogram for "hut" (Fig. 3.18a) features a roof-shaped angle atop a square space. The character for "people meet", i.e. protected meeting point, looks very similar (see Fig. 3.18b). The concepts of dwelling, protection, feeling of security and continuity were so closely associated with the gable roof here that this formed took on symbolic meaning. The form of the gable roof was also constructionally and functionally determined into the modern period: as protection against the elements the roof surface had to be sloped so the rainwater could flow off it. Later the space under the roof also served as a storage area. The gable roof was a symbol of protection par excellence. It communicated both semantic and aesthetic information, speaking to the intellect and the emotions alike.

Fig. 3.16 Le Corbusier, single-family house in Lége, France. **a** after completion, **b** after modification (based on Moore Charles, Allen Gerald, Lyndon Donlyn, The Place of Houses,1994, Holt, Rinehart and Winston)

3.8 Acceptance of Styles

Fig. 3.17 Farmhouse, 1797, canton of Bern, Switzerland (today Ballenberg open-air museum)

Fig. 3.18 **a** Japanese ideogram for "hut" (sha), **b** Japanese ideogram for "people meet" (au)

The spatial separation of work and living spaces in the nineteenth century meant that the attic no longer had to be used for storage. New building material and techniques made it possible to construct flat roofs that could also have a protective function.

From this point of view, the replacement of the pitched roof with a flat roof was a logical step. In 1926, in his "Five Points of Architecture", Le Corbusier praised the flat roof and the new surfaces it provided: "the flat roof requires, first of all, consistent utilisation for living purposes: roof terrace, roof garden … Roof gardens have lush vegetation. Shrubs, even small trees up to a height of 3–4 m can easily be planted. By doing this, the roof garden becomes the most favoured place in the house. In general, roof gardens stand for the retrieval of the entire built area" (Le Corbusier 1981, p. 94) (see Fig. 3.19).

With this seemingly logical change in roof form, architects responded to the latest technical possibilities and found functional advantages in them. However, they failed to take into account the preferences of the user. On an intellectual level the flat roof seemed acceptable, but the change in form also meant that the roof lost its meaning as a symbol. The emotional and intellectual meaning ascribed to the roof could no longer be expressed through this new form.

Fig. 3.19 a Surface comparison between **a** a conventional house and **b** a house erected on columns with a flat roof and open ground floor area (based on Le Corbusier, 1929)

Many forms have a cultural meaning and serve as symbolic signs over and above their possible functional value. The overall content these signs express forms a type of language. A change of style and the associated change of the forms that are used also bring about a change of this language, which needs to be understood not only by architects but also the broad population.

It was precisely this that failed to happen with Modernism. Architecture was adapted to new technologies and a new stylistic idiom emerged.

In addition, twentieth-century Modernism was not the only prevailing style. Several styles were used in juxtaposition and simultaneously, with the result that it was no longer possible to become accustomed to the new languages.

In order for a new style to be accepted on a broad basis its language, i.e. the cultural-symbolic content of its signs, needs to be understood. Previously, building styles had prevailed for centuries. The gradual understanding of the new language proceeded in parallel with the changing of forms. When these changes could no longer be emotionally processed, intellectual and emotional life became separated. The primary task of the semiotic language was no longer met.

The separation of emotions and the intellect reached its highpoint in Modernism. The wonders of technology at the beginning of the twentieth century exerted such a fascination that the emotional aspect was neglected. The disappearance of most mystical, religious and symbolic networks in Western culture during the twentieth century had a disastrous effect on art in general and architecture in particular. As the art psychologist Rudolf Arnheim writes, "When things are nothing other than things, then forms, colours and tones are nothing other than forms, colours and tones, and art becomes a technique of entertaining the senses" (Arnheim 1980, p. 19). In Modernism the cultural-symbolic content of signs was no longer attributed significance; indeed, the emotional statement of form was avoided as far as possible. This left Modernism without a language.

3.8 Acceptance of Styles

The post-modern style used signs again and in the process fell back on the old language: columns and pitched roofs were accepted again. In this sense the post-modern was a step backwards: it was a readjustment to the old language (see Fig. 3.4b).

Today's attitude to dwelling can also be seen as holding onto an old language or as not understanding a new language. The saying "my home is my castle" still applies, at least in Europe. For many the dream home is still a free-standing single-family house: one's own house with one's own garden, however small. However, with the constant increase in land and building prices, this ideal is realizable for an ever shrinking number of people, and both living and garden spaces must be reduced constantly.

Up until the age of industrialization in the nineteenth century, people lived in extended families. The house served as a dwelling and a workplace (see Fig. 3.17). Industrialization brought about, on the one hand, a spatial separation of dwelling and working and, on the other, the decline of the extended family. This increased the need for dwellings, irrespective of the absolute growth in population.

The centralization of industry and the associated problems of transport between the dwelling and the workplace resulted in an ever increasing number of people being squeezed together in an ever decreasing amount of space. Land became scarce and therefore expensive, and large apartment blocks were built in an attempt to counter this trend.

The dream of one's own family home still survives today, although living areas are constantly becoming smaller and the so-called garden has shrunk to a forecourt. The goal of acquiring a generously proportioned, individual dwelling surrounded by enough open space for private and collective activities is only seldom realizable today. The desired advantages are being replaced by a serious of disadvantages: the relatively large external surface means that dwellings require a large investment in heating and maintenance, and, although the "garden" has nothing to offer anymore, it needs to be maintained (see Fig. 3.20).

Today's compact housing development, a middle course between the anonymous apartment block and the individual single-family home, is an attempt to better adapt

Fig. 3.20 The "dream" of one's own home, street with house near Bern, Switzerland

dwelling to changed circumstances. Despite its clear advantages, this form of dwelling is finding it very difficult to establish itself. The opinion that optimal dwelling is only possible in a single-family home can only be changed very slowly.

References

Adorno, Theodor W.: Ästhetische Theorie, Frankfurt am Main, 1974 (1970)
Arnheim, Rudolf: Die Form und der Konsument, Collage Art Journal, 19/1959 (in: Zur Psychologie der Kunst, Frankfurt am Main, 1980)
Bense, Max: Einführung in die informationstheoretische Ästhetik, Hamburg, 1969
Eysenck, H. J.: Dimensions of Personality, London, 1947
Freud, Sigmund: Das Unbehagen in der Kultur, Frankfurt, 1970 (1 930)
Giedion, Siegfried: "Raum, Zeit, Architektur", Zürich, 1978, (original title: Space, Time and Architecture, Cambridge, Mass., 1941)
Giurgola, Romaldo: Louis 1. Kahn, Zürich, 1979
Grütter, Jörg Kurt: Chinesische Architektur als Abbild des Universums, Schweizer Ingenieur und Architekt, 8/1997
Hall, Edward T.: Die Sprache des Raumes, Düsseldorf, 1976 (original title: The Hidden Dimension, 1966)
Hollein, Hans: Absolute Architektur, 1962 (in: Programme und Manifeste zur Architektur des 20. Jahrhunderts, Braunschweig, 1981)
Johnson, Philip: Texte zur Architektur, Stuttgart, 1982 (original title: Philip Johnson Writings, Oxford, 1979)
Kägi, Erich A.: Die Angst vor dem Neuen, NZZ 16/17.8.1997
Kris, Ernst: Die ästhetische Illusion – Phänomene der Kunst in der Sicht der Psychoanalyse, Frankfurt am Main, 1977 (original title: Psychoanalytic Explorations in Art, New York, 1952)
Le Corbusier: Fünf Punkte zu einer neuen Architektur, 1926 (in: Programme und Manifeste zur Architektur des 20. Jahrhunderts, Braunschweig, 1981)
Le Corbusier: Ausblick auf eine Architektur, Berlin, 1969 (original title: Vers une architecture, Paris, 1923)
Munro, T.: Evolution in the Arts and other Theories of Cultural History, Cleveland, 1963
Muthesius, Hermann: Werkbundziele, 1911 (in: Programme und Manifeste zur Architektur des 20. Jahrhunderts, Braunschweig, 1981)
Norberg-Schulz, Christian: Meaning in Western Architecture, London, 1975, (original title: Significato nell' architettura occidentale,Milano,1974)
Panofsky, Erwin: Sinn und Deutung in der bildenden Kunst, Du Mont, 1978 (1955)
Rykwert, Joseph: Ornament ist kein Verbrechen, Cologne, 1983 (original title: The Necessity of Artifice, London, 1982)
Smith, Peter F.: Architektur und Ästhetik, Stuttgart, 1981 (original title: Architecture and the Human Dimension, London, 1979)
Vogt, Adolf Max: Revolutions-Architektur, Cologne, 1974

Site and Surroundings

4

Contents

4.1 Influence of Surroundings on the Perception of Architecture . 105
4.2 Site . 108
4.3 Type of Surroundings and Choice of Site . 110
4.4 The Relationship of Human Beings to Nature and Their Surroundings 112
4.5 The Relationship of Buildings to Their Surroundings. 116
 4.5.1 Adaptation—Contrast—Confrontation . 116
 4.5.2 The Relationship to the Ground. 119
 4.5.3 The Relationship Between Interior and Exterior . 122
4.6 Streets and Squares . 130
References. 131

4.1 Influence of Surroundings on the Perception of Architecture

There are multiple relationships between each individual and his or her surroundings, only a few of which are fully defined at the time of birth. Most of these relationships are formed through learning; in only a few cases are they based on instinctive reactions. This means that forming a relationship to our surroundings entails learning the meaning of the different objects around us, where they are and how we have to behave in relation to them. As we increase our range of experience we form a whole network of stored information which ultimately enables us to control our environment even when it is not directly perceivable. In our minds particular objects are always linked to a certain environment. For example, on our internal "memory screen" a bicycle appears on the street or attached to a bike rack, not in a bathtub or a refrigerator. In the case of buildings,

© Springer Fachmedien Wiesbaden GmbH, part of Springer Nature 2020
J. K. Grütter, *Basics of Perception in Architecture*,
https://doi.org/10.1007/978-3-658-31156-8_4

which are not mobile and thus always occupy the same location, this connection is even stronger. We always "see" the Eiffel Tower beside the Seine in Paris, not on some mountain or in a soup plate (see Fig. 4.1). It is not only in reality that architecture appears closely tied to its surroundings: even in our memories the two are inseparable.

This is indicative of the intrinsic influence our surroundings have on our perception of architecture and of the importance of these surroundings to the planning process. Buildings engage in a constant dialogue with their surroundings, and it has been proved that two identical buildings are perceived differently in different contexts (Joedicke 1975, p. 372). It follows that experiencing a building is not limited to the structure itself but also includes it surroundings.

The more a building is adapted to its surroundings, the more it is integrated within it, then the less the influence these surroundings exert on our perception of the building. Conversely, the more original, the more unexpected a building is, then the greater the contrast between it and its surroundings and the greater the influence these surroundings will have on the perception of the building (Joedicke 1975, p. 372). In information-theoretical terms this means that the flow of information in the case of original messages is so large that super-signs are formed (see Sect. 1.3.3) or that the

Fig. 4.1 **a** The Eiffel Tower in Paris, **b** Paris Las Vegas Hotel, Las Vegas, USA

4.1 Influence of Surroundings on the Perception of Architecture

conventional surroundings are incorporated in perception to a greater degree in order to reduce the level of originality.

It would be wrong to reduce the surroundings which influence the perception of a building to a factor that is merely included optically in the respective field of view. For Richard Neutra the surroundings provided not only the visual framework for a building. He was convinced that they could have a direct effect on the human psyche. With his "Health House", built for the physician Philip Lovell in Los Angeles in 1927, Neutra became one of the first architects to attempt to create a biologically correct housing model. The "biological" aspect did not relate to building materials and heating systems, as would be expected today, but mainly to the incorporation of the building's surroundings, which, Neutra was convinced, had a beneficial effect on the nervous system.

The evaluation of a building depends not only on its immediate surroundings, i.e. the adjacent houses, but also the wider surroundings, the neighbourhood and the entire district. A "neighbourhood" refers to the area that can be comprehended clearly and experienced as a whole, which is defined as an area of 30 to 40 hectares or between 550 by 550 m and 630 by 630 m (Canter 1973). In the case of animals, behavioural scientists speak of territoriality and different distances. Invisible boundaries define different areas that are decisive for the behaviour of animals. The distances define gaps that evoke different reactions in the animals. For example, the escape distance defines how close another creature can come to the animal before the latter flees. Human behaviour is also influenced by such distances and territories, the sizes of which are culturally conditioned and can vary (see Sect. 5.2.3).

The evaluation of a dwelling is highly influenced by its surroundings. Inhabitants must be able to experience their immediate surroundings as their own, i.e. they must be able to identify with them. On the one hand, this requires a certain degree of spatial variety, which in turn facilitates a diversity of experience, and, on the other, a balanced mixture of private, semi-private and common areas. A large proportion of psychological damage can be traced back to a lack of unforced contact possibilities or, conversely, to unavoidable contact and the stress this produces. Such damage is often a direct result of poor building decisions. For example, many people feel their privacy is violated in narrow lifts or corridors and are therefore unwilling to communicate (Ladde 1974, p. 154). Others feel that their personal "territory" is being intruded upon, that their "escape distance" has been compromised but there is no possibility of escape (see Sect. 5.2.4).

Various attempts have been made to demonstrate these connections scientifically. In 1872, in "The Expression of the Emotions in Man and Animals", Charles Darwin commented that the pupils of cats in a frightening situation do not become smaller even under strong light but only once the animal has calmed down. Drawing on this observation, an experimental investigation was conducted of the connection between an architectural situation and the emotional reaction of people as indicated by their pupil size. The results showed that test subjects from different cultures reacted differently to certain shapes. This means that certain shapes evoke different emotional reactions in different cultures. This proves only that the nature of our surroundings, i.e. architecture and

its context, can evoke different emotions and thereby influence the way we act but not which type of surroundings evoke which emotions. Interesting here is the observation that the change in pupil size and thus the emotional reaction is greater in architects than in other test subjects (Payne 1973, p. 76). This is probably because the eye of the architect has been more sensitized by a particular range of experience than the eye of other people.

4.2 Site

Every object has a location, every action occurs at a site. However, site is more than an abstract concept and includes more than the mere position. Different objects and different actions require different sites. The site is a specially designated place or spatial segment characterized by the elements that define it. Space can be transplanted, a site cannot. An object is located on a site and claims space. A site does not have to be occupied, does not have to be marked by an object; it can also be defined by contrasts. Building also means creating an artificial site. Sites created by people have the task of accentuating a particular place. The natural structures on the site are emphasized; the particular features that people believe they can distinguish are rendered visible. As Christian Norberg-Schulz comments, "The existential purpose of building is therefore to make a site become a 'place', that is, to uncover the meaning potentially present in the given environment" (Norberg-Schulz 1982, p. 18).

The character of a site can be denoted by different factors. The most important role in this regard is played by its contrast with its surroundings: differences in terms of topography, form, material or colour. However, a site can also acquire a particular meaning from a special event. Such sites often memorials or pilgrimage churches. A site can also acquire a symbolic meaning that goes beyond its memorializing function. For example, the Rütli meadow on Lake Lucerne in Switzerland has long been a symbol of freedom. It was here in 1291 that the representatives of the three original cantons swore loyalty and allegiance to one another against their common oppressor, thereby laying the foundation of the Swiss Confederacy. Here we have a site that retrospectively acquired a symbolic meaning. Conversely, a location can be defined by symbolic criteria. For example, between the fifth and third centuries BCE the doctrine of "wind and water" (feng shui) emerged in ancient China. This doctrine comprised a series of rules governing the location of a new house (Thilo 1978, p. 220). The doctrine retained legitimacy for over two millennia and is still applied to some extent today. Feng shui has three major aspects: the concept of yin and yang (doctrine of polarity), the theory of the five elements, and the doctrine of the connections between the microcosm and the macrocosm. These doctrines were used to determine the locations of buildings, furnishings and so on. For example, the family of a married son preferred to live in the eastern part of the extended family's building group. The sun rises in the east, it is the side of emerging yang, of the spring, and for this reason an eastern location within the building group was linked with the hope of many offspring (see Fig. 3.11).

4.2 Site

As already discussed, we connect our idea of a building with a very particular location and its surroundings. This connection first becomes really clear when an object that we connect with a fixed location is transferred to another site. For us, the Eiffel Tower is intimately connected with Paris; indeed, it is a symbol of this city. When we find the same tower, although only half as high, standing in front of a Las Vegas hotel, the effect at first glance is jarring (see Fig. 4.1).

The Isa Shrine, which is probably the oldest Shinto shrine in Japan, represents a very particular example in this regard. Its distinctive characteristic is that it is rebuilt every twenty years on alternate fields lying adjacent to one another. The origins of the shrine are not precisely documented, but it is mentioned in one of the first Japanese chronicles (Nihon Shoki, 720 CE). According to this source, worship of the sun goddess Amatarasu Omikami began in Isa some 2000 years ago. At the outset the site of this worship was marked only by a flat enclosed area. The current shrine buildings were first erected in the second half of the seventh century. Since then the buildings, with one exception, have been rebuilt from new wood every 20 years, with each rebuilding alternating between the two sites (see Fig. 4.2).

Fig. 4.2 Inner Shinto shrine, Ise, Japan (see Fig. 9.22). Above is the empty field where the shrine will be rebuilt after 20 years have elapsed

The "soul" of the shrine complex is a small post embedded in the ground, the so-called heart post. It forms the point around which the shrine's main building is erected. There is a heart post at each location, and the one that stands alone in the empty field for twenty years is protected by a specially built wooden structure (Watanabe 1974, p. 28). The eternal and the ephemeral are not mutually exclusive here; rather, they supplement one another. This corresponds to the philosophy of yin and yang, which is based on a concept of the coexistence of contradictory elements, the notions of "as well as" and "either or" (see Sect. 4.4).

4.3 Type of Surroundings and Choice of Site

For construction the most important aspects of the surroundings are their topographical form and the configuration and character of their surfaces: built up, vegetated, etc. These qualities are discernible in both urban contexts and the natural environment and have a decisive effect on our perception. Are we amongst a sea of houses, in a sandy desert or on a cobbled square? Just as the material of the spatially defining elements influences our perception of the space, so too do the structure and material qualities of our surroundings influence the way we discern them. Changes to the form, structure or material of our surroundings produces contrasts: the river bank, the river mouth, the boundary of a built-up area, the summit, the forest edge, the bottom of a valley, etc. Such points or lines of contrast give rise to sites, to places that stand out from their surroundings. The landscape as wider environment has a significant influence on the choice of location and the type of building. As Frank Lloyd Wright put it, "In any and every case the site is the beginning of the building that aspires to architecture. And this is true whatever the site or the building may be" (Wright 1970, p. 322).

Points or lines of contrast in the landscape were always the preferred sites for human settlement: river mouths, hill ridges, river loops, overhanging rock faces, etc. The surroundings had a formative role in shaping what was built and the site it was built on.

In ancient Egypt the natural environment had a formative effect on not only what was built but ultimately the entire prevailing world view. The Nile formed a north–south axis with desert on both sides. The river, whose waters were the source of the fertility of the narrow strips of land along the axis, was the lifeblood of the population and as a result acquired a symbolic significance as the embodiment of life that went beyond its function as a source of irrigation. The sun, as the provider of light, was worshipped in the person of the god Ra (Norberg-Schulz 1975, p. 10). Its east–west trajectory and the axis of the Nile form an orthogonal arrangement system, which also found expression in ancient Egyptian architecture. The pyramids were constructed on the left bank of the Nile, providing burial sites for the dead pharaohs on the side of the setting sun. Research has shown that the orientation of the pyramids deviates from the cardinal points by only a few degrees (Canival 1964, p. 132). The temple and tomb complexes in Upper Egypt lie at the foot of an abrupt rise in the terrain that forms a boundary between the Nile Valley and the desert. Their axes also run at right angles to the north–south axis of the river (see Fig. 4.3).

4.3 Type of Surroundings and Choice of Site

Fig. 4.3 Arrangement system in ancient Egypt

The landscape of Greece is fundamentally different from that of Egypt. The Nile divides a giant plain into two parts, whereas in Greece the landscape is dotted with mountains and repeatedly interrupted by bays. This gives rise to different types of surroundings in which each site is distinguished by a different characteristic that evoked different reactions. The Greek gods were accorded special sites: places that radiated a particularly strong sense of harmony were dedicated to Zeus, and sites at which people assembled were dedicated to the goddess Athena (Norberg-Schulz 1975, p. 47). The arrangement of buildings was determined by the topography; the natural order dominated what was built, which could thus not be subjected to a purely geometric arrangement. The floor plans of Greek building groups often seem almost chaotic because the third dimension, the topographical form of the surroundings, which codetermined the position of the individual buildings and thus their interrelationships, is not apparent (see Fig. 4.4).

Ancient Roman architecture is not as landscape-oriented as its Egyptian and Greek counterparts. The Roman Empire developed out of a city-state. The world empire that emerged was subject to a strict arrangement system which divided this vast area into four parts, with the capital Rome forming its centre and the midpoint of the world. This system also governed relationships within a town or building group. Most towns founded by

Fig. 4.4 a Ancient Greek arrangement system, b Acropolis of Pergamon, late third century to second century BCE, near modern Bergama, Turkey

Fig. 4.5 a Ancient Roman arrangement system, **b** Diocletian's Palace, 300 CE, Split, Croatia (see also Fig. 2.17) GOTT

the Romans were based on an orthogonal grid with main axes running at right angles to one another. This arrangement is often not found in its pure form because later expansion no longer took the original grid into consideration or topographical features prevented strict adherence. Nevertheless, in Roman architecture the location was determined less by the landscape and topography than by a symbolic arrangement system, which was in turn shaped by a political worldview (see Fig. 4.5).

4.4 The Relationship of Human Beings to Nature and Their Surroundings

In order to understand the relationship between buildings and their surroundings we need first to examine the prevailing attitude of people to these surroundings and thus to nature in general. All building is essentially an intervention in the existing environment, in nature. The form this intervention takes is closely dependent on the attitude of the people involved. For instance, traditional Japanese culture and other Far Eastern cultures were characterized by a close relationship between human beings and nature. Here, too,

4.4 The Relationship of Human Beings to Nature and Their Surroundings

human beings feared nature, which could produce phenomena such as earthquakes and tsunamis. On the other hand, they also endeavoured to live in harmony with and as part of nature, which they regarded as encompassing the divine. People were thus linked to the natural environment by manifold relationships, which facilitated the survival of both the human being and nature (see Fig. 4.6).

In Occidental culture nature was regarded as created by God and human beings were supposed to subdue it. Whereas in the Eastern model the divine, as the supernatural, is intimately bound to nature—indeed, is a part of it—thereby forming a unified entity which also encompasses the human being, in the Western model the tripartite structure gave rise to a whole series of dualistic relationships such as God–human, God–nature, nature–human, subject–object, etc. In all these relationships one of the original three entities is excluded (see Fig. 4.6).

For a long time the human being was powerless in the face of nature. Since in the Western tradition nature was not inherently connected to the divine, there was no possibility of interpreting it as something mystical, something supernatural, and thereby accepting it (Grütter 1976, p. 465). The human being feared nature and sought to combat it.

As organic beings humans are part of nature, living within it and dependent on it. Both the natural world and what humans build are subject to the same physical laws. It therefore seems self-evident that nature serves humans as a model in many spheres, including building. One often encounters the opinion that nature has achieved perfection when it comes to creating optimally functional structures. However, this is not the case. As the biologist and philosopher of nature Adolf Portmann writes, "The plain, purely purposeful form that many celebrate as natural is a rare special case—it is precisely in animal forms that we are far more often confronted with phenomenon that cannot be comprehended by such concepts … So often it seems we are seeing the products of sweeping imaginations that suggest to us vagaries, the capricious play of creative powers rather than technical necessity" (Portmann 1960, p. 36).

Fig. 4.6 The relationship between the divine, nature and the human being. **a** Japanese model, **b** Western model

For example, a comparison between the swan and the giraffe, both creatures with extremely long necks, reveals fundamental structural differences. The swan has more cervical vertebrae than other birds due the greater length of its neck. The giraffe also has an extremely long neck compared with other mammals. Like other mammals, the giraffe has only seven cervical vertebrae but they are far larger than those found in other species.

Moreover, the visible markings on many creatures, such as various types of mussel, have neither a signalling nor a technical function. Nature can serve as a model for human beings but does not have to. It is said that Brunelleschi used a hen's egg as the model when building the dome of Florence Cathedral. Joseph Paxton is said to have been inspired by the leaves of *Victoria regia,* a giant water lily, when designing the Crystal Palace, and JørnUtzon is said to have derived the form of the roof of the Sydney Opera House from an orange.

Nevertheless, it would be wrong to assume that every good architectural structure can be traced back to a natural model. Countering the claim that his tensile structures were copies of cobwebs, Frei Otto wrote, "When these extremely lightweight structures were designed and engineered and their statics were calculated and tested, their creators were no more familiar with the webs of spiders that any interested layperson. But when the new technique of tensile membrane roofing had reached a certain level of development, one could see the webs of spiders with other, trained eyes; one could 'recognize' them" (Otto 1982, p. 8).

The relationship of the human being to nature is also discernible in the relationship of built structures to a garden. Different attitudes to nature in the Western and Eastern worlds have produced different relationships between the built environment and the garden, the immediate natural environment.

One of France's contributions to Baroque architecture was the organization of exterior space (Giedion 1978, p. 106). With the construction of Versailles, Louis XIV, who also saw himself as the ruler of nature and, indeed, of the cosmos, wanted to make his mark as an absolutist monarch. The king's bedroom was oriented towards the east and the rising sun, which set in the west as indicated by the axis of the palace garden. This cycle was symbolically re-enacted in the ceremonies of the "lever" and "coucher" of the monarch. The enormous garden complex represented the translation of the Baroque idea of infinite space into exterior space. As Nikolaus Pevsner writes, "The garden front of the palace, 1800 feet long, faces Le Notre's magnificent park with its vast parterres of flowers, its cross-shaped sheet of water, fountains, seemingly endless parallel or radiating avenues, and walks between tall, trimmed hedges—Nature subdued by the hand of Man to serve the greatness of the king, whose bedroom was placed right in the centre of the whole composition" (Pevsner 1967, p. 364). The building is in contact with nature, the garden is juxtaposed with the building and together they form a great unity; however they are certainly not equal partners. The surroundings have not been left in their natural state but rather subjected to the strict geometry of the building (see Fig. 4.7).

The so-called English landscape garden was developed in eighteenth-century England partly under the influence of the ideas of Jean Jacques Rousseau. In this model the

4.4 The Relationship of Human Beings to Nature and Their Surroundings

landscape was no longer subjected to an artificial geometry but was largely left in a natural state. The attitude to nature was different from that found in France. The strictly rational built complex and the picturesque, natural surroundings were juxtaposed as equal partners. The imposition of an artificial geometry was rejected here as something unnatural (see. Fig. 4.7).

At the end of the seventeenth century the statesman and writer Joseph Addison formulated this new approach as follows: "For my part I would rather look upon a tree in all its luxuriance and diffusion of boughs and branches, than when it is cut and trimmed into a mathematical figure" (Pevsner 1967, p. 381).

The idea of linking housing with nature also became increasing popular. First realized in the case of the king's residence, this development spread to the ancestral seats of the nobility and then to the wealthy bourgeoisie. During the nineteenth century this tendency also had an influence on urban development. At the beginning of the century John Nash was commissioned to design apartment buildings for a park in London that belonged to the crown. The result was a large building complex set in the midst of natural surroundings. The project inspired the idea of the garden city, which emerged at the end of the nineteenth century. The garden city was seen as providing a contrast to the industrial agglomeration and, at least in the beginning, had a social character (Frampton 1983, p. 40).

As already discussed, the relationship of human beings to nature in the Western world was fundamentally different to that in the Far East. In the I Ching, one of the oldest written sources pertaining to Chinese culture (seventh or eighth century BCE), the oppositional pair of yin and yang and their interaction are described (Brockhaus 1969,

Fig. 4.7 The relationship between gardens and buildings in **a** France and **b** England

Fig. 4.8 a The relationship between gardens and buildings in China, **b** Master of the Nets Garden, 1140 (eighteenth century), Suzhou, China

p. 810). In this concept all natural phenomena contain or presuppose an oppositional element. For example "large" is only recognized as such in comparison with "small". The elements of this oppositional pair do not conflict with one another but rather mutually necessitate each other. Conflicts between opposites are prevented by supplementation; only in this way can completeness emerge. This train of thought became the foundation of most Far Eastern philosophies and a key to the question of the relationship of the built structure to its surroundings. Nature and architecture are not in opposition but rather permeate and supplement one another. Since not every house can stand alone in a large garden the connection with nature is often limited to the relationship between interior and exterior space (see Sect. 4.5.3). What is important is that both elements are present, since it is only through the presence of one that the other can be fully recognized (see Fig. 4.8).

4.5 The Relationship of Buildings to Their Surroundings

4.5.1 Adaptation—Contrast—Confrontation

What is the character of the relationship of a building, as something artificial, to its surroundings, to its natural environment or in the urban context to its built environment? In simple terms we can distinguish between three different types of relationship. The first

4.5 The Relationship of Buildings to Their Surroundings

possibility is adaptation: the new building takes on the language of the existing surroundings formally, materially, technically, etc. However, buildings can also form a contrast to their surroundings, setting themselves off from their environment as something special, something different. The third possibility is confrontation: buildings and their surroundings confront one another as opposites (see Fig. 4.9).

Adaptation to the surroundings, on the one hand, can avoid chaos but, on the other, hinders development and renewal. Strict building regulations such as stipulated styles of roof, colours or materials aim to hinder too much diversity and thus the potential for chaos but can, as a consequence of a high level of redundancy, lead to monotony (see Fig. 4.10).

The second type of relationship involves consciously setting a building off from its surroundings and is the opposite of adaptation. The building forms a contrast to its surroundings. In the urban context there can be different reasons for consciously setting off a building from its adjacent structures. For example, the new head office of a firm may be deliberately distinguished from the buildings housing other firms. In information-theoretical terms "different" means unforeseen, i.e. original. However, if a

Fig. 4.9 The relationship of buildings to their surroundings: **a** adaptation, **b** contrast, **c** confrontation

Fig. 4.10 Kaija and HeikkiSirén, 1973, factory facade, Tampere, Finland (right: old building, left: new building)

message is still to be understood, the new element must have a minimal connection to what has preceded it. This means that even where there is a deliberate intent to set off a building from its surroundings and to form a contrast with them, the building concerned must adopt certain elements of these surroundings (see Fig. 4.11).

The third type of a relationship between buildings and their surroundings is confrontation. This possibility can be seen as a sub-group of the second type but differs from it in a decisive aspect. Whereas in the second type the emphasis is above all on generating a contrast between the new building and its surroundings, the third group is characterized by confrontation. The building is deliberately designed to create an opposition to its surroundings; it exhibits no similarity to them either in terms of form, material or colour (Fig. 6.2 middle).

All three possibilities entail a more or less significant influence of the building concerned on its surroundings and vice verse in both urban and non-urban contexts. Each object is perceived in association with its surroundings and these surroundings thereby influence perception. The degree of influence increases the more the new building is set off from its surroundings (see Sect. 4.1). In the first case, that of adaptation, the surroundings are dominant; the new building is subordinated to its surroundings, it adapts to them. The second case is based on the difference between the building and its surroundings; a contrast is created. The two elements are juxtaposed and neither of them dominates the other. In the third case the building and its surroundings confront one another. The influence that they exercise on one another is more powerful than in the second case; the new building dominates its surroundings. Conversely, these surroundings also have a much greater influence on the perception of the building than in the first and second cases.

The erection of a building is always also an intervention in what already exists. Together with what already exists this intervention gives rise to a new whole. As Luigi Snozzi writes, "The concept of landscape as our field of intervention is understood as a

Fig. 4.11 Buildings in Pudong, Shanghai, China

4.5 The Relationship of Buildings to Their Surroundings

moment in a long transformative process in which the human being converts nature into culture … It is not a question, for example, of integrating a building into the landscape but rather one of building a new landscape. It is not a question of integrating oneself in the historical city and adapting to it. It is a question of incorporating the historical city into a form of spatial organization, i.e. into the new city" (Snozzi 1978, p. 494). Snozzi does not negate nature; he views it as an equivalent partner. The newly created object does not have to adapt to its surroundings but it has to include them in the planning process and create a new whole with them.

As a part of nature the human being cannot relinquish it completely. But building also means rebelling against nature. Sibyl Moholy-Nagy argues that while science, even at its most abstract, emanates from the laws of nature, building emanates from the human will to achieve independence from the cyclical existential limitations of nature and the inadequate defensive possibilities of the herd. In the formational phase of social development, the discovery of artificial walls, spaces, warmth, light and food storage was geomorphically oriented, a term deriving from *ge* (earth) and *morphé* (form) and, in this context, meaning that human settlements were adapted to landscape forms and climatic conditions. However, she argues, this adaptation was also based in a free choice as to the most advantageous conditions for the control of nature (Moholy-Nagy 1970, p. 19).

The three basic types of relationship between built structures and their surroundings discussed above are, in very simplified terms, similar to the three types of relationship between built structures and their gardens (see Fig. 4.12).

In the Chinese garden nature and buildings supplement one another. The surroundings, the garden, have a strong influence on the built structures, which are adapted to the natural conditions. In the English landscape garden there is a contrast between the free forms of nature and the strict geometry of the buildings. In the case of the French garden the two elements are least compatible: the built structures dominate the nature of the garden, which is adapted to them.

4.5.2 The Relationship to the Ground

Since every building has a fixed location it is always linked in a certain way to the ground. On a general level, we can distinguish between four different possibilities (see Fig. 4.13).

a) The building is buried in the ground thereby forming a kind of cave. The natural cave provided prehistoric humans with a dwelling and protection and was formed without any human intervention. Cave-like spaces are not primarily created through the combination of different parts but through the removal of material from the ground or through the use of existing underground cavities. The relationship of the "building" to its surroundings is a subordinate one: the surroundings dominate. This type

a	b	c
CONFRONTATION	CONTRAST	ADAPTATION
FRANCE	ENGLAND	CHINA

Fig. 4.12 The three possible relationships between buildings and their surroundings (see Fig. 4.7 and 4.8) and the three corresponding possible relationships between buildings and gardens (see Fig. 4.9)

Fig. 4.13 The relationship between buildings and the ground

of building does not have an exterior form; its design is only discernible from within (example: TimoSuomalainen, 1969, church built directly into solid rock, Helsinki, Finland: Fig. 4.14).

b) The building stands directly on the unaltered ground. There is no difference in level between the surroundings and the building, which allows for an intensive relationship between interior and exterior. Horizontal spatial separation and thus territorial

4.5 The Relationship of Buildings to Their Surroundings

Fig. 4.14 TimoSuomalainen, 1969, church, Helsinki, Finland

delimitation are secondary here (example: Renzo Piano and Richard Rogers, 1977, Centre Pompidou, Paris, France: Fig. 6.6).
c) The building stands on a plinth, is raised above ground level and thereby acquires a certain degree of independence. The plinth creates a clear delimitation from the ground. In order to enter the building a step, a difference in height, has to be overcome. The plinth and platform are found in many ancient cultures. Their function was, on the one hand, to delimit a territory and, on the other, to separate something special from the profane world (example: JørnUtzon, 1977, Sydney Opera House, Sydney, Australia: Fig. 6.20a).
d) The fourth type of relationship between a building and the ground is the elevation of the building on supports. The building gains a degree of autonomy by being raised above the terrain and as a result does not need to take the latter's form into consideration. The building can be positioned over water or on a sloped terrain. The horizontal relationship between the interior space and the surroundings is very weak; the change from inside to outside entails a vertical shift (example: Oscar Niemeyer, 1992, Contemporary Art Museum, Niterói, Rio de Janeiro, Brazil: Fig. 6.2b).

The perceived "weight" of a building, i.e. whether we perceive a building as heavy or light, depends at least in part on its relationship to the ground. The actual physical weight, even if the observer is aware of it, does not correspond to the perceived weight (Arnheim 1980, p. 228). Along with the relationship between the building and the ground, this depends on different factors: material, type and number of openings, form, etc. A building standing on a plinth appears heavier than the same building elevated on supports. The larger base area of the former creates an impression of "groundedness" and solidity. This may be one of the reasons why most monuments are mounted on plinths, which add perceived weight to the symbolic weight of what is being represented.

Mausoleums in ancient Rome were built according to a prescribed model. The plinth with its perceived weight served as the burial chamber. The storey above was devoted to the glorification of the deceased, and the uppermost storey symbolized the heavenly realm in which the deceased lived on forever (Picard 1965, p. 179).The way in which a building is linked to the ground also has an influence on its perceived proportions (see Sect. 7.3).

4.5.3 The Relationship Between Interior and Exterior

Human beings first began to build because they had to protect themselves against their environment. They had to create space that was separate from outside; they had to create interiors.

In the building process interior space is separated from peripheral and exterior space by spatially defining elements. As the philosopher Otto Friedrich Bollnow comments, "This duality of interior and exterior space is fundamental to the further composition of experienced space in general, indeed, for human life in general" (Bollnow 1980, p. 130). Focussing particularly on dwelling he writes, "Both of these aspects, which exist in a polar tension, are equally necessary, and the inner health of the human being is based on the equilibrium of the two: work in the exterior space of the world and rest in the interior space of the house" (Bollnow 1980, p. 138). Human beings rely on both interior and exterior space and must also be able to move between them. For this reason the interior can never be completely separated from the exterior; there must be a more or less intensive relationship between them. The character of this relationship is mainly determined by the type of openings created in the spatially defining elements and the spatial relationship of these elements to one another. The arrangement and design of these connections between inside and outside arises from the contradiction between, on the one hand, separating a protected space from the surrounding environment and, on the other, creating connections between the two since both belong to people's living space. This contradiction becomes clear if we compare the character of interior and exterior space. While the former is always limited and contained, if only by a transparent piece of glass, the latter is infinitely large. This opposition becomes even clearer when we envision a simple space from inside and outside, for example, a dice with six square sides. The dice is recognizable as such from inside and outside. Nevertheless, what we perceive is very different in the two cases. In the interior we are encased by the walls, which establish clear boundaries; from the outside we experience the dice as a self-contained body or a sculpture confronting us as an object in its surroundings. Despite this oppositional aspect more or less intensive relationships arise between inside and outside. The character of these relationships is one of the most important aspects of architecture per se.

In many cases the partition between inside and outside is a wall which allows the form of the interior to be discerned from outside. However, this is not always the case. In many Baroque churches the interior is deliberately designed not to conform to the

4.5 The Relationship of Buildings to Their Surroundings

exterior. In the case of many modern buildings the form of the interior is also not discernible from outside (example: Frank O. Gehry, 2002, Walt Disney Hall, Los Angeles, USA: Fig. 6.20b).Robert Venturi comments, "The contrast between the interior and the exterior can be one of the main manifestations of the contradictions inherent in the architecture." However, he goes on to argue, one of the most self-evident and widespread orthodoxies of the twentieth century was the doctrine that precisely here no break is permitted: The interior should be represented by the exterior (Venturi 1978, p. 105). As we have seen there is always also a perceived opposition between inside and outside, and the desire for a formal visualization of this opposition is therefore understandable.

A glance at nature shows that relationships there are similar. The external forms of animals are subject to laws that are very different from those governing their internal organization and there are no direct formal connections between inside and outside. The inner organs are organized according to the most rational possible use of space. As Adolf Portmann writes, "In the case of birds and mammals the image of closely packed entrails is so familiar that it has become almost self-evident for us. We are hardly aware that the structural plan of the exterior has been completely abandoned in this interior structure" (Portmann 1960, p. 28). The external forms of animals are diverse and appeal to our visual perception: symmetry, geometric patterns, diverse forms and colours. The visible exterior is subject to design laws quite distinct from those governing the interior and the results are correspondingly different. Every child can distinguish a lion from a tiger. However, differentiating between these animals based purely on their entrails or skeletons is no easy task even for a specialist (Portmann 1960, p. 33).

Ultimately the question of whether the exterior of a building should reflect its interior, whether the interior form should be discernible from the outside, is a question of style. If there is a direct formal relationship between inside and outside, this corresponds to a clear arrangement system. A solution in which the interior is not discernible from the outside corresponds to a more irrational design which speaks more to the emotions than the intellect and thus corresponds more to a style associated with the third level on the scale between simple and complex (Fig. 3.7 and 3.12).

The degree of similarity between interior and exterior form is closely connected with the type of openings found on a building. The larger the openings in the structure, the more pronounced is the connection between interior and exterior and the smaller the divergence between interior and exterior forms.

In simplified terms, the history of space in Western culture can be divided into three different epochs with three different conceptions of space (see Chapter 5). In the first epoch, architecture was understood as sculpture; interior space had no significance and as a result there was no important relationship generated between outside and inside. In the second epoch the interior space became the central concern of architecture. There was only an inside or an outside, an "either/or". The function of the openings in the outside wall was limited to the provision of entrances and exits and light from outside. It was only in the third epoch, from the beginning of the twentieth century onwards, that

the interior and exterior were linked by an intensive connection that rendered the boundaries between inside and outside diffuse and complex.

Painting played a pioneering role in influencing the emergence of the third conception of space and thus the emergence of a new relationship between inside and outside. Different architects sought to apply new ideas developing in the realm of painting to architecture. In its "Manifesto V" of 1923 the De Stijl group proclaimed, "By breaking with containment (walls, etc.) we have transcended the duality of interior and exterior" (De Stijl 1981, p. 62). One year later, in 1924, Theo van Doesburg, one of the group's members, wrote, "The new architecture has opened the walls and so done away with the separation of inside and outside" (Van Doesburg 1981, p. 74) (see Fig. 2.7 and 6.14). In a drawing for his Brick Country House project from 1923 (see Fig. 5.16) Mies van der Rohe allows the interior and exterior spatial zones to flow into one another, thereby abrogating the boundary between them. In the Barcelona Pavilion from 1929 (see Fig. 2.7 and 6.15a) the interior space is visually extended to the exterior enclosing wall. The wall panels form continual lines from the interior to the exterior and even the ceiling panel extends far out into the exterior space.

An intensive spatial connection between inside and outside thus became an important concern of Modernism. In Finland people have always been heavily reliant on nature and have therefore had a special relationship with it. In the case of the Säynätsalo Town Hall designed by Alvar Aalto (see Fig. 7.12) the transition from the inside to the outside occurs via an intimate inner courtyard. In Aalto's Villa Mairea the large living and dining area is only separated by a glass wall from the garden, which, enclosed on three sides by the living area, terrace and sauna, is in turn connected with the wider surroundings (see Fig. 4.15). On the other hand, through the use of different natural, partly untreated materials inside the house, Aalto allows nature to penetrate the interior.

Frank Lloyd Wright's projects, developed independently of what was happening in Europe, exhibit a similar spatial relationship between interior and exterior. In a television broadcast in 1953 Wright commented on this theme as follows: "Then there was the open plan—instead of a building being a series of boxes and boxes inside boxes, it became more and more open—more and more aware of space—the outside gradually came in more and more and the inside went outside more" (Wright 1969, p. 295). His residential buildings are closely linked with their surroundings. Due to their external form, which includes different wings, these structures and their surroundings permeate one another. In Wright's view every building and its surroundings should form a unified entity (see Fig. 4.16).

In1910 he wrote, *"In organic architecture ... it is quite impossible to consider the building as one thing, its furnishings another and its setting and environment still another. ... The spirit in which these buildings are conceived sees all these together at work as one thing"* (Wright 1981a, b, p. 22). As might be expected, Wright's preferred building materials were all natural: wood, granite, etc. During his first creative period in Chicago he used neither steel frames nor reinforced concrete on his buildings (Giedion 1978, p. 269). His organic concept, which called for a particularly earthy architecture,

4.5 The Relationship of Buildings to Their Surroundings

Fig. 4.15 Alvar Aalto, 1939, Villa Mairea, Noormarkku, Finland

Fig. 4.16 Wright Frank Lloyd, 1902, Ward Willits House, Highland Park, near Chicago, USA (see Fig. 5.35)

and his conception of dwelling in general did not permit him to glaze entire walls, as, for example, Mies van der Rohe did. The interior-exterior relationships forged by Wright were more differentiated: "This sense of spaciousness generates the need to focus on the exterior and extend the interior. Garden and building may now be one. In any good organic structure it is difficult to say where the garden ends and where the house begins or the house ends and the garden begins—and that is all as it should be, because organic architecture declares that we are by nature ground-loving animals" (Wright 1981a, b, p. 201). Wright's affinity to nature is expressed not only in the way he deals with the relationship between interior and exterior but also in his entire attitude to space, the result of which he calls organic architecture. This concept encompasses not only questions of space but also questions of material and form. Wright's architecture and conceptual framework came to Europe for the first time in the form of an exhibition in 1910,

where they were received with great interest and had a decisive influence on the whole of European architectural development.

This idea of allowing a building to enter into a dialogue with its surroundings was not a completely new one in Europe. In the sixteenth century Palladio was already designing villas whose external forms, like those designed by Aalto and Wright (see Fig. 4.15 and 4.16), forged a connection with their surroundings. Here, nature and building are not equal partners; the building dominates but nevertheless the two are connected (see Fig. 4.17).

The form of the Villa Trissino (Fig. 7.21) with its arcades extends far into its surroundings. The exterior form of the Villa Barbaro in Maser is also multifaceted and is underscored in its immediate surroundings by garden buildings and retaining walls (Fig. 4.17). This arrangement creates different spatial zones which are more or less self-contained: the area under the arcades, the rear-facing part of the villa with the nymphaeum, the garden areas separated from one another by different levels, etc. The actual residential area in the middle of the complex protrudes, allowing light to penetrate the interior from three sides and varied views of the surroundings. The frescoes inside the villa are in part painted to create an impression of looking through an opening in the wall into the landscape. Here, Palladio has anticipated an important motif of the Baroque: the use of artistic means to extend the space optically into the endlessness of the surroundings. As Nikolaus Pevsner writes, "Now to get the totality of a Palladian countryside composition one has to add to such a nucleus the curved colonnades and low out-buildings by which the villa takes in the land around. This embracing attitude proved of the greatest historical consequence. For here for the first time in Western architecture landscape and building were conceived as belonging to each other, as dependent on each other" (Pevsner 1967, p. 225).

An intensive relationship between inside and outside was always an important factor in traditional Japanese architecture and underwent a process of development over the

Fig. 4.17 Andrea Palladio, 1557, Villa Barbaro, Maser, Italy

4.5 The Relationship of Buildings to Their Surroundings

course of centuries. A major reason for this was the special relationship the Japanese have with nature. As we have seen, in Far Eastern culture the concept of the relationship between nature and the human being is different from the concept predominant in the West (see Sect. 4.4). In the Far Eastern context people did not confront nature as a foe but rather sought to live in harmony with it. Buildings therefore were supposed to form a unified entity with nature, with the surroundings. A consequence of this unity between architecture and nature is that the relationship between inside and outside is also understood in Japan differently from in Western culture. Whereas in Western culture inside and outside are oppositional concepts, Japanese people conceive of their home as a unity of living space and garden. The transition from inside to outside is formed continuously; it leads from the tatami matting of the interior space via the wooden floor of the veranda to the stepping stones and gravel outside in the garden and into the wider surroundings. Light, wind, cold, heat and odours come from these surroundings and influence life in the building. The roof covers the veranda and protrudes into the garden area.

The shape of buildings also contributes to the intensive relationship between structures and their surroundings. In the case of the Katsura Imperial Villa built in the seventeenth century in Kyoto (Fig. 5.43) the different wings of the building and the surroundings mesh with one another in a way similar to that found in the villas of Frank Lloyd Wright (see Fig. 4.16).

In many cases the transitions between inside and outside are still more differentiated. The Katsura Imperial Villa's so-called moon viewing platform (Fig. 4.18) at the end of one of the wings is on the same level as the veranda floor and the tatami matting inside the building, i.e. at least in terms of height this structure belongs to the interior area. The roof of the building covers only a small part of the platform, which in turn makes it a part of the exterior area. A shift in the use of materials is also evident. The smooth-sanded veranda floor projects an artificiality that forms a contrast to the bamboo poles on the platform, which are untreated and therefore seem to belong more to the exterior space. The position of the platform at a far end of the villa, where the floor plan projects into the garden like the bow of a boat, creates the impression of interior space projecting into the exterior space.

Fig. 4.18 Katsura Imperial Villa, moon viewing platform, seventeenth century, Kyoto, Japan

Conversely, the villa's Shoi-ken teahouse suggests an exterior space projecting into the interior space (see Fig. 4.19). Here the roof protrudes over a zone that is on the same level as the garden. The ground is composed of hard-packed earth and a series of stepping stones that increase in height towards the veranda until they reach the level of the interior space. The lack of uniformity in nature characterized by the choice of materials and the apparently arbitrary arrangement of the stepping stones permeates the strict geometry of the interior space. The permeation by nature into the artificially created interior space is also seen in the corner posts of the tokonoma, an alcove that forms the centre of every dwelling. The posts are left in their natural untreated form and present a visual contrast to the strictly modular character of the supports and sliding panels.

Whereas in the West a barrier is usually a partition that is physically difficult to negotiate, in Japan a partition can have a more symbolic character. For instance, the territories of certain natural divinities are indicated only be a stretched string or a row of small stones. The sacred "interior space", the holy area, is symbolically partitioned off from the profane world (Fig. 5.26a). In Ise the main sanctum is enclosed by four wooden fences that above all form a visual and territorial demarcation. The further we move into the interior the smaller the distance between the posts making up the individual fences. The innermost fence is practically a wooden wall which does not allow a view into the interior. And the number of people who are permitted to passes through the gates of the different barriers decreases as one moves further inside. While the outermost gate is open for all visitors, only the emperor and the most senior Shinto priests may pass through the innermost gate (see Fig. 4.2).

Today the transition between inside and outside in the Western cultural sphere tends to proceed incrementally. When moving from the public street space to the private living space, several interim zones are traversed: front garden, forecourt, entrance area, corridor, porch, etc. By contrast, in the Islamic cultural sphere there is a strict separation between inside and outside, between the public space and the private, family living space. Here, the traditional dwelling is a courtyard house, with the individual rooms

Fig. 4.19 Katsura Imperial Villa, Shoi-ken teahouse, seventeenth century, Kyoto, Japan

4.5 The Relationship of Buildings to Their Surroundings 129

Fig. 4.20 Traditional courtyard house and street in the old town of Aleppo, Syria

a

WESTERN CULTURAL SPHERE

b

ISLAMIC CULTURAL SPHERE

Fig. 4.21 a extroverted house with incremental transition between inside and outside, **b** introverted house with a strict separation between inside and outside

oriented towards the inner courtyard rather than the street. The public street space is bordered on both sides by walls the only openings in which are the entrance doors to the houses. They are the only connecting elements between outside and inside; there are no windows (Fig. 4.20). The Western dwelling tends to be extroverted whereas the traditional Islamic dwelling is introverted (Fig. 4.21).

4.6 Streets and Squares

The cities of Western antiquity were small worlds artificially created by people. With all their monuments they were memorials to their builders. Streets and squares were the basic elements of these cities; they were sites at which public life took place. In the urban context they belong to the immediate surroundings of the living area (see Sect. 9.7).

The street serves as a transit zone, as a sphere of movement, the square as a centre, as a site of action and encounter. The public square, as a site of encounter, as the antithesis of the private interior space, has a central significance for the developmental history of humanity. Indeed, it can be seen as the site of the crystallization of cohabitation. Louis I. Kahn argues that, because the human being recognizes he cannot achieve anything that is solely his, he requires a place where what he wants coincides with what others want, a place that allows him to have what he wants while also making it possible for others to receive it (Giurgola 1979, p. 96).

The answer to the question as to the maximum size of a square that is still perceived as such depends on its dimensions and its boundaries. The maximum size should be determined by the human need for territorial security. In 1909 Camillo Sitte argued that where public squares were too large "a nervous illness has been diagnosed: 'shyness of squares' (Sitte 1983, p. 56). The size of many old Italian squares was determined by the distance from which a face can be recognized. 'Shyness of squares' seems to arise when this maximum distance for communication is exceeded (Smith 1981, p. 137). A sensation of fear can also develop when the opposite is the case, namely when a space is too restricted. As in the case of animals, territoriality plays an important role for people.

Culturally conditioned differences also apply to the assessment of the meaning of the city, its streets and its squares. For instance, in the Islamic cultural sphere the city

Fig. 4.22 Old town of Cairo, Egypt (section)

does not have the same meaning as it does in the Western cultural sphere. As nomads the Arabs originally had no urban tradition; the idea of the permanent city had no appeal for them. In the Koran the city is mostly referred to in a negative context. For example, the destruction of cities due to natural catastrophes is described as a consequence of divine rage, an admonishment to the faithful to be proud of their cities (Vogt-Göknil 1978, p. 33). In these cities the role of streets and squares was very different to their role in the West. In the Arab world streets are often cul-de-sacs that serve only as access routes to individual buildings (see Fig. 4.22). The squares do not form centres; they are open spaces used for markets.

References

Arnheim, Rudolf: Die Dynamik der architektonischen Form, Cologne, 1980 (original title: The Dynamics of Architectural Form, Los Angeles, 1977)
Bollnow, Otto F.: Mensch und Raum, Stuttgart, 1980 (1963) Brockhaus Enzyklopädie, Wiesbaden, 1969
Canival, Jean-Louis de: Ägypten, Fribourg, 1964
Canter, David V. (ed.): Architekturpsychologie, Düsseldorf: Bertelsmann 1973
De Stijl: Manifest V, 1923 (in: Programme und Manifeste zur Architektur des 20. Jahrhunderts, Braunschweig, 1981)
Frampton, Kenneth: Die Architektur der Moderne, Stuttgart, 1983 (Original title: Modern Architecture, London, 1980)
Giedion, Siegfried: Raum, Zeit, Architektur, Zürich, 1978 (original title: Space, Time and Architecture, Cambridge, Mass., 1941)
Giurgola, Romaldo: Louis I. Kahn, Zürich, 1979
Grütter, Jörg Kurt: Traditionelle japanische Architektur (in: Bauen und Wohnen, 12/1976)
Joedicke, Jürgen: Der Einfluss der Umgebung beim Erleben von Architekur (in: Bauen und Wohnen, 9/1975)
Ladde, Ernst E.: Die engere Umwelt der Wohnung (in: Bauen undWohnen, 4/1974)
Moholy-Nagy, Sibyl: Die Stadt als Schicksal, Munich, 1970 (original title: Matrix of Man—An Illustrated History of Urban Environment, New York, 1968)
Norberg-Schulz, Christian: Genius Loci, Stuttgart, 1982 (Original title: Genius Loci, Milan, 1979)
Norberg-Schulz, Christian: Meaning in Western Architecture, London, 1975 (original title: Significato nell' architettura occidentale, Milan,1974)
Otto, Frei: Natürliche Konstruktionen, Stuttgart, 1982
Payne, Ifan: Pupillenreaktion auf architektonische Reize (in: Architekturpsychologie, Düsseldorf, 1973. Original title: Architectural Psychology, London, 1970)
Pevsner, Nikolaus: Europäische Architektur, Munich, 1967
Picard, Gilbert: Imperium Romanum, Fribourg, 1965
Portmann, Adolf : Tiergestalt, Basel, 1960
Sitte, Camillo: Der Städtebau, Braunschweig, 1983 (1909)
Smith, Peter F.: Architektur und Ästhetik, Stuttgart, 1981 (Original title: Architecture and the Human Dimension, London, 1979)
Snozzi, Luigi: Architektur als Formproblem (in: Werk, Bauen undWohnen, 12/1978)
Thilo,Thomas: Klassische chinesische Baukunst, Zürich, 1978 (1977)
Van Doesburg, Theo: Auf dem Weg zu einer plastischen Architektur, 1924 (in: Programme und Manifeste zur Architektur des 20. Jahrhunderts, Braunschweig, 1981)

Venturi, Robert: Komplexität und Widerspruch in der Architektur, Braunschweig, 1978 (Original title: Complexity and Contradiction in Architecture, New York, 1966)

Vogt-Göknil, Ulya, Die Moschee, Grundformen der sakralen Baukunst, Zürich, 1978

Watanabe, Yasutada: Shinto Art: Ise and Izumo Shrines, New York, 1974 (originally published in Japanese, Tokyo, 1964)

Wright, Frank Lloyd: television broadcast, NBC, 17 May 1953 (in: Humane Architektur, Berlin, 1969)

Wright, Frank Lloyd: Organische Architektur, 1910 (in: Programme und Manifeste zur Architektur des 20. Jahrhunderts, Braunschweig, 1981)

Wright, Frank Lloyd: The Future of Architecture, New York, 1970 (1953) (translation: J.K. Grütter)

Wright, Frank Lloyd: lecture in London, 1939 (in: Programme und Manifeste zur Architektur des 20. Jahrhunderts, Braunschweig, 1981)

Space

Contents

5.1 On the History of Space ... 133
 5.1.1 The Three Conceptions of Space in Western Culture ... 135
5.2 Types of Space ... 150
 5.2.1 Mathematical Space and Experienced Space ... 150
 5.2.2 Daytime Space and Night-Time Space ... 151
 5.2.3 Private Space and Public Space ... 151
 5.2.4 Experienced Space ... 152
 5.2.5 Intermediate Space ... 154
 5.2.6 Emptiness ... 157
5.3 Elements of Space ... 159
 5.3.1 Material and Surface ... 161
 5.3.2 Openings ... 163
5.4 Spatial Organisation ... 165
 5.4.1 The Relationship Between Different Spaces ... 165
 5.4.2 Spatial Flexibility and Spatial Polyvalence ... 169
 5.4.3 Culturally Determined Types of Orientation in Space ... 174
References ... 178

5.1 On the History of Space

What is space? The obvious way to define space is perhaps as emptiness that can accommodate something, that can be filled. Space is nothing concrete and nevertheless measurable: "There's enough space available" … "The space is full" … This conception corresponds to that formulated by Aristotle, who, in his writings, was the first Occidental thinker to deal with the concept of space. He compared space to a vessel, a void that had to be enclosed in order to exist and was thus always finite (Dessoir 1925, p. 166) (Fig. 5.1).

Fig. 5.1 The two conceptions of space: **a** Aristotle, space as a void (fourth century BCE), **b** Giordano Bruno, space as the in-between (sixteenth century)

In the sixteenth century the Italian philosopher and astronomer Giordano Bruno developed another conception of space.

He made the idea of the infinite one of the main pillars of his philosophy, arguing that space was perceivable via the things located within it: space as surrounding or intermediate space. As he saw it, space was a system of relationships between things and did not, as in Aristotle's theory, have to be enclosed. This meant that it was also no longer necessarily finite (Dessoir 1925, p. 387) (Fig. 5.1).

Human beings have a need for space that protects them from the influences of their environment. This need is as old as humanity itself and has hardly changed to this day. The protective space, the living space, was and is something very particular. It is the point of departure for human orientation; it is the focal point from which human beings can construct their spatial relationships. The design of this space is dependent on the technological possibilities available and, far more importantly, is the expression of a particular intellectual attitude on the part of its builders and inhabitants. Louis I. Kahn argues that the essence of space encapsulates the spirit of and will to a particular type of being (Kahn 1981, p. 162). The type of being and thus the spirit of spatial design are subject to continual change; they are culture-dependent.

A space and its beholder have a particular relationship with one another. Space is not given or constant; it is defined by reference points and can be experienced in different ways depending on the location and mood of the beholder, the time of day or year, etc. The environment, above all the architectural environment created by people, consists of a more or less complex relational configuration of different spatial arrangement systems which dominate, overlay, permeate and compete with one another.

Such spatial constellations are found everywhere. The space of a city consists of a multitude of such spatial relationships: between street spaces, and between street spaces, squares and buildings. Within a building, different spaces can be distinguished from one

5.1 On the History of Space

another that refer to each other and the building's surrounding space. Finally, each individual room is divided into further spatial zones by its furnishings.

The more ordered these spatial structures are, the easier the comprehension of the space as a whole.

5.1.1 The Three Conceptions of Space in Western Culture

A distinction can be made between three fundamentally different conceptions of space that have emerged in Western culture over the course of history (Fig. 5.2). The first is characteristic of the epochs of the ancient civilizations of Mesopotamia, Egypt and Greece. Here, architecture was a sculpture radiating out into infinite space that established a relationship to the cosmos (Fig. 5.3). The interior space played a secondary role and was attributed little significance.

ca. 100 CE ca. 1900

Fig. 5.2 The three conceptions of space in Western culture

Fig. 5.3 **a** Pyramids of Huni and Sneferu, end of the Third Dynasty, Medum, Egypt, **b** Temple of Heracles, 500 BCE, Agrigento, Sicily, Italy

In contrast to the plastic architecture of the Greeks, Roman architecture is often characterized as spatial architecture. For the first time large interiors were built for different purposes. The interior space was modelled and activated, becoming a primary element of architecture.

The epoch of the third conception of space began around the end of the nineteenth century. Here, space is no longer a contained vessel but a zone. This shift brought with it a transformation of the relationship between interior and exterior space. The open space, for example, one defined by pillars, already existed in ancient Greek and Roman architecture. However, in these cases it is only found together with an enclosed space, as a subordinate, connecting element between this enclosed space and the exterior space. The open space as a primary element, as a zone, is an invention of modernity.

5.1.1.1 Epoch of the First Conception of Space

In the architecture of the ancient Egyptians the interior space played a secondary role. This was not due solely, as is often claimed, to technical reasons, i.e. because the architects of the time did not have ability to build such spaces (Canival 1964, p. 131). The Egyptians used the barrel vault to roof large spans as early as the eighteenth century BCE, although not as a visible spatial element, i.e. to support foundations and masonry. They therefore had the means to exceed the human scale and create large interior spaces. However, this was not their intention. Their architecture also had symbolic content and was developed out of the desire to represent the cosmos. The Egyptians believed in life after death, and the manner in which approached interior space mirrored the idea that the human being was always on a journey that never ended. Every interior space was thus a step on this eternal peregrination and could therefore not have any special significance (see Sect. 9.6).

There is no specific word for space in ancient Greek. Space was denoted as "the in-between"; space-defining elements were more important than the space itself. For Aristotle space was the content of a vessel. This concept excluded a unitary approach to space and prevented the attribution of primary significance to interior space in Greek architecture. Space was pluralistic and depended on the elements surrounding and enclosing it and on its function.

5.1.1.2 Epoch of the Second Conception of Space

The epoch of the second conception of space began with the large-scale building projects undertaken by the Romans and extended until well into the nineteenth century. In this context, space was conceptualized as interior space, which became the most important element of architecture. In ancient Rome this development reached its first highpoint with the spatial design of thermal baths. Their structure was only made possible by technical improvements in the construction of structural vaults, which were no longer assembled from large, worked stones but with the help of a mixture of a special type of mortar and bricks produced in one pour (Picard 1965, p. 176). The result was an unprecedented degree of stability and the possibility of considerably reducing the weight of a

5.1 On the History of Space

construction. This method of building can be seen as a precursor of modern concrete construction. The material used could absorb considerable compressive forces. However, since the Romans were not acquainted with techniques of reinforcement, they were unable to transfer bending forces with their constructions.

The new conception of space developed by the Romans encompassed two fundamentally different spatial forms, which played a decisive role in the subsequent development of spatial design: the central-plan space and the longitudinal space.

The purest form of the Roman central-plan space is the Pantheon, which was built in the second century. The structure is composed of a hemisphere with a diameter of 43 m lying on a cylinder the height of which is the same as the radius of the sphere such that a sphere can be inscribed in the space (Fig. 5.4). In formal terms the vestibule does not fit with the main space and was probably added later (Picard 1965, p. 111). However, Norberg-Schulz attributes a special significance to this vestibule. The axis of the entrance leads through the central-plan space to an apse on the side opposite the entrance. The axis represents the path of history, which is connected with the cosmic order in the round building. In this central-plan space the axis is no longer discernible, fostering a feeling in the human observer of a divinely inspired conqueror making history according to a cosmic plan (Norberg-Schulz 1975, p. 101).

Fig. 5.4 Pantheon, 120 CE, Rome, Italy

The basic type of longitudinal space is the Roman basilica, the beginnings of which date back to the second century BCE (Picard 1965, p. 105). In its original form it was a rectangular assembly space with the entrance located on one of the latitudinal or longitudinal sides. The basilica became the prototype of the Christian church.

After the Roman period, sacral architecture became the chief architectural medium and remained so for centuries, with the central and longitudinal spaces providing basic points of departure. Christianity derived the fundamentals of its architecture from its own doctrine: from the promise of redemption and the path to this goal, symbolized by a centre and a pathway.

With the division of the Roman Empire in the fourth century, developments in the east and west diverged. In simplified terms it can be argued that early Christian architecture in the east under Emperor Constantine adopted the concept of the central-plan space as its basic type while the longitudinal space become dominant in the west. Perhaps this choice can be explained by the fact that in Rome Christianity had to fight for survival for 250 years, whereas in the east the foundation of the new capital by an emperor sympathetic to Christianity made the Christian goal seem closer, with the result that the concept of the pathway declined in significance (Fig. 5.9).

For a long time the challenge of designing churches lay in finding ways to unify these two basic types. One of the first attempts was the Church of the Nativity in Bethlehem, constructed in 333 CE (Fig. 5.5). In this case the connection was limited to a simple juxtaposition: a nave with an attached octagonal central-plan building, a construction that nevertheless clearly illustrates the Christian idea of the path to a goal.

The highpoint of Eastern Roman or Byzantine architecture was the construction of the Hagia Sophia in Constantinople in 537 CE (Fig. 5.6). Whereas the weight of the Pantheon dome is evenly distributed along the wall surrounding the interior space, in the Hagia Sophia the vertical loads are partly distributed across two half-domes. This allows the church space to be designed as a combination of central-plan and longitudinal spaces. This type of building subsequently had a formative influence on Islamic architecture.

Fig. 5.5 Church of the Nativity, 333, Bethlehem (reconstruction)

5.1 On the History of Space

Fig. 5.6 Hagia Sophia, 537, Istanbul (formerly Constantinople), Turkey

When the Hagia Sophia was constructed, the intention was to incorporate the sky into the interior space. The court poet of the Byzantine emperor Justinian, who had the church built, wrote of its roof that it enveloped the church like a radiant sky (Zevi 1974, p. 87). A line of windows along the lower edge of the main dome creates the impression that the dome is floating. In addition, the perceived materiality of the cross-walls is diminished with the help of openings, creating an impression of something unreal and removed from the world. This aspect of the Byzantine style resulted in a structure on which the force vectors were no longer clearly readable. This contrasts with Roman architecture, which, although it was the first to abandon the human scale, retained the readability of these vectors (Krautheimer 1965, p. 160). The central-plan space and its centralizing idea were maintained in the Hagia Sofia. But in contrast to all older central-plan buildings, the structure's multiple openings and infiltrating light forged a relationship with the outside.

The paradigm for the early Christian longitudinal church in the West is the Roman basilica. This type was adopted not only by Christians. Various heathen sects used this model for their cultic spaces (Pevsner 1967, p. 22), something that is all the more comprehensible when we consider that early Christianity competed with these sects for adherents over three centuries.

One of the best examples of an early Christian longitudinal church is the Basilica of Santa Sabina in Rome (Fig. 5.7). The building is composed of a longitudinal main nave, two side aisles and an apse – a stunted central-plan building. This design symbolized the idea of the path and the goal.

The development of the cruciform floor plan represented another step in the attempt to link a central-plan and a longitudinal space. The best example of this type among the extant churches is the Basilica of San Marco in Venice (Fig. 5.8). The current church was built in the eleventh century on the foundations of an older church, which was itself a copy of the now destroyed Church of the Holy Apostles in Constantinople dating from the sixth century, the epoch of Emperor Justinian.

Fig. 5.7 Basilica of Santa Sabina, 430, Rome, Italy

Fig. 5.8 Basilica of San Marco, 1094, Venice, Italy

5.1 On the History of Space

The concept of the cruciform floor plan with five domes stems from the sixth century. In the case of the Hagia Sophia, which was also built during the reign of Justinian, the longitudinal aspect was less important than the idea of the central space. In the case the San Marco the two intersecting arms are just as important as the five central domes, which together form a cross, thereby underscoring the centralistic idea (see Fig. 5.9). Here, too, the light admitted by the elevated windows illuminates the upper part of the church space, leaving the people below in semi-darkness and lending the interior a spiritual dimension.

As discussed in Sect. 3.1, in the Romanesque church the individual should no longer be merely a marvelling spectator but included in what is happening and unified with God, becoming part of the system (see Fig. 3.1). The Romanesque church space was a longitudinal space. This longitudinal aspect is interrupted only by adding a transept, which can be done in different ways: a continuous transept is inserted between the choir and the nave, or a transept smaller that the main nave is attached to the latter on both sides. The typical Romanesque form is a combination of these two variants: the main nave and transept are of the same height and form interpenetrating spaces. This produces a cruciform floor plan life like that found in the Basilica of San Marco.

It was in the Romanesque period that the exterior of the church first became important. The exterior wall is structured like the interior wall and the tower becomes an important formal element. The design of the exterior reflects a concept of spiritual opening. The church had an outward-looking, missionary task, which needed to be reflected in formal and spatial terms.

In the Gothic period the wall was dematerialised. The bearing structure is reduced to a skeleton which, as far as possible, is positioned on the outside of the building (see Fig. 5.10). The technical means of achieving this –pointed arches, flying buttresses and ribbed vaults – were not Gothic inventions, but during this period they were improved, combined and placed at the service of an idea. (Pevsner 1967, p. 87). The location of the

Fig. 5.9 The development of the cruciform floor plan as a combination of a central-plan space and a longitudinal space

Fig. 5.10 Gothic cathedral, thirteenth century, Beauvais, France (cross section)

bearing structure on the outside surface creates an optical instability in the interior and thus a tension. In contrast to the Romanesque style, where the church space is dissected by the individual bays, in the Gothic period the emphasis is on unity. Despite the cross vaults the nave becomes a unified element, which is echoed on the outside of the building, where the constructional elements and the tower meld with the church into a unit.

The two basic spatial themes of sacral architecture, central-plan and longitudinal space, are also found in the Gothic period but in a modified form. The opening up of the church space toward the outside gives rise to a relationship with the surroundings, that is, with the entire urban organism, and the church thereby itself becomes the centre, the focus of the urban space. The elongated space of the nave becomes the final section of a long path that ends at the altar in the choir. The last stage of this path is signalled by the large, inviting church door (see Fig. 5.11).

The Renaissance is the first stylistic epoch that is manifested not only in sacral building. Apart from the Church, wealthy merchants now commissioned buildings, thereby enabling the prevailing style to find expression in profane structures as well. In Florence, which is regarded as the cradle of the Renaissance, the new idea was able to develop over almost half a century before extending out over the region. After the darkness of the Middle Ages, people began to look back again to antiquity. The magnitude and harmony of this period again became ideals, and the human being again became the focus of attention. As Nikolaus Pevsner writes, "Now a flourishing trading republic will tend

5.1 On the History of Space

Fig. 5.11 The Gothic cathedral in the urban context, the path and the church as centre

Fig. 5.12 Filippo Brunelleschi, 1436, Basilica of Santo Spirito, Florence, Italy (preliminary design study)

to worldly ideals, not to the transcendental; to the active, not to meditation; to clarity, not to the obscure" (Pevsner 1967, p. 176). In line with this outlook, spatial design became based on concepts of clarity, logic, harmony and proportionality. Space was structured according to elementary geometric principles. Architecture became a mathematical science that aimed to represent the cosmic order. Space consisted of elements that were unified into a whole using geometric tools (Fig. 5.12).

The beginning of the Renaissance in the early fifteenth century was marked by the invention of perspective depiction. For the first time objects were depicted on a surface similarly to the way they were perceived. However, this type of depiction only shows the object from a particular point of view; the factor of movement is thereby excluded. The invention of perspective drawing, together with the new conception of the status of the human being, indicate why the central-plan building corresponded more to the spirit of

the Renaissance than did the longitudinal space. The human being positions himself in the centre of things and no longer attempts to approach the transcendental divine. For the first time in the history of space the human being is no longer dominated by the space: the precise order of architecture becomes visible and readable. Bruno Zevi argues that it is at this time that the foundations of the idea of modern architecture were laid. From this point on the human being dictated the laws of architecture and not vice versa (Zevi 1974, p. 114). Divine perfection was no longer sought in the hereafter but was regarded as manifesting itself directly in nature and thus in human beings themselves.

Harmony and balance are the key features of the Renaissance, tension and ambiguity those of the following epoch, that of Mannerism, which thereby became the connecting link between the Renaissance and the Baroque. In the sixteenth century the rather naive belief of the individual in himself and his morality was lost and replaced by doubt and fear.

One of the best examples of the contradictory nature of Mannerism is Michelangelo's vestibule for the Biblioteca Laurenziana in Florence (Fig. 5.13). The "windows" are only niches; the columns do not support anything but simply stand between massive bearing-wall sections. The function of the individual elements is deliberately reduced to absurdity; the flow of forces is no longer readable.

In the Baroque the clarity of the Renaissance is abandoned completely. The Baroque space is full of contradictions and is designed to deceive our senses (Fig. 3.9). Why these deceptions? Nikolaus Pevsner argues, "The answer is closely connected with the religious consciousness of the time. To the Christian Church the highest reality is the miracle of the Divine Presence, as revealed in the mystery of the transubstantiation. In the seventeenth and eighteenth centuries - an age in which Catholic dogmas, mysteries and miracles were no longer, as they had been in the Middle Ages, unconditionally accepted by all - this reality became the subject of fierce struggles within the Church, set off by resistance to the heresy and scepticism that were appearing everywhere. To restore the heretics to the fold and convince the sceptics Baroque church architecture had both to inflame the mind and to mesmerize it. To present the reality of the supernatural in visible form architects exploited the deceptive, unreal, magical world of illusion" (Pevsner 1967, p. 294). This explanation seems all the more plausible when we recall that at the beginning of the seventeenth century Galileo Galilei founded modern physics, thereby challenging the philosophical framework of the church.

This contradictory character also relates to the two basic spatial types of sacral building: central-plan and longitudinal space. The Baroque does not elaborate a relationship between the two but instead combines them into an oval form that, rather than symbolizing the path or the centre, unifies them (see Figs. 6.26 and 6.27). The oval space becomes the most important spatial creation produced by the Baroque; its elements are no longer discernible, resulting in the impression that the space extends infinitely. Columbus and Magellan nullified medieval conceptions of distance. Otto F. Bollnow argues that in the Baroque this intoxication with infinity reaches its apex: "The interior space dissolves into infinity without ceasing to be interior space" (Bollnow 1980, p. 88).

Fig. 5.13 Michelangelo, 1560, vestibule of the Biblioteca Laurenziana, Florence, Italy

The Baroque age was followed by a period of fundamental transformation: the era of industrial and social revolution. However, these upheavals initially did not lead to architectural renewal. On the contrary, the period up until around 1890 can be characterized as an epoch of neo-styles, ranging from Neoclassical to Neo-Baroque. Pevsner explains this development as follows: "Now those to whom visual sensibility was given saw so much beauty destroyed all around by the sudden immense and uncontrolled growth of cities and factories that they despaired of their century and turned to a more inspiring past" (Pevsner 1967, p. 416). The architect and architectural theorist Otto Wagner (1841–1918) had a similar view. He was also of the view that art in general and architecture in particular were an expression of the prevailing world order. This was possible as long as development proceeded slowly. In the nineteenth century industrialization and all its effects generated events at high speed: "… events moved

faster than any development in the arts. This naturally led to 'art' rushing to catch up, to it seeking salvation and believing it had found it everywhere, and to so many 'artists' yelling 'Eureka' on finding a traditional style and then seeking and finding enthusiastic followers of their view" (Wagner 1979, p. 32) (see Sect. 3.8). However, as early as 1895 Wagner prophesied, "We are close to the end of this movement. This frequent deviation from the broad paths of imitation and ordinariness, this idealized aspiration to truth in art, this yearning for liberation: with gigantic force they pervade everything, tearing down all before them that could hinder certain victory" (Wagner 1979, p. 40).

An important reason for what Pevsner calls the "antagonism to the present" was certainly the loss of the total work of art, the "Gesamtkunstwerk". In the nineteenth century the unity of the arts was lost completely: each artistic genre went its own way and there was no direct connection between them anymore. This meant that a unified style shared by all genres was impossible.

The fact that in the nineteenth century building commissions were no longer concentrated on churches and palaces supported this development. The requirements placed on a building style thereby became more numerous and multifaceted. Modernism attempted to do justice to these new complex tasks by reducing all demands to the lowest common denominator: formal diversity was streamlined and the style of everything "unnecessary" was expurgated. Hans Sedlmayer points here to a parallel with French revolutionary architecture: Ledoux also promulgated the equalization of all building tasks, although at the time this was for ideological reasons. In his opinion the prioritization of, for example, the sacral building was no longer valid, and the design vernacular was reduced to a small number of basic forms, as was the case later in Modernism (Sedlmayr 1983, p. 64). Sedlmayer sees in the revolutionary architecture of the eighteenth century an important source for the development of Modernism in general (Sedlmayr 1983, p. 80). The spectrum of new buildings, which extended from memorials and museums to factories and office buildings and from halls and theatres to residential buildings, called for a pluralistic conception of space: halls constituted large, multifunctional spaces, office buildings consisted of spatial units that could be added to both vertically and horizontally, etc.

The new building materials steel and concrete, which initially were used above all by engineers for their bridges and hall constructions, permitted spans that far exceeded what had previously been deemed possible. Load-bearing systems combining vertical supports and ceilings facilitated the free arrangement of non-load-bearing, partitioning elements. The Crystal Palace constructed by Joseph Paxton for the World Exhibition held in London in 1851 was the first building that made no reference to a style that had gone before it. However, similar structures had already been built in the form of greenhouses and railway station halls (see Fig. 2.41). The Crystal Palace, a pure skeleton-frame structure, consisted for the most part of standardized and prefabricated elements made of glass, iron and wood. Paxton was not an architect: he had started his career as a gardener and then worked on the construction of greenhouses.

The skeleton-frame structure is nothing new: even Greek temples and Gothic cathedrals can be characterized as such. The use of wood hardly allows for another way of building, since a system of supports and beams is most suited to this material. However, the spatial possibilities offered by this system, at least in the Western world, were not fully exploited until the mid-nineteenth century.

5.1.1.3 Epoch of the Third Conception of Space

Up until Modernism the conception of what space should be largely accorded with the notion formulated by Aristotle: space is a limited, enclosed and finite void. Modernism's understanding of space can be compared with the concept formulated by Giordano Bruno: space is surrounding or intermediate space, no longer clearly limited and thus no longer necessarily finite (Fig. 5.1). The English language distinguishes between "room" and "space". "Room" corresponds more to the Aristotelian concept: the coherent space, the vessel, such as the interior of the Pantheon (Fig. 5.4). "Space" is understood as the space between things, the intermediate space, just as Giordano Bruno described it in the sixteenth century: spaces as zones that can dissolve into one another, as in the case of the Farnsworth House built by Mies van der Rohe in Plano near Chicago in 1950 (Fig. 5.14). Here we find an intense relationship between inside and outside. This relationship is generated not by building sections protruding into the surroundings, as seen in buildings by Alvar Aalto and Frank Lloyd Wright (see Figs. 4.15 and 4.16), but rather by the large glazed external walls.

The Crystal Palace along with the Eiffel Tower erected by the engineer Gustave Eiffel in Paris for the World Exhibition of 1889 were important portents of the development leading to the third conception of space (Fig. 5.2). The modern steel skeleton-frame structure, which had its roots in the early industrial buildings constructed in England in the eighteenth century and the engineering structures of the nineteenth century, was further developed above all in the high-rise buildings produced by the Chicago School (Fig. 5.15a). Concrete-like building materials had been around for a long time and yet it was not until 1892 that the developer François Hennebique patented a process that made it possible to produce skeleton-frame structures using reinforced concrete (Frampton 1983, p. 22) (Fig. 5.15b).

Fig. 5.14 Mies van der Rohe, 1950, Farnsworth House, Plano, USA. **a** floor plan and **b** elevation

Fig. 5.15 a William le Baron Jenney, 1891, fireproof steel-frame structure, Chicago, USA, **b** François Hennebique, 1892, monolithic reinforced concrete connection

In 1904 August Perret, with his apartment building on rue Franklin in Paris, became the first architect to use a concrete skeleton-frame for residential construction (Fig. 5.38b). In 1914 Le Corbusier, who had worked in Perret's office, extended the idea with his Domino House (Fig. 5.39), linking it above all with the "plan-libre", or free plan. According to Colin Rowe the skeleton-frame structure had now acquired a significance comparable with that of the pillar in antiquity (Rowe 1980, p. 25).

The skeleton-frame structure became an important catalyst for the International Style, the modern form of architecture par excellence. Henry-Russell Hitchcock and Philip Johnson described the function of this load-bearing system and the effects of its use in their book "The International Style", written for the eponymous exhibition held at the Museum of Modern Art in New York in 1932, as follows: "Contemporary methods of construction provide a cage or skeleton of supports. This skeleton as it appears before the building is enclosed is familiar to everyone. Whether the supports are of metal or of reinforced concrete, the effect from a distance is of a grille of verticals and horizontals. For protection against the weather it is necessary that this skeleton should be in some way enclosed by walls. In traditional masonry construction the walls were themselves the supports. Now the walls are merely subordinate elements fitted like screens between the supports or carried like a shell outside of them. The building is like a boat or an umbrella with strong internal support and a continuous outside covering. In buildings of the past the masonry wall provided both support and protection against the weather" (Hitchcock and Johnson 1985, p. 41).

Painting exerted an important influence on modern architecture. As Siegfried Giedion writes: "Painters very different in type but sharing a common isolation from the public worked steadily toward a new conception of space. And no one can understand contemporary architecture, become aware of the feelings hidden behind it, unless he has grasped the spirit animating this painting" (Giedion 1978, p. 279). Theo van Doesburg, a painter

and co-founder of the De Stijl movement, later also worked as an architect. His painting "Rhythm of a Russian Dance", which he produced in 1918, bears strong similarities with the "Brick Country House" designed by Mies van der Rohe in 1923 (Fig. 5.16).

Ultimately the concept of intermeshing spatial zones was not a totally new idea; it was also an element of traditional Japanese architecture. The Katsura Imperial Villa, which was built in Kyoto in the seventeenth century for an imperial prince, is a wooden skeleton-frame structure built on a grid that corresponds to the proportions of the tatami matting inside the building (ca. 90 cm × 180 cm). Flexible spatial partitioning is facilitated by sliding walls made of paper and wood (Fig. 5.43).

The "International Style" presented in a New York exhibition in 1932 presented a unified appearance for only for a short time. Modernism did not consist of a unitary style in the way, for example, the Romanesque did. Fifty-three years after the famous exhibition, Henry-Russell Hitchcock compared the architectural history of the twentieth century to a river that prior to 1920 flowed slowly and freely with many eddies and branches but then, during the 1920s, contracted to a narrow channel so that the water shot forward with an "almost revolutionary force, before, in the early thirties, widening and forming meanders again" (Hitchcock und Johnson 1985, p. 18). Under the influence of a range of improvements in materials and new technologies, cubist, constructivist and expressionist currents emerged. These currents were also a "revolt against reason", as Pevsner puts it (Pevsner 1967, p. 487) (Fig. 5.17). They emerged from the search for new paths.

The "revolt against reason" in the 1960s and 1970s was a search for the new and at the same time an admission that modern architecture was in crisis. The reasons for this may have been the separation of intellect and emotion as well as the loss of the total

Fig. 5.16 Example of the influence of painting on Modernism: **a** copy of the painting by Theo van Doesburg (1918, Rhythm of a Russian Dance), **b** simplified rendering of the image, **c** Ludwig Mies van der Rohe, 1923, "Brick Country House" (project)

Fig. 5.17 "Revolt against reason" (Pevsner). **a** Eero Saarinen, 1962, former TWA terminal, New York, USA (see Fig. 6.19), **b** Le Corbusier, 1950, chapel, Ronchamp, France

work of art (see Sect. 3.8). So-called Postmodernism was an interim result of this search. After Modernism's break with all preceding styles, Postmodernism re-embraced the fundamental principles of earlier epochs. Architecture should no longer create only pure, abstract, stereometric spatial relationships but go beyond their function to make vivid, symbolic statements. Already in the 1960s Robert Venturi proposed a renunciation of "either or" in favour of "as well as". Architecture no longer needed to be unambiguous but could also include ambiguities and contradictions. The ambiguity of space already seen in the Baroque era once again gained currency (see Fig. 3.4b).

5.2 Types of Space

5.2.1 Mathematical Space and Experienced Space

Space can be divided into three categories: geographic space, actual living space and architectural interior or intermediate space. In perceptual terms the first category is an abstract space since it cannot be directly perceived. In our minds it is composed of many individual pieces of information, or we discern it by technical means in the form of a map or a model. Living space is a semi-abstract space. We can directly perceive some of its features but we experience many others on the basis of individual pieces of information or are not aware of them at all. The third type of space is concretely perceivable. It is directly experienced interior or intermediate space, discernible via the elements that delimit it.

Today buildings are usually constructed with the help of plans. The architect translates his spatial ideas into a two-dimensional drawing. The building contractor in turn uses these plans to construct a three-dimensional, material space, which can be directly experience as such by every beholder (see Fig. 1.14). The space represented on the plans – the so-called mathematical space – and the experienced space are fundamentally different; they are in no sense identical. Bollnow describes their connection as follows: "The

mathematical space is arrived at from the experienced space by dispensing with the different concrete life references and reducing life to a mere intellectual subject" (Bollnow 1980, p. 23). In the mathematical space all points are of equal value; any direction can be made into an axis. The experienced space always has a centre, the location of the beholder, and an axis, which is associated with the posture of the beholder. In the experienced space the individual elements have a relationship to one another: behind, in front, left, right, etc. This relationship is structured and is in turn dependent above all on the location of the beholder; it is thus subjective. The experienced space is thereby strongly linked to the beholder and is therefore perceived differently by different people, indeed, by the same beholder, depending on his psychological state at any one moment. Socio-psychological aspects play a decisive role here (see Sect. 1.4).

Distances constitute an important difference between mathematical and experienced space. The perceived distance between two points usually does not correspond to the measured distance. For instance, on a plan two rooms in different apartments may be separated only by a wall, but in experiential terms they are miles away from one another. Here, too, socio-psychological aspects are decisive. As already discussed, the distance of a route leading to the city centre is perceived as shorter than the distance of one leading away from the centre even if they are equal in mathematical terms (see Sect. 1.3.7).

5.2.2 Daytime Space and Night-Time Space

In his analysis of experienced space, Bollnow draws a distinction between daytime and night-time space, between the way the beholder experiences a space by day or by night: "Daytime space has priority for the experience of space. Our familiar notions of space are derived from daytime space, and if we want to identify night-time space in its uniqueness, we first have to distance it from daytime space" (Bollnow 1980, p. 217). Daytime space is clearly laid out; intermediate spaces and delimitations are discernible; the space has a direction based on the location of the beholder; it appears three-dimensional. Night-time space does not have extent or discernible depth or direction; often the individual objects within it are difficult to recognize as such. The night-time space seems indeterminate. Daytime and night-time spaces are two extremes that are distinguished by the prevailing type of illumination: the daytime space is filled with light while the night-time space is more or less in darkness (Fig. 5.18). Between these two extremes are innumerable intermediate stages that are dependent on artificial lighting or the time of day or weather conditions.

5.2.3 Private Space and Public Space

Mathematical space makes no distinction between private and public. However, in the case of experienced space this distinction is vital. As "herd animals" human beings are,

Fig. 5.18 **a** Daytime space and **b** night-time space in Hong Kong

on the one hand, dependent on the community. Contact with their fellow human beings is the precondition for every social relationship. On the other hand, the individual needs seclusion, privacy for reflection and recuperation. Private and public space are closely related although their polar opposition is always maintained. A proportional relationship exists between, on the one hand, the intensity of the interaction between private and public space and, on the other, the urban character of a residential quarter: the more intensive this interaction is, the more urban the environment (Bahrdt 1961, p. 38). The cave is seen as the archetype of private space and, according to Norberg-Schulz, constitutes, along with the pillar, a basic element of building in general: "… the column originally was erected to represent the phallus, while the cave represented the womb from which the new life comes. The combination of these two iconic architectures created the first real works of architecture" (Norberg-Schulz 1980, p. 179).

The dwelling as private space forms a fixed reference point for the human being; it is the subjectively experienced centre, the site from which the human being departs and to which he always returns again. To dwell means more than merely residing somewhere; to dwell is to be at home.

The dwelling in which one was born, grew up, lived and died was for a long time the primary human site from beginning to end. Among many peoples, the dead were buried with small clay models of dwellings in order to ensure they retained their home following death (Rykwert 1983, p. 151).

5.2.4 Experienced Space

Along with private and public spaces, which are stationary and frequented by the individual as required, around every human being there exist invisible territories and zones that directly correlate with the respective location of the individual. Similarly to the case of animals, the human experience involves invisible boundaries and distances that help to regulate coexistence. The human builds for the human. Let us therefore focus on the

5.2 Types of Space

human individual and ask ourselves what happens around him in spatial terms, how he perceives what are often invisible spaces and zones, and how he reacts to them.

Edward Hall distinguishes between four different spatial zones that lie concentrically around every individual: the intimate zone, the personal zone, the social zone and the public zone (Hall 1976, p. 118) (Fig. 5.19). If one individual penetrates the intimate zone of another the result is usually physical contact. Perception then occurs no longer primarily via the visual sensory organ but rather via the senses of touch and smell. A physical approach of this kind can be divided into three different types or situations. One type involves people who know each other well and are also close to one another in a figurative sense. In this situation such an encounter is voluntary. The second possibility involves a struggle, whether in the context of sport or because two people are hostile to one another. The third type is exemplified by the penetration by a doctor of a patient's intimate zone during a medical examination.

People who voluntarily encounter one another in their personal zone usually have a relationship to each other; there is direct contact between them; they speak to one another.

The social zone lies between the personal and the public zones. Within this sphere individuals do not have direct contact with one another but they also cannot completely ignore each other. Such situations occur, for example, in restaurants or in small shops.

In the public zone there is no direct connection between the individual persons; they have nothing to do with one another and their convergence is purely coincidental.

Fig. 5.19 The four invisible zones around the human being (based on Edward Hall)

Fig. 5.20 People (dots, see Fig. 5.19) with their different invisible zones in the built environment

We can envisage the different zones as concentric circles around each individual. The radii of the different circles can vary; they are culturally conditioned and situation-dependent. For example, if an American finds himself in the same space as another person, politeness dictates that he should make contact with this individual because for him their two personal zones overlap. A Japanese person in the same situation, by contrast, has the option of not interacting at all. For him the personal zone is much more confined and he therefore feels no compulsion to communicate with the other person (Hall 1976, p. 143).

Spatial interpersonal relationships effectuate a complex system of approach, flight, evasion, avoidance, etc. The built, architectural space must therefore not only take into account a mathematically defined utilization program; it must also take into consideration all types of these socio-psychological relationships. The task of architecture is also to create preconditions conducive to different types of encounters, i.e. overlaps between the zones (Fig. 5.20).

5.2.5 Intermediate Space

Giordano Bruno defined space as a system of relationships between things (Fig. 5.1).

Space is surrounding or intermediate space. Intermediate spaces are necessary for the discernment of objects; without them we would be unable to perceive individual objects. They play a decisive role for relationships between individual elements.

As soon as several buildings enter our field of vision they enter into a relationship mediated by the spaces between them. If two of them touch, then one will appear to be a part of the other; if they are too far apart, there will no longer be a relationship between

5.2 Types of Space

them. Intermediate space generates a relationship between the individual buildings and thereby exerts a decisive influence on the architecturally designed environment. The type of intermediate space is primarily determined by three factors: the size of the elements that delimit the intermediate space, their proportion, and the distance between and shape of these elements (Fig. 5.21). However, when it comes to experiencing intermediate spaces and, indeed, spaces in general, it is not only these factors that are decisive. Socio-psychological aspects and the mood or atmosphere prevailing at these sites are also important (Fig. 5.22).

The most conspicuous intermediate space in the urban sphere is the street. It has to be more than only a traffic space. The facades of the adjoining buildings, which define the "street" as intermediate space, must be subject to certain design rules so that the street space can be perceived as a unit. Street spaces suppress the self-contained character of the adjoining buildings. However, the facades of these structures remain part of the building not the street. In contrast to the space of the urban square, the space of the street is an eccentric one. It has no central point; it is a longitudinal space with an axis.

The rules applying to the design of the urban square are similar to those for the street. In the Baroque period space was, at least visually, extended into infinity. It therefore made sense to include the surroundings of a building in its spatial concept. The urban square was more than merely a useable space; it was accepted as a fully-fledged three-dimensional element and its design was one of the primary concerns of architecture.

The advent of Postmodernism saw the rediscovery of the street and the urban square as public open spaces. In this view, urban life needed once again to be consciously invested with meaning, and the neighbourhood as public space was seen as the appropriate framework for such investment. Public space once again became a primary concern of planners. Charles Jencks argues that this shift marks "a return to the public realm. In the past this meant the agora, assembly area, mosque or gymnasium – a place for people to debate their varying views of the good life, or assert their communality" (Jencks 1978, p. 108).

Fig. 5.21 The three factors determining the type of intermediate spaces: **a** size, **b** proportion and **c** distance between and shape of bordering elements

Fig. 5.22 Mood and atmosphere are also important for the experience of space. Two formally similar intermediate spaces: **a** old town of Ibiza, Spain, **b** Ando Tadao, 1993, Conference Pavilion, Weil am Rhein, Germany (see Fig. 7.6)

The significance of open space in front of a building has never been underestimated by great architects. For example, the facades of Palladio's city palaces differ fundamentally in accordance with whether they adjoin a narrow street or a city square, whether or not there is open space in front of them (Fig. 5.23). The facades of the palaces located on narrow streets are structured according to the principle of translational symmetry, or sequencing, which emphasizes the continuity of the street. The buildings on open squares are more comparable with Palladio's villas than the palaces on narrow streets. Their facades are designed axisymmetrically. The open square, or the open field in the case of the villas, affords a quite different point of view. The proportions of the facades are easier to discern from a distance.

In the case of the Palazzo Chiericati in Vicenza the axial symmetry is further supported by the vertical threefold division of the façade and the associated emphasis of the central section (see Sect. 7.4). The covered veranda and the row of columns enclosing it lend the façade depth. As a result the open space of the square engages with the architectural space of the building and vice versa. Rather than confronting one another anonymously the palace and the square enter into a dialogue. With this composition Palladio already anticipated an idea fundamental to the Baroque.

Fig. 5.23 Andrea Palladio, **a** 1542, Palazzo Thiene, Vicenza, Italy, **b** 1550, Palazzo Chiericati, Vicenza, Italy (see Fig. 7.10)

Ludwig Mies van der Rohe also took into account the significance of open space when designing the Seagram Building in New York. By setting the building back from the street front he created a plaza. In front of the building the street space widens into a large open space that allows the visitor a frontal approach. The structure does not simply blend into the row of other skyscrapers along the street but, due to its forecourt, acquires a special status that distinguishes it from the mass of other buildings. Unlike most of the other buildings in Manhattan the Seagram Building is not only tangentially experienced. Instead, the visitor has the possibility of approaching the building from the front and thereby fully experiencing its size.

5.2.6 Emptiness

Where does intermediate space end and emptiness begin? As we saw in Sect. 5.2.5 the type of intermediate space created depends primarily in three factors: the size of the elements that border it, their proportion, and the distance between and shape of the elements. When these three factors have no influence over the space between two objects, this space can be described as emptiness. We experience extreme emptiness in situations in which no objects are discernible at all, such as in complete darkness or on the open sea under a cloudless sky. As discussed in chapter 1, people can experience disturbances when in the complete absence of perceptual stimuli.

Monotonousness cannot be equated with emptiness but also involves the absence of perceptual stimuli. In the anonymous residential districts found in many large cities the individual buildings are often designed and arranged such that uniformity is predominant

and the surroundings have very little informational content, with the result that very few or no perceptual stimuli are available. In the absence of an effective reference system spatial coordination is no longer possible. The individual experiences a sense of monotonousness, of abandonment, of emptiness.

Modernist urban models such as Le Corbusier's Plan Voisin were therefore doomed to fail from the beginning (Fig. 5.24). The buildings in these cities were self-contained objects, often featuring uniform facades, which appeared to claim a great deal of space, thus contradicting the idea of the traditional city. Colin Rowe characterizes the difference between the two urban models as that between, on the one hand, a collection of lacunae in a largely unstructured mass and, on the other, a collection of masses in a largely pristine emptiness. The two cases, he argues, are based on completely different categories of figure – in one case space, in the other object (Rowe 1984, p. 88).

By creating a force field in an almost empty space, tension can be generated with very little effort. A good example is the Zen stone garden of the Ryoanji Temple in Kyoto in Japan, in which several natural stones lie irregularly distributed in a rectangular field 9 m wide and 23 m long.

The ground is level and covered with gravel. The field is enclosed on three sides by a wall. Without stones the courtyard would be drab and empty. The forms of the stones and their relationships to one another give rise to contrasts and equilibrium, which radiate

Fig. 5.24 Le Corbusier, Plan Voisin, 1925, Paris, France: self-contained new buildings in the interconnected city centre of Paris

Fig. 5.25 **a** Zen stone garden of the Ryoanji Temple, 1473, Kyoto, Japan, **b** schematic representation of the arrangement of stones, **c** schematic representation of Wassily Kandinsky's painting "9 ascending dots" (copy)

calm and beauty while also generating tension. Although the garden is over 500 years old its concept is comparable with that of abstract painting. In 1926 Wassily Kandinsky painted "9 ascending dots". Here, too, the dots have a particular spatial relationship with one another which generates a perceptual tension (Fig. 5.25).

5.3 Elements of Space

Every human action has a spatial aspect. Action takes place; it needs space. Architectural interior space is space created by people which primarily serves to provide protection against natural forces. This means that a space is separated from its surroundings to allow people to control it more effectively; an interior space is created. Space becomes discernible via the elements that delimit it, and its character depends on the way in which these elements are organized. As Charles Moore writes, "When … you make a room out of a floor, four walls and a ceiling, you will have, besides those six things a seventh as well: space, a thing probably more memorable than any of the physical things that made it" (Moore 1979, p. 149). Or as Louis I. Kahn puts it, "Space is not space unless you can see the evidence of how it was made" (Klotz and Cook 1974, p. 246).

For technical and economical reasons most spatial demarcations consist of horizontal and vertical elements: floor, ceiling and walls. For practical reasons the floor, as the lower spatially delimiting element, is usually horizontal. Variations are possible to only a limited degree: differences in level, changes in texture, different materials. The relationship between the floor planes of different spaces has a decisive influence on the character

of a spatial composition. The floor is often the continuous element that helps to link the individual spaces in a spatial sequence. Conversely, differences in floor level can be used to form defined areas. For example, in many churches the choir is separated from the rest of the space by several steps. A floor or ground surface can in itself already define a type of space: a territory, a district, a zone. In different religions, for example Japanese Shinto, a holy district consists of only a marked area of ground that acquires a special significance through being invested with symbolism (Fig. 5.26a).

The ceiling or the roof forms the upper spatially delimiting element. In a multi-storey building the ceiling is also the floor of the space directly above and must therefore be horizontal. Today, this is the only limitation placed on the form taken by roofing. This form, as well as its construction and materiality, have a decisive influence on the overall character of a space (Fig. 5.26b). As in the case of the floor, differences in the level of the ceiling of a space can be used to divide the space into different zones.

Walls constitute the vertical delimitation of a space. They can be formed differently depending on the relationship of the space to its surroundings, thereby imbuing spaces with different characters. As a rule, spaces have floors but do not necessarily need walls. Should the latter be absent, then the only vertical elements are the ceiling-bearing columns. The openness between such columns may be restricted to providing a clear view to the outside: the surfaces between the columns can be glazed and thus rendered transparent. In climatic terms the interior space is separate from its surroundings; in visual terms it flows out into them. The greater the degree to which an interior space is separated from the exterior space, the more independent it is from outside conditions. In the case of the Farnsworth House by Mies van der Rohe (Fig. 5.14) apart from the non-load-bearing components it is above all the horizontal elements, i.e. the floor and ceiling, which define the space. Although columns are not planar elements they can have a spatially defining effect and form different zones. Decisive here is their position in the space (Fig. 5.27).

Fig. 5.26 Upper and lower spatial delimitations: **a** holy district in Ise, Japan, **b** Jean Nouvel, 2000, Culture and Congress Centre (KKL), Lucerne, Switzerland

5.3 Elements of Space

Fig. 5.27 Within a space, columns can define different zones

Space becomes discernible via the elements that define it. However, we are less influenced by these physical elements than by what they generate, namely the actual space, its form and the atmosphere it creates.

This space is determined in accordance with the following criteria:

(a) The dimensions of the spatially defining elements.
(b) The arrangement of these elements. Together with the dimensions they determine the size, scale, proportion and form of the space.
(c) The type of elements: material, surface, texture and colour.
(d) The openings in and between the elements which regulate the relationships of spaces to one another and to the surroundings.

5.3.1 Material and Surface

In an essay on architecture titled "Baukunst" written by Goethe in 1795 he describes material as more important than purpose or aesthetic effect when it comes to the assessment of architecture (Kruft 1982). The influence on the effect of a space by materials making up spatially defining elements is often underestimated. The structures of the two roofs in Fig. 5.28 are similar: they are both tent constructions. However, the two spaces have fundamentally different characters due the difference between their roofing materials.

Before modern technology made almost anything possible, forms were determined by the possibilities offered by the building materials used. Different materials facilitate certain formal designs. For example, a delicate architecture can be realized more easily with slender steel columns and girders and a dense, heavy architecture more easily with concrete. Louis I. Kahn attached particular importance to the correct utilization of materials: "If you ask brick what it wants, it will say 'Well, I like an arch? …..If you're dealing with brick don't use it as just a secondary choice, or because it's cheaper. No, you have got to put it into absolute glory, and that is the only position that it deserves" (Kahn 1975, p. 281).

Beyond their technical qualities, materials have often been attributed different symbolic meanings. Reflecting an awareness of the fact that identity counts for little and life

Fig. 5.28 2 Two similar roof constructions, different materials: **a** Kenzo Tange, 1964, sports centre, Tokyo, Japan, **b** Günter Behnisch, 1972, stadium roof, Munich, Germany

is ephemeral, houses in China consisted of simple ephemeral materials such as wood and clay. In contrast to the European concept of the ruler, in China a ruler was not revered as an individual but as the member of a dynasty. The idea of the durableness of such a dynasty was given expression in underground tombs (see Fig. 6.24). These were constructed using solid stone arches and were meant to last for eternity. The aboveground palace and temple complexes represented the power of the emperor but, like the individual rulers, they were ephemeral and therefore consisted of materials similar to those used for simple houses (Thilo 1978, p. 223).

In ancient Egypt only tombs and the temple complexes linked to them were built of solid stone. Egyptians believed in life continuing after death and therefore that everything linked to earthly existence was ephemeral. But as the setting for life after death, the gigantic tomb complexes were built to be as durable as possible (see Fig. 5.3a).

Building materials are not only a means to an end. The beauty of their surfaces has always been used for decorative purposes (see Fig. 5.29). Adolf Loos, for instance,

Fig. 5.29 Building materials and surfaces as a means of decoration: **a** Herzog & de Meuron, 2004, Forum Building, Barcelona, Spain, **b** Mies van der Rohe, 1929, Barcelona Pavilion, Barcelona, Spain, **c** JørnUtzon, 1973, Opera House, Sydney, Australia

saw in high-quality materials an alternative to ornament: "One should consider that high-quality materials and good work do not merely compensate for a lack of ornament but that they are in fact far superior to it in terms of exquisiteness" (Loos 1982, p. 134). It is the material that ultimately determines the type and appearance of an object's surface. Due to their different surface structures and colours, different materials can form contrasts with one another that make them architecturally effective elements.

When experiencing architecture the sense of touch is the second-most important sense after sight. When we touch an object we come into direct contact with its surface and can thus also experience the materials in haptic terms. For instance, walking across a marble floor leaves us with a sensation quite different to what we feel when our feet come into direct contact with a carpet. Surface structures also play an important role in the acoustics of a space: smooth surfaces reflect sound whereas soft, porous materials absorb it (see Sect. 1.3.1).

5.3.2 Openings

For Le Corbusier openings were a central element of architecture: "The entire history of architecture revolves exclusively around the openings in the walls" (Le Corbusier 1981, p. 94). The degree of openness of a space or a building determines the extent of its relationship to the adjoining space or to the surroundings. The type of openings has a fundamental influence on the relationship between inside and outside. The larger the openings the more the interior is exposed to influences from outside.

The essence of open and closed is linked to two fundamentally different concepts of building. A space can be thought of, in the Aristotelian sense, as a vessel in whose walls openings are cut as required, or it can be thought of as open and only closed where required. The second spatial type corresponds to the conception formulated by Giordano Bruno (Fig. 5.1). A system composed of load-bearing walls, a so-called solid structure, is basically closed and is subsequently equipped with openings as required. In the case of the second type, the skeleton-frame structure, the load-bearing system consists of columns and beams. The system is basically open and is closed where required. Every building concept lies somewhere between these two extremes, which have a fundamental influence on the character of a building (Fig. 5.30). An example often used to characterize the first type is a solid concrete building, while the second type is exemplified by a light steel and glass structure. However, the distinction is far older. Ancient Roman architecture is a solid architecture, composed of walls and vaults made of brick and mortar with openings made where needed. Ancient Greek architecture is a skeleton-frame architecture dominated by pillars and beams with intermediate spaces forming the openings (see Figs. 5.3b and 5.4).

Architecture creates interior space, i.e. space separated from its surroundings. The strength of this separation depends on the type of openings used. In order to render the space discernible as such a minimal separation is required. On the other hand, in most

Fig. 5.30 **a** solid structure and **b** skeleton-frame structure

cases a total separation is not appropriate. In cases where the interior space is climatically separated from the exterior space the openings consist of doors and windows. The door allows an authorized person to enter and leave a space but also makes it possible to bar entry to unauthorized persons. Beyond its structural function the threshold has a symbolic significance. Crossing the threshold means entering another sphere. The symbolism of a door is also illustrated by the fact that in ancient Rome it could be "detached" and exist autonomously as a triumphal arch. In China, standing on the

Fig. 5.31 The degree of opening depends on the size, position and form of the spatially defining elements

threshold brings bad luck because one finds oneself in an indeterminate situation: one is neither inside nor outside.

The degree of opening depends on the size, position and form of the spatially defining elements (Fig. 5.31). No vertical elements are required for a space to be minimally defined: a delimited area of ground, as found in Ise (Fig. 5.26a), or a roof suffice for this purpose. The absence of vertical separating elements results in a maximal link between the space and its surroundings, between inside and outside (A in Fig. 5.31). Columns have a weaker separating effect than wall panels, however small these may be, because the former are perceived as independent elements and not as directional (B in Fig. 5.31). Openings between individual enclosing surfaces separate these surfaces from one another, thereby emphasizing their autonomy. Openings appear more pronounced when they are located in the corners of a space (D in Fig. 5.31), which results in the corner not being clearly discernible as a spatially defining element. The relationship between inside and outside is weakest when the opening is cut out of an element that completely closes off a space, i.e. when the opening forms a hole (F in Fig. 5.31).

5.4 Spatial Organisation

5.4.1 The Relationship Between Different Spaces

A space seldom exists alone, and when this is the case, the space is often divided into different zones (see Fig. 5.27). This relationship of spaces to one another can be very different, and a distinction can be drawn between four basic types (Fig. 5.32).

In the first group a smaller space is located within a bigger one (Figs. 5.32a and 5.33). The inner space is dependent on the volume surrounding it and cannot have a direct connection to the exterior space. The interior area of the larger space forms the surroundings of the smaller one. There must be a clear difference between the spaces in terms of size. If the difference in size is too small, the surrounding space can become difficult to discern as such. The otherness of the smaller space can be emphasized by form and orientation. We already find different variations of this spatial connection in Greek and Roman

Fig. 5.32 Different ways of relating different spaces to one another

Fig. 5.33 Oswald Mathias Ungers, 1984, Deutsches Architekturmuseum, Frankfurt, Germany

architecture. In traditional Christian sacral architecture the altar is often covered by a canopy. As a result a smaller space is defined within the larger church space, emphasizing the special character of the altar as a site.

The second group comprises overlapping or interpenetrating spaces (Figs. 5.32b and 5.34). The different volumes have common areas yet otherwise more or less retain their autonomy. The spatial interpenetration can be both horizontal and vertical and plays a primary role in the relationship between inside and outside. In the course of history, spatial interpenetration has repeatedly played an important role in design. For example, the interpenetration of central-plan and longitudinal space is a major theme of Christian sacral architecture (Fig. 5.9).

The third type of spatial relationship is juxtaposition (Fig. 5.32c). The spaces are located next to one another and retain their full autonomy, but they are connected both spatially and visually. The type of connection depends on the design of the elements separating the two spaces: the bigger the separation the more each space retains its autonomy. A partition wall with an opening permits a connection but does not make it obligatory. However, the separation can also consist merely of columns which divide different spatial zones (Fig. 5.27).

The fourth type involves a connection via a third space (Fig. 5.32d). The two spaces no longer have direct contact, and their relationship is shaped by a third, connecting space. In the Ward W. Willits house by Frank Lloyd Wright the main spaces are not

5.4 Spatial Organisation

Fig. 5.34 I.M. Pei, 1978, National Gallery of Art, Washington D.C., USA (see Figs. 6.2c and 6.29)

directly linked to one another but can only be reached via a smaller connecting space (Fig. 5.35). This third space can also be, for example, a corridor from which the spaces can be accessed.

Stairs and ramps As vertical spatial connections stairs and ramps are highly significant. When ascending and descending these connections the beholder sees the space from a constantly changing perspective. This movement is therefore associated with a certain degree of curiosity: what awaits me above or below? Also important here is the time factor: time to look around and register the changes in perspective. In antiquity, stairways, like doors, often had strong psychological and symbolic significance over and above their functional aspect. They led up to something higher, away from the profane. Good examples are the stairways built by the Mayans of Central America and those constructed in ancient Persia (Fig. 5.36).

In the Middle Ages most stairways functioned only as connections for vertical movement. They were not regarded as spatial elements and consequently were located in unimportant parts of buildings. In the Renaissance they were also not ascribed a great deal of significance as dynamic elements within building interiors (Pevsner 1967, p. 303). Bramante used stairways to shape exterior spaces, above all to support depth effects. Palladio, too, was only interested in outside stairways. Since interior stairways were mostly used by servants, he located them in side rooms. By contrast, he attributed great significance to outside stairs as underscoring the concept of hierarchy. It was in the Baroque period, when the vertical penetration of space became extremely important, that the interior stairway first acquired real significance as an element of spatial design.

The ramp, as a variant of the stairway, allows for a gentler surmounting of differences in height and was already extensively used by the ancient Egyptians and Persians.

Fig. 5.35 Frank Lloyd Wright, 1902, Ward W. Willits House, Highland Park, near Chicago, USA (see Fig. 4.16) The main spaces (blue) are linked via small connecting spaces (red)

Fig. 5.36 Stairs and ramps: **a** Persepolis, fifth/fourth century BCE, Iran, **b** Oscar Niemeyer, 1960, National Congress building, Brasilia, Brazil

Le Corbusier included ramps in his designs wherever spatial conditions permitted. In Wright's Guggenheim Museum the entire main exhibition space became a large ramp (Fig. 6.25). As a result viewing the works of art becomes a continuous experience and is no longer divided into stages defined by spaces and levels.

5.4.2 Spatial Flexibility and Spatial Polyvalence

Architectural space is usually something fixed and defined. However, for different reasons the need may arise to conceive of a space that can be altered: enlarged or diminished, or, if required, connected with other spaces. When a system offers the possibility of altering space, of adapting it to different requirements without altering the system or its basic elements, then the space has the quality of flexibility. We will focus here on spatial flexibility, although it is not the only type of flexibility associated with building.

Since a space is formed by the elements that define it, it is above all these elements that must be flexible. In technical terms this means that the two functions of load-bearing and partitioning need to be dealt with separately. The basic structure of the load-bearing primary system must be such that the spatially separating elements can be shifted. Total flexibility is not possible, since the fact that a system and its basic structure have to be maintained sets certain limits.

Because a precondition of flexibility is the separate treatment of load-bearing and partitioning elements the history of flexibility in Europe is closely tied to the development of the skeleton-frame structure in the modern era. In the large spinning works of the eighteenth century the solid interior walls were replaced with cast-iron columns, which proved to be the beginning of a development the led to modern skeleton-frame structures with non-load-bearing lightweight facades (Fig. 5.37).

Fig. 5.37 a Development of the skeleton-frame structure from the solid structure in the eighteenth century, b Charles Bage, spinning mill, 1797, Shrewsbury, England

Already at the end of the nineteenth century many residential buildings in Chicago were designed without spatially dividing elements so that they could later be adapted to the wishes of residents (Fig. 5.38a). In 1904 Parisian architect August Perret built Europe's first residential building to feature a reinforced concrete frame, which permitted considerable freedom in the design of the floor plan (Fig. 5.38b). The partitioning walls were made of brick or plaster and could be removed with relatively little effort and without necessitating changes to the building's load-bearing structure.

In 1914 Le Corbusier, who had worked in Perret's office, adopted the idea for his Domino House (Fig. 5.39) with its "plan libre": "The system of supports bears the floor slabs and extends to the roof. The partition walls can be positioned as required, and no particular arrangement is bound to another. There are no longer any bearing walls but only membranes of different strengths. The consequence is absolute freedom when it comes to designing the floor plan, the freedom to enjoy selecting from the palette of possibilities" (Bösiger 1974, p. 128).

In the following years this idea was adopted and disseminated by different architects, including Theo van Doesburg, who in 1924 drew on it for his theory of elementary design: "The new architecture is open. The whole consists of a space which is divided in accordance with different functional requirements. This division is achieved by means of dividing surfaces (inside) or protective surfaces (outside). The former, which separate the different functional spaces from one another, can be moveable, that is, the dividing surfaces (formerly the interior walls) can be replaced by adjustable intermediate surfaces or panels" (Van Doesburg 1981, p. 74) (see Fig. 6.14). In 1927 Ludwig Mies van der Rohe went a step further in his apartment-building design for the Weissenhof Estate in Stuttgart: chipboard walls which could be pressed onto the ceiling by tightening screws allowed the residents themselves to move the walls to create the spaces they wanted (Giedion 1978, p. 364). This took the development almost to the point it has arrived at today. Now better solutions have been found for the integration of the

Fig. 5.38 a Holabird and Roche, Marquette Building, 1894, Chicago, USA, b Auguste Perret, apartment building on rue Franklin, 1904, Paris, France

5.4 Spatial Organisation

Fig. 5.39 Le Corbusier, Domino House (project), 1914

individual parts and the wall elements that are now available on the market have better structural-physical properties.

The skeleton-frame structure became a catalyst of Modernism par excellence and fundamentally shaped the appearance of this style. In 1932 Henry-Russell Hitchcock and Philip Johnson wrote, "The great majority of buildings are in reality, as well as in effect, mere planes surrounding a volume. With skeleton construction enveloped only by a protective screen, the architect can hardly avoid achieving this effect of surfaces, of volume." Floor plans, they argued, could now be approached with far greater freedom than in the past, since the small diameter of supports meant that they no longer constituted a serious obstacle (Hitchcock and Johnson 1985, p. 41–42).

The spatial flexibility achieved by means of moveable elements has always been controversial. Flexible architecture is relatively expensive and the fact that many parts need to be moveable can give rise to additional technical problems. Sometimes flexible spaces have been created where there was no need for them. For instance, it has been shown that flexible walls in residential buildings are practically never moved by the residents despite the system providing this option. In the Centre George Pompidou in Paris, designed by Renzo Piano and Richard Rogers, the 50-m wide exhibition spaces are free of columns. The aim was to achieve maximum spatial flexibility for different types of exhibitions. In the meantime it has become clear that this generosity was overdone: such freedom cannot be exploited (Frampton 1983, p. 240) (see Fig. 6.6).

The goal of every flexible type of architecture is to create the possibility of adapting spaces to changing uses. The flexibility so far discussed consists in the adaptation of spatially defining elements to new utilization scenarios.

Another way of reacting to this problem is the creation of multifunctional, so-called polyvalent spaces: spaces that can serve different functions without the need to make any changes to them. Robert Venturi writes that the multifunctional space may be a convincing answer to the efforts of modern architecture to achieve flexibility. Spaces designed

for a type of purpose rather than a special purpose, and equipped with moveable furnishings rather than moveable partition walls, he argues, also foster a flexibility of perception rather than merely physical disposability; they communicate a necessary feeling of reliability. Genuine ambiguity, he argues, can also mean useful flexibility (Venturi 1978, p. 50). The multifunctional space may have several origins. One of them is found in the old American country house, the centre of which is formed by the fireplace, around which all main spaces are arranged. These spaces are connected by sliding doors (Fig. 5.40).

Frank Lloyd Wright drew an this tradition and aspired to the greatest possible degree of polyvalence in his residential buildings by creating different spatial zones that merge into one another rather than using walls to divide the floor plan into individual spaces.

Spatial polyvalence has yet another origin in the USA. Most of the residential buildings made of wood can be extended in accordance with social and economic conditions. Siegfried Giedion even argues that this flexible treatment of the house, which has been common since colonial times, is a key to American culture in general (Giedion 1978, p. 142).

The project for a total theatre in Berlin designed by Walter Gropius in 1927 provided for the staging of different types of performances without requiring structural changes to the theatre space. The only change consisted in turning the central rostrum section with the small stage 180 degrees (Fig. 5.41).

Hermann Hertzberger is a well-known representative of polyvalent architecture. In his view it is impossible for each individual to plan specifically and therefore space needs to be created that allows for interpretations. The office building he designed for an insurance company in Apeldoorn in the Netherlands illustrates this concept. The building consists of square platforms layered over one another that are laterally separated by light wells. The platforms form a network of different zones, which can be combined with one another as required (Fig. 5.42).

Fig. 5.40 G. Woodward, 1873, project for a country house

5.4 Spatial Organisation

Fig. 5.41 Walter Gropius, Total theatre for Berlin (project), 1927 (3 different arrangements of stage and audience area)

Fig. 5.42 Hermann Hertzberger, 1974, office building, Apeldoorn, Netherlands

The traditional Japanese dwelling is a mixture of polyvalent space and flexible spatially defining elements. As already discussed in Sect. 4.4, in Japan there has always been a particularly intensive relationship between inside and outside. Accordingly, the individual spaces are not separated from one another in a permanent manner.

Fig. 5.43 Katsura Imperial Villa, seventeenth century, Kyoto, Japan (see Fig. 3.13)

The walls between the supports never consisted of permanent elements. In the old Shinden style bamboo curtains that could be rolled upwards were hung between the supports as partitions. In the fourteenth century the Shinden style was replaced by the Shoin style, which brought with it the sliding walls still commonly used to separate spaces from one another and from the veranda (Yoshida 1951, p. 139). Since most of the spaces are not ascribed a fixed use and since a Japanese house has only a very few pieces of furniture, a polyvalent spatial system is created which allows for spaces to be opened, closed and connected with one another as required (Fig. 5.43).

5.4.3 Culturally Determined Types of Orientation in Space

In the Islamic cultural sphere space was and in part still is perceived differently from the way it is in the Western world. Different conceptions of space and orientation developed in the two cultural spheres.

Up until the end of the nineteenth century, interior space in the West was a closed area delimited from the outside (see Sect. 5.1.1). The individual moved along an axis in the direction of particular point. His goal could be a town, the end of a road, an important

Fig. 5.44 Orientation in the Western cultural sphere towards a point: **a** left: street in Chicago, USA, **b** left: cathedral, eleventh century, Speyer, Germany

building or the altar reached via the church nave. Orientation was in a particular direction, often expressed by an arrow pointing to a particular point (Fig. 5.44).

Islam originated among a desert people. Most Arabs were nomads with no building tradition. They moved through the desert by night, and the space in which they lived was only delimited by the ground and the firmament, whose stars appeared like a nocturnal roof. Space was not very strictly defined; it appeared infinite and dynamic. "Serve him who made you the earth a carpet and the sky a ceiling" (Surah 2:20). This quote from the Koran underscores this concept. Humans orientate themselves in relation to the horizon, to the line that separates earth and sky. For them place is not a fixed element but is fluid. For this reason no one direction is dominant (Stierlin 1979, p. 82) (Fig. 5.45).

The areas conquered by the Arabs were often inhabited by peoples with a highly developed building culture, and their knowledge and skill was adopted for the construction of mosques. Traditional Islamic architecture includes a number of different types of building. The oldest type, the so-called hypostyle mosque, was, however, more or less directly derived from the courtyard house of Mohammed, where his followers

Fig. 5.45 Orientation in the Islamic cultural sphere in relation to a line: **a** Nubian Desert, Egypt, **b** mosque (today a cathedral) from the eighth century onwards, Cordoba, Spain

assembled. In contrast to most of his followers he was not a nomad but a merchant from Medina.

The Great Mosque of Cordoba (in Fig. 5.45b), which was built only 155 years after the death of Mohammed, is a hypostyle mosque. Its design clearly translates the original Arab nomad conception of space. The space is not strictly defined and the walls are not clearly discernible, which gives rise to an impression of the infinite. There is no clear structure or spatial hierarchy. The relatively low room height emphasizes the horizontal and creates the impression of an endless expanse. The only spatially connecting element here is the floor.

The spaces of the Umayyad Mosque in Damascus, built in the eighth century, and of the original church it replaced illustrate the two different conceptions of orientation within space. The mosque today stands on a plot 160 m long and 100 m wide, which was originally a different kind of sacred site. In the first century the Romans built a Temple of Jupiter surrounded by walls on a site on which the Roman emperor Theodosius (379–395) later had a five-nave basilica dedicated to John the Baptist built. Between 706 and 715 the caliph Al-Walid I had the church replaced by a mosque. The church was not destroyed but taken apart. The individual elements, such as the 40 six-metre-high monolithic ancient pillars, were reused to build the mosque. The space orientated to a point was not adopted. Instead, its components were used to produce a new space orientated to a line. The space is not entered at a single location, such as the gate that granted access to the old church. The whole longitudinal façade is open, allowing access from the entire courtyard (Figs. 5.46 and 5.47).

5.4 Spatial Organisation 177

Fig. 5.46 a Church inside the old walls of the Roman Temple of Jupiter, **b** Conversion of the complex into the Umayyad Mosque, 708–714, Damascus, Syria (left: schematic representation, right: floor plan)

Fig. 5.47 Umayyad Mosque, 708–714, Damascus, Syria

References

Bahrdt, H.P.: Die moderne Großstadt, Hamburg, 1961
Bollnow, Otto F.: Mensch und Raum, Stuttgart, 1980 (1963)
Bösiger, Willy: Le Corbusier et Pierre Jeanneret, Oeuvre complète de 1910–1929, Zürich, 1974 (1964)
Canival, Jean-Louis de: Aegypten, Fribourg, 1964
Dessoir, Max: Die Geschichte der Philosophie, Wiesbaden, 1925
Frampton, Kenneth: Die Architektur der Moderne, Stuttgart, 1983 (original title: Modern Architecture, London, 1980)
Giedion, Siegfried: Raum, Zeit, Architektur, Zürich, 1978 (original title: Space, Time and Architecture, Cambridge, Mass., 1941)
Hall, Edward T.: Die Sprache des Raumes, Düsseldorf, 1976 (original title: The Hidden Dimension, 1966)
Henri Stierlin: Architektur des Islam, Zürich, 1979
Hitchcock, Henry-Russell and Johnson, Philip: Der Internationale Stil, Braunschweig, 1985 (original title: The International Style, New York, 1932)
Jencks, Charles: Die Sprache der Postmodernen Architektur, Stuttgart, 1978 (original title: The Language of Post-Modern Architecture, London, 1978)
Kahn, I. Louis: I Love Beginnings, lecture at the Aspen Design Conference, 1973 (in: Louis I. Kahn, Tokyo, 1975)
Kahn, I. Louis: Werkbundziele, Ordnung ist, 1960 (in: Programme und Manifeste zur Architektur des 20. Jahrhunderts, Braunschweig, 1981)
Klotz, Heinrich and Cook, John W.: Architektur im Widerspruch, Zürich, 1974 (original title: Conversations with Architects, New York, 1973)
Krautheimer, Richard: Early Christian and Byzantine Architecture, Harmondsworth, 1965
Kruft, H.W.: Goethe und die Architektur (in Neue Zürcher Zeitung, 20 March 1982)
Le Corbusier: Fünf Punkte zu einer neuen Architektur, 1926 (in: Programme und Manifeste zur Architektur des 20. Jahrhunderts, Braunschweig, 1981)
Loos, Adolf: Trotzdem, Vienna, 1982 (1931)
Moore, Charles: The Place of Houses, New York, 1979 (1974)
Norberg-Schulz, Christian: Logik der Baukunst, Braunschweig, 1980 (1970) (original title: Intentions in Architecture, Oslo, 1963)
Norberg-Schulz, Christian: Meaning in Western Architecture, London, 1975 (original title: Significato nell' architettura occidentale, Milano, 1974)
Pevsner, Nikolaus: Europäische Architektur, Munich, 1967
Picard, Gilbert: Imperium Romanum, Fribourg, 1965
Rowe, Colin: Chicago Frame (in: Archithese, 4/1980 (originally published in: Architectural Review 1956))
Rowe, Colin: Collage City, Basel, 1984 (originally published in an abridged form in: Architectural Review, 1975)
Rykwert, Joseph: Ornament ist kein Verbrechen, Cologne, 1983 (original title: The Necessity of Artifice, London, 1982)
Sedlmayr, Hans: Verlust der Mitte, Frankfurt am Main, 1983 (1948)
Thilo, Thomas: Klassische chinesische Baukunst, Zürich, 1978 (1977)

References

Van Doesburg, Theo: Auf dem Wege zu einer plastischen Architektur, 1924 (in: Programme und Manifeste zur Architektur des 20. Jahrhunderts, Braunschweig, 1981)
Venturi, Robert: Komplexität und Widerspruch in der Architektur, Braunschweig, 1978 (original title: Complexity and Contradiction in Architecture, New York, 1966)
Wagner, Otto: Die Baukunst unserer Zeit, Vienna, 1979 (1895)
Yoshida, Tetsuro: Japanische Architektur, Tübingen, 1951
Zevi, Bruno: Architecture as Space, New York, 1974 (1957)

Form

6

Contents

6.1 Form and Culture . 181
6.2 Choice of Form . 182
6.3 Form and Shape . 190
6.4 Form and Structure . 190
6.5 Regular Forms . 193
 6.5.1 Horizontal and Vertical . 194
 6.5.2 The Line . 194
 6.5.3 The Flat Surface . 197
 6.5.4 The Curved Surface . 199
 6.5.5 The Circle . 202
 6.5.6 The Ellipse . 206
 6.5.7 The Sphere . 208
 6.5.8 The Square and the Cube . 211
 6.5.9 The Rectangle . 212
 6.5.10 The Triangle and the Pyramid . 212
 6.5.11 The Hexagon and the Octagon . 214
6.6 Irregular Forms . 216
6.7 Formal Contradiction . 216
References . 218

6.1 Form and Culture

Philip Drew compares form with a language, arguing that just as thought is formulated through language, the creation of physical forms is dependent on mental concepts and primal forms (Drew 1972, p. 21). Just as language consists of words, every design vernacular is composed of various basic patterns or elemental forms. In Sect. 1.2.5 we saw

that every message includes a certain amount of redundancy, i.e. a portion of its signs is not informative but "waste". There is redundancy in every design vernacular. A very low level of redundancy means that few parts of a design are superfluous. Many engineering constructions from the nineteenth century have a very low level of redundancy; their form is mainly determined by structural requirements (Figs. 6.3 and 2.41). In the case of many ancient and so-called primitive cultures the redundancy level of the design vernacular is low; every form is justified and has its function. In 1964 Bernhard Rudofsky presented this architecture in a highly regarded exhibition titled "Architecture without Architects" in New York.

Design vernaculars emerge through a long process of evolution. The success and stability of a culture are also based on a functioning design vernacular. Forms, as the visual expression of intellectual content, serve as semantic signs. The design vernacular is the expression of these signs as a whole; it renders visual the basic intellectual attitude of a culture. Form is conditioned by its content. As Theodor W. Adorno puts it, "Aesthetic success is essentially measured by whether the formed object is able to awaken the content sedimented in the form" (Adorno 1974, p. 329). With its design vernacular, every building is an indicator of the prevailing culture; it helps to make abstract ideas visible.

The development of a design vernacular to maturity, i.e. to the point where its spectrum is sufficiently wide to represent an entire culture, needs time and a source of friction against which it can shape itself. A change to the design vernacular that is too rapid results in the loss of a culture.

6.2 Choice of Form

In Sect. 3.1 we saw that one of the tasks of architecture is to illustrate the ideas of a society and its culture with concrete forms. Over millennia cultures developed slowly enough to allow architecture enough time to adapt stylistically to social and cultural changes (see Fig. 3.1).

The choice of building materials was limited and availability depended on the region concerned. The formal language it was possible to elaborate with these materials and their technical and constructional potential was therefore subject to narrow limits. For example, the stave churches built between the twelfth and fifteenth centuries in Scandinavia have a form different to that of the stone Gothic churches built at roughly the same time (Fig. 6.1).

The nineteenth century was the era of the neo-style. A large proportion of new buildings were designed in old styles or at least featured segments in old styles. The industrialization that began at the end of the eighteenth century was a decisive factor here because the great social upheavals it triggered were instrumental in the emergence of the new design vernacular.

The new rationalized, industrial manufacture of cars, ships, aircraft and consumer goods ultimately brought calls for changes in architecture. In 1938 the Belgian architect

Fig. 6.1 Stave church, thirteenth century, Hedal, Norway

and designer Henry van de Velde argued that the real forms of things were concealed and that the revolt against the falsification of form and the past at the time was a moral revolt (Giedion 1978, p. 206). In 1911 Hermann Muthesius, the Deutscher Werkbund's first programmatic thinker, wrote, "Helping form take its rightful place again must be the fundamental task of our time, must be the stated aim of every contemporary endeavour to achieve artistic reform" (Muthesius 1981, p. 23). Although these demands were not specifically directed at architecture but rather at the applied arts and the building trade in general, they had a powerful influence on developments in the architectural field. The abandonment of ornament and decoration allowed the simplicity of form, the form itself, to once again come into its own.

Previously the limitations on the availability of materials had in turn significantly limited the formal possibilities available (see Fig. 6.1). The new building methods, materials and technologies developed in the twentieth century made almost anything possible. Now forms were often chosen arbitrarily and as a result frequently lost their semantic expressiveness, which meant they were often not understood by the wider public. The

Fig. 6.2 Buildings with the same function (museums) but different forms: **a** Renzo Piano, 2004, Zentrum Paul Klee, Bern, Switzerland, **b** OscarNiemeyer, 1992, Contemporary Art Museum, Niteroi, Rio de Janeiro, Brazil, **c** I.M. Pei, 1978, National Gallery of Art, Washington D.C., USA (see Fig. 5.34)

question as to who or what now determined form and thus the appearance of a building was posed anew (Fig. 6.2).

In 1899, in his book "Histoire de l'Architecture", the architectural historian AugusteChoisy described form as the logical consequence of technique (Banham 1964, p. 16). The famous statement "form follows function" is attributed to Louis Sullivan (Frampton 1983, p. 49) although this is open to question (Blake 1977, p. 16). The statement became a guiding principal for the functionalists. One of its most important exponents, above all during the 1920s, was Walter Gropius, who embraced this principle from the beginning. In 1923 he wrote, "We want architecture adapted to our world of machines, radios and fast cars, architecture the function of which is clearly discernible in its relationship to form" (Jencks 1973, p. 109). The functionalists believed that building in accordance with strictly practical requirements automatically led to aesthetically satisfactory results. The purpose led directly to beauty.

Nature was often cited as a model for the connection between requirements and aesthetics. Frank Lloyd Wright held the view that in nature everything had its place, nothing was superfluous and everything was well arranged. He sought to realize a similar order in his architecture (Wright 1969, p. 190): "Nature became my Bible" (Wright 1969, p. 17). Today we know, however, that in nature form is certainly not always derived from function (see Sect. 4.4).

In 1920 the two sculptors Naum Gabo and Antoine Pevsner published the "Realistic Manifesto" in Moscow: "We reject the decorative line. We demand of every line in the work of art that it shall serve solely to define the inner directions of force in the body to be portrayed" (Gabo and Pevsner 1981, p. 53). Their description of the fundamental principle of Constructivism had a major impact on the buildings designed by the Russian architects El Lissitzky, the Wesnin brothers and WladimirTatlin, who today are regarded as the founders of the new Constructivism. This development would not have been possible without the pioneering achievements of a number of engineers and other people responsible for the design of new railway stations and conservatories. The Eiffel

6.2 Choice of Form

Fig. 6.3 Burton+Turner, 1884, Palm House, Kew, near London, England (see Fig. 2.41)

Tower was a purely constructive project, and the form of the Crystal Palace built by Joseph Paxton in 1851was also dictated by manufacturing and construction methods (see Fig. 2.41 and 6.3).

Le Corbusier, at least in his early work, was also a functionalist for whom the technology of the twentieth century provided a model. In his view giving an object form was the central aspect of architecture: "Contour and profile are the touchstone of the architect. Here he reveals himself as artist or mere engineer" (Le Corbusier 1969, p. 157). Ludwig Mies van der Rohe is also often described as a functionalist. In his view: "Form is not the goal but the result of our work. There is no form as such. Form as goal is formalism; that we reject" (Mies van der Rohe 1987, p. 40).

The chapel he designed for the Illinois Institute of Technology (IIT) looks like a small industrial warehouse and resembles all the buildings he designed for the institute (Fig. 6.4). The function of the building cannot be read directly from its form; its appearance does not suggest a sacral building. Was form perhaps here the goal rather than the result?

Louis I. Kahn also draws a distinction here, arguing that form can be said to follow function when it is seen as an essence and that the part corresponding to its essence is that which is supposed to function in a particular way. How a building will influence an individual, he argues, is not a question of function. He regards the word 'function' as relating to technical aspects. It follows that one cannot say that a building must also fulfil 'psychological functions' since psychology is not a function. The functional aspect is only realized by the instruments with which a psychological reaction can be elicited. Kahn compares this difference to the distinction between the soul and the intellect. The functional aspect is the intellect; the soul, the form, is not something that can be regulated as needed. Architecture, he argues, begins once the function has been thoroughly comprehended (Klotz and Cook 1974, p. 239). What Kahn means here is that when it

Fig. 6.4 Ludwig Mies van der Rohe, 1956, chapel at the Illinois Institute of Technology (IIT), Chicago, USA

comes to building, several formal solutions are possible all of which are functionally satisfactory. A particular function usually permits more than one single form (see Fig. 6.2).

The statement "form follows function" has been modified and argued about frequently. The Krier brothers have argued the opposite, that "function follows form" (Frampton 1983, p. 246), a claim that is confusing at first glance but which can be seen as valid on closer consideration. Although today we no longer build "for eternity", most buildings are designed to last more than half a century. By contrast, their uses can change extremely quickly. This is can be particularly extreme in the industrial sphere, where whole branches may be adapted to evermore rapidly developing technologies within a few years. Today industrial buildings are often only shells that need to be as polyvalent as possible. Here function follows form: industrial buildings are offered on the market like used cars; the more polyvalent, the better they are (see Sect. 5.4.2).

Recycling has now also become a buzzword in the field of architecture. In his book "Form Follows Fiasco" (Blake 1977) Peter Blake explores the reutilization of old buildings and comes to the conclusion that repurposing often even improves the spatial and aesthetic qualities of such buildings. As the title of his book indicates, he goes a step further: "Form not only does not necessarily follow function … It may, in fact, be the mortal enemy of the latter" (Blake 1977, p. 16). A space whose form has been specially and exclusively adapted for a certain use will probably not subsequently prove suitable for another function (see Sect. 5.4.2).

Buildings with extreme dimensions, heights or spans often require extreme structures, which in turn shape the form of the building. Here it is more a case of "form follows structure" (see Fig. 6.3). The Greek temple can already be described as a constructivist building, since it illustrates the principle of load and support in a clearly readable

manner. The Roman arch also provides a clearly readable example of the constructive principle of mutually supporting stones. The Greek temple is shaped by a different design vernacular from the Roman brick building. Whereas the appearance of the former is based on an orthogonal grid, that of the second is dominated by the roundness of the arch. The two types of formal expression also correspond to different structural systems. In the case of the Greek temple, beams are subject to strong bending forces, whereas the Roman arch is subject almost exclusively to compressive forces. Both are examples of how forms can be influenced by structural factors (Fig. 6.5).

Louis I. Kahn also calls for a kind of "form follows structure": "If we were to train ourselves to draw as we build, from the bottom up, when we do, stopping our pencil to make a mark at the joints of pouring or erecting, ornament would grow out of our love for the expression of method. It would follow that pasting over the construction of light and acoustical material, the burying of tortured and unwanted ducts, conduits and pipe lines would become intolerable. The desire to express how it is done would filter through the entire society of building, to architect, engineer, builder and draftsman" (Frampton 1983, p. 209). Every building is constructed; it is assembled. What Kahn calls for is the honesty and courage to show the way a building is constructed, to show something that is in any case already there. This is nothing new: it is precisely what the great engineering constructions of the nineteenth century achieved (Fig. 6.3).

Fig. 6.5 a Parthenon, ca. 480 BCE, Acropolis, Athens, Greece, **b** Basilica of Maxentius, 320, Forum Romanum, Rome, Italy

As discussed above, in the Russian Constructivism of the 1920s and 1930s structure shifted to the foreground and shaped the appearance of buildings. Subsequent decades also saw the repeated creation of buildings whose appearance was influenced by their structure. One example is the Centre Georges Pompidou in Paris by Renzo Piano und Richard Rogers, which was completed in 1977 (Fig. 6.6). Louis I. Kahn's demand for the display of load-bearing and connective systems is more than met here: the structure itself becomes an event that shapes the character of the building and lends it a special character.

In perceptual terms the Centre Georges Pompidou has a high degree of originality: compared with its surroundings the building is something completely new and unpredictable. Despite the large quantity of information the building presents, it also offers several possibilities for the formation of super-signs, for summarization (see Sect. 1.3.3). The façade of the building consists of several levels or layers—conduits for the movement of people, the supporting frame, the façade cladding and installations—which can easily be separated in perceptual terms. The proportions of semantic and aesthetic information are balanced (see Sect. 1.2.4). The entire structure, the visible installations and the escalators speak more to the intellect, whereas the delicate geometry, the colours and the contrasts between light and dark impact our subconscious mind. The building satisfies our curiosity and simultaneously addresses our emotions. Despite its large volume the building does not "oppose" the beholder. The structure visually dissolves the large exterior walls and permits an intensive relationship between interior and exterior. This lends the expansive front of the building a depth that facilitates the beholder's appreciation of the structure as a whole. A tension is generated between the building volume and the open forecourt that intensifies the entire perceptual experience.

Even in the case of buildings whose appearance is shaped by their structure the architect has design possibilities within a narrowly defined framework. Philip Johnson warns

Fig. 6.6 Renzo Piano and Richard Rogers, 1977, Centre Pompidou, Paris, France

6.2 Choice of Form

against failing to make use of these possibilities: "Structure is a very dangerous thing to cling to. You can be led to believe that clear structure clearly expressed will end up being architecture by itself" (Johnson 1982, p. 72). In his view, the dome of the American pavilion designed for the 1967 World Expo in Montreal by Buckminster Fuller (Fig. 6.7) does not constitute architecture: "I have nothing against discontinuous domes, but for goodness sakes, let's not call it architecture. Have you ever seen Bucky trying to put a door into one of his domed buildings? He's never succeeded, and wisely, when he does them, he doesn't put any covering on them, so they are magnificent pieces of pure sculpture. Sculpture alone cannot result in architecture because architecture has problems that Bucky Fuller has not faced, like how do you get in and out" (Johnson 1982, p. 72).

What considerations inform the choice of form? Every style employs formal means to render intellectual content visible and favours forms whose structure best corresponds to this intellectual content. The form as such is not the main focus; otherwise we would speak of formalism. It is only the medium for an intellectual statement. The form of a circle, for example, is the same on all sides and does not have a directional orientation; it signals calm and directs attention to a centre, to a midpoint. These characteristics corresponded to the ideology of the Renaissance and this form was therefore often used as a basic pattern in this period. Changes to the basic intellectual attitude also brought changes to the prevailing architectural style and thus also the spectrum of favoured forms. Forms are therefore also style-specific.

The connection between content and form applies to all areas of the visual arts. An abstract painting also seeks to make a statement; it has intellectual content. The forms and colours employed are the media via which this message is communicated. The art psychologist Rudolf Arnheim argues that "the individual stimulus configuration only enters into the perceptual process to the extent that it triggers a specific pattern of general sensory categories which represents the stimulus in a way very similar to the way

Fig. 6.7 Buckminster Fuller, 1967, US pavilion for the 1967 World Exposition in Montreal, Canada (see Fig. 6.30a)

a scientific description of a network of general concepts is presented as corresponding to a real phenomenon" (Arnheim 1980, p. 32). Form is to visual perception what numbers and letters are to a chemical formula. Every abstract representation of intellectual content, which includes every architectural work, is a representation of its structural characteristics expressed through specific forms and organized in accordance with a predetermined pattern. This also means that an adequate visually perceptible form must be found for every statement; a design vernacular is required (see Sect. 6.1).

6.3 Form and Shape

The concept of form is closely connected with that of shape. Both terms refer to the appearance of an object and yet their meanings are not identical.

Let us look at the problem from the perspective of an architect. Louis I. Kahn argues that form "is not shape, shape is a design affair, but form is the realization of the inseparable parts of something. Design is to put into being what realization, form, tells us. One can also say that form is the nature of a thing and a design aspires at a particular point in time to apply the laws of this nature" (Kahn 1975, p. 281). Form lies in the nature of the thing, i.e. it is determined by the thing's content, is thus prescribed and cannot be arbitrarily manipulated. To shape something means to design it; that means to choose the form such that it corresponds to the idea of the design.

Formal design accordingly depends on several factors. The form of a wall opening, for example, is in part determined by the material used and the structure of the wall: an opening in a brick wall requires an arch, whereas openings in steel and glass structures tend to be angular. Form is conditioned by its content. As Adorno puts it, "Aesthetic success is essentially measured by whether the formed object is able to awaken the content sedimented in the form" (Adorno 1974, p. 210).

Shape denotes the way forms are applied and how they relate to one another. The two concepts are so closely linked with one another that they can only be separated theoretically. Every form is shaped, and the shape of an object always contains its form.

6.4 Form and Structure

A space is defined by the elements that border it. These elements and their relationship to one another codetermine the character of space; they form it. The first step in any attempt to categorize the infinite wealth of forms is to divide them into regular and irregular forms.

Regular forms are subject to particular laws of geometry. The information they convey has a high level of redundancy, i.e. there is a high degree of predictability; the form can be completed and constructed based on a small amount of information (see Fig. 1.4). Regular forms have a structural framework: formal rules that regulate the

6.4 Form and Structure

relationship between individual parts (Moles 1971, p. 99). The perception of shape begins with the search for such a structural framework, which can consist, for example, of an axis of symmetry, similar side lengths or angles, focal points etc. (Fig. 6.8). The structural framework seldom coincides with the contours of a shape and can often not be seen directly since it is usually not denoted by lines or points. Nevertheless, in the perception of a shape the structural framework can be more important than the overall progression of the contour lines (Fig. 6.8A–D). As long as the structural framework of

Constant structural framework, altered contours → same shape

Constant form, altered position → partly new shape

Altered structural framework → new shape

Altered form → new structural framework

Fig. 6.8 Form and structural framework

an object is adaptable to changes in the position of an object, we recognize the same shape (Fig. 6.8E–G). However, if we rotate the triangle shown here 180° (Fig. 6.8H), our perception of the shape changes. The base becomes the "roof"; the figure shifts from a stable to an unstable state. When the structural framework is changed, a new shape emerges: a square becomes a rhomboid (Fig. 6.8K). When shifting a figure to a new position makes it possible to discern a new structural framework, then the shape we perceive also changes. For example, when we turn the square in Fig. 6.8I 45°, the old structural framework can become a new structural framework without changing its position. This also changes the perceived shape: the corners are emphasized and the sides become secondary (Fig. 6.8L). Sometimes a small change to the form can lead to a new structural framework. In Fig. 6.8N–Q the triangles have equally long base lines and equal heights; only the position of the vertices is slightly changed in each case. However, this shift suffices to produce a new structural framework.

When forming a super-sign we schematize, i.e. the structural framework is maintained while the form is simplified (see Fig. 1.12). Abstraction is also a simplification, a reduction of form to the point where not much more than the structural framework remains.

The irregular form has no structural framework; it is not predictable and therefore original. As we saw in Sect. 1.2.3, however, the original message must have a minimal connection with what has preceded it. If this is not the case, we will not be able to comprehend it. Based on the law of experience we bring irregular forms into connection with a figure we are familiar with, i.e. we awaken associations (see Sect. 1.3.4.3). Regular forms allow for simplification, while irregular forms evoke associations. The former contain more semantic, the latter more aesthetic information. Apart from functional and technical influences the type of form that should be used in a given situation is a matter of style and one of the fundamental questions of architecture.

At the beginning of the twentieth century, when the attempt was underway to utilize a number of aspects of industrialization in the building sector, a range of people campaigned for the use of strict, regular form. In 1929, El Lissitzky, one of the main exponents of Constructivism, wrote, "Our times demand designs that emerge from elemental forms (geometry). The struggle with the aesthetics of the chaotic is taking its course" (El Lissizky 1981, p. 113). This attitude resulted above all from a desire to express the austere, simple aesthetic helping to shape the zeitgeist) in the sphere of architecture as well. With reference to Mies van der Rohe, Siegfried Giedion writes of this development, "This continuous pressure for the conquest of pure form has been accompanied by an ever stricter renunciation of all that seemed to the architect hampering or nonessential. It is this demand for the absolute that lies behind Mies van der Rohe's often deliberately misinterpreted saying: 'Less is more'" (Giedion 1978, p. 370).

A close connection exists between the shape of an object—regular or irregular— and its perceived "weight". Regular, simple forms appear heavier than complex ones (Fig. 6.9a), vertically aligned heavier than obliquely aligned ones (Fig. 6.9b) (see Fig. 7.5). The position of a figure within an overall composition can also codetermine its "weight". If it is compatible with the structural framework of the entire composition and

Fig. 6.9 Shape and its perceived "weight"

is integrated into a context rather than being isolated, it will appear heavier (Fig. 6.9c). The German philosopher Arthur Schopenhauer saw the real stuff of building aesthetics in the interplay between the different perceived "weights". For him, rendering visible the different structural-technical characteristics of materials and forms was the real task of architecture (Sörgel 1918, p. 40). Balance can also depend on the type of shape. Simple forms, above all symmetrical ones, appear more balanced than other forms. Irrespective of the materials involved, we experience certain forms, above all round and continuous ones, as "soft" and square, angular ones as "hard".

6.5 Regular Forms

As a concept, form is abstract. In order to exist, a form must enter into a symbiotic relationship with a medium. Form becomes visible in a structure, an object, a space. When we speak of types of form, we must first ask how they become discernible. Every space is a three-dimensional structure and, accordingly, has a three-dimensional shape. In perceptual terms, elements that define a space are for the most part two-dimensional planes, which are in turn defined by lines. Depending on the epoch, either regular or irregular forms dominate. In search of the "pure" form, revolutionary architects, both French and Russian, equated architecture with geometry (see Fig. 3.14). This development already produced some of the most important dogmas of Modernism and had a seminal influence on it. Hans Sedlmayr identifies the primary features of this movement as follows: "The tendency to detach from the ground; the possibility to invert above and below, which is connected with the preference for the flat roof; the leaning toward homogeneous, flat surfaces devoid of breaks, plastic elements, without profiles: the transformation of walls

into abstract boundary surfaces, which later leads to the ideal of a spatial skin of pure glass" (Sedlmayr 1983, p. 97).

6.5.1 Horizontal and Vertical

In Sect. 1.3.7 we discussed the significance of horizontal and vertical planes of reference for orientation within a space. Here we will discuss their influence on the visual manifestation of form.

In every instance of visual perception, vertical and horizontal lines are preferred over diagonals because they produce the weakest stimulus configuration. Twice as many eye muscles are moved when the eye is shifted up and down as are moved when to is shifted to the left and right. This is one of the main reasons why our visual perception is predominantly oriented along the horizontal. "Lying" forms, i.e. those that extend along the horizontal, are more easily perceived, which also means, however, that they have a lower degree of originality than "standing" forms. The difference in how we perceive these two directions also creates a difference in the sense of distance they evoke: the same length appears much greater to us when viewed in the vertical than it does in the horizontal. In Frank Lloyd Wright's view, vertical details had an immeasurably greater significance than horizontal ones (Wright 1969, p. 139). In the case of many of the villas near Chicago that he designed in his initial creative period, the so-called first golden age, the built volume is enclosed by horizontally structured lines, creating a contrast to the verticality of the chimney (Fig. 6.10).

6.5.2 The Line

In a drawing, a line is a two-dimensional structure. In architecture, lines occur as boundaries of surfaces. In this capacity they can have a more or less expressive function. In

Fig. 6.10 Frank Lloyd Wright, 1906, F.+L. Robie House, Chicago, USA

6.5 Regular Forms

the case of the Greek temple the line is clearly readable as a strict delimitation; in the Baroque period it recedes into the background and is often difficult to make out at all (Fig. 6.11). Lines and surfaces complement one another: if one is heavily emphasized, the other tends to shift into the background and vice versa. Paul Klee characterized the first as "active" lines, which result in "passive" planes, and the second as "passive" lines, which generate "active" planes (Klee 1985, p. 11).

In contrast to a curved line, a straight one appears rigid and precise. A straight line does not have to be directly visible. In our minds, we often link distinctive points with lines. The connections between urban architectural elements, for example, particularly distinctive buildings, form axes that we perceive as lines in our spatial imagination. A straight line can indicate a direction; it can connect but also delimit and separate. In contrast to a horizontal or a vertical line, an oblique straight line has a certain dynamic: it runs from the lower left to the upper right or the upper left to the lower right. Every architectural style expresses intellectual content by formal-spatial means. Verticals and horizontals are included in a design to a greater or lesser degree depending on the nature of the architectural statement. The Renaissance, which was marked by clarity and logic, was characterized by emphatically vertical-horizontal structures, whereas in the Baroque era these directions were avoided in favour of oblique and curved lines. An oblique line is always assessed with reference to the vertical or horizontal. If it runs from the lower left to the upper right, it creates the impression of an ascent; if it slants in the opposite direction, it creates the impression of a descent.

In contrast to a straight line, a curved line always creates a dynamic impression. A curve can be divided into two main types: the regular, geometric curve, for example, a

Fig. 6.11 The line in the Greek temple and in the Baroque period: **a** Propylaea, 437–32 BCE, Acropolis, Athens, Greece, **b** Peter Thumb, 1746–50, Pilgrimage Church, Birnau, Germany

parabola or a sector of a circle, and the random, irregular curve. Here, too, the level of redundancy steadily decreases in the progression from the straight line via the regular geometric curve to the irregular curve.

In traditional Japanese and Chinese architecture eaves are often curved slightly upwards, creating a roof line that is also slightly curved, which is particularly evident in the corners (Fig. 6.12). In structural terms there are two reasons for the use of this form. In order to offer sufficient protection during the wet season the roof needs to project relatively far outwards. Curving the eaves upwards allows light into the building interior despite the size of this projecting section. The second reason has to do with the system of consoles that form part of the load-bearing structure. The weight of the roof is transferred via a number of consoles into the supporting pillars. This structure requires height, which can minimised by curving the roof upwards. However, the curve also has aesthetic significance. Japanese architecture is based on the skeleton-frame structure, with verticals dominated by the supporting pillars and horizontals dominated by the roof, plinth and joists. The curved line of the roof mediates between these two extremes and creates a dynamism that reduces the apparent heaviness of the building.

Fig. 6.12 **a** The upward-curved roof line on Japanese and Chinese buildings, **b** corner of the pagoda of Daigo-ji Temple, 951, Kyoto, Japan

6.5.3 The Flat Surface

Lines can delimit a figure, thereby becoming the contours of a surface. The surface plays a decisive role in architecture; as a wall surface it is often the concluding element of a space. It is one of the basic elements of the architect's building set. The external appearance of a building is shaped by its outer surfaces, its facades. As closures, as separations between the inside and outside, these surfaces are always planar, although not mandatorily designed such that every building appears as a closed volume (Fig. 6.13).

Every type of architecture thus relies on surfaces that separate a built interior space from the surroundings, and on lines that delimit these surfaces. Depending on its style, a building's appearance may be characterized more by lines or by surfaces. Heinrich Wölfflin refers to the second alternative as "painterly". Emphasizing one or the other produces quite different effects: "one is an art of being, the other an art of appearance" (Wölfflin 1984, p. 36). As we have seen, Klee distinguished between "active" and "passive" lines and planes. A line can be emphasized by a special form or a special position so that it establishes boundaries, isolates and creates clarity. Blurring or concealing delimitation results in a lack of clarity; the appearance of change gives rise to tension and dynamism. Like that of Greek antiquity, the architecture of the Renaissance is one of clear lines while the Baroque devalues the line as boundary (Figs. 6.11 and 6.14).

The pure surface as an expressive architectural element and its aesthetic value fell into oblivion for a long time, and it was only around the turn of the nineteenth to twentieth century that they were rediscovered (Giedion 1978, p. 31). In 1894 Otto Wagner already prophesied: "The new architecture will be dominated by plate-like, tabular surfaces and the impending use of materials in their original state" (Wagner 1979, p. 136). At the beginning of the twentieth century, the precisely delimited, flat wall panel became the primary spatially defining element in the modernist conception of space (see Fig. 5.2).

Fig. 6.13 Different appearances of space-enclosing surfaces: **a** Childs and SOM, 2003, Time Warner Center, New York, **b** LAB architecture studio, 2003, Federation Square, Melbourne, Australia

Fig. 6.14 Theo van Doesburg, 1923, study for a building (copy)

Ludwig Mies van der Rohe's 1923 project for a country house (see Fig. 5.16) features a space delimited only by rectangular wall panels. Theo van Doesburg's study for a building from the same year employs a similar design over two floors (Fig. 6.14). The Barcelona Pavilion by Mies van der Rohe (Figs. 6.15 and 2.7) built in 1929 was the first realized building to be based on this concept.

Painting also played a pioneering role in this development. At the beginning of the twentieth century Cubism already experimented with interpenetrating surfaces, and Siegfried Giedion argues that this development was comparable to the discovery of perspective in the Renaissance and its importance for all subsequent stylistic changes: "Surface, which was formerly held to possess no intrinsic capacity for expression, and so at best could only find decorative utilization, has now become the basis of composition … With the Cubist's conquest of space, and the abandonment of one predetermined

Fig. 6.15 Ludwig Mies van der Rohe: **a** 1929, Barcelona Pavilion, Barcelona, Spain (see Fig. 2.7), **b** 1968, Neue Nationalgalerie, Berlin, Germany

angle of vision which went hand in hand with it, surface acquired a significance it had never known before" (Giedion 1978, p. 297).

Ludwig Mies van der Rohe initially used surfaces as spatially delimiting wall and roof panels. In his later buildings the defining elements are above all horizontal surfaces. In the case of the Bacardi Office Building in Mexico City, which was completed in 1961, the entire upper floor is designed as a vertical panel, whereas his last building, the Neue Nationalgalerie in Berlin opened in 1968, is dominated by the plinth platform and a horizontal roof plate lying on eight pillars. The autonomy of the roof is strengthened by the position of the pillars. They do not stand at the corners of the building but are set inwards so that the roof plate protrudes significantly and the edge of the roof forms a continuous line (Fig. 6.15b).

Urban squares are also horizontal surfaces which decisively shape the spatial character of a city (see Sect. 4.6).

6.5.4 The Curved Surface

A surface can form a flat or a curved plane. Different types of curvature produce different convex or concave surfaces and forms. The curvature conveys a certain dynamic; it enters into dialogue with the surrounding space. Depending on whether it is convex or concave it opposes or embraces the surroundings; it rebuffs or invites. In the former case the body is more dominant, in the latter the space. The convex form is dominant over the concave form. This means that where a choice must be made between a convex and a concave form, the beholder will tend to decide for the former: the convex form becomes the figure, the concave form the background (Arnheim 1978, p. 221). A flat wall appears neutral in relation to the adjacent spaces, whereas a concave wall forms a recess which the space can permeate (Fig. 6.16).

The concave form is inviting and therefore eminently suited to emphasizing an entrance. The two "wings" open up like arms and receive the visitor in a welcoming manner. Francesco Borromini utilized this form to accentuate the entrances of his churches (Fig. 6.17).

Overlapping concave and convex forms on an object generate tension. The beholder is constantly torn between the inviting concave forms and the somewhat resistant convex ones. The effect of such "superimpositions" is based on the principle of contradictory stimulus configurations (see Sect. 1.2.7).

Both Le Corbusier and Frank Lloyd Wright favoured curved, round forms in their later work in contrast to the orthogonal geometry that dominated the early phases of their careers. Le Corbusier first employed the curved outer wall on his Maison Suisse, a student dormitory, at the Cité Universitaire in Paris (1931–1933) (Fig. 6.18). According to Siegfried Giedion this constituted the first use of a curved exterior wall in the history of modern architecture (Giedion 1978, p. 338). The chapel in Ronchamp, which was built almost 20 years later in 1950, is the first of Le Corbusier's designs in which the entire

Fig. 6.16 The dynamics of convex and concave forms

Fig. 6.17 Francesco Borromini, 1652, Sant'Agnese church, Rome, Italy

Fig. 6.18 **a** Le Corbusier, 1933, Maison Suisse, Cité Universitaire, Paris, France, **b** Frank Lloyd Wright, 1939, S. C. Johnson & Son, Racine, Wisconsin, USA

building is dominated by curved rather than angular forms (see Fig. 5.17b). Whereas in case of the student dormitory in Paris the concave form has no specific function, the curved walls in Ronchamp, like the walls of Borromini's church (Fig. 6.17), are the welcoming elements that receive the visitor. The convex-shaped roof forms a kind of counter

6.5 Regular Forms

form to the concave wall: one is resistant, the other welcoming. This duality, the synthesis of welcoming and resistant, underlies the essence of this church and is, indeed, a basic feature of every Christian sacral building: the church as "God's fortress", which is open to everyone of goodwill. The two antithetical forms, the convex and the concave, provide a formal expression of this basic idea.

Wright employed round forms for the first time for the headquarters of S. C. Johnson & Son in Racine, Wisconsin (1936–1939). Most of the building's corners are rounded to a greater or lesser degree (Fig. 6.18). In the case of the Solomon R. Guggenheim Museum in New York (1946–1959) the curve becomes the dominant form. Here, too, we find an interplay between concave and convex (Fig. 6.25).

The former TWA Flight Center at New York's JFK Airport, designed by Eero Saarinen and built between 1956 and 1962, is another building dominated by curved forms (Figs. 6.19 and 5.17a). In this case the reasons for using this design were neither functional nor structural. The building is a metaphor, a symbol of starting, taking off, of flying in general and was thus conceived as an advertisement for the airline. It has already been pointed out that, based on the law of experience, irregular forms evoke associations. The more unusual a form appears to the beholder, the more readily he will sift through his memory in search of objects comparable with this form. In the case of the building by Saarinen the most obvious comparison is with a bird spreading its wings for take-off. In addition to its metaphorical meaning the form also supports the building's functional sequence. The concave approach area leads the visitor to the entrance, which is additionally emphasized by a giant awning, the tail of the bird. Inside the visitor reaches the Great Hall, which offers a panoramic view of the airfield. The round forms of the interior design express movement and thus directly refer to the actual function of the building.

The examples discussed here show that the curved form can be chosen for different reasons. Le Corbusier's church in Ronchamp, with its concave and convex curves,

Fig. 6.19 Eero Saarinen, 1962, former TWA flight terminal, New York, USA (see Fig. 3.17)

Fig. 6.20 **a** JørnUtzon, 1977, Sydney Opera House, Sydney, Australia, **b** Frank O. Gehry, 2002, Walt Disney Hall, Los Angeles, USA

expresses a fundamental characteristic of the Christian sacral building: an attitude that is simultaneously defensive, protective and inviting. The spiral shaped ramp in the Guggenheim Museum by Frank Lloyd Wright (Fig. 6.25) on the one hand facilitates a new exhibition concept and, on the other, enables the building to set itself off clearly from its surroundings. Saarinen's TWA building adopted the curved form for metaphorical reasons: the bird taking flight is an advertisement for the airline.

Eero Saarinen played an important role in the construction of the Sydney Opera House, which was completed in 1977 (Fig. 6.20a). As a jury member for the competition to choose a design for the building it was Saarinen who, thanks to his experience building the TWA terminal, was able to convince his sceptical colleagues that JørnUtzon's could actually be built. The building complex, which is not only an opera house but an entire cultural centre, is prominently located on a peninsula in Sydney Harbour. The form of the curved "shells" is supposed to recall the sails of a ship. Thanks to the new design possibilities provided by computers, the realization of special, irregularly shaped buildings has become easier. Today the creations of Frank O. Gehry are the most well-known examples of such buildings (Fig. 6.20b). His aim is to create buildings that look like provisional solutions. They are supposed to awaken the impression of forms that have been improvised, thrown together quickly, provisionally and unsystematically. He has said that he does not like things that are complete, definitive and finished. He prefers buildings that can be interpreted "seven million ways" and for this reason he avoids "stiff" structures like the Pantheon or any other Greek temple (Rauterberg 2008, p. 63).

6.5.5 The Circle

The circle is one of the simplest stimulus configurations. It is a non-directional form, i.e. no direction is privileged. A circular form can only be altered in terms of size (Fig. 6.28). Carl Gustav Jung noted that in many dreams the circle and the square appear as basic

6.5 Regular Forms

forms symbolizing wholeness and simplicity (Jung 1976, p. 240). A point on the contour marking the boundary of a circle revolves at a constant distance from a precisely determinable but mostly invisible central point. A circle has neither a beginning nor an end; it represents an infinite movement that always leads back to a starting point—a phenomenon that is utilized in the wheel as a locomotive aid. The circle also mirrors the form of the sun and the moon and as a result has always had a powerful symbolic significance. Already in antiquity the circular form, aside from its symbolic meaning, played an important role in the determination of proportions. Vitruvius asserted that the human body was designed by nature such that the tips of the fingers and toes of a human figure lying on its back with arms and legs apart should touch the boundary of a circle with the navel as its centre. In the first chapter of the third book of his work *De architectura*, which was written some 2000 years ago, he concluded: "Therefore, since nature has designed the human body so that its members are duly proportioned to the frame as a whole, it appears that the ancients had good reason for their rule that in perfect buildings the different members must be in exact symmetrical relations to the whole general scheme" (Vitruv 1981, p. 139). Vitruvius states that in the architecture of the ancient Greeks the circular form is found relatively seldom. The Greek theatres have the form of segments of a circle (Fig. 6.21a). However these constructions were not proper buildings. Soil was removed from the sloping site to create a semicircular area embedded in the slope. Here the rounded form was chosen for functional reasons. It is suited to a whole range of events and therefore continued to be used into the modern era (Fig. 6.21b).

A building method using columns and beams tends to require an orthogonal grid, i.e. the round form is less suited to such structures. Nevertheless, in Greek architecture we do find temples with round ground plans. Why this apparent contradiction? Tholos, the general term for a round temple, means, in the original sense of the word, pit, fire pit or stove (Fig. 6.22a). In early Greek mythology the gods were house and family divinities, who were honoured with sacrifices burned in the stove-fire during daily meals. These offerings simultaneously commemorated people's ancestors. This multiple function, as

Fig. 6.21 **a** theatre, fourth century BCE, Delphi, Greece, **b** JoaquínRucoba, 1874, bullfighting arena, Málaga, Spain

Fig. 6.22 **a** round temple, 390 BCE, Delphi, Greece, **b** Temple of Heaven, 1420, Beijing, China

stove, meeting point and sacrificial site, was best represented by a circular form. This formal arrangement, which represented all erstwhile functions of the fireplace, as it were, was repeatedly adopted for temple forms (Gradmann 1968, p. 12).

A similar phenomenon is found in traditional Chinese architecture. In this case, too, most buildings are column-and-beam structures. However, rather than stone, most of them are built of wood. As a consequence, almost all buildings have a rectangular ground plan. Traditional Chinese architecture is a reflection of the dominant world view at the time of building (see Fig. 3.11). As described in Sect. 3.5, the circle represents the heavenly, the square the terrestrial. The Temple of Heaven in Beijing (Fig. 6.22b), built in 1420, is accordingly based on a circular ground plan, even though is consists of columns and beams. The fact that the complex had to represent the Chinese world view was more important than potential structural difficulties. This was also the approach of the ancient Greeks.

The circle is the dominant formal element in ancient Roman architecture, although less in ground plans than in verticals as arches (Fig. 6.23). The arch, and thus the vault, was not a Roman invention. However, the Romans did develop a building technique using bricks and mortar that enabled them to achieve an unprecedented degree of stability combined with a relatively low weight, which in turn allowed them to construct large spans. The triumphal arch is the prototypical Roman arch, and its beginnings date back to the second century BCE (Picard 1965, p. 174). Most Roman constructional forms can be derived from simple arches. Arranging this element in series created perforated walls, which were stacked on top of one another to create aqueducts and subsequently, in an elliptical form, amphitheatres. Finally, an arch rotating on its own axis produces a dome.

Domes and barrel vaults were used above all in thermal baths, where they replaced wooden ceilings to prevent conflagrations. The most important domed structure built in this period, the Pantheon (Fig. 5.4), played a pioneering role in the history of space over the next one and a half millennia. The central-plan space, based on the form of a circle, became, with the longitudinal space, the main theme of sacral architecture. The Roman basilica became the model for the early Christian church, although in the latter case the vault was replaced by a beam structure (see Sect. 5.1).

6.5 Regular Forms

Fig. 6.23 The arch as a basic element of Roman architecture

The arch was also an important formal element in the Romanesque period. Its semicircular form supported the dominant concept of the time: a structured space with a clear arrangement (see Fig. 3.1). During the Gothic period the circular form was used only in isolated cases for a few elements, such as rose windows. The function of these round openings, which are often positioned above the main entrance, is complex. On the one hand, they help to direct the necessary light into the interior; the illumination provided by such round windows underscores the direction of the main nave, thereby helping to indicate the path, the direction of movement, towards the altar. On the other hand, they have a symbolic significance. The circular form was also understood as referring to the sun or the rose, a symbol of the Virgin Mary (Hofstätter 1968, p. 50).

In the Renaissance the circle again became a primary element of architecture. The fact that the human being once again took centre stage meant that the idea of a path to the divine declined in importance. The circle, as an unvarying structural form with a definitive centre, was the dominant means of architectural expression in this era.

In the second chapter of the fourth book of his treatise on architecture, Andrea Palladio writes about the temple forms used by the Greeks and concludes with reference to the Renaissance, "And therefore we also, who have no false gods, in order to observe the decorum concerning the form of temples seek the most perfect and most excellent. And since the circle is such because it is the only one among all forms that is simple, uniform, equal, strong and capacious, let us make our temples round. For which purposes this form is particularly fit because it is bounded by a single line on which no beginning or end can be discerned—one cannot be distinguished from the other—and because this form consists of segments that are all the same and which all participate in the figure as a whole. Finally, the outermost points in all segments are equidistant from the centre" (Palladio 1983, p. 274).

As already discussed (see Sect. 3.5), in traditional Chinese architecture the circle represented the heavenly aspect, the square the terrestrial. This division is precisely reflected in the structure of the mausoleum of the Wanli Emperor, built in Dingling outside Beijing in 1592. In order to reach the actual burial chamber, visitors have to traverse several rectangular courtyards. The caesura between the courtyards is in each case emphasized by a building-like gateway. The courtyards represent the earthly life of the emperor divided into different stages. The burial chamber is located under a circular mound, which represents Heaven, where the emperor was thought to live on in a palace similar the one he had lived in on Earth. It is for this reason that the spaces making up the actual tomb are again rectangular (Fig. 6.24).

With its circular spiralling ramp, the Guggenheim Museum in New York ushered in a new era in museum construction. Instead of an indiscernible number of juxtaposed spaces, the design was based on a clear and easily traversable pathway that provided the visitor with precise orientation at all times. This circular form is mirrored on the exterior of the building and clear distinguishes it from its surroundings (Fig. 6.25). In Wright's later work, the circular form increasingly became a purely decorative element of his designs, which ultimately attracted considerable criticism (Jencks 1973, p. 140).

6.5.6 The Ellipse

The ellipse can be described as a special form of the circle; it is generated, for example, when a circle is projected onto an inclined plane. In contrast to a circle, an ellipse has two directions, one of which is dominant. The proportions of an ellipse can be altered (Fig. 6.28). This shape was utilized on a large scale for the first time in the Roman

6.5 Regular Forms

Fig. 6.24 Mausoleum of the Wanli Emperor, 1592, Dingling, near Beijing, China: the rectangular earthly areas and the circular heavenly area

Fig. 6.25 Frank Lloyd Wright, 1959, Solomon R. Guggenheim Museum, New York, USA

amphitheatre. The ellipse was required to position as many members of the audience as possible in a circular pattern around the presented event. Moreover, the elongated shape of the "stage" better suited the different forms of performance than the circle.

Christian sacral architecture employs two basic motifs which are difficult to reconcile in spatial terms: the pathway and the centre. In the Baroque period the rectangle, as a formal expression of the pathway, and the circle, as a manifestation of the central aspect, were unified in the ellipse, which became the preferred formal theme of this architectural epoch (Figs. 6.26 and 6.27).

The elliptical form has a dynamism that the circle lacks. Convex and concave curves, which are often segments of an ellipse, were used to create a relationship to the surroundings. In the design of public squares the dynamism of the ellipse was also deployed in public spaces. Bernini framed the square in front of St. Peter's Basilica with massive elliptical colonnades, accentuating the central and focal point of the elliptical space with an obelisk and two fountains (Figs. 2.30 and 9.21). In modern architecture we find the form of the ellipse almost exclusively in the design of sporting complexes, reflecting their prototype, the Roman amphitheatre.

6.5.7 The Sphere

The sphere is the three-dimensional variant of the circle, or, conversely, the circle is a projection of the sphere (see Fig. 2.6). Plato thought that, as the most complete body, the sphere was contained in all the regular bodies making up the universe (Rykwert 1983, p. 97). This idea was adopted by medieval philosophy and gained renewed popularity during the Renaissance, when it was discovered that the Earth was spherical.

Fig. 6.26 The ellipse as combination of rectangle (path) and circle (centre)

6.5 Regular Forms

Fig. 6.27 Balthasar Neumann, 1772, Basilica of the Fourteen Holy Helpers, Bamberg, Germany: **a** floor plan, **b** geometric structure based on the form of an ellipse

	●	⬬	■	▬	▲
PROPORTIONS	constant	variable	constant	variable	variable
STRUCTURAL FRAMEWORK	constant	constant	variable	variable	variable
ANGLE SIZE	constant	constant	constant	constant	variable
NUMBER OF SIDES	constant	constant	constant	constant	constant

Fig. 6.28 Variable and constant properties of different basic shapes

The works of French revolutionary architects Etienne-Louis Boullée (1728–1799) and Claude-Nicolas Ledoux (1736–1806) largely consist of unrealized projects, due in part to the restricted constructional possibilities at the time and the limited range of materials. Boullée's utopian buildings are made up of strictly geometric forms: "Exhausted by the mute sterility of irregular bodies, I turned to regular ones" (Boulleé 1983, p. 118). Of the sphere he wrote, "The spherical body is in all respects the image of perfection. It unites exact symmetry with perfect regularity and the greatest variety; its form is the simplest, its outline the most genial, and, finally, it is the darling of light effects" (Boullée 1983, p. 118). In both the French and Russian revolutionary periods the spherical form became the extreme type in the progressive phase of architectural aesthetics, which was characterized by a tendency to reduce architectural vocabulary to a few basic geometric forms (Vogt 1974, p. 93) (see Fig. 3.14).

Le Corbusier regarded the sphere as one of the five primary forms of a body. The sphere is the only primary body that repudiates the laws of gravity and negates the Earth as basis. Since it has no flat surfaces, from a functional standpoint it is ill-suited to the formation of architectural spaces. Indeed, in contrast to the other basic forms described by Le Corbusier, such as the cube, cylinder, pyramid and cone, it is an anti-architectural form.

Buckminster Fuller's geodesic dome built to house the US pavilion at the 1967 World Exposition in Montreal can be seen as a realization of Boullée's idea in the broadest sense. The sphere, which has a diameter of 76 m, was intended to represent outer space (Figs. 6.7 and 6.30a).

The complete form of a sphere is seldom used in architecture. However, parts of a sphere are frequently used architectural elements, the most common of which is the dome. For a long time, the dome, along with the arch, provided the only way to roof large spaces without using columns. Its absolute form created an impression of all-encompassing spatial closure (see Figs. 5.4 and 5.6). A sphere can be inscribed in the Pantheon in Rome, where the maximum height of around 43 m corresponds exactly to the diameter of the floor plan. The hemispherical dome represents the firmament, or, as Palladio writes, the "image of the world" (Palladio 1983, p. 358). The absolute form of the sphere makes it eminently suited to every type of glorification, or, as Louis I. Kahn put it, every type of cult (Kahn 1969, p. 15). Just as the Pantheon glorified the Roman Empire and all its gods, Boullée's memorial to Isaac Newton was a hymn of praise to this scientific genius (see Fig. 3.14a). In an unpublished treatise Boullée referred to the project as follows: "Sublime mind! Prodigious and profound genius! Divine being! Newton, deign to accept the homage of my feeble talents" (Boulleé 1983, p. 120). Fuller's dome in Montreal also serves to glorify, in this case the conquest of outer space.

The shells of the Sydney Opera House by JørnUtzon are also segments of a sphere. However, in this case the typical characteristics of the sphere, namely its closed, non-directional and tranquil qualities have been deliberately avoided (Fig. 6.20a). The sphere was chosen here for other reasons. Due to the fact that all the shells have the same radius and thus all points on their surfaces are equidistant from an imaginary centre, they all have the same curvature. This allowed for relatively simple prefabrication and meant

6.5 Regular Forms

that very expensive on-site formwork could be avoided. Utzon himself compared the design process to dividing an orange into similar segments (Giedion 1978, p. 411).

6.5.8 The Square and the Cube

Like the circle, the square has always had symbolic significance. The number four can refer to the four cardinal points and the four seasons and is therefore seen as the number of the cosmos (Naredi-Rainer 1982, p. 67). The symbolic character of this number is very old and was adopted by the Christianity: the Four Evangelists, the four parts of the cross. Due to the form of the cross the number four has also had an influence on sacral building and thereby on the main theme of architecture as such, at least up until the Renaissance.

In contrast to the circle, the square is directional and has at least two directions: those of the two central axes or those of the two diagonals (see Fig. 6.8l). The lines bordering a square consist of four sides of equal length. Its corners are right-angled, i.e. the sides meet at an angle of 90°. In perceptual terms, this angle is the simplest; it indicates both vertical and horizontal directions. The preference for the right angle has also been influenced by the laws of gravity.

The cube is the three-dimensional variant of the square: a body with six square sides and eight right-angled corners (Fig. 2.29). However, our perception of it is subject to different constraints. In everyday life we often experience the square as a warped rectangle (see Sect. 1.3.5). In Sect. 1.3.7 we saw that we tend to perceive elements to the upper right in our visual field as bigger than they actually are (see Fig. 1.35). A vertical eye movement requires more energy than a horizontal one. As a result a cube appears to be slightly higher than it is wide despite the fact that all sides are the same length.

Fig. 6.29 I.M. Pei, 1978, National Gallery of Art, Washington D.C., USA (see Figs. 6.2c and 5.34)

Moreover, the formation and design of the individual sides and what they are made of can also influence their perceived size.

The formation of the corners of buildings constantly creates special architectural problems. Problems of proportionality were already encountered in the construction of the corners of ancient Greek temples due to the change in direction of the ashlars positioned on top of the pillars. Philip Johnson wrote that in a sense every piece of architecture could be assessed based on the design of its corners (Johnson 1982, p. 93).

6.5.9 The Rectangle

The rectangular has similar characteristics to the square but differs from the latter in several fundamental respects. Only two opposite sides are of the same length, and the two principal directions are not equally weighted. The rectangle thus has a length and a width. In contrast to a square, the proportions of a rectangle can be altered. The angle size remains the same in both basic shapes, namely 90 degrees (Fig. 6.28). The square can also be described as a special form of the rectangle and vice versa. In terms of optical perception an ideal rectangle is 1.63 times as long as it is wide, which corresponds to the golden ratio (Schuster and Beisl 1978, p. 33) (see Fig. 7.8). If the difference between length and width is less than this, the shape appears to us as an "inaccurate" square; if it is greater we perceive it as too long. If the length is more than twice the width, we tend to perceive a rod-shaped element rather than a rectangle.

The rectangle is the most commonly used shape in architecture. Round, square and irregular shapes tend to be exceptions. In certain stylistic epochs, for example the Baroque period, the rectangle was less frequently employed than in others. Ancient Greek architecture is based almost exclusively on an orthogonal grid. Although the Romans employed arches and circular forms extensively, their world order was founded on two perpendicular axes (see Fig. 4.5). Roman towns were built on a right-angled grid (Fig. 2.17).

6.5.10 The Triangle and the Pyramid

As already shown, our perception of the triangle is heavily dependent on its structural framework (see Sect. 6.4). While in the cases of the circle and the square the proportions and shape always remain the same, the proportional relationship between the length and width of a rectangle and thus its shape can change. What remains are the four right-angled corners. In the case of the triangle not only the proportions and shape can change but also the size of the three corner angles. The only characteristics shared by two extremely different triangles are the number of sides and corners and sum of all three angles, which is 180 degrees. Of all the regular shapes discussed so far the triangle is the most "irregular". It is for this reason that its structural framework plays such an important role in our perception of it (Figs. 6.8 and 6.28). Circle, square and triangle

6.5 Regular Forms

are the three simplest shapes. We already encounter them as ornaments on handcrafted objects from the early period of human culture. Whereas the circle is a symbol of insularity and completion, the triangle indicates composition, even aggression. The circle is introverted and static, the triangle extroverted and dynamic.

The choice of a triangular shape can be based on different reasons. The extension to the National Gallery in Washington D.C. designed by I.M. Pei is located on a triangular plot in a very exposed position within sight of the Capitol. The building adopts the shape of the plot, which in turn dictates the entire organization of the interior space (Figs. 6.2c, 6.29 and 5.34).

In contrast to the square and rectangle, the triangle is a statically determinate shape. Bodies made up of triangles are inherently stable, a characteristic that is exploited about all in framework structures. Alexander Graham Bell (1874–1922), who is known above all as the inventor of the telephone, also contributed significantly to the development of three-dimensional bearing structures based on the triangle (Wachsmann 1959, p. 29). At the end of the nineteenth century he recognized the extraordinary stability of tetrahedron structures, which he designed and had prefabricated out of metal rods. The three-dimensional plane load-bearing structures used today would be unimaginable without Bell's pioneering work. For example, the sphere designed by Buckminster Fuller for the American Pavilion at the 1967 World Exposition in Montreal is also based on this principle of the statically stable triangle (Figs. 6.7 and 6.30). Fuller endeavoured to build large, statically stable structures using as little material as possible, an approach typified by his famous slogan "Don't fight forces, use them."

The Hearst Tower in New York, which was designed by Norman Foster and completed in 2006, also features a supporting structure composed of triangles on its façade, a design that fundamentally contributes to the stability of the building (Fig. 6.30b).

Fig. 6.30 Structures based on a triangular shape: **a** Buckminster Fuller, 1967, US Pavilion, EXPO, Montreal, Canada (see Fig. 6.7), **b** Norman Foster, 2006, Hearst Tower, New York, USA

Fig. 6.31 Carlo Rossi, 1828–34, Architect Rossi Street, St. Petersburg, Russia (see Fig. 1.32)

A tetrahedron is a pyramid with a triangular base. The square-based pyramid is closely related to the tetrahedron: the square can be divided into two triangles by a diagonal bar. The pyramid as cubic form is a fundamental perceptual phenomenon. Perspective distortion results in two lines that are parallel in Euclidean space being perceived as converging. We see every cubic form as approximating a pyramid, i.e. with converging edges.

This phenomenon is best observed in the case of a straight street with identical facades on either side. Although the width of the street and the height of the buildings remain constant from the front to the rear, the lines formed by the street converge towards the rear (Fig. 6.31).

In perceptual terms, the pyramid shape is characterized by a duality. On the one hand, the enlargement of the mass from top to bottom creates a sense of weight pulling down; on the other hand, the tapering sides appear to push upwards. These complementary forces create a tension that makes the pyramid a highly dynamic form. In modern architecture only a few buildings have a pyramidal shape, and in these instances this form is usually limited to the exterior appearance (Fig. 6.32).

6.5.11 The Hexagon and the Octagon

The circle can be described as a polygon with an infinite number of corners. The more corners a regular polygon has, the more its form resembles that of a circle.

A regular hexagon can be divided into six equilateral triangles, which each have three identical angles of 60 degrees. These geometrical characteristics allow hexagons to be combined into larger structures more easily than, say, circles. Honeycomb is a good example. Many natural crystals are also structured on the basis of the 60 degree angle. When observed from the front, a building with a square or rectangular floor plan loses

6.5 Regular Forms

Fig. 6.32 The pyramid: **a** I.M. Pei, 1989, Louvre extension, Paris, France (see Figs. 2.1 and 2.31), **b** Veldon Simpson, 1993, Luxor Hotel and Casino, Las Vegas, USA

its depth, i.e. we see only the front side as a surface. In the case of a cylindrical body a cubic form is perceivable but, since the circle is non-directional, the body no longer has an actual front. If the ground plan is hexagonal or octagonal, the beholder sees a front while also perceiving the spatial depth of the body (Fig. 6.33).

When a square floor plan is covered by a round dome, this is often achieved by using several superimposed polygons, the corners of which decrease in number from bottom

Fig. 6.33 The perception of depth in the case of square, circular and hexagonal ground plans

Fig. 6.34 **a** Mosque/cathedral, from eighth century, Córdoba, Spain, **b** Baptistery, from 1059, Florence, Italy

to top (Fig. 6.34a). The octagon was also the preferred form for the floor plan of many baptisteries. The reasons for this were above all symbolic: the eight day was the day of Christ's resurrection and thus of eternal life (Fig. 6.34b) (Reinle 1976, p. 126).

6.6 Irregular Forms

The following is a brief summary of what has been said so far about irregular forms.

In contrast to regular forms, irregular ones are not subject to any geometric laws. As a result their message is highly original: it contains a great deal of information and either very little or no redundancy (see Sect. 1.2.3). Irregular forms awaken associations; the beholder sifts through his memories for similar objects in an attempt to link the irregular form with a figure he is familiar with. Irregular forms thus speak more to our emotions than to our intellect; they contain more aesthetic than semantic information (see Sect. 1.2.4).

Thanks to computers, designing objects with irregular forms is easier today than it used to be. However, the industrial production of such objects, above all of component parts, is more complex than the production of parts with regular forms.

6.7 Formal Contradiction

The shape of a building, its optical appearance, is very rarely dominated by a single geometric form (see Figs. 2.6 and 2.29). Such a form can be the basic form that shapes the appearance of the building. However, in most cases additional forms or form segments

6.7 Formal Contradiction

can be discerned. These can support one another such that a harmonious, unitary image is generated, or they can contradict one another. A contradiction is an assertion of the opposite, a response stating the opposite, an incompatible relationship between two circumstances. Contradiction also entails something unexpected; it generates tension, not harmony (Fig. 6.35).

The floor plan of the conference centre by Tadao Ando in the German town of Weil am Rhein (see Figs. 5.22 and 7.6) is structured using three basic forms, the circle, square and rectangle. These are combined in a way that results in multi-layered spatial sequences. The simplicity of the basic forms, supported by the systematic use of exposed concrete, contradicts the complexity of the spaces that are generated.

The arrangement of columns in the school building by Livio Vacchini in Montagnola in Switzerland is also contradictory (see Fig. 7.25). The beholder expects to see more columns on the ground floor, which is subject to greater loads, than on the upper level. This contradiction creates tension and makes observing the simple geometric courtyard an interesting experience.

This duality is referred to by Robert Venturi in his book "Complexity and Contradiction in Architecture" as follows: "I prefer 'both-and' to 'either-or', black and white, and sometimes gray, to black or white. A valid architecture evokes many levels of meaning" (Venturi 1978, p. 24). At first glance the exhibition building in Weil am Rhein built by Herzog & deMeuron in 2011 appears like a collection of small houses arbitrarily stacked on top of one another (Fig. 6.36). Their form suggests an aspiration to be independent buildings. The observer does not see a whole but rather several, randomly stacked independent buildings, like a child's building blocks. This contradiction is confusing; an exciting structure emerges from rather monotone component parts. The form of the individual houses is also partly readable in the interior. However, the overlaps and intersections repeatedly produce new exciting spatial sequences which contradict the conventional exterior forms of the individual houses. As Robert Venturi argues, the

Fig. 6.35 Irregular forms: Eric O. Moss, 1998, "Umbrella", Westside, Los Angeles, USA

Fig. 6.36 Herzog & de Meuron, 2011, exhibition building, Weil am Rhein, Germany

simultaneous perception of interdependent levels of meaning forces the beholder into a conflict of evaluation, leading him to hesitate and enlivening his entire way of viewing things (Venturi 1978, p. 38).

References

Adorno, Theodor W.: Ästhetische Theorie, Frankfurt am Main, 1974 (1970)
Arnheim, Rudolf: Wahrnehmungsabstraktion und Kunst, Psychological Review54/1947 (in: Zur Psychologie der Kunst, Frankfurt am Main, 1980)
Arnheim, Rudolf: Kunst und Sehen, Berlin, 1978 (original title: Art and Visual Perception, Berkeley, 1954)
Banham, Reyner: Die Revolution der Architektur, 1964, Munich
Blake, Peter: Form Follows Fiasco, 1977, Boston
Boulleé, Etienne-Louis: Architecture, Essai sur l'Art, 1793 (in: Der Hang zum Gesamtkunstwerk, Aarau, 1983)
Drew, Philip: Die dritte Generation, Teufen, 1972
Frampton, Kenneth: Die Architektur der Moderne, Stuttgart, 1983 (original title Modern Architecture, London, 1980)
Gabo, Naum und Pevsner, Antoine: Grundprinzipien des Konstruktivismus, 1920 (in: Programme und Manifeste zur Architektur des 20. Jahrhunderts, Braunschweig, 1981)
Giedion, Siegfried: Raum, Zeit, Architektur, Zürich, 1978 (original title: Space, Time and Architecture, Cambridge, Mass., 1941)
Gradmann, Erwin: Aufsätze zur Architektur, Basel, 1968
Hofstätter, Hans: Gotik, Fribourg, 1968
Jencks, Charles: Modern Movements in Architecture, New York, 1973
Johnson, Philip: Texte zur Architektur, Stuttgart, 1982 (original title: Philip Johnson Writings, Oxford, 1979)
Jung, Karl Gustav: Aion, Olten, 1976
Kahn, Louis I., Space and the Inspirations, lecture at the New England Conservatory, 14 Nov. 1967 (in: L'architecture d'aujourd'hui, 2/1969) *Kahn, Louis I.,* I Love Beginnings, lecture at the Aspen Design Conference, 1973 (in: Louis I. Kahn, Tokyo, 1975)
Klee, Paul: Pädagogisches Skizzenbuch, Mainz, 1985 (1925)

References

Klotz, Heinrich und Cook, John W.: Architektur im Widerspruch, Zürich, 1974 (original title: Conversations with Architects, New York, 1973)

Le Corbusier Ausblick auf eine Architektur, 1969, Berlin (original title: Vers une architecture, Paris, 1923)

Lissizky, El: Ideologischer Überbau, 1929 (in: Programme und Manifeste zur Architektur des 20. Jahrhunderts, Braunschweig, 1981)

Mies van der Rohe, Ludwig: G, no. 2, September 1923 (in: Klotz, Heinrich (ed), Mies van der Rohe, 1987, Stuttgart)

Moles, Abraham A.: Informationstheorie und ästhetische Wahrnehmung, Cologne, 1971 (1958)

Muthesius, Herrmann: Werkbundziele, 1911 (in: Programme und Manifeste zur Architektur des 20. Jahrhunderts, Braunschweig, 1981)

Naredi-Rainer, Paul von: Architektur und Harmonie, Cologne, 1982

Palladio, Andrea: Die vier Bücher zur Architektur, Zürich, 1983 (1570)

Picard, Gilbert: Imperium Romanum, Fribourg, 1965

Rauterberg, Hanno: Worauf wir bauen, Munich, 2008

Reinle, Adolf: Zeichensprache der Architektur, Zürich, 1976

Rykwert, Joseph: Ornament ist kein Verbrechen, Cologne, 1983 (original title: The Necessity of Artifice, London, 1982)

Schuster, Martin und Beisl, Horst: Kunstpsychologie—wodurch Kunstwerke wirken, Cologne, 1978

Sedlmayr, Hans: Verlust der Mitte, Frankfurt am Main, 1983 (1948)

Sörgel, Herman: Einführung in die Architektur-Ästhetik, Munich, 1918

Venturi, Robert: Komplexität und Widerspruch in der Architektur, 1978, Braunschweig (Complexity and Contradiction in Architecture, 1966, New York)

Vitruv: 10 Bücher über Architektur, Darmstadt, 1981 (ca. 30 BCE)

Vogt, Adolf Max: Revolutionsarchitektur, Cologne, 1974

Wachsmann, Konrad: Wendepunkt des Bauens, Wiesbaden, 1959

Wagner, Otto: Die Baukunst unserer Zeit, Vienna, 1979 (1895)

Wölfflin, Heinrich: Kunstgeschichtliche Grundbegriffe, Basel, 1984 (1915)

Wright, Frank Lloyd: Im Reich der Ideen, Vorlesung am Chicago Art Institute, 1931 (in: Humane Architektur, Berlin, 1969)

Wright, Frank Lloyd: Vortrag in London, 1939 (in: Humane Architektur, Berlin, 1969)

Harmony

Contents

7.1 Harmony and Balance ... 221
7.2 Tension.. 223
7.3 Proportion and Scale .. 226
7.4 Symmetry and Rhythm .. 232
 7.4.1 Bilateral Symmetry .. 233
 7.4.2 Translational Symmetry... 238
 7.4.3 Rhythm... 240
7.5 Hierarchy ... 240
References.. 245

7.1 Harmony and Balance

The concept of harmony is found in most areas of the humanities and natural sciences. In the field of aesthetics, harmony denotes order and accordance between all elements of a phenomenon (Brockhaus Enzyklopädie 1969, p. 180). In ancient Greek mythology, Harmonia was the daughter of Ares, the god of war, and Aphrodite, the goddess of beauty and love (Grimal 1977, p. 212). Harmony emerges from the combination of two contrasting elements.

Perception requires contrast. A figure can only be seen if it is silhouetted against a background, if contrasting elements are present at the same time.

Every instance of perception is organized in accordance with certain principles, resulting in an order based on either logical or aesthetic concepts. The former tends to lead to a scientific interpretation, the latter to an artistic one (Frey 1976, p. 236).

Harmony is an important aspect of architectural aesthetics and is not limited to the spatial dimension. Materials, colours and surface structures must also accord with one another and subordinate themselves to a higher order. All physical and psychological systems tend towards a state characterized by the highest attainable level of equilibrium and the lowest attainable level of tension (Arnheim 1978, p. 18). In terms of optical perception, harmony demands visual balance. Our perceptual apparatus endeavours to find optical equilibrium in every stimulus configuration, for example by "automatically" adapting a slightly skewed corner to a 90-degree angle.

In a balanced composition all the parts are arranged such that the impression is created that "everything is in the right place" and any change would produce disorder. Imbalance leads to contradictory stimulus configuration and thereby to tension and insecurity. Balance is not always the goal; sometimes generating tension by means of formal contradiction is precisely the architect's intention (see Fig. 7.1).

Every shape, irrespective of its potential physical weight, has a perceived weight. Perceived weight is influenced by different factors, such as size, form, location, brightness, material and colour (see Fig. 6.9). A compact, closed volume may appear to the beholder as "heavier" than an open, textured structure (see Fig. 5.28). A bright object may appear lighter than a dark one, a small one lighter than a large one (Fig. 7.2).

The contextual significance of a building, which is in turn highly dependent on socio-psychological factors, also has an influence on the object's perceived weight. A grave marker or a memorial can appear "heavier" than a warehouse. It attracts the beholder's attention to a greater degree and has more significance for him. The tomb of the Achaemenid ruler Cyrus the Great, who reigned over a vast empire, appears rather modest at first glance. However, an awareness of who is buried here inevitably adds to the perceived weight of the layered stones (Fig. 7.3).

Finally, a perceived direction can influence our sense of balance. Many stimulus configurations are directional. Moreover, the semantic content of a phenomenon or an

Fig. 7.1 F.O. Gehry, 1989, Vitra Design Museum, Weil am Rhein, Germany

Fig. 7.2 Group M, 2002, pavilion, Neuchâtel, Switzerland (see Fig. 2.6)

Fig. 7.3 Tomb of Cyrus the Great (sixth century BCE), Achaemenid ruler, near Pasargad, Iran

explicit sign can indicate a specific direction, as in the case of a parked car or an arrow drawing (Fig. 7.4).

7.2 Tension

Every perception is an interplay between directional tensions. The so-called gestalt laws are based on the fact that each stimulus configuration is interpreted in such a way that the resulting structure is as simple as possible, which translates as a reduction in tension. The formation of super-signs (see Sect. 1.3.3) also entails a reduction in the amount of information and thus less tension.

Fig. 7.4 Zaha Hadid, 1993, former fire station, Weil am Rhein, Germany

On the one hand, every instance of perception is an attempt to find order, to ascertain a structure and thus to reduce tension. On the other hand, we also need to experience tension, a complete lack of which can lead to boredom. As human beings we are torn between the desire to increase tension and the desire to decrease it.

Tension does not simply imply disorder, yet there is a close connection between tension and order. Strict order usually means a low level of tension and vice versa.

In Sect. 3.4 we saw that over the course of history it is possible to identify a periodic development from a simple to a more complex arrangement system (see Fig. 3.7).

This tendency is thus linked with an increase in tensions: the more complex an arrangement, the greater the tension. We also saw that a complex order, and thus more tension, tends to speak more to emotions than to intellect (see Fig. 3.12). An individual with a rather extroverted personality structure will therefore need more tension than an introverted person. A perception charged with tension tends to contain more aesthetic than semantic information (see Sect. 1.2.4).

Tension can be generated in different ways. Basically, the greater the level of complexity, the more numerous the contradictions and the less order, which results in a higher level of tension.

Tension is generated most often in situations where there is a departure from the commonplace. The perception of a diagonal or a curve is associated with the wish to adapt it to an orthogonal horizontal-vertical system or a straight line (Fig. 7.5). This also allows the informational content of the message to be reduced. In depth perception the perspectival diagonal is perceived as a horizontal: the perceptual image containing less tension is preferred.

The ellipse and the rectangle already constitute deviations from the clearly defined forms of the circle and the square and in this sense project something indeterminate. Tension can also be generated with an unusual, oppositional or contradictory arrangement or confrontation of different elements.

7.2 Tension

Fig. 7.5 P. Johnson, 1990, Torres KIO (Puerta de Europa), Madrid, Spain

In Michelangelo's vestibule in the Biblioteca Laurenziana in Florence the columns are positioned in wall niches (see Fig. 5.13). Is it the walls or the columns that are doing the supporting here? The relationship between support and load is obfuscated, which generates tension.

In the case of the conference centre designed by Tadao Ando and built in Weil am Rhein, Germany, in 1993, tension is generated by the opposition of two different factors which shape the impression made by the building: on the one hand, the rigour and sparseness of the exposed concrete, the only material used for the ceilings and walls, and, on the other, the complex division of space. The latter is also based on simple elements, the basic ones being a square, a rectangle and a circle (Fig. 7.6). These basic forms have been dissected into pieces and then offset from and interlaced with one another.

Fig. 7.6 Ando Tadao, 1993, conference centre, Weil am Rhein, Germany (see Fig. 5.22b)

7.3 Proportion and Scale

Proportion is an important element of harmony. It is an abstract value which can only be illustrated with reference to shape. The concept of proportion is defined in different ways according to its sphere of application. In architecture it denotes the relationship between two or more sizes.

A basic distinction can be made between two types of proportion: arithmetic and geometric. Arithmetic proportion is based on simple numerical relationships that refer to a basic unit. For example, the ratio between the parts of a Greek temple is founded on a modular unit called the Doric foot (Fig. 7.7).

The golden ratio, the basis of the Modulor devised by Le Corbusier, is a geometric proportion. In this case, the size relationship between parts is not mathematically calculated but determined by means of a geometric operation. This operation, which was first described by Euclid, involves the division of a line into two unequal parts, the shorter of which is in the same ratio to the longer one as the longer one is to the whole line. This is expressed in an algebraic formula as: $A: B = (A+B): A$ (Fig. 7.8). Experiments have shown that a rectangle with sides that accord with the golden ratio is perceived as having

Fig. 7.7 Arithmetic proportion. Temple of Athena (formerly Temple of Ceres), 510 BCE, Peastum, Italy (based on Friedrich Krauss). Measurements in Doric feet ($A = 32.8$ cm)

7.3 Proportion and Scale

Fig. 7.8 The golden ratio: $A: B = (A+B): A$

an ideal proportion, i.e. as corresponding most readily with the average person's sense of beauty (Fechner 1876, p. 184).

Why do we find certain proportions, such as the golden ratio, pleasing? In Sect. 1.3.4.1 we saw that, in accordance with the law of good gestalt, when perceiving incomplete shapes we tend to complete and improve them. The proportion of a rectangle can extend from one with four equal sides, i.e. a square, to a form that is far longer than it is wide. A rectangle with measurements that accord with the golden ratio is neither a badly proportioned square nor a clearly directional bar: it has good gestalt.

This does not mean that all rectangles should as far as possible accord with the golden ratio. In the Baroque period, for example, such rectangles were avoided as part of a deliberate strategy to create tension. People need clarity and simplicity as a basis for orientation and a sense of inner peace but they also need diversity and tension.

Form as such is independent of style, but the way it is implemented depends on its historical context. By contrast, proportions are universal and timeless. An example of this is the similarity pointed out by Colin Rowe between the proportions of two villas, one by Andrea Palladio and one by Le Corbusier (Frampton 1983, p. 136) (Fig. 7.9). The villa designed by Palladio for a Venetian noble and built in the mid-sixteenth century in Malcontenta near Venice is a rigorously symmetrical solid building. The rooms are grouped around a large cruciform central space and in the longitudinal direction are divided in a rhythm of 2:1:2:1:2. A similar division is possible in the transverse direction. The villa by Le Corbusier was built in Garches in 1927. In formal terms the two buildings have little in common. The villa in Garches is a skeleton-frame structure with several additional bearing walls and an asymmetric floor plan. Nevertheless, the grid pattern of Palladio's villa can be superimposed on this ground plan.

Whereas Palladio positions the solid walls on the grid lines and thereby also expresses the proportion in formal terms, in the case of Le Corbusier's building only the pillars are positioned on the grid. The non-bearing walls are positioned such that a quite different division of the interior space is created. The proportion of the load-bearing system is deliberately concealed to allow for a different type of formal expression. For structural

Fig. 7.9 Comparison between the proportions of the villa in Malcontenta by Andrea Palladio (sixteenth century) (**a**) and the villa in Garches by Le Corbusier (1927) (**b**) (based on Colin Rowe)

reasons Le Corbusier worked with an arithmetic proportion but based the formal aspect of the building on a geometric proportion. The ratio of the open terrace to the closed building section is 3:5, which almost corresponds to the golden ratio.

Both Palladio and Corbusier used the proportions 3:4, 4:4 and 4:6 (or $1:1^{1}/_{3}, 1:1, 1:1^{1}/_{2}$), which as time signatures in music produce pleasing beats (Rasmussen 1980, p. 112). At the beginning of the first book on architecture, Vitruvius explicitly argues that the architect must understand something of music and be acquainted with the theory of sound and the mathematical relationships between tones (Vitruv 1981, p. 29). Particularly in the early phase of his career, Palladio employed musical proportions for his designs (Ackerman 1980, p. 141), and the villa in Malcontenta is no exception in this respect. Le Corbusier also had a close relationship with music, his mother and brother both being musicians. Many renowned architects have stated that their designs have often been influenced by musical compositions. Erich Mendelsohn, for instance, is known to have always listened to the music of Bach when designing (Rasmussen 1980, p. 136).

Historically the connection between architecture and music was not limited to only a few architects. Nikolaus Pevsner argues that there are striking parallels between Baroque architecture and music, not only with regard to the related ideational structure but also in terms of artistic quality (Pevsner 1967, p. 283). This influence was not one-sided: Steen

7.3 Proportion and Scale

Rasmussen, drawing on the work of British architectural theorist Hope Bagenal, points out that early Christian choral music was adapted to the architecture of the time. The "predecessor" of St. Peter's Basilica in Rome was a five-aisled basilica. The shape and size of this church resulted in normal speech and singing echoing so much that the text was incomprehensible. "For this reason a rhythmic pattern was used, a kind of recitative or exposition. There was probably a certain note that resonated particularly effectively in the church space. When the sonorous Latin vowels rang out, they could be heard in all their richness by the entire congregation. The note echoed from all sides; one heard the stones speak" (Rasmussen 1980, p. 220). The rhythm of the psalms and prayers was precisely geared to the length of the echo, which made the text comprehensible even at the back of the church. Gregorian chanting was created to suit the shape and size of the old St. Peter's Basilica (Rasmussen 1980, p. 211).

The conscious use of proportions is not restricted to surfaces such as a facades and floor plans, as is evident in Palladio's work. In the twenty-third chapter of the first book of his architectural treatise, Palladio provides a precise description of how the height of rooms should relate to the dimensions of the floor plan (Palladio 1983, p. 86). However, he went further than this, creating harmonious relationships between entire spatial sequences and volume compositions.

In the Palazzo Chiericati in Vicenza (Figs. 7.10 and 5.23b) the size of the rooms decreases from the central main space outwards to the smallest rooms in the building's wings. The smallest room measures 12×18 Vicentine feet, the next smallest 18×18, the next 18×30 and finally the main room 16×54. If the main room were 18 feet wide, all room widths and lengths could be divided by 6, resulting in the ratios 2:3, 3:3, 3:5 and 1:3, which in turn correspond to musical harmonies (Vitruv 1981, p. 137).

Fig. 7.10 **a** Andrea Palladio, 1550, Palazzo Chiericati, Vicenza, Italy, **b** room dimensions in Vincentine feet, **c** ratio of length to width (see Fig. 5.23)

The proportions of the three smaller rooms also correspond to the room types that Palladio regards as "seven of the most beautiful and most proportionate types of rooms". These are the round room and rectangular rooms with the following length ratios: 1:1, 1:1$\sqrt{2}$, 1:1$^1/_3$, 1:1$^1/_2$, 1:1$^2/_3$, 1:2 (Weyl 1981, p. 11).

The central main space in the Palazzo Chiericati is enclosed at both ends by semi-circular niches, which reduce its perceived overall length. A reduced size of 16 × 48 feet produces two 16 × 24-foot rooms separated from the axis of symmetry with a proportion of 1:1½, which in turn corresponds to one of Palladio's seven ideal "room types". By creating a sequence of rooms with dimensions that harmonize with one another, Palladio includes the temporal dimension in his architectural composition, since the experience of this sequence of ratios requires movement and thus time.

The perception of proportion is not only determined by measured, absolute size ratios; it can also be influenced by a range of other factors. For example, colouring can alter the optical perception of a proportion (see Sect. 10.6.2). Today we have to assume that ancient Egyptian architecture was experienced differently at the time it was built to the way it is perceived today, because it was at least in part painted (Canival 1964, p. 142). A proportion can also be influenced by marginal conditions. For example, the overall proportion of a building positioned on a plinth is perceived differently to the same building standing directly on the ground. The plinth separates the building volume from the ground and allows it to appear as a whole, as something self-contained. A clear separation between the building volume and the ground can make the building appear to be much bigger than it is, to seem partly "sunken" into the ground, and therefore differently proportioned to what is actually seen (Fig. 7.11).

Like proportion, the effective size also has an influence on perception. The semantic meaning of certain forms can change depending on their size. A spherical interior on a human scale, i.e. with a diameter of a few metres, can communicate a feeling of shelter and security. On a gigantic scale the feeling of security disappears. In spite of the retained form, the space now has the opposite effect. The visitor now feels overwhelmed.

The experience of architecture is not static. So-called size constancy (see Sect. 1.3.5) enables the observer to perceive a building in its correct dimensions from different distances. Nevertheless, we see a building differently from a distance to the way we see it close up. What is important is that architecture can be read and understood both from a distance and close up. Robert Venturi criticized the fact that in Modernism there was no

Fig. 7.11 Perceived proportion of a building with different structural arrangements

7.3 Proportion and Scale

longer any juxtaposition of different scales (Venturi 1978, p. 100), by which he meant different levels of perception. And yet it is precisely the coexistence of different scales on the same building that facilitates accurate perception from both longer and shorter distances. While the shape of a whole building and its structuring features can only be read from a certain distance, details and ornamentation are stimulus configurations that can only be discerned from close up. In Sect. 1.3.3 we saw that, when observing from a distance, at first glance similar signs or organizational structures are automatically summarized into a super-sign (see Fig. 1.12). The observer then progressively "discovers" details on another level, on another scale.

In his design for the Säynätsalo Town Hall (Fig. 7.12) Alvar Aalto grouped the rooms around a courtyard in which public meetings can take place. The courtyard has an intimate quality; its size is adapted to the human scale and as a result it forms a pleasing contrast to the endless "sea" of trees in the surroundings. The inner courtyard is one storey higher than the area surrounding the building. As a result the interior facades around the courtyard are only one storey high. From this perspective the scale of the building appears proportional to the size of the courtyard. From the outside, where the building is

Fig. 7.12 Alvar Aalto, 1952, Town Hall, Säynätsalo, Finland

framed by its forested surroundings, the additional pitched roof section makes the building appear three stories high, allowing it to assume the scale of the surrounding trees. In this way the differently perceived dimensions of the building correspond to the respective spatial relationships.

Monumentality has always also been used to demonstrate power. The deliberate abrogation of human norms, including in terms of size, results in something exceptional. The form of the pyramid makes it difficult to estimate its true size. Its converging lines strengthen the perspective effect and make the structure appear infinitely high. As a result it appears to exceed the human scale and, in its monumentality, becomes a symbol; in ancient Egypt a symbol of the power of the gods and the pharaohs.

The attempt to abrogate a sense of scale is also found in the Baroque period, when the infinite visual extension of space was used as a means of expressing the existence of the transcendental.

The filigree architecture of London's Crystal Palace has a similar effect. A contemporary critic wrote at the time, "We do not know whether the mesh is floating a hundred or a thousand feet above us, whether the ceiling is flat or formed by a multitude of small roofs, for the shadowing that would otherwise help the mind to understand the impressions on the visual nerve is absent" (Bucher 1851, p. 174). This effect was intentional; the building represents a deliberate attempt to move beyond every conventional scale. Its monumentality was intended to demonstrate, on the one hand, the splendour and glory of the British Empire and, on the other, the "unlimited" possibilities of what was then the new industrialization.

The concept of the "scale-less" is closely connected with that of the sublime. The interior space of a Gothic church does not permit size comparison with the everyday world or with the observer. Such spaces have their own scale, an "absolute scale" as Kant termed it, which does not permit any comparison. In his essay "On the Sublime" Friedrich von Schiller wrote, "The feeling of the sublime is a mixed feeling. It is at once a painful state, which in its paroxysm is manifested by a kind of shudder, and a joyous state, that may rise to rapture, and which, without being properly a pleasure, is greatly preferred to every kind of pleasure by delicate souls" (Schiller 1844, p. 383).

7.4 Symmetry and Rhythm

The word symmetry comes from Greek and means naturally graceful, harmonious and well-shaped. The concept of symmetry was not always as narrowly defined as it is today. In the first century BCE Vitruvius wrote, "The composition of a temple is based on symmetry, whose principles architects should take the greatest care to master. Symmetry derives from proportion, which the Greeks call *analogia*. Proportion is a correspondence among the measures of the parts of an entire work, and of the whole to a certain part (*modulus*) selected as standard. From this result the principles of symmetry" (Vitruv 1981, p. 137). Vitruvius understood symmetry as the relationship between parts and of parts to

7.4 Symmetry and Rhythm

the whole based on a standard unit of measurement. For him, symmetry was closely ties to the concept of proportion and beauty per se (Weyl 1981, p. 11). Today the concept of symmetry is more narrowly defined and refers to a structural-spatial arrangement system. This arrangement can in turn contribute to a harmonious perception and thereby to the sensation of beauty. Mathematics and physics distinguish between different types of symmetry: mirror symmetry, rotational symmetry, translational symmetry, permutation symmetry, etc.

In 1924 the George Pólya proved mathematically that in the case of two-dimensional ornamentation there are 17 different possible types of symmetry (Pólya 1924, p. 278). Surprisingly, all 17 of these types can already be found in ancient Egyptian ornamentation.

In architecture, symmetry is usually restricted to two specific types: bilateral and translational symmetry. In the first case, which is also known as axial symmetry, a figure is reflected around an axis resulting in a figure on both sides of the axis which is divisible into two identical halves on either side of a median axis. Corresponding points on the two figures thus created are identically positioned in relation to the axis. Translational symmetry entails a repetition of identical parts, or a sequence.

7.4.1 Bilateral Symmetry

Bilateral symmetry is also found in nature: "There must be a reason for this, and, indeed, one does not have to look far to find it. Symmetry can be expected where equilibrium predominates" (Weyl 1981, p. 33). Here, the physicist and mathematician Hermann Weyl is referring to physical equilibrium, and, as we have seen, perceptual and physical equilibrium are based on similar conditions (see Sect. 7.1).

As regards their external appearance, human beings and most animals seem at first glance to be symmetrically structured. On the other hand, this symmetry is in most cases limited to the exterior, since the organization of the inner organs is asymmetrical. The external form – and the associated distribution of weight – is responsible for physical equilibrium. Animals that do not exhibit any symmetry, even in their external form, are extremely rare. The zoologist Adolf Portmann makes the interesting observation that in the case of completely transparent animals even the internal organs are symmetrically arranged. Everything that cannot be symmetrically arranged is concealed in an opaque covering (Portmann 1960, p. 61).

Symmetry results from equilibrium and represents the normal case. This means that is not symmetry but asymmetry that constitutes the exception. Symmetry as mirror-inverted correspondence is an objective fact which, seen in mathematical terms, is independent of spatial position. In subjective terms the multitude of mathematically equivalent directions are reduced to three directions of movement: left/right, up/down and forwards/backwards. Accordingly, in visual perception the spatial relationship between object and beholder plays a decisive role. The symmetry of an object is experienced differently depending on its spatial relationship with the beholder: in accordance with the three

Fig. 7.13 The experience of bilateral symmetry based on the direction of movement: **a** width dimension, **b** height dimension, **c** depth dimension

directions of movement in the width dimension, the height dimension and the depth dimension (Fig. 7.13).

Strictly speaking bilateral symmetry can only be experienced in the width dimension. This means that the beholder must be standing on the axis of symmetry in front of and facing the object (Fig. 7.13a). This position makes the state of equilibrium most readily discernible; perception is ordered and low in tension. However, the designer of a symmetrical building will in many cases also wish to retain a level of tension. This can be achieved with secondary building measures, for example with a pool of water lying on the central axis, which prevents the visitor from registering a location on the axis. The fundamental difference between, on the one hand, the height and depth dimensions and, on the other, the width dimension is based on the heterogeneity of directions on both sides of the axis. In the case of symmetry in the height dimension we experience the direction upwards differently to the one downwards and accordingly evaluate them differently. The beholder can only perceive symmetry in the depth dimension due to the phenomenon of the size constancy (see Sect. 1.3.5).

Symmetry in the width dimension emphasizes the frontal, the planar, and suppresses depth perception. By contrast, due to its rhythmic segmentation, symmetry in the depth dimension intensifies the experience of depth. The question of whether in the case of mirror inversion in the depth dimension we can still speak of perceptual bilateral symmetry is a justified one. Depth implies a path and movement, symmetry calm and balance. Even bilateral symmetry in the width dimension is ultimately not an absolute

7.4 Symmetry and Rhythm

mirror inversion. As we have seen, when it comes to orientation within a space it is only from a mathematical perspective that there is no difference between left and right (see Sect. 5.2.1). In terms of visual perception and its socio-psychological interpretation the two sides are not equivalent. Although we do not register this difference consciously, it exercises an unconscious influence on our perception.

Up until the beginning of the twentieth century, symmetry was one of the most important elements in architectural design. Andrea Palladio wrote, "One must take care that the right side corresponds to the left and is equal to it in order to ensure one is designed identically with the other …" and "The windows on the right side must also correspond to those on the left and the upper ones must be positioned straight above the lower ones (Palladio 1983, pp. 84, 91). The façade of the Villa Godi Palladio built in 1542 features a number of symmetrical partitions (Fig. 7.14). Moreover, the individual parts are also symmetrically designed.

Some parts of the façade of the Palazzo Ca' d'Oro, which was built by Matteo Raverti in Venice in 1421–40, are symmetrically arranged while other parts contradict this order. The irregularity is somewhat jarring and creates tension. It reduces the static quality of the façade, making it dynamic and partly contradictory (Fig. 7.15).

People find asymmetry and symmetry equally pleasing, but the desire for tension is more readily satisfied by an irregular arrangement.

Symmetry as a design element has been differently utilized in different stylistic epochs.

Fig. 7.14 Andrea Palladio, 1542, Villa Godi, Lonedo, Italy: different levels of symmetry

Fig. 7.15 Matteo Raverti, 1421–40, Palazzo Ca' d' Oro, Venice, Italy

Gottfried Semper identified three "principles of configuration" as the basis of aesthetically pleasing and unified form: symmetry, proportion and direction (see Rykwert 1983, p. 220). And in 1895 Otto Wagner declared himself an opponent of everything asymmetrical: "The imitation of asymmetrical buildings and the intentionally use of asymmetry in a composition in order to achieve a supposedly picturesque effect is entirely reprehensible; all such old models have evolved by way of subsequent generations making successive spatial changes to symmetrical building complexes, which has resulted in asymmetry. However, there is nothing of the original intent to be found here" (Wagner 1979, p. 51).

At the beginning of the twentieth century many conventional elements of architectural design were rejected. Along with the concept of enclosed space, symmetry was assigned to history. In 1924 Theo van Doesburg wrote in his "Theory of Elementary Design": "The new architecture has eliminated both monotonous repetition and the rigid similarity of two halves – the mirror image, symmetry" (Van Doesburg 1981, p. 74). Instead of symmetry the new architecture offers a balanced relationship between unequal parts, that is, between parts which, because of their different functional character, differ in position, dimension, proportion and location. The equal importance of these parts is based on the equilibrium of their inequality and not on their equality (Van Doesburg 1981, p. 75) (see Fig. 6.14). In his early work Ludwig Mies van der Rohe rejected symmetry (see Fig. 2.7), but then from 1933, when he developed his competition design from the new *Reichsbank* in Berlin, symmetry increasingly became one of his most important design tools. This development was influenced by the work of Karl Friedrich Schinkel, of whom Mies van der Rohe was a great admirer (Fig. 7.16).

Modernism did not reject symmetry in general but it was not utilized with the same rigor and dominance that characterized, for example, antiquity and the Renaissance.

7.4 Symmetry and Rhythm

Fig. 7.16 **a** Karl Friedrich Schinkel, 1830, Altes Museum, Berlin, Germany, **b** Ludwig Mies van der Rohe, 1956, Crown Hall, Chicago, USA (see Fig. 7.19b)

From now on equal measures and equilibrium served rather as a means of providing structural variety.

The openings in the two longitudinal facades of the Casa Polloni built by Campi Pessina in Origlio in 1981 are in part symmetrically arranged (Fig. 7.17). However, as in the case of the Palazzo Ca' d' Oro (Fig. 7.15), there are deviations here. On the street side (Fig. 7.17 above) the two small windows in the upper storey are positioned asymmetrically. At first glance, this exception to the general arrangement is disconcerting, but it also generates tension and animates the view of the rather monotonous wall. On the garden side (Fig. 7.17 below) the openings in the middle section are symmetrical. The other openings to the left and right are positioned at different distances from the central axis. However, due to their different sizes the façade as a whole appears to be in equilibrium: to the left there are more windows but they are directly adjacent to the middle section; to the right there are less openings but they are further away from the central axis.

Modernism replaced the role of symmetry as a design tool with a preference for modular regularity. In 1932 Henry-Russell Hitchcock and Philip Johnson wrote, "Modern standardization gives automatically a high degree of consistency in the parts. Hence modern architects have no need of the discipline of bilateral or axial symmetry to achieve aesthetic order" (Hitchcock and Johnson 1985, p. 54). Frank Lloyd Wright argued that while we may have a preference for symmetry and rhythm because they are part of life, using them for their own sake is pretentious and should always be avoided (Wright 1969, p. 99). Paul Rudolf argued that while symmetry was an expedient design tool when it came to buildings used by large crowds of people, such as airports (and even there the sun refused to shine symmetrically), the open quality of twentieth-century architecture made pure symmetry inapplicable in most cases (Klotz and Cook 1974, p. 108). Rudolf described his Yale Art and Architecture Building as an asymmetrical

Fig. 7.17 Campi Pessina, 1981, Casa Polloni, Origlio, Switzerland: **a** street facade, **b** garden facade

structure, arguing that he could not conceive of a symmetrical building occupying such a corner site (Klotz and Cook 1974, p. 108). And yet this very building is a good example of what Frank Lloyd Wright referred to as the concealed symmetry of Modernism. The design of the bearing structure produces a regular grid mirrored along two axes of symmetry (Fig. 7.18).

7.4.2 Translational Symmetry

We understand translation as the repetition of congruent elements. The principle of sequencing is found everywhere. In Sect. 1.2.5 we saw that regularity generates expectations: the greater the degree of regularity, the greater the degree of predictability and the greater the degree of redundancy. Even a three or four-fold repetition generates an expectation of further regularities (Schuster and Beisl 1978, p. 49). The formation of super-signs is a search for regularities. We rely on such regularities because they allow us to reduce the information we need to store in order to perceive our surroundings. On the other hand, the frequent repetition of an element leads to a diminution of its aesthetic

7.4 Symmetry and Rhythm

Fig. 7.18 Paul Rudolf, 1963, Yale Art and Architecture Building, New Haven, USA: **a** second upper level, **b** pictorial schematic with bearing elements and axes

value. The American mathematician George David Birkhoff took this fact into account in his calculation of the aesthetic measure in the second thesis of his fundamental theorem (Gunzenhäuser 1975, p. 28) (see Sect. 8.6). In the case of repetition, each individual element loses a degree of its autonomy to the benefit of the whole.

In architecture the principle of sequencing can be considered from two standpoints: an aesthetic one – and thereby the information-theoretical standpoint of perception –and a technical-structural one.

The stringing together of identical elements is a basic principle of building and is found in all stylistic epochs (Fig. 7.19). The reasons behind the application of this principle are not always the same. Stringing together identical elements can make a path measurable, which can in turn contribute to an increase in its experiential density. According to Kenneth Frampton, the repetition of identical elements was one of the most important

Fig. 7.19 Sequence of elements: **a** Mortuary Temple of Hatshepsut, 18th Dynasty, Upper Egypt, **b**Ludwig Mies van der Rohe, 1956, Crown Hall, ITT, Chicago, USA (see Fig. 7.16b)

design tools of fascist architecture in Germany and Italy (Frampton 1983, p. 176). In Charles Jencks' opinion, "The effect of extreme repetition may be monotony or a hypnotic trance: positively it can elicit feelings of the sublime and the inevitable because it so incessantly returns to the same theme. … Both Mussolini and Hitler used it as a form of thought control knowing that before people can be coerced they first have to be hypnotized and then bored" (Jencks 1980, p. 62).

7.4.3 Rhythm

Regularity leads to rhythm. Rhythm is produced not only by the repetition of identical elements but also by the repetition of identical element groups, so-called periods. The perception of periods is time-limited. If the repetition takes place within less than 1/10 s, then we perceive continuousness. If a time period is longer than five to ten seconds it is no longer perceived as such since no repetition is expected. The optimal length of a period for perception is one second (Moles 1971, p. 107). The most important aspect of periodicity perception is the regularity of element groups. Too great a deviation from what has gone before or a too complexly structured element group can disrupt perception as a period and thus the rhythm. In itself rhythm does not create order. But it can fundamentally contribute to strengthening an existing ordering principle. In this context a regular repetition can be so discrete that is not consciously perceived as such. Rhythm is one of the essential characteristics of every type of perception. As Le Corbusier saw it, determining the relative distances between objects simultaneously reveals rhythms, "rhythms apparent to the eye and clear in their relations to one another. And these rhythms are the very root of human activities" (Le Corbusier 1969, p. 65). Rhythm is not a phenomenon restricted to architecture: we need only think of music and dance. Repetitions at regular temporal intervals are vital for human beings. Their fundamental needs, such as sleeping and eating, have to be satisfied in a particular rhythm.

7.5 Hierarchy

In most cases, several elements, such as structural elements or buildings, are found together, and their relationship to one another is determined by a certain arrangement. The elements can be strictly equivalent in relation to one another, or their interrelationships can be hierarchical. Strict equivalence is seldom found in architecture. Even if on a plan two spaces appear the same and correspond in terms of both size and form, in reality they will be slightly different due to their position and the way they are accessed.

Hierarchy can be discerned from different standpoints. We can distinguish between visual and ideational factors. The visual factors are size, form and position (Fig. 7.20). One element can be distinguished from others in terms of size, its form can rank it in a particular way, or it can have a special spatial relationship to other elements, i.e. it is

7.5 Hierarchy

Fig. 7.20 Visual factors that can influence the hierarchy: **a** size, **b** form and **c** position

emphasized due to its position. A particular type of surface or material can also lend a building or building component a particular status within the whole.

However, hierarchy can also be based on purely ideational factors, such as the symbolic meaning of an element and particular cultural or personal criteria. In many cases an ideational hierarchy is additionally underscored by visually perceptible means, i.e. by way of a visual hierarchy.

Most buildings by Andrea Palladio exhibit a strict hierarchy. In the second chapter of the first book of his treatise on architecture, written in 1570, he compares a building with the human body: "But our Lord God has arranged our parts so that the most beautiful are in positions most exposed to view and the more unpleasant are hidden. And so we too when building place the most important and prestigious parts in full view and the less beautiful in locations concealed from our eyes as far as possible, such that all unsightly aspects of the building and all those things that would be a source of embarrassment and could make the beautiful parts ugly can be accommodated" (Palladio 1983, p. 114). Palladio arranged spaces hierarchically in accordance with their functions and expressed this ranking in visually perceptible means. Symmetry is one such means. The most important parts of the building are centrally located on the axis of symmetry, while the other rooms are laterally positioned in accordance with their place in the spatial hierarchy (see Fig. 7.10).

In Sect. 5.2.5 we saw how Palladio, when designing external facades, distinguished between buildings adjoining open squares and those facing onto narrow streets (see Fig. 5.23). The first type exhibits a strict bilateral symmetry, while the second tends to employ a translational symmetry, the principle of sequencing.

The same is true of the Villa Trissino in Meledo (Fig. 7.21). The front of the building exhibits a clear structure. In the middle, on the axis of symmetry, there is a visual highpoint towards which the visitor is supposed to move when approaching.

The path thus defined is increasingly enclosed at the sides by symmetrically arranged wings. This gives rise to a spatial hierarchy, which ascends up to the building's round central space.

Perceptual hierarchies have also always served to represent worldly power. In ancient China architecture served as a means of elucidating a rigid social structure. This was achieved by various means. Here, too, there was also a connection between order of

Fig. 7.21 Andrea Palladio, Villa Trissino (project), Meledo, Italy

precedence and symmetry. The higher the status of a building, of its function, the more imperative the use of symmetry in its design was seen to be (Thilo 1978, p. 14).

The axis of symmetry implies a path and thus movement. The time factor helps to elucidate the approach to a highpoint. Temples, cultural buildings and palaces were for the most part built in a strictly symmetrical form. The main building was often elevated on a terrace (Figs. 7.22 and 7.23). In ancient China the materials, colours and ornamentation of the roof provided further means of emphasizing the status of a building. They also indicated a hierarchy. Buildings were roofed with tiles, straw or clay. The roofs of the most important buildings consisted of coloured, fired and glazed tiles, with colours strictly prescribed in accordance with the type of building concerned (Thilo 1978, p. 67). The type of roof ornamentation, the ridge endings and the lowest row of tiles were officially prescribed in accordance with a building's status.

7.5 Hierarchy

Fig. 7.22 Central section of the imperial palace, fifteenth century, Beijing, China (Forbidden City)

Fig. 7.23 Imperial palace (Forbidden City), Hall of Supreme Harmony (throne room), fifteenth century, Beijing, China

Wherever parts are joined together – whether they are houses, rooms or individual building elements – status differentiation, hierarchy, can emerge. On the large scale, structural hierarchy is often dictated by ideational significance, i.e. a building is designed to make a pre-existing ideational hierarchy visible. A church building, for example, must express the overarching dominance of the divine.

On smaller scales different ways of combining elements can also be used to emphasize certain aspects, i.e. create hierarchies. For example, in the illustration below (Fig. 7.24) we see four fields arranged in two rows, one on top of the other. These fields can be seen as representing a façade structure bordered by rod-shaped elements. There are different ways of combining these fields, each of which results in a different appearance and thus another statement. In case A the horizontal is dominant over the vertical: the two lower and the two upper units are joined respectively. Case B is the opposite. The vertical appears more important: the right-hand units belong together as do the left-hand

Fig. 7.24 Possible forms of hierarchy resulting from different arrangements of elements (for example in the design of a facade)

ones. In case C the separation between left and right is more pronounced. We see two independent vertical units, each of which is divided horizontally. In case E the autonomy of the four units is emphasized. In case F we have the opposite situation in that the independence of the four elements is diminished and their unity emphasized. In order to create the desired visual impression made by the juxtaposed units (cases A to F) the parts must be accordingly combined. Thus, for case D, where neither the vertical nor the horizontal elements are dominant, a non-directional construction for the joins needs to found. Every constructional decision, from the large to the small scale, has an influence on the hierarchy of parts and thereby on the overall appearance of a building. In this sense design cannot be considered as separate from construction. Every design encompasses construction and vice versa.

Hierarchy can be consciously taken to the point of absurdity in order to generate tension. In the case of a school designed by Livio Vacchini in Montagnola the roof on the transverse side of the two-storey building rests on five pillars, whereas the entire building load on the ground floor is supported by only two corner pillars (Fig. 7.25a). Common sense tells us that the lower storey has to bear a greater load and should therefore have more pillars. The hierarchy of load distribution no longer makes sense: it has been "inverted". This has been achieved by means of a technical trick. The balustrade on the upper floor functions as a supporting girder that is able to bear the load. The contradictory character of our visual perception of this arrangement is strengthened by the fact that the pillars on the upper floor are oversized in terms of statics. The way this statics system functions is only comprehensible to a specialist and, even in this case, such a solution seems counterintuitive. Laypeople suspect that the connection between load and

Fig. 7.25 Livio Vacchini, 1984, school building, Montagnola, Switzerland. The "illogical" arrangement of the pillars results in tension: **a** view of the courtyard, **b** detail near the entrance to the courtyard

bearing structure has been taken to the point of absurdity. As a result, a powerful tension is generated by the courtyard in spite of its strict and simple geometry. A similar situation is found in the area of the main entrance. On the ground floor a pillar stands in the middle of the transit area (Fig. 7.25b). It does not "have to" stand there in order to absorb a load from above. On the other hand, on the upper floor the pillars are in the position one would expect to find them in on the ground floor in order to ensure the transit area remains unhindered.

References

Ackerman, James S.: Palladio, Stuttgart, 1980 (original title: Palladio, Harmondsworth, 1966)
Arnheim, Rudolf: Kunst und Sehen, Berlin, 1978 (original title: Art and Visual Perception, Berkeley, 1954)
Brockhaus Enzyklopädie, Wiesbaden, 1969, vol. 8
Bucher, I.: Kulturhistorische Skizzen, Frankfurt am Main, 1851
Canival, Jean-Louis de: Aegypten, Fribourg, 1964
Fechner, Gustav: Vorschule der Ästhetik, Leipzig, 1876
Frampton, Kenneth: Die Architektur der Moderne, Stuttgart, 1983 (original title: Modern Architecture, London, 1980)
Frey, Dagobert.: Bausteine zu einer Philosophie der Kunst, Darmstadt, 1976
Grimal, Pierre: Mythen der Völker, vol. 1, Frankfurt am Main, 1977 (1967) (original title: Mythologies, Paris, 1963)
Gunzenhäuser, Rul: Maß und Information als ästhetische Kategorien, Baden-Baden, 1975 (1962)
Hitchcock, Henry-Russell und Johnson, Philip: Der Internationale Stil, Braunschweig, 1985 (original title: The International Style, New York, 1932)
Jencks, Charles: Late-Modern Architecture, London, 1980

Klotz, Heinrich und Cook, John W.: Architektur im Widerspruch, Zürich, 1974 (original title: Conversations With Architects, New York, 1973)

Le Corbusier: Ausblick auf eine Architektur, Berlin, 1969 (original title: Vers une architecture, Paris, 1923)

Moles, Abraham A.: Informationstheorie und ästhetische Wahrnehmung, Cologne, 1971 (1958)

Palladio Andrea, Die vier Bücher der Architektur, Zürich, (1570) 1983

Pevsner, Nikolaus: Europäische Architektur, Munich, 1967

Pólya, G.: Über die Analogie der Kristallsymmetrie in der Ebene (in: Zeitschrift für Kristallographie, 1924, no. 60)

Portmann, Adolf: Die Tiergestalt, Basel, 1960

Rasmussen, Steen E.: Architektur Erlebnis, Stuttgart, 1980 (original title: Omat opleve arkitektur, Kopenhagen, 1959)

Rykwert, Joseph: Ornament ist kein Verbrechen, Cologne, 1983 (original title: The Necessity of Artifice, London, 1982)

Schiller, Friedrich von: Sämtliche Werke, vol. 10, Stuttgart, 1844

Schuster, Martin and Beisl, Horst: Kunstpsychologie – wodurch Kunstwerke wirken, Cologne, 1978

Thilo, Thomas: Klassische chinesische Baukunst, Zürich, 1978 (1977)

Van Doesburg, Theo: Auf dem Wege zu einer plastischen Architektur, 1924 (in: Programme und Manifeste zur Architektur des 20. Jahrhunderts, Braunschweig, 1981)

Venturi, Robert: Komplexität und Widerspruch in der Architektur, Braunschweig, 1978 (original title: Complexity and Contradiction in Architecture, New York, 1966)

Vitruv: 10 Bücher über Architektur, Darmstadt, 1981 (ca. 30 BCE)

Wagner, Otto: Die Baukunst unserer Zeit, Vienna, 1979 (1895)

Weyl, Hermann: Symmetrie, Basel, 1981 (1955)

Wright, Frank Lloyd: Vortrag in London, 1939 (in: Humane Architektur, Berlin, 1969)

Aesthetics and Beauty

Contents

8.1	Aesthetics and Architecture	247
8.2	Beauty Through the Ages	250
8.3	The Point of Beauty	254
8.4	What is Beautiful? – the Sensation of Beauty	254
8.5	Fashion and Taste	259
8.6	The Measurability of Beauty	261
References		268

8.1 Aesthetics and Architecture

The word aesthetics comes from Greek and means perception. Aesthetics entails the investigation in the broadest sense of the way in which the environment is perceived and of the individual's position within this environment.

A painting is usually produced in a painter's studio. The painter's freedom in terms of what he or she can paint is, at most, limited by the size of the canvas. Once completed, the painting can been offered for sale; it is purchased by someone who likes it and finds the requested price acceptable. It is then seen for the most part only by people who want to see it: by the owner or by visitors to a museum or an exhibition.

The situation is different in the case of architecture. Here, the degree of freedom is restricted by factors such as utilization, construction, statics, financing, economics and building regulations. Aesthetics is not the only aspect that requires consideration when it comes to architecture; nevertheless, it plays a major role. The design process entails finding a balance between a range of factors, and the result is a compromise. Moreover, the completed building is necessarily seen by every visitor and passer-by.

© Springer Fachmedien Wiesbaden GmbH, part of Springer Nature 2020
J. K. Grütter, *Basics of Perception in Architecture*,
https://doi.org/10.1007/978-3-658-31156-8_8

Architecture is not produced in a vacuum: buildings are commissioned by clients and their planning is informed by various specialists and circumscribed by legal strictures and physical laws. As a result we often hear the complaint that "good" building is difficult to achieve today. However, it is also possible to agree with Pier Luigi Nervi's conviction that in spite of all these restrictions "there always remains a margin of freedom sufficient to show the personality of the creator of the work and, if he be an artist, to allow that his creation, even in its strict technical obedience, become a real and true work of art" (Nervi 1965, p. 187). Whether each building actually becomes a work of art is another matter. However, we can be certain that it is the intention of every "good" architect to create "good" architecture. The characterization "good" here can be understood as referring to, on the one hand, adherence to all the rules of building physics, economics, utilization, etc. and, on the other, a satisfactory aesthetic design.

Peter F. Smith distinguishes between three levels of aesthetic value. The development of an aesthetic, he argues, can be compared to the dynamics of oceans. On the surface there are waves with a very high frequency and small amplitudes which are sustained by much longer and deeper waves. Underneath these surface movements are deep currents involving large masses of water which are hardly affected at all by what is happening on the surface. The small waves can be seen as representing changes in fashion, while the large waves on which their existence depends represent the style of a particular cultural epoch. Underneath these two wave movements flow the deep currents of fundamental aesthetic values (Smith 1981, p. 208) (Fig. 8.1). The largest changes occur on the level of fashion. These changes follow one another in short time intervals and have a significant influence on prevailing tastes. The human brain, Smith argues, has the capacity to adjust very quickly when it comes to questions of fashion and taste. Fashion, he writes, is the foam floating on the actual culture (Smith 1981, p. 208).

Fig. 8.1 The 3 levels of aesthetic value (based on Peter F. Smith)

8.1 Aesthetics and Architecture

Each of these levels builds on the one below it. The latest currents of fashion are fluctuations in styles that in turn build on fundamental aesthetic values. As a whole the system is characterized by a certain degree of inertia. Changes on all three levels require a minimum period of time, which is shorter on the level of fashion than on the level of fundamental aesthetic values.

Temporary fashions are short-lived. They sound out the scope offered by the prevailing style. The elements of a fashion are weakly determined in the sense that they are subject to taste.

Changes on the intermediate level, the level of style, occur in the medium term. Style, according to Panofsky, has to do with the third level of architectural meaning (see Sect. 3.1). Style reflects the prevailing value system; it gives visual expression to intellectual values. New ideas are precipitated in stylistic development.

The aesthetic values associated with the third level have to do with the concepts of harmony, proportion, tension, rhythm, etc. They change very slowly; indeed, it is more appropriate to speak of a shift of focus than of change.

An alteration to the social value system will have little effect on fundamental aesthetic values. For example, in different epochs with different value systems the golden ratio has always been seen as an ideal proportion, although it has been utilized differently in different stylistic periods. In the Renaissance it was often employed to generate harmony, but less so in the Baroque, which was an epoch in which the emphasis was more on tension.

The fact that for a long time the work of engineers had nothing to do with art, and by extension taste, and therefore only had to meet the demands of utility is surely one of the reasons why the late nineteenth and early twentieth century were marked by so many outstanding achievements in the fields of ship, aircraft, car, bridge and warehouse construction. This was work that was not subject to short-term currents of fashion (Fig. 8.2).

Fig. 8.2 Car, Jaguar 1947

8.2 Beauty Through the Ages

For over two and a half thousand years thinkers have reflected on the question of beauty. From the beginning this reflection has been based on two approaches, a subject-based one, which regards the perception of beauty as dependent on the observer, and an object-based one, which regards such perception as dependent on what is being observed. This duality is a theme that extends up to the present.

For Plato (427–347 BCE) the perception of beauty was a question of the object, not of the observer. He distinguished between two types of beauty: on the one hand, that of nature and living things, and, on the other, that of geometry, the straight line and the circle. He regarded the beauty of nature as relative, the beauty of geometry, including that of objects created by human beings, as absolute.

Aristotle (384–322 BCE) subjectified the perception of beauty, arguing that the attitude of the beholder also played an important role. In Hellenism individual creativity shifted to the foreground. Architecture was regarded as the expression of mathematical beauty and based on harmony, symmetry and order (Naredi-Rainer 1982, p. 16).

Vitruvius (first century BCE) wrote that the construction of buildings had to take into account stability, utility and agreeableness. Beauty, he argued, was one of the three determining principles of architecture, along with durability and utility. Beauty was achieved "when the building has a pleasant and agreeable appearance and the symmetry of the component parts exhibits the correct symmetry calculation" (Vitruv 1981, p. 45). Vitruvius used the term symmetry in the sense of what we now call proportion. In his view a building was beautiful when its proportions accorded with certain rules. He summarized what he regarded as the aesthetic factors of architecture in six points (Vitruv 1981, p. 37):

(a) The size relationships of individual parts to one another and to the whole.
(b) The relationship of the parts to one another and their arrangement within the whole.
(c) The graceful appearance of the individual component parts and of the whole.
(d) The modular relationship of the individual components to one another and to the whole. A basic unit that is encountered everywhere on the building.
(e) The facilities that need to be adapted to the form of utilization.
(f) The appropriateness of materials and costs in light of the form of utilization.

For Vitruvius the experience of beauty was above all dependent on the observed object, not the observer. For Plotinus (205–270 BCE), in contrast to Plato, beauty could be experienced via the senses; its source lay in the soul, and the human being experienced it subjectively.

Augustine of Hippo (354–430) equated beauty with number in the sense that he believed it to be discernible in the form determined by number, a concept practically identical with Plato's idea of the beauty of geometry (Smith 1981, p. 21).

According to Leon Battista Alberti (1404–1472) beauty consisted in the congruence of all parts: nothing could be added, subtracted or changed without impairing the harmony of the whole. For him beauty was a concordance and harmony of parts resulting in a whole based on number, proportion and order, as required by *concinnitas*, the regulating law of nature as applied to the arts (Smith 1981, p. 23).

Following Vitruvius, Andrea Palladio (1508–1580) described beauty as one of the three elements that, along with utilization and construction, determine whether "a building is worthy of praise" (Palladio 1983, p. 20). Palladio adopted Alberti's view that beauty arises from the beautiful form and the correspondence of the whole to the individual parts, as it does from the correspondence of the parts to each other and of these in turn to the whole such that the building appears as a unitary and complete entity (Palladio 1983, p. 20). For Palladio beauty could only be experienced concretely in the context of architecture.

In the eighteenth century the concept of beauty became increasingly subjectified as witnessed by its association with terms such as "feeling", "taste" and "sensation". Beauty was linked with perception and the beholder was integrated into this process. The philosopher Alexander Gottlieb Baumgartner (1714–1762) established the concept of aesthetics as one that could be regarded as parallel to the concepts of "ethics" and "logic". The significance of reason for ethics paralleled that of taste for aesthetics. Taste, feeling and sensation were now integrated into the doctrine of beauty (Brockhaus Enzyklopädie 1967, p. 811).

Immanuel Kant (1724–1802) believed that it was taste alone that determined what was and was not beautiful. What is deemed beautiful, he argued, is that which places perception in a harmonious state. The beauty of a form should be perceived independently of thinking (Brockhaus Enzyklopädie 1967, p. 806).

Drawing on Plato and Kant, Georg Friedrich Wilhelm Hegel (1770–1831) distinguished between two types of beauty: natural beauty and artistic beauty, but regarded the latter as superior to the former, "for the beauty of art is beauty born and reborn of the spirit" (Hegel 1967, p. 20). For Hegel the perception of artistic beauty is not innate or instinctive but must be learned. The educated sense of beauty was what he called taste. Adorno criticized Hegel's distinction between natural and artistic beauty on the grounds that art and nature could not be separated (Adorno 1974, p. 267).

The philosopher and mathematician Bernard Bolzano (1781–1848), a contemporary of Hegel's, also opposed the latter's theory, arguing that the recognition of beauty did not require mental work: "An object can be called beautiful if the mere contemplation of it is capable of bringing us pleasure, contemplation that comes so easily to us that not even in a single case do we need to become clearly conscious of the individual thoughts" (Bolzano 1972, p. 16). Every augmentation of our powers, he argues, is perceived as pleasure, every diminution of them as pain. In this view, the recognition of beauty is achieved without great effort and augments our powers.

In 1860 Gustav Fechner (1801–1887) attempted to quantify the relationship between a stimulus as information and its assimilation by the recipient, making perception a

scientific discipline (Fechner 1860). According to his theories, the sensation of beauty is dependent on both the object, i.e. the thing that is observed, and the subject, i.e. the observer.

As already discussed, Plato distinguished between two types of beauty, that of nature and that of geometry. And since Plato this dual concept of beauty has been retained. Hegel's aesthetic philosophy is also based on a duality, in his case between natural and artistic beauty. The concepts have changed over the centuries, from Plato's "beauty of geometry" to Hegel's "artistic beauty" to Le Corbusier's "engineer's aesthetic", but their meaning, or their content, has fundamentally remained the same (Fig. 8.3).

The dichotomy between nature and what humans create reflects the struggle of human beings armed with their tools, which we today call technology, against the forces of nature. Significantly, this way of thinking is purely Western. In Eastern philosophies the two poles are not seen as in conflict with one another but rather as mutually supplementary. Indeed, one of the major concerns of Zen Buddhism is bridging this dualistic thinking. The artificial, i.e. what is built by people and the technology used to build it, and the natural are not opposites but a unity. This principle was also a major concern of the advocates of Japanese Metabolism, who attempted to make an architectural contribution to overcoming the technology-nature conflict.

Fig. 8.3 The engineer's aesthetic and natural beauty: **a** Charles Fowler, 1828–32, Covent Garden, The Market Building, London, UK, **b** orchid

In modern architecture the two ideals of beauty are perhaps most readily evident in the different conceptions of beauty that inform the work of Frank Lloyd Wright and the early Le Corbusier. The former derived his concept of beauty from nature, while the latter, as a champion of modern technology, found beauty in the forms of modern engineering products.

Frank Lloyd Wright speaks of beauty in connection with flowers: "This structure proceeds from the general to the particular in a most inevitable way, arriving at the blossom to proclaim in its lines and for the nature of the structure that bore it. It is an organic thing. Law and order are the basis of its finished grace and beauty: its beauty is the expression of fundamental conditions in line, form and colour, true to them, and existing to fulfil them according to design" (Wright 1969, p. 65). Nature fascinated Wright not only because of its visible variety of forms and colours. For him natural beauty was characterized above all by conformity to laws and order, balance and unity. "When we perceive a thing to be beautiful," he writes, "it is because we instinctively recognize the rightness of the thing" (Wright 1969, p. 66). This means that we also recognize and accept its conformity to laws and order. Or, in the words of Otto Wagner, "An impractical thing cannot be beautiful" (Wagner 1979, p. 31). Adolf Loos expressed a similar idea when he wrote, "By beauty we understand the highest perfection; that is why an object that is not practical could not possibly be beautiful" (Loos 1981, p. 82). He even went so far as to claim, "Finding beauty only in the form rather than making it dependent on the ornament is the goal to which all of humanity aspires" (Loos 1981, p. 97).

In 1923 Le Corbusier compared the beauty of architecture with the aesthetic of cars, aircraft and ships, which he referred to as the engineer's aesthetic: "The engineer's aesthetic and architecture are two things that march together and follow one from the other: the one being now at its full height, the other in an unhappy state of retrogression. The engineer, inspired by the law of economy and governed by mathematical calculation, puts us in accord with universal law. He achieves harmony. The architect, by his arrangement of forms, realizes an order which is a pure creation of his spirit; by forms and shapes he affects our senses to an acute degree and provokes plastic emotions; by the relationships which he creates he wakes profound echoes in us, he gives us the measure of an order which we feel to be in accordance with that of our world, he determines the various movements of our heart and of our understanding; it is then that we experience the sense of beauty" (Le Corbusier 1969, p. 21). Le Corbusier's admiration for large ships, cars and airplanes led him to claim: "The house is a machine for living in" (Le Corbusier 1969, p. 80). Moreover, he argued: "Were the problem of dwelling and the apartment so thoroughly studied as the chassis of an automobile, we would soon see a transformation and improvement of our housing. If houses were produced in series by industry like chassis, we would very soon see surprising yet sound, reasonable forms emerge and the corresponding aesthetic would also formulate itself with astounding precision" (Le Corbusier 1969, p. 105). However, soon afterwards Le Corbusier began losing his enthusiasm for the machine age.

The two conceptions of beauty as based either in nature or in human creativity have also played a significant role in the history of painting. In 1910, in his "Technical Manifesto", Umberto Boccioni claimed that a racing car was more beautiful than the "Nike of Samothrace" (Tavel 1984, p. 14), the statue of the Greek goddess of victory now standing in the Louvre in Paris. Influenced by Cubism, both Mondrian and Doesburg painted purely geometric pictures early in their careers. Fernand Léger described the laws of geometryas the origin of aesthetics, arguing that architecture from the ancient Greeks to the present followed geometric laws (Léger 1970, p. 53). Surprisingly, technology played a secondary role for Kazimir Malevich, who is regarded as the founder of abstract painting: "If we compare artworks with products of practical technology from different epochs, we will see that the artworks maintain their worth even when they belong to the past while the products of technology lose their worth as they age" (Tavel 1984, p. 15).

8.3 The Point of Beauty

Why beauty? What are the reasons for seeking out beauty? In his book "Civilization and Its Discontents", which was published in 1930, Sigmund Freud attempted to explain the meaning of beauty as follows: "Life, as we find it, is too hard for us; it brings us too many pains, disappointments and impossible tasks. In order to bear it we cannot dispense with palliative measures" (Freud 1970, p. 73). According to Freud, suffering and discontent are above all a consequence of the non-satisfaction of instinctual drives. One way of alleviating this discontent, he argues, is to make oneself independent of the world and seek gratification in internal psychological processes. This facilitates the displacement of drives such that their fulfilment is independent of the outside world. He describes the enjoyment of artworks as bearers of aesthetic values as one possible form of phantasy gratification: "Gratification is gained from illusions that are recognized as such without their deviation from reality detracting from their enjoyment" (Freud 1970, p. 78). However, the gratification provided by the enjoyment of art, he argues, is much weaker than the direct gratification of drives: "Art affects us as a mild narcotic and can provide only a temporary refuge for us from the hardships of life" (Freud 1970, p. 78). Art is always connected with beauty, which is therefore seen indirectly by Freud as a palliative measure. As an element of culture, beauty is indispensable for the human being. This is evident in the fact that people everywhere seek and have always sought to beautify their surroundings.

8.4 What is Beautiful? – the Sensation of Beauty

The experience of beauty is relatively new for human beings. It is predominantly a function of the front part of the brain, which only became fully developed some 40,000 years ago. The evaluation of something as beautiful or not beautiful is an extremely

complicated process, one that is informed by not only the characteristics of an object, for example proportions such as the golden ratio, but also the personality structure of the beholder, his psychological state at a specific moment, his character, his social milieu and his cultural background. These so-called socio-psychological aspects (see Sects. 1.4 and 3.6) exert a fundamental influence on perception and thus co-determine every individual's experience of beauty.

Drawing on the work of Carl Gustav Jung, the British psychologist Hans Jürgen Eysenck argues that introverted individuals tend to control their feelings with their intellect to a greater degree than the extrovert does (Eysenck 1947). In the case of introverts a small amount of information triggers reactions, while for extroverts boredom sets in more quickly. The former more readily perceive complexity and are therefore more quickly satiated. They prefer architecture in which a certain degree of order and balance predominates. The psychologist Cyril Burt, one of Hans Jürgen Eysenck's teachers, additionally distinguishes between stable and unstable introverts and extroverts (Schuster and Beisl 1978, p. 165), and Jean Cardinet attempts to delineate the different perceptual preferences characterizing these four types (Cardinet 1958, p. 45–69). Burt's and Cardinet's results can be summarized as follows (Figs. 8.4 and 3.12):

The stable and introverted type prefers visible order and tends to reject movement and emotional expression. He confronts the object from an intellectual distance.

The unstable introverted type prefers abstract presentations that include a certain degree of order.

The stable extroverted type does not like abstraction or designs that are too simple and has a preference for functionality.

The unstable extrovert loves movement, aggression and emotionalism.

Information theory attempts to establish what is beautiful in purely objective terms by mathematical means. If the amount of aesthetic information in a message is sufficiently large for the recipient to form super-signs that order his perception and shift it to a higher level, he will perceive the object as beautiful. "Beautiful" objects facilitate optimal perception. They have a gratifying effect; they function, as Freud would put it, as "palliative measures" (see Sect. 1.3.3).

The degree of originality must exceed receptive capacity to a small degree on several levels. Aesthetic gratification thus consists in part in the fact that ordered relationships are discovered in a stimulus configuration that is initially experienced as unordered or chaotic (Dörner and Vehrs 1975, p. 321–334). Perception shifts onto hierarchically higher levels as long as the recipient, due to his mentality and the way he has been culturally structured, is able to form further super-signs. This mechanism also explains why we are always discovering new things in an image, why our reaction to an object can change, and why different people attach different degrees of aesthetic value to an object. Experience, knowledge and socio-psychological aspects play important roles in the process of aesthetic evaluation. If the beholder is familiar with the respective style or fashion, then the process of forming super-signs will be easier.

Fig. 8.4 Connection between beholder's personality structure and perceptual preferences

The sensation of beauty and originality are connected, and the latter is in turn connected with unpredictability. As a result, following the initially powerful impression made by an object the sense of originality abates and this may lead to a diminution of the aesthetic effect. On the other hand, the repeated perception of something can result in a learning process which leads to greater understanding and thus a more intensive aesthetic experience (see Fig. 1.6).

As discussed in Sect. 1.2.4, semantic information communicates concrete facts; it teaches us something. Aesthetic information tends to speak to our feelings and is partly responsible for the perception of beauty.

There are a great many occurrences and objective qualities that generate a sensation of beauty in the beholder. Peter F. Smith distinguishes between four fundamentally

8.4 What is Beautiful? – the Sensation of Beauty

different types of aesthetic experience (Smith 1981, p. 17). All people have a natural, innate capacity to react to special forms, sounds, colours and rhythms. Balance and harmony are automatically perceived as such by the beholder and experienced as beautiful. This effect can be achieved with regularities, equilibrium and good proportions.

Smith refers to this capacity as "first order aesthetics", and cites the facades of many of Palladio's villas as an example (see Fig. 8.5). Another aspect that can lead to the sensation of beauty is the tension between difference and similarity. Peter F. Smith refers to this as "second order aesthetics": the perception of a basic structure which is subjected to complex variations. A case in point is the church in Ronchamp built by Le Corbusier in 1950. Although the building is made up of the usual structural components of a church – a belfry, walls and a roof – these elements are formed in such an unconventional way that the resulting contradiction of what the viewer expects generates complexity (see Fig. 5.17b).

The combination of individual parts to form a whole also generates a sensation of beauty, a phenomenon Peter F. Smith terms "third order aesthetics" and which he sees as a combination of the first and second order variants.

The observation of numerous details which are difficult to classify on account of their variety and complexity can also be satisfying and generate a sensation of beauty. This type of perception corresponds to "fourth order aesthetics", which is often linked to the second and third order variants. The type of information processing involved here is for the most part done by the brain's limbic system, which is also where emotions are processed (Fig. 8.6).

Other special aspects of the object can have an influence on the experience of beauty, such as knowledge of the historical background of a building. The relatively small tomb of the Achaemenid ruler Cyrus the Great lies in a remote part of the Iranian Plateau near

Fig. 8.5 Andrea Palladio, 1566–69, Villa Almerico Capra Valmarana (La Rotonda), Vicenza, Italy

Fig. 8.6 Street in Shanghai, China

Pasargad (see Fig. 7.3). The knowledge that this site is the burial place of the ruler of a vast empire lends it a certain aesthetic value for the observer. Similarly, the Taj Mahal in India, built by the Mughal emperor Shah Jahan to honour his favourite wife, has a particular effect on the observer that goes beyond its formal qualities. The knowledge that Shah Jahan wanted to built an identical structure in black marble as a tomb for himself directly opposite the Taj Mahal on the other side of the river and as a result was overthrown by his son, who wanted to save the ruling dynasty from bankruptcy, imbues the building with an additional, particular quality.

Many old buildings that have neither special formal characteristics nor historical reference points nevertheless strike us as beautiful. Peter F. Smith argues that human beings have repeatedly sought to find comfort in the face of their own mortality by constructing

Fig. 8.7 The so-called Roman Ruin built in 1787 in the park of Schönbrunn Palace in Vienna, Austria

works of art that symbolize permanence and thereby reveal an acceptable aspect of the aging (Smith 1981, p. 166). As a symbol of the eternal, the age of a building can thus have a positive effect on our sense of beauty. Dilapidated buildings whose age is evident have always also been a theme of architecture, as seen in Romanticism, where we find instances of "ruins" actually being constructed as ruins (Fig. 8.7).

8.5 Fashion and Taste

One of the most important factors influencing our sense of beauty is the prevailing cultural model: the fashion or currently accepted style (Fig. 8.1). We often have difficulty finding art from other cultures beautiful. For instance, many Western listeners experience traditional Indian music as monotonous and boring. The Gothic building style, which is today considered a cornerstone of European cultural history, was for a long time seen as barbaric and unattractive. This was an opinion in part shaped by Giorgio Vasari, an important sixteenth-century architect who was highly critical of the multitudinous ornamental niches bedecking Gothic buildings, which, he argued, created an impression of extreme instability and interlacing surfaces that seemed constructed of paper rather than brick or marble (Hofstätter 1968, p. 43). In 1772 Goethe was one of the first to rediscover the power of Gothic architecture, in his case when confronted with the spectacle of Strasbourg Cathedral. He wrote that the building's dignity and magnificence instilled in him a powerful impression consisting of thousands of individual harmonizing components, which, as a result of their sheer multitude, he could savour and enjoy but not differentiate or explain (Goethe 1965, p. 21).

Every fashion or style offers a certain scope for variation. If the prevailing level of tolerance of novelty is exceeded, the reaction is often negative. Because a work is no longer in keeping with the prevailing norms, it can no longer be perceived as beautiful. Think of all the painters who today, after their deaths, are famous but during their lifetimes were unaccepted and unknown. On the level of fashion, but less on the level of style, beauty is to a certain degree relative, dependent on certain subjective factors. On the level of fashion the idea of beauty can change quickly. This is probably most obvious in the case of clothing fashions. Here, the opinion of what is beautiful can change diametrically within the space of a single year.

Taste, like personality structure, has a fundamental influence on the perception of beauty. Taste is something very subjective and personal: "There's no accounting for taste." This means in turn that the assessment of aesthetic quality, of beauty, is ultimately subjective. Everyone can have their own opinion in accordance with their particular taste. In his lectures on aesthetics, Hegel states, "Given the aforementioned lack of a criterion for the endless forms of nature, when it comes to the choice of objects and their beauty and ugliness the ultimate arbiter is mere subjective taste, which does not permit itself to be bound by rules or to be open to dispute" (Hegel 1967, p. 70).

Beauty is not perceived directly via the senses in the way that, say, cold or noise is. Hegel argues that our sense of beauty "is not a blind instinct specifically determined by nature, one that is capable of intrinsically distinguishing what is beautiful." Our sense of beauty, he says, requires cultivation, and this cultivated sense is what we call taste (Hegel 1967, p. 57). What we perceive as beautiful is determined by taste, which is in turn trained. This ultimately means that a sense of beauty can be learned and instilled. Such a conclusion can be seen as providing support for the argument that, rather than according with the tastes of the client, architectural designs should above all aim to achieve the greatest possible aesthetic value. As Theodor W. Adorno writes, "The strongest pillar of subjective aesthetics, the concept of aesthetic feeling, derives from objectivity, not the reverse" (Adorno 1974, p. 246).

This is not an opinion shared by everybody. The English poet and politician Joseph Addison (1672–1719) argued that taste should not follow art but that art should follow taste (Germann 1980, p. 217). One of the most prominent proponents of this opinion was the architect Morris Lapidus, who happily accepted the charge that his architecture was kitsch and promoted a mediocrity of taste. For Lapidus the task of the architect was not to improve people's taste but to build what the average person liked. (Klotz und Cook 1974, p. 202).

On the façade of the Team Disney Building built by Michael Graves in Burbank in 1991 giant sculptures of dwarves serve as columns (see Fig. 3.4b). Is this a building responding to prevailing public taste? Or are we dealing here with kitsch?

But what is kitsch? Theodor W. Adorno writes, "In the history of art, the dialectic of the ugly has drawn the category of the beautiful into itself as well; in this respect, kitsch

is the beautiful as the ugly, tabooed in the name of the same beauty that it once was and that it now contradicts because of the absence of its own opposite" (Adorno 1974, p. 77). Kitsch is ugliness presented in accordance with the rules of beauty, whereby non-existent feelings are simulated. "Kitsch is art that cannot or does not want to be taken seriously and yet, by virtue of its appearance, postulates aesthetic earnestness" (Adorno 1974, p. 466). However, because the rules of beauty can change it is possible for kitsch to become art and vice versa. For example, for a long time naïve art was not accepted as art and derided as kitsch. On the other hand, such derision can also result from all too frequent repetition or imitation, which depletes originality to such an extent that the work or object in question ultimately becomes marked by such a high degree of redundancy that it is no longer interesting.

8.6 The Measurability of Beauty

For more than 150 years, attempts have been made to quantify beauty by empirical means. Using experiments and questionnaires, we can determine who finds what pleasing. For example, it has been shown that both women and men find faces with a high degree of symmetry more beautiful than less symmetrical ones.

The American mathematician George David Birkhoff actually attempted to develop a method of calculating aesthetic measure. Between 1928 and 1932 Birkhoff wrote four papers on problems of perception in which he attempted to compare objects such as vases, simple drawings, spoken poetry and musical compositions from an aesthetic point of view. In this endeavour, Birkhoff focused purely on the object itself, excluding the effect of the personality structure of the perceiver.

An object is perceived as a combination of signs. This requires effort on the part of the beholder, the degree of which differs according to the object concerned. The degree of effort is directly proportional to certain qualities of the object, which Birkhoff denotes as complexity (C) and regards as quantifiable. The value arrived at quantifies the degree of effort entailed in sensory perception.

According to Birkhoff, in order to be able to better control perception when regarding an object, the beholder looks for ordering principles. Finding such principles is a precondition for the emergence of a feeling of pleasure. Such ordering principles can include, for example, sequence and symmetry. The numerical quantity O is a measure of the concentration of such ordering principles. Birkhoff defines aesthetic measure (M) as the ratio of order to complexity: $M = O/C$ (Gunzenhäuser 1975, p. 25).

To determine the measure of the complexity C of a vase, Birkhoff first determined so-called characteristic points, which are points on the contour curvature that draw the particular attention of the observer. Essentially these are:

(a) The four points marking the limits of the contour
(b) The points on the contour with horizontal and vertical tangents
(c) End points in the contour
(d) Break points
(e) The points on the axis intersected by the maximum or minimum radius of the contour.

In order to determine the measure of order O Birkhoff defined four elements. Here he proceeded from the fact that horizontal and vertical lines that are of the same length or have a ratio of 1:2 particularly draw the observer's attention:

(a) Number of such ratios between vertical lines running through characteristic contour points (V)
(b) Number of such ratios between horizontal lines running through characteristic contour points (H)
(c) Number of such ratios in a vertical and horizontal direction, whereby the ratios already counted under a) and b) are no longer taken in consideration (HV)
(d) Number of such ratios between tangent directions running through characteristic contour points (T) (see Fig. 8.8).

The aesthetic measure M is arrived at using the formula in Fig. 8.8 (Gunzenhäuser 1975, p. 40).

Birkhoff tested his formula above all on musical and poetic works, but also on pieces of jewellery and vases, and it is his attempt to determine the aesthetic measure of vase forms that is discussed here as a representative example. He focused exclusively on the contours of rotationally symmetric vases. Decoration, surface structure and handles were not considered (Gunzenhäuser 1975, p. 39) (Fig. 8.9).

The example shows how even determining the values of O and C allows for different interpretations. Birkhoff himself admitted that the determination of the ratios permitted certain tolerance margins and that even in the case of such simple vase forms the calculation of the aesthetic measure required a degree of experience.

If, in order to determine the aesthetic mass of the entire vase, surface structure and decoration are now included in the calculation, the overall determination already becomes dependent on so many interpretable factors that it can no longer be objective.

$$M = \frac{H + V + HV + T}{C}$$

Fig. 8.8 Formula for the calculation of aesthetic measure (M) (based on George David Birkhoff)

8.6 The Measurability of Beauty

| M = 0.58 | M = 0.67 | M = 0.70 | M = 1 |

Fig. 8.9 Vase forms and their aesthetic measure (based on George David Birkhoff)

The applicability of the formula is limited, and it does not suffice as the basis for a comprehensive theory of the perception of beauty. The formula is restricted to the semiotic aspect and therefore cannot provide a comprehensive aesthetic value. The beholder and his specific qualities are not integrated into the process (see Sect. 1.4). Birkhoff can evaluate the composition of a piece of music but not its interpretation by a musician and certainly not the aesthetic feeling that each individual listener experiences. He was aware of the shortcomings of his theory and later supplemented it with further rules which consist of five theses (Gunzenhäuser 1975, p. 67):

(a) If an object has symbolic value for the beholder, the aesthetic measure can no longer be measured with the above formula.
(b) If an object has a recurring ordering element, it cannot be evaluated using its actual frequency.
(c) If certain ordering elements are only almost maintained (e.g., if an angle is 42° instead of 45°), the calculated value M will not accord with the feeling of pleasure.
(d) Every instance of perception requires a highpoint, a centre or an endpoint at which it can be concluded.
(e) If two objects with identical O values but different C values are compared, the M magnitudes resulting in reality are no longer inversely proportional to the two C magnitudes as calculated mathematically.

Birkhoff was initially of the opinion that the higher the aesthetic measure, the greater was the degree of enjoyment: the least possible complexity combined with the greatest possible order. However, other scholars came to different conclusions. In 1941 H. J. Eysenck argued that the aesthetic measure M consisted of the product of C and O. However, this hypothesis was also not confirmed by empirical experiments.

Birkhoff's formula cannot be used to determine the aesthetic measure of architectural spaces. The number of elements defining the space is too large, making an objective selection impossible. Elements such as light and movement are very difficult to integrate

into the Birkhoff formula. Moreover, as already mentioned, the socio-psychological background of the beholder is not taken into account. Calculating beauty using Birkhoff's method seems possible only within a very restricted scope, one for which architectural space is far too complex.

Nevertheless, Birkhoff's findings do tell us something about the appearance of our environment. There is a connection between, on the one hand, the type of arrangement and the complexity of the perceived elements and, on the other, the aesthetic expression of the whole.

In psychology different behaviour patterns that depend on several factors can be represented with a Gaussian curve. For example, the connection between stress and achievement: a certain amount of stress will increase achievement, but when a particular limit is exceeded, the level of achievement declines. It is probably correct to assume that there is no linear dependency between pleasure and complexity or order and that the relation can be represented by a curve with an optimum at $M=1$ (see Fig. 8.10).

The aesthetic measure $M=1$ requires a balanced relationship between the measure of order O and the measure of complexity C. When the measure of order is high, i.e. when there are many ordering reference points, the degree of complexity must also be high so that the two magnitudes produce a quotient of 1.

The individual parts can be arranged in very different ways, and the measure of order can accordingly be larger or smaller (Fig. 8.11). For example, the measure O will be greater in the case of a balanced or symmetrical arrangement than in the case of an unbalanced or asymmetrical one. It is similar in the case of the formal qualities of the object which Birkhoff refers to as complexity (C) (Fig. 8.12). The greater the perceptual effort of the beholder the greater this complexity is. For example, we know that closed, integrated forms are more easily perceived than open, unfinished ones. Irregular forms have more informational content than regular ones. That means that their complexity is greater and therefore also the effort expended in perceiving them.

The following examples are meant to illustrate tendencies. The figures used are estimates and have not been calculated. The images are segments selected to support the accompanying statements, and therefore no conclusions can be drawn about the aesthetic quality of the entire buildings.

Figure 8.13 shows two extremes: to the left a facade segment, to the right an interior space. The degree of order in Fig. 8.13a is very high, in Fig. 8.13b very low. The complexity of the parts is very low in the facade segment: in formal terms the discernible elements are very similar and are all the same colour. In the image to the right (Fig. 8.13b), we find the opposite case. Here we are confronted with many different parts, different

Fig. 8.10 Aesthetic measure $M=1$ indicates a balanced relation between O and C

$$M = \frac{O}{C} = 1$$

8.6 The Measurability of Beauty

BALANCE

SYMMETRY

HIERARCHY

GRID

DIRECTIONAL

VERTICAL-HORIZONTAL

STRAIGHT-CURVED

ECT.

Fig. 8.11 Criteria for the measure of order O

colours and different orientations: the degree of complexity is high. The result is a rather high aesthetic measure M to the left and a rather low one to the right. The image to the left (Fig. 8.13a) is rather boring, and to make it more interesting the high measure of order would have to be combined with a higher level of complexity. Conversely, the image to the right seems rather chaotic (Fig. 8.13b): here the measure of order is very low while the measure of complexity is very high.

Basically, an aesthetic measure with a value of 1 can be attained in two ways. In Fig. 8.14a both the measure of complexity and the measure of order are relatively low. In Fig. 8.14b we see a high measure of complexity as well as a high measure of order.

Fig. 8.12 Criteria for the measure of complexity C

The question as to which of the two perceptions is experienced as more beautiful also depends on the personality structure of the observer (see Fig. 8.4 and Sect. 8.4). A stable, introverted person has a preference for calm, ordered and unemotional perceptual experiences and in this case would probably prefer Fig. 8.14a. By contrast, an extroverted person who tends to be unstable will prefer a dynamic, aggressive and emotional representation, i.e. in this case Fig. 8.14b. In Sect. 3.4 we saw that as styles

8.6 The Measurability of Beauty

Fig. 8.13 Examples of high and low values for the aesthetic measure M (highly simplified). **a** Philip Johnson, 1982, office building in San Francisco, USA, **b** Peter Behnisch, 1987, university library, Eichstätt, Germany

Fig. 8.14 Two examples of an aesthetic measure $M = 1$ (highly simplified). **a** Ando Tadao, 1993, conference centre, Weil am Rhein, Germany, **b** Abbey Library, 1758–67, St. Gallen, Switzerland

develop over the course of time the degree of order constantly becomes more complex until a point is reached where orientation becomes difficult and there is a return to a simpler system.

Beauty cannot be precisely measured in mathematical terms. Nevertheless, it is possible to make different statements on this subject. Different perceptual patterns will be experienced as beautiful depending on the personality structure of the beholder and socio-psychological aspects. In this process the degree of order and complexity involved in the perceptual experience plays a decisive role.

References

Adorno, Theodor W.: Ästhetische Theorie, Frankfurt am Main, 1974 (1970)
Bolzano, Bernard: Untersuchungen zur Grundlegung der Ästhetik, Frankfurt am Main, 1972 (ca. 1830)
Brockhaus Enzyklopädie, Wiesbaden, 1967, vol. 1
Cardinet, J.: Préferences esthétiques et personnalité, (in: Année Psychologique, 58/1958)
Dörner, D. and Vehrs, W.: Ästhetische Befriedigung und Unbestimmtheitsreduktion (in: Psychological Revue, 37/1975)
Eysenck, H. J.: Dimensions of Personality, London, 1947
Fechner, Gustav: Elemente der Psychophysik, Leipzig, 1860
Freud, Sigmund: Das Unbehagen in der Kultur, Frankfurt am Main, 1970 (1930)
Germann, Georg: Einführung in die Geschichte der Architektur, Darmstadt, 1980
Goethe, Johann Wolfgang: Schriften zur Kultur, Zürich, 1965 (1772)
Gunzenhäuser, Rul: Maß und Information als ästhetische Kategorien, Baden-Baden, 1975 (1962)
Hegel, Georg F. W.: Einleitung in die Ästhetik, Munich, 1967 (1835)
Hofstätter, Hans H.: Gotik, Fribourg, 1968
Klotz, Heinrich and Cook, John W.: Architektur im Widerspruch, Zürich, 1974 (Original title: Conversations with Architects, New York, 1973)
Le Corbusier: Ausblick auf eine Architektur, Berlin, 1969 (Original title: Vers une architecture, Paris, 1923)
Léger, Fernand: Fonctions de la peinture, Paris, 1970 (1965)
Loos, Adolf: Ins Leere gesprochen, Vienna, 1981 (1921)
Naredi-Rainer, Paul von: Architektur und Harmonie, Cologne, 1982
Nervi, Piere Luigi: Aesthetics and Technology in Building, Cambridge, Mass., 1965
Palladio, Andrea: Die vier Bücher zur Architektur, Zürich, 1983 (1570)
Schuster, Martin and Beisl, Horst: Kunstpsychologie – wodurch Kunstwerke wirken, Cologne, 1978
Smith, Peter F.: Architektur und Ästhetik, Stuttgart, 1981 (Original title: Architecture and the Human Dimension, London, 1979)
Tavel, Hans Christoph von: Die Sprache der Geometrie, Bern, 1984
Vitruv: 10 Bücher über Architektur, Darmstadt, 1981 (ca. 30 BCE)
Wagner, Otto: Die Baukunst unserer Zeit, Vienna, 1979 (1895)
Wright, Frank Lloyd: exhibition catalogue, Florence, 1951 (in: Humane Architektur, Berlin, 1969)

Movement and Path

9

Contents

9.1 Movement 269
9.2 Time.................. 273
9.3 On the History of Movement in Art and Architecture 275
9.4 Dynamism 278
9.5 Rhythm................ 286
9.6 Path 288
9.7 Axis and Direction....... 297
References................ 299

9.1 Movement

At first glance, movement and time would seem to have nothing to do with architecture. True, buildings are also subject to the "ravages of time", but, compared with the duration of a human life, for the most part, even today, they endure for a long time. Unlike music and dance, for example, architecture does not include the temporal dimension. A piece of music has a beginning, lasts for a certain time span and then ends at a precisely defined point in time.

Buildings are static, immobile; only certain parts of them such doors and windows can be moved. Ballet dancers move in accordance with predetermined rules; it is through movement that they express themselves. Architecture, by contrast, requires movement on the part of the beholder; in order to fully experience a space, he or she must move within it. This requires time, thereby making time the fourth dimension of spatial perception.

Movement is relative. When we look out the window of a moving train, we get the impression that the landscape is racing past us. We perceive ourselves as standing still

and our surroundings as moving although we know that reality is otherwise. If the train is standing still in a railway station and our view through the window shows us only the train on the adjacent track, when one of the trains starts to move we cannot tell which of them is moving, our train or the one on the adjacent track. This question can only be answered if we have further reference points, for example the railway station building, which we know cannot move. If two trains move out of the station next to one another at the same speed and in the same direction, an observer in one of the two trains will not be able to discern whether they are moving at all. He needs further reference points, for example the wider surroundings or the jolting of the wheels on the tracks. The effect of relative movement can be used quite deliberately in architecture. In the various revolving panorama and skyline restaurants found on mountain tops and high-rise buildings an illusion is created of the surroundings passing the "stationary" observer, who no longer perceives his own movement. A similar effect is experienced by a driver passing though a narrow street or someone using an escalator or a glass-walled elevator. However, in these cases the effect is not as pronounced because one's own movement is linked with activity or is at least clearly perceivable.

The Italian psychologist Fabio Metelli deduced the optical perception of different forms in motion based on their contours and arrived at two propositions:

(a) A physically moving point that corresponds chromatically to all moving or stationary points on its trajectory cannot be perceived as moving. Thus, for example, a point on a circle rotating around its centre is not perceived as moving. Metelli characterizes the boundary of such a figure as kinetically ineffective.
(b) A physically moving point that that does not correspond to all moving or stationary points on its trajectory cannot be perceived as continually at rest. Metelli characterizes the boundary of such figures as kinetically effective (Metelli 1965, p. 85) (Fig. 9.1).

A movement can only be perceived by a person when it is neither too fast nor too slow. The hand on a clock traces a circle once in twelve hours. We can discern that it has

Fig. 9.1 Kinetically ineffective (**a**) and effective (**b**) contours (based on Metelli)

9.1 Movement

changed its position after some time, but the speed of its movement is too slow to be perceived by the observer. On the other hand, the tips of a propeller move so fast that we are no longer able to see them.

Like movement, speed is also relative. The perception of movement and thus also of speed is based on two principles: The moving object is tracked by the eye, meaning that a projection of the object remains on the retina at the same place, or the eye rests during the perceptual act on another object so that the projection of the first, moving object moves on the retina. In the second type of perception the speed of movement is perceived as somewhat greater than in the first (Metzger 1975, p. 572). In the optical perception of movement both types are usually involved simultaneously: Although the eye tracks the moving object, it does not do so precisely. In addition to these two possible ways of perceiving movement and speed, there exists a third, which involves so-called kinaesthetic perception (see Sect. 1.3.7). This type of perception is not visual and is only actively operational when the observer is moving.

Perceived speed is also relative insofar as it is directly dependent in the type of moving object. If a racing car and a horse and cart move forward at the same speed, we perceive the cart as moving very quickly and the racing car as moving rather slowly.

Movement can also be perceived where it actually does not exist. A film is a sequence of stationary images each of which is a little different from the previous one. Because the images follow one another so quickly (in the normal case at a rate of 24 images per second) that we no longer see them individually, the observer perceives the difference between them as movement.

In Sect. 1.3.7 it was explained that we do not perceive movements as equivalent in all directions. A movement from left to right seems to the observer to be more effortless than one from right to left. Horizontal movements are simpler to perceive than vertical ones, and in the latter case, due to the existence of gravity, a downward movement is perceived as easier than one in the reverse direction. The third spatial coordinate concerns forwards and backwards. A forward movement appears easier because it is goal-oriented and points to the future. In information-theoretical terms a forward movement tends to be associated with originality, a backward movement with redundancy. This means that curiosity tends to drive us forward to a greater degree than the familiar draws us back.

One of the most important principles of sensory perception is the fact that an aware subject must become active in order to perceive something. Here it is important to note that the more static the stimulus configuration of what is to be perceived, the more active the beholder needs to become, while the more movement exhibited by the stimulus configuration, the more passive the beholder is. When watching a film the beholder is not required to employ any gross motor skills; the eyes are the only organs that need to be moved. The opposite applies when experiencing architecture. The object being observed is static and therefore requires a greater degree of activity from the beholder. The type of movement also has an influence on perception. For example, when dancing, our sense of space is fundamentally different to how we experience it when walking. Wandering is a special form of

locomotion. Wandering is an end in itself: its primary purpose does not entail the achievement of a particular goal. As a result it generates a different relationship to space.

Movement presupposes space. The different designations for spaces in which we move point to the fact that human beings have different ways of moving: corridor, course, path, street, lane, trail, freeway, etc. The space of human movement existed as paths and trails prior to the any form of human settlement. Nomadism is the earliest form of human life and it presupposes above all paths. For the nomad the path is more important than the place, the space of movement more important than the space of rest. As an image of life, the "path" has served as a symbol of humanity from time immemorial; it plays an important role in sacral architecture (Bollnow 1980, p. 104) (see Sect. 5.1). Today human development could be seen as partly regressing back to nomadism. At the end of the 1970s the mobile home industry in the USA was already accounting for a fifth of the annual production of dwelling units (Venturi 1979, p. 177). Vincent Scully even argues that the mobile home represents the prototype of the architecture of tomorrow (Scully 1980, p. 150). Movement always implies speed. For a long time the locomotive speed of the human being was restricted. Visual perception when the observer is mounted on a galloping horse is not essentially different from visual perception when the observer is walking. However, the invention of the car brought a fundamental change in perceptual terms. Greater speed significantly reduces the area the eye is able to monitor. Every instance of acceleration reduces the field of vision, thereby demanding increasingly more abstract orientation possibilities. It becomes less and less possible to register details. For this reason our surroundings are experienced from a moving car in a very different way to how we perceive them when on foot.

Today the car is often also the main means of transport within the city. Great expense and effort is devoted to the construction of city freeways that permit driving at high speed even in the city (Fig. 9.2). However, the majority of optical stimuli on

Fig. 9.2 City freeway, Los Angeles, USA

Fig. 9.3 Las Vegas Strip, USA

offer in cities are still oriented to the pedestrian and they are therefore difficult to perceive effectively from a moving car. For the motorist the experiential offering is simply too great. This implies a new urban order that either banishes the car from the city or is more responsive to its speed. Robert Venturi describes Las Vegas as an archetype of such a city, arguing that although the buildings on the Las Vegas Strip suggest a number of historical styles, its urban spaces do not draw on historical spaces. Las Vegas space, he claims, is neither contained nor closed in the style of the Middle Ages, nor classically balanced and proportioned like Renaissance space, nor charged by a rhythmically ordered movement like Baroque space, and nor does it flow around freestanding space makers like Modern space. Nevertheless, the Strip, he argues, is not chaos but a new spatial order that relates the car and highway in an architecture that abandons pure form in favour of mixed media (Venturi 1979, p. 91). The Las Vegas Strip, the city's "main street", contradicts our notions of urban space. The distance between the individual buildings corresponds more to the perceptual capacity of an observer looking out of a moving car than that of a pedestrian. It is only speed that brings the individual elements together into a cohesive whole (Fig. 9.3).

9.2 Time

Every movement requires time; without time we could not perceive any movement at all.

Although time is measurable, we cannot envisage every time interval. For most people, a tenth of a second and a hundred years are merely mathematical values. When considering millennia or even millions of years, our ability to perceive time fails completely; we know that such intervals are extremely long, but we cannot envisage exactly how long they are. Our natural environment as we know it today evolved over the course of

enormous stretches of time. Valleys were formed by rivers, and lakes and oceans were created by geological shifts. Measured on this scale, the human-built environment, which is only a few thousand years old, is relatively young.

Today, cities are seldom planned and built as whole entities. They change over the course of time: older buildings are demolished or altered and new ones are constructed. How far these constructional changes are permitted to go and how much time is required between them in order to ensure that people can still identify with a particular location depends on different factors. Constructional changes often bring about social and cultural upheaval. Like architectural styles, cultural and social structures require far longer to change than the substance of buildings. For this reason, constructional changes have to take into account the social and cultural structures prevailing at a location if they are not to destroy them. In the absence of such structures people lose their sense of orientation and the possibility of identifying with their changing location, which can lead to a sense of dislocation.

The extent to which and in what way human beings may alter their surroundings without destroying prevailing social and cultural structures is thus the decisive question. Christian Norberg-Schulz identifies three important factors in this context, which he calls primary structural properties: settlement form, construction method and characteristic motifs. "Such properties are always capable of various interpretations if they are properly understood, and therefore do not hamper stylistic changes and individual creativity. If the primary structural properties are respected, the general atmosphere or spirit will not get lost. For it is precisely this spirit that binds an individual to 'his' place and is experienced by a visitor as a particular local quality" (Schulz 1982, p. 180). Constructional changes always lead to long-term shifts in social and cultural structures. This complicated interplay can easily become unbalanced as a result of spurious constructional changes.

Elaborating his "theory of permanence", Aldo Rossi argues, "Permanence is something material und, in as far as it is a form that endures, also something spirtual. And it is precisely this permanence of form in the midst of constant changes that represents an important urban phenomenon" (Rossi 1973, p. 40). The most important factors for urban permanence in Rossi's view are the city map, streets and monuments. In order to be able to retain this permanence the city or settlement must be seen as a whole. Its historical genesis, its development and its relationship to its natural surroundings need to be considered in relation to each new building project.

Mario Botta also identifies three factors as decisive for the relationship between new buildings and their existing environment: the physical quality of the surroundings, their historical framework, and the changes within different time cycles. Architecture's surroundings change it in step with time: "One can say that the terrain is in a constant dialogue with its architecture, as an evolution of time and history" (Botta 1980, p. 36).

Time has an indirect but important influence on our cognition of our surroundings. Up to now we have distinguished between two types of change to our surroundings. Such change can be limited to perception, conditioned by different times of the day and year.

Or such change actually takes place with the demolition or recreation of building substance. Age-related changes can be characterized as a third type. Depending on the building material, maintenance and climatic factors, a building will sooner or later deteriorate.

Old buildings have a special influence on the beholder. Ruins have also always exerted a particular fascination, reminding us that we live in a constantly changing environment with a past and a future. The Rome of the eighteenth century that we are familiar with from the etchings by Giovanni Battista Piranesi is a good example. The beholder often experiences old things and even ruins as beautiful because their age and thus also their past and time can be read on them (see Sects. 8.4 and Fig. 8.7). Evidence of age makes visible the fact that a building has not only a spatial but also a temporal dimension.

Many of the austere steel and glass buildings of Modernism disavow a temporal reference. Many materials, such as chromium steel and glass, do not betray any age. During Modernism, the idea of "eternal youth" was not only a maxim of architecture.

For Eric Owen Moss, the new is a mix of the old and the newly added. The new is detached from the conventional structure of the pre-existing but is also heavily dependent upon it. The new does not attempt to enter into a dialogue with or adapt to the old or its surroundings. On the contrary, it tries to contrast itself with the old as far as possible. This gives rise to a constant tension; in Moss's buildings the factor of time can be discerned everywhere.

In California, where Eric Owen Moss works, everything is fast-paced and in flux. New elements are being added to existing structures constantly. Moss believes that this compels architects to offer temporary and non-definitive solutions: "The form itself is not static, History is in motion, so space is in motion. My aim is to build that motion in Architecture" (Giaconia 2006, p. 8). Since 1988 he has been remodelling an old commercial district in Culver City outside Los Angeles. The existing buildings are not demolished but remodelled, and in such a way that both the old and the new remain recognizable (see Fig. 6.35). One of the most important sources of inspiration for his approach is the Shinto shrine in Ise near Kyoto in Japan, which dates back to the seventh century. As discussed in Sect. 4.2, here the eternal and the ephemeral supplement rather than exclude one another. In Ise and in the buildings in Culver City by Eric Owen Moss the old and the new are simultaneously represented, and the factor of time is thus also made perceptible.

9.3 On the History of Movement in Art and Architecture

From the beginning of perspective painting in the Renaissance up until the advent of Cubism in the early twentieth century, visual perception was conceived of as originating from a single point. Cubism expanded the spatial concept informing perspective representation. Now objects were no longer represented from a single vantage point. The same picture showed several views seen from different positions. In this way movement, and thus time, were integrated into painting. Attempts to represent movement of course

predated Cubism, but such representations were restricted to a snap-shot. Statues and paintings from many cultures and epochs depict a moment within a movement sequence such that the beholder can conclude that the represented figure is in motion.

Whereas Cubism regarded the experience of space as a temporal sequence, Futurism, which followed it, sought to integrate the element of movement into the image. Both Cubism and Futurism dispense with the static character of perspective representation. In cubist painting, simultaneously capturing an object from different sides represents an attempt to emphasize its spatial aspect. The futurists attempted to capture the principle of dynamics pictorially. The representation of a woman in several stages of a movement created by Marcel Duchamp in 1911 and titled "Dulcinée" is the first known simultaneous representation of successive movement sequences in a painting (Schmoll 1977, p. 267).

The development of technology at the time, and in particular the perceived beauty of the mechanical speed achieved by cars, trains and planes, also influenced the development of art. In 1909 the Italian writer Filippo Tommaso Marinetti celebrated "adventurous steamers that sniff the horizon; deep-chested locomotives whose wheels paw the tracks like the hooves of enormous steel horses bridled by tubing; and the sleek flight of planes whose propellers chatter in the wind like banners and seem to cheer like an enthusiastic crowd" (Marinetti 1909). And in 1913, in the preface for an exhibition catalogue, the sculptor Umberto Boccioni wrote that he was seeking to depict "not pure form, but pure plastic rhythm; not the construction of bodies, but the construction of the action of bodies. I have then as my ideal not pyramidical architecture (static) but spiral architecture (dynamism)" (Frampton 1983, p. 75).

As so often the case, painting had a powerful influence on the development of architecture during this period. It was now commonly assumed that in order to understand a spatial composition the beholder need to move within it, to regard it from different standpoints. Time, and thus movement, became an important dimension of architecture. This development was closely linked to the new conception of space that emerged at the beginning of the twentieth century (see Sect. 5.1.1). In 1924, when formulating his theory of elementary design, Theo van Doesburg described this shift as follows: "The new architecture takes account not only of space but also of the dimension of time. Through the unity of space and time, architectural appearance is lent a new and completely plastic aspect (four-dimensional plastic space–time aspects)" (Van Doesburg 1981, p. 74) (see Fig. 6.14). Intermeshed spaces can only be experienced to their full extent if one moves within them.

Architect Antonio Sant'Elia was the first to attempt to apply futurist ideas to architecture. In his designs for the Citta Nuova project, skyscrapers sprout from the ground, and traffic routes, railway tracks, elevators and escalators all became parts of a dynamic whole. In the manifesto on "Futurist Architecture" he composed with the poet Filippo Tommaso Marinetti he writes that the futurist building should be "like a gigantic machine. Lifts must no longer hide away like solitary worms in the stairwells, but the stairs – now useless – must be abolished, and the lifts must swarm up the facades like

serpents of glass and iron". In this vision, the street "will no longer lie like a doormat at the level of the thresholds, but plunge stories deep into the earth, gathering up the traffic of the metropolis connected for necessary transfers to metal cat-walks and high-speed conveyer belts" (Sant'Elia and Marinetti 1981, p. 32). Along with other members of the futurist movement, Sant' Elia perished in the First World War, and this architectural current came to an abrupt end.

However, the idea of dynamic form lived on and influenced a number of expressionists, including above all Erich Mendelsohn. In a lecture titled "Dynamics and Function" delivered in Amsterdam in 1923, he characterized his approach as follows: "Form the world that awaits you. Use the dynamics of your blood to form the functions of your reality; elevate these functions to the level of dynamic super-naturalness" (Mendelsohn 1981, p. 69).

Mendelsohn wanted the genesis of his buildings to remain visible, the power of the spaces to be readable and buildings to connect with their surroundings. As Bruno Zevi writes, "For Mendelsohn it is impossible to 'dissect' the architectural object into plan, section and elevation. A building is the framework for dynamic human activities and its value is measured by how effectively it announces this to us. … Its fixed three-dimensionality extends beyond the static finiteness of the traditional perspective characterizing the Renaissance legacy" (Zevi 1983, p. 28).

At the beginning of the twentieth century, movement became an important dimension of architecture. The spatial structure of the Barcelona Pavilion by Ludwig Mies van der Rohe (see Figs. 2.7 and 6.15a) cannot be comprehended from a single location; it demands of the observer movement and thus time. Le Corbusier also applied the ideas of Cubism to architecture. As Giedion comments, "It is impossible to comprehend the Savoie house (built 1928–31) from a single point, it is a construction in space–time" (Giedion 1978, p. 31). In the Villa La Roche, designed by Le Corbusier and built in Paris in 1925, the design of the walkways is even more impressive. Here the architect already designed what he called a "Promenade architecturale" (see Fig. 9.4).

This pathway, this promenade, already begins outside the building. A cul-de-sac leads to a square in front of the house. The front door is relatively small and suggests the eye of a needle through which visitors to the house must step. It is a caesura between outside and inside. The three-storey lobby does not have a window at ground level. Light permeates the space from above through different windows on the two upper levels, inviting the visitor to proceed up to the mezzanine. A walkway leads through the various spaces in the building, allowing the beholder to experience its spatial diversity and complexity from different perspectives. The prescribed route through the structure allows the way it is seen and thus experienced to be steered and shaped. As Le Corbusier concluded in 1929, "Architecture is a concatenation of successive events. … Each individual step offers the eye a new sound element of the architectural composition" (Blum 1988, p. 21).

Of course, larger building complexes had previously also only been comprehensible in spatial terms when observers took the time to walk through them. Here too, perception required movement. However, their spatial arrangement could usually be discerned

Fig. 9.4 "Promenade architecturale" in the Villa La Roche in Paris (1925, Le Corbusier)

from one point or at least from a single axis (see the description of the pathway across St Peter's Square in Rome, Sect. 9.6). It was through the influence of Cubism that the temporal dimension first became an important aspect of architecture. It is only through the passage of time and thereby movement that it becomes possible to experience space and the links between different spatial zones.

9.4 Dynamism

The functional designs of the cars, planes and ships industrially produced at the beginning of the twentieth century evoked a general fascination, and their dynamism and speed had a significant influence on thinking at the time. In his "Manifesto of Futurism" published in *Le Figaro* on 29 February 1909 Marinetti wrote, "We affirm that the entire world has been enriched by a new beauty: the beauty of speed". The futurists wanted to make movement and dynamism visible and to represent them in painting but also in architecture. In 1914 Antonio Sant'Elia, the most important exponent of Futurism in

9.4 Dynamism

the field of architecture, wrote, "We must invent and rebuild ex novo our modern city like an immense and tumultuous shipyard, active, mobile and everywhere dynamic, and the modern building like a gigantic machine. Lifts must no longer hide away like solitary worms in the stairwells, but the stairs—now useless—must be abolished, and the lifts must swarm up the facades like serpents of glass and iron" (Frampton 1983, p. 77). The task of dynamic forms is to make forces visible, point out pathways and established connections.

Dynamism is the foundation of all visual experience. According to Rudolf Arnheim, every perception is "an interplay between directed tensions. These tensions are not somehow interpolated into static images by observers for personal reasons. Rather, these tensions are just as inseparable from a perceived object as size, contour, location and colour. Since these tensions have intensity and direction they can be described as psychological 'forces'" (Arnheim 1978, p. 14).

There are different theories as to why a shape is perceived as dynamic. For instance, the sensation of dynamism may be dependent on the experience of the beholder: a photograph of a bullfighter confronting a bull seems dynamic because the beholder knows that the figures are moving (see Fig. 9.5). But it is precisely this explanation that cannot apply when it comes to architectural forms. At best we might apply the theory that the associations are not with the object itself but with it forms, directions and brightness values. Arnheim regards both theories to be false. Based on the insights of Wassily Kandinsky, he defines visual dynamism as directed tension: "There are, however, tangible indications that the visual field is permeated by active forces. If the size and form of patterns that we see differ from the image projected onto the retina, then dynamic processes within the nervous system must be altering the stimulus information" (Arnheim 1978, p. 421).

Fig. 9.5 Our experience tells us that the bullfighter and the bull are in motion

Dynamism is a fundamental element of every visual experience. It is not a physical property. The perceptual stimuli on the retina first acquire their dynamic effect when they are processed in the brain. Rudolf Arnheim is also of the view that the dynamic effect of a stimulus configuration is probably even more important for how it is perceived than are its proportion or shape (Arnheim 1980, p. 87). This dynamic effect forms the character of the appearance of the configuration. Every perception includes a greater or lesser degree of dynamism, the intensity of which varies depending on the stylistic epoch or work. A building whose expressiveness is shaped by symmetry and balanced proportions will appear less dynamic than a building whose elements are contradictory and complex (see Figs. 8.5 and 9.6).

There is a tendency when seeing oblique lines to interpret them as horizontally or vertically converging because this makes for a weaker stimulus configuration and therefore less information to store. For the eye it is easier to perceive two converging lines than receding parallels, which gives rise to the impression of depth.

The tension generated by oblique lines is one of the causes of depth perception. Whenever a stimulus configuration is registered, there is a tendency to create equilibrium in order to reduce the amount of information that needs to be processed. This does not mean that dynamic perceptions are suppressed; however, they are organized in such a way that as much potential energy as possible can be brought into equilibrium. Two parallel lines or walls are perceived as converging in the distance, as in the case of long, straight corridors (see Fig. 9.7). These apparently converging lines thereby indicate a direction and thus generate dynamism, a quality exploited in the use of the directional arrow symbol (see Fig. 9.8a–d). The fact that this symbol is universally understood irrespective of culture and language indicates that the experience of dynamism is a general

Fig. 9.6 Denton Corker Marshall, 2000, Art and Design Bld., Monash University, Melbourne, Australia

9.4 Dynamism

Fig. 9.7 Portico di San Luca, 1674–1739, Bologna, Italy

Fig. 9.8 Two parallel lines create the perception of depth, a quality exploited in the case of the directional arrow symbol (see Fig. 6.31)

feature of perception. This dynamism is augmented when the gradient of the diagonals is irregular, giving rise to a curve, the architectural utilization and effect of which was discussed in Sects. 6.5.2 and 6.5.4

The effect of parallel lines that apparently converge in the distance is similar to that of spiraling lines, as formed, for example, by the banister of a circular staircase. The circles traced by the banister are perceived as becoming progressively smaller, creating a suction effect and thereby a powerful dynamic (see Fig. 9.9).

The perceived dynamism of a curve is generated first and foremost by the instinctive attempt on the part of the beholder to adapt the observed line to a regular, geometric form: the horizontal, the vertical, the circular, etc. (Fig. 9.10).

Unevenly curved forms appear very dynamic. This unevenness and dynamism can be taken to such lengths that it requires some effort on the part of the beholder to organize and understand what he or she is seeing (see Fig. 9.11).

The observer attempts to organize perceptual patterns such that regularities emerge, again in the interest of information reduction. Powerful dynamic effects are also yielded by so-called stroboscopic compositions: elements that are basically the same but differ in terms of one feature. For example, a series of the equally sized squares whose brightness

Fig. 9.9 Theo Hotz, 1991, conference building, Zurich, Switzerland

Fig. 9.10 The perceived dynamism of the curve as deviation from the straight line or the circle

9.4 Dynamism

Fig. 9.11 Massimiliano Fuksas, 2008, Armani shop, New York, USA

or hue constantly changes from left to right. The dynamism of many daily visual experiences is based on this principle (see Fig. 9.12).

Dynamism in visual perception is not solely associated with slanted or curved lines. Every form has an inherent dynamism, which is made "visible" with so-called gamma movement (Arnheim 1978, p. 440) (Fig. 9.13).

For example, when a triangle on an illuminated sign lights up briefly and then goes off, for a short time we continue to see rays of light that correspond to the directional dynamic. These rays often proceed along the axes of the structural framework (see Fig. 6.8). The dynamic varies with the shape of the figure. The corners of an equilateral triangle point like arrows in the respective directions of their extension and thereby exert a powerful dynamic effect. A rectangular has a particular directional dynamic based on its position and proportion.

Converging lines not only indicate a direction and in doing so express a certain degree of dynamism; they also create a sense of depth and distance. The Scala Regia by Gian Lorenzo Bernini in the Vatican (Fig. 9.14) is the main entrance to the Vatican Palace and is positioned at a critical architectural location between the palace and St. Peter's Basilica. The distance between the point of arrival at the bottom and the entrance

Fig. 9.12 Visual dynamism (reinforcement grid)

Fig. 9.13 Gamma movement in simple forms

9.4 Dynamism

Fig. 9.14 Gian Lorenzo Bernini, 1666, Scala Regia, Vatican

above is relatively short. In order to emphasize the importance of the pathway leading to the Pope, Bernini attempted to extend it in optical terms. The stairway is progressively tapered both in terms of height and width, augmenting the sense of depth and creating an illusion that the structure is much longer than it really is. The series of stairs is interrupted by two landings, which, in contrast to the rather dark stair sections, are brightly lit. The landings and the rhythm created by the variations between light and dark divide the pathway into stages and thereby make it more perceptible. On the first landing the visitor has to turn 90 degrees to the left. This stage is marked by an equestrian statue of the emperor Constantine, a sculpture that attracts the attention of visitors and "articulates" their movement up from St. Peter's Basilica below.

Increasing perceived distance by way of converging lines was a technique well known to the Greeks, who tapered pillars towards the top to create perspectival distance and thereby the illusion of greater height.

Flowing or falling water also exudes dynamism. Many rivers are important transport routes: they evoke movement. In the Islamic cultural sphere we often find a fountain in the middle of a courtyard, the water from which flows away in small open channels in all four directions and in part into the interior of the rooms surrounding the courtyard. The dynamic effect of the flowing water refers to the exterior space, while the rooms bordering the courtyard point to the interior space (Fig. 9.15). Here water also has a symbolic significance. It is the origin of life, the source of the vegetation in the garden, which in turn represents paradise (Stierlin 1979, p. 132).

Fig. 9.15 Bagh-e Fin, 1590, Kashan, Iran

9.5 Rhythm

Rhythm is a fundamental property of life in general. The philosopher Otto Friedrich Bollnow argues, "Just as the individual must go forth from the home in order to perform his work in the world, so must he, feeling the fresh morning, repeatedly enter into alert, active life in order to be able to surrender to sleep again after his work has been done. Both movements are inseparably linked, like breathing in and breathing out" (Bollnow 1980, p. 190). This rhythm of life proceeds parallel to the cyclical processes of nature: daytime and night time, seasons, etc.

9.5 Rhythm

We are all familiar with the concept of rhythm above all in connection with music and dance, both branches of the arts in which movement plays an important role. Rhythm designates a repetition based on certain laws; as a result it evokes expectations and leads to redundancy. In architecture rhythm can be generated in several ways: with the help of spatial contrasts between open and closed, wide and narrow, etc., or by means of lighting and colour effects, for example by changing between bright and dark zones. The change between narrow street space and open square, the rhythm of the narrow and enclosing and the wide and unfettered is an important element of urban planning. In the case of Bernini's Scala Regia (see Fig. 9.14) this change takes place in optical rather than spatial terms, and is created by the dark stairway zones and the brightly lit landings.

We also find this use of lighting as a tool in urban space. The architectural and art historian Sibyl Moholy-Nagy compares two cities of antiquity, Ostia, the harbour town of Rome, and Bukhara, in what is now Uzbekistan, which was a prosperous oasis city and a trading centre for Asian and European caravans (see Fig. 9.16). Both were linear cities, which is to say that their most important buildings, such as sacral buildings, public buildings, palaces, storehouses, etc., were aligned along the main street. In Ostia this was done on a purely functional basis, whereas in Bukhara, in accordance with the rules of the bazaar, the street also became an optical event. The decisive difference in terms of optical experience between Ostia and Bukhara, Moholy-Nagy argues, and thereby the difference between the pragmatic and the aesthetic conception of the city, is found in the sensation derived from glimpses into lateral porticos and courtyards with their finely worked stucco and marble, and the fountains and channels of the kind still found places like Granada; Morocco and Tangier. The choice of directions of movement in Bukhara, she states, varied and enlivened the traffic, for which only limited possibilities were offered in Ostia (Moholy-Nagy 1970, p. 208).

Ostia was organized along a straight street, which in purely optical terms offered no variation to the right or left. By contrast, Bukhara offered an interesting sequence of different glimpses and passageways to the left and right. The path through the city was optically broadened in a certain rhythm, an arrangement comparable to the sequence of squares and narrow streets found in medieval cities (Fig. 9.16).

Fig. 9.16 Movement spaces in **a** Ostia, **b** Bukhara and **c** the medieval city

9.6 Path

The word path is used here as an umbrella term for all types of traffic area. Paths connect places, places of human activity or rest and in doing so they fundamentally shape the way we experience space. As Otto Friedrich Bollnow writes, "The hodological (experienced) space describes the system of paths along which I can reach individual positions in the space. In this sense it is comparable to a network of lines of force flowing through this space. As Sartre correctly surmised, the totality of the paths emanating from the respective location of the individual determines the situation of the individual in the space" (Bollnow 1980, p. 203). Architecture is static. But with the help of the path we can forge a connection between space and the dimension of time, one of the cornerstones of our existence. Path, along with location, is one of the two basic elements of every instance of spatial organization. One points to movement and is thus linked with the factor of time, the other to rest and communication. Movement on a path is directional; it leads forwards. In temporal terms it leads into the future; the converse direction is the past. The path to a goal is often more important than the goal itself, and in such cases the organization and formation of the path concerned acquire primary importance. Most paths are divided into stages, which make them easier to quantify. Making things quantifiable is important because when faced with the prospect of psychological exertion the brain tends to overreact (Smith 1981, p. 178). A straight, single staircase appears longer and more arduous to negotiate than a spiral staircase or one that is divided up by landings. A path often also seems shorter when at the beginning the goal is not visible, when the user has to reach several intermediate goals or negotiate several stages before arriving at his main goal.

The character of a path is shaped by different factors. Its form and position, whether it is straight or curved, leads upwards or downwards etc. are all crucial in this respect. Contradicting a statement made above, Terence R. Lee hypothesized that straight paths are perceived as shorter than curved ones and that the extent of this effect depends on the number of curves (Lee 1973, p. 45). Both hypotheses can be proved correct depending on the circumstances. An important factor is whether the precise location of the goal and the length of the path are known in advance.

Socio-psychological aspects also influence the perception of distance. We have already discussed the fact that a path in the direction of a city centre appears shorter than one leading in the opposite direction. We have also seen that there are fundamental differences between mathematical space and experienced space (see Sect. 5.2.1). Accordingly, mathematical distances are different from experienced ones. Two paths that are of equal length on a map can be experienced as quite different when we walk them in reality.

The way a path leads to a goal also plays an important role. Does the visitor approach the goal frontally or does the layout of the route allow him to see the goal from different sides before he reaches it? A further factor is the relationship of the path to its

9.6 Path

surroundings. Does the path lead through a space enclosed from all sides, such as a tunnel, or does it permit an unobstructed view of the surroundings, such as when one is walking on a bridge? Are the surroundings on both sides of the path the same or is the view on the left different to the one on the right? The possible ways in which a route can be laid out are endless. Figure 9.17 shows just a few, which can be supplemented as required and combined with one another.

An entrance can be the final goal or merely a stage. Stepping or driving through an entrance constitutes a change, one that can be more or less pronounced. Different measures can be used to enhance the intensity of a change. The caesura formed by an entrance on a path can be amplified by introducing other simultaneous changes: differences in height, form, colour or illumination, or by using different materials.

The significance of an entrance can also be defined by its position within a spatial composition. The main entrance to a structure is usually located in a position that logically accords with the path prescribed by the way the structure is approached. Side entrances need to be located in positions in keeping with their function but play a subordinate role for the overall appearance of a building.

The ancient Egyptians believed in eternal life and regarded earthly existence as only a stage on a long path. This is represented in spatial terms in the Mortuary Temple of Ramses III (Fig. 9.18). The path inside the temple is divided into stages. It leads through six spaces which are connected with one another only by narrow portals and which become successively smaller in terms of both floor plan and height. Each of the first four spaces is set a little higher than the preceding space and is accessed via a ramp. In the two rearmost spaces the floor level is unchanged but the ceiling is slightly inclined to the back, which produces an additional perspectival distortion.

Fig. 9.17 Influence of topography on how a path is experienced (examples)

Fig. 9.18 Mortuary Temple of Ramses III, twelfth century BCE, Medinet Habu, Egypt

The level of illumination lessens from space to space. The first courtyard is two-sided, the second surrounded on four sides by an open gallery, which means that in the first courtyard two walls can be illuminated by the sun whereas in the next courtyard all four walls are in shadow. The following spaces are roofed, although in numbers three and four the middle zone, which serves as transit area, is illuminated by skylights in the ceiling. The spaces are arranged in a strict hierarchy and the path leads by stages from the sun-drenched outside surroundings to the narrow, dark space of the sanctuary. In this way the path from birth to death is represented in spatial terms. The nature of life beyond death is undefined, which is reflected in the use of darkness in its spatial representation. The darkness of the night-time space is indeterminate as is the nature of life after death (see Sect. 5.2.2). The path thus does not lead to a precisely determined goal, as in a Gothic cathedral, for example. The darkness suggests an indeterminate continuity.

Greek architectural is sculptural. The interior space does not have a great deal of significance, but the path leading to the building does. The path on the Athenian Acropolis that leads to the Parthenon enables the visitor to see the different buildings from different sides (Fig. 9.19). The ascent to the Propylaea zigzags so that the field of vision constantly changes and each bend in the path becomes the start of a new stage. The lateral buildings enclose the path in such as way as to create a concave, welcoming forecourt, which leads through the tunnel-like entrance before revealing a diagonal view of the Parthenon from below. A long ramp running alongside the temple leads the visitor

9.6 Path

Fig. 9.19 The path leading up to the front of the Parthenon on the Acropolis, Athens, Greece

up to the same level as the building, who reaches the front only after having first seen the structure from different angles and distances.

Greek sculpture also demands movement from its beholders. In order to understand a piece of such sculpture they must regard it from all sides. This contrasts with Roman sculpture, the position of which was often integrated into the architectural context, for example by setting it into an alcove, thus clearly defining the side from which the work was to be viewed (Picard 1965, p. 109).

The spatial concept of occidental sacred architecture, from the early Christian basilica to the present, represents the symbolic path, the path of life, the path to God. This path has been formed differently in different epochs (Fig. 9.20). In the early Christian basilica it leads directly to the entrance to the altar in the apse. Subsequent structuring of the space into zones becomes an important feature of Romanesque architecture. The segmentation of the space, emphasized by the arrangement of the bays, lends the nave a rhythm, thereby creating a spatial dynamism. In Gothic architecture the path through the nave is interrupted again in front of the altar by the transept. The rapid succession of

Fig. 9.20 The way to the altar in the interior of the Church in different style periods **a** Early Christian, **b** Romanesque, **c** Gothic, **d** Baroque

pillars and arcades forms a powerful rhythm which underscores the movement of visitors, only allowing them to come to a standstill and shift their gaze to the left or right once they are level with the transept. No such space for pause was provided in the early Christian church. The visitor moved directly from the entrance to the altar. The formation of architectural space in the Gothic period was intended to intimate a continuation of that space into the infinite. The church space was "the window to eternity", but not in itself the absolute, definitive goal. In Renaissance architecture the path leads to the centre. The central interior space of the Renaissance church was the place where the human being as an autonomous being confronted the divine. This place was absolute and therefore excluded everything dynamic. In the Baroque the central-plan space and the longitudinal space were combined to form an ellipse (see Figs. 6.26 and 6.27). As a result the Baroque path to the altar was also divided into stages. The gaze continually strays to the left and right, compelling visitors to interrupt their forward movement.

The route leading across the large square in front of the St. Peter's Basilica in Rome to the entrance, then into the church and up to the altar is also organized into different stages. The different segments are rhythmically structured and support or inhibit the prevailing dynamism depending on their formal design (Fig. 9.21).

The oval "square" is accessed via a long street, from which visitors step onto the expanse of the elliptical space, which they cross in a transverse direction. The longitudinal axis extends to the left and right. In this way the form of the square restricts more than it supports movement toward the church. The square constitutes a caesura on the path to the church. Its surface is inclined on all sides toward its centre. Here there is also no emphasis on the route to the church through a continually declining or rising level. After traversing the square, visitors reaches the position at which the great colonnades, like two clamps, narrow the path again to form the rhombic area in front of the basilica. The narrowing and widening of the path space is another way of generating dynamism. In the rhombic area the lateral barriers of the space diverge in the direction

9.6 Path

Fig. 9.21 St. Peter's Basilica and Square: narrowing and widening of the path to the altar, directional dynamic and path segments (see Fig. 2.30)

of the basilica. The design strategy used in the case of the Scala Regia (see Fig. 9.14) is reversed here. The distorting perspective effect is abrogated by the diverging lines, which in perceptual terms optically decreases the actual distance and counteracts the

directional dynamic. The facade of the church seems closer and consequently smaller than it is in reality. Here the direction of the space changes. Whereas the ellipse is crossed transverse to its primary direction, the dynamic of its form tends to pull to the left and right rather than forwards; in the rhombic area it is the symmetry of the wide church facade that tends to dominant and define the primary direction. The path leads across several intermediate stages to the main portal, and this process is continued in the interior of the church, along the path to the altar. Here, too, the space is rhythmically divided. The three bays added by Carlo Maderno to Bramante's original central plan form further stages on the path to the altar, which is centrally located under the great dome.

Section 4.2 included a description of the Shinto shrine in Ise, Japan. The shrine is the most sacred Shinto site and as a consequence is a significant destination for pilgrims. The main shrine is surrounded by four wooden fences, which create an artificial distance between the sacred site and the profane surroundings (see Fig. 4.2). In Ise this creation of distance and division into stages does not begin at the outermost fence but already at the home of the pilgrim. Each place, each day constitutes a stage on his path. On the site of the shrine itself, a further stage commences when the pilgrim steps through the first "torii" gate, which marks the beginning of the sacred district (Fig. 9.22). The river that must be crossed, the following torii gates, and every bend in the path all mark further stages. From the slightly raised bridge the pilgrim views the surroundings in three dimensions. On the following path segments the scope of this view is progressively

Fig. 9.22 The path to the Inner Shrine of Ise, Japan (see Figs. 4.2 and 9.23)

9.6 Path 295

Fig. 9.23 Spatial concept and scope of view on the path to the Inner Shrine of Ise, Japan (see Fig. 9.22)

reduced. The path leads through a field covered by grass and small bushes. Here the view is still open in the direction of movement and on both sides (Fig. 9.23).

On the segment of the path leading through the forest the view is restricted by giant cedars and is only open in the direction of movement. This restriction is repeated once more when the visitor reaches the four fences. The space between the posts making up the outermost fence is relatively large and thus allows for a view through the barrier. The innermost fence is a closed wooden wall that does not allow for any view at all. The four fences do not serve as a physical barrier: the outermost would suffice if this was the aim. The fences constitute another four stages on the path to the goal; however, they serve this purpose in purely visual terms. Here, too, the role of the path is to prepare the visitor in stages for what is to come. The view is successively restricted and at the same time the visitor is increasingly surrounded by the nature.

Dividing a path into stages makes it tangible and therefore quantifiable. The successively added stages serve as units of measure. Their organization implies an escalation and thus a dynamic tension. This stage-by-stage preparation for what is coming was already in evidence in the Japanese context when we discussed the relationship between the interior and exterior (see Figs. 4.18 and 4.19). The division of space there often takes place within a confined area and in a subtle way that is characteristic of the Japanese or Oriental mindset, one which avoids "either or" in favour of "as well as".

In the case of both St. Peter's Basilica in Rome and the Shinto shrine in Ise the path provides a means of artificially creating distance between the profane and the divine. The main portal of St. Peter's marks the boundary between the everyday world of the human being and the holy interior space of the church. The monumental bulk of the church building and the great emptiness of the square confront one another. This relationship corresponds to the Christian concept of the place of the human being in relation to the divine. The complex is also supposed to represent the power of the divine. The natural

world, as a third pole, does not exercise any influence on this dualistic relationship. In Ise we find no strict separation, no portal, no inside-outside. The shrine also lacks a monumental building; the divine dimension is represented here by the giant cedars, by nature itself. The divine and the visitor do not confront one another but instead form a great unity together with nature (see Fig. 4.6). The task of creating distance between the profane and the divine is, in accordance with the prevailing philosophical conception, solved differently in Rome and Ise. Whereas in the case of St. Peter's Basilica the path of the visitor is designed to lead from the small-scale everyday world to the supernatural, monumental grandeur of God, in Ise the individual is prepared for the divine by means of the timeless peace and uniqueness of nature.

As it was for Le Corbusier, for Luigi Snozzi the path within a building was an important element of its architecture. In the house he designed in Brione (Fig. 9.24) this path begins outside and leads through the building onto a terrace, from where the visitor can enjoy a view of the surroundings. Like in the case of the four fences at the Shinto shrine in Ise, the view provided by the layout of the house functions as a type of continuation of the walked path. Commenting on this experience of the path, Luigi Snozzi writes, "Structured into different moments, they (the paths) allow the visitor to take possession of the place in stages and to experience all its particularities. ... Thirty meters in front of the house a portal marks the entrance: here one takes a path that follows a contour

Fig. 9.24 Luigi Snozzi, 1976, house in Brione, Switzerland

line and thus facilitates initial contact with the surrounding landscape. One reaches a small bridge that crosses the stream, thereby drawing attention to it. Here one reaches the house; one enters. In semi-darkness, a narrow, single-flight stairway follows the curve of the wall, which takes up the curve of the hill and leads us to the residential level. A large south-facing window provides a view through the trees in the foreground down to the lake below. ... The terrace ends with a small roofed area like a pergola. ... It is no accident that it is precisely here at this endpoint that the visitor, as if enchanted, discerns the entire landscape lying below, the lake and the mountains, the city and its outskirts" (Snozzi 1984, p. 24).

9.7 Axis and Direction

The concept of path is closely connected with the concepts of axis and direction. A place refers to a particular position which is made the midpoint, the centre. Place and centre stand for rest, which contrasts with the movement that is implied by changing location over the course of time. Every movement requires a path, which in turn indicates a direction. The history of space is also a history of rest and movement, one that alternately manifests itself in central-plan and longitudinal space.

Due to their organic structure human beings as message receivers are directional. Their optical perception is directional: their visual acuity is limited a range of 2° to 3°. The directive axis is the foundation of all human orientation and therefore also an important ordering element when it comes to experiencing architecture. As Le Corbusier states, "Architecture is based on axes. ... The axis is a line of direction to a goal. The axis needs a goal, also in architecture" (Le Corbusier 1969, p. 141). An axis does not have to be straight; it can change its direction along a path.

Human orientation in space is based on horizontal and vertical directions. In many cultures the cardinal directions and the path of the sun also have specific meanings (see Sect. 4.3). For the Romans their capital city was the centre of the world and the point of departure for every orientation (see Fig. 4.5). In ancient China the imperial palace in Beijing was the centre not only of power but also of spatial orientation (see Fig. 3.11). Axes indicate a direction; they connect different objects with one another and are accordingly dominant elements in urban planning. In the sixteenth century pope Sixtus V had the seven most famous reliquary churches in Rome connected by pilgrimage streets, thereby altering the entire structure and appearance of the city (Moholy-Nagy 1970, p. 47). Aldo Rossi argues that this project, which focused on the incorporation of elements that already existed, created a structural unity in the city's architecture that "Rome had not known even in antiquity. The new street system had both practical and ideational meaning" (Rossi 1973, p. 111). However, it was not the pilgrims who were most impressed by this new city architecture but Europe's absolutist monarchs, which resulted in this type of urban planning attaining a seminal status all over Europe. Nevertheless, Christopher Wren's plan to rebuild London following the Great Fire of 1666, which

envisioned several central squares and broad, straight streets, was rejected, which became a cause of much speculation. The king, Charles II, who had grown up and been educated at the court of Louis XIV in France, was greatly influenced by the French monarch and harboured absolutist ambitions himself. But in the wake of the English Civil War and the temporary abolition of the monarchy the position of the king was too weak to allow him to realize Wren's plan in such an important international trading hub.

Broad and splendid streets punctuated by spacious squares symbolize order and power. Streets gained increasing autonomy and became an event in themselves. They were modeled on the street used to hold triumphs in ancient Rome, when successful military commanders celebrated their victories with parades. On this street the events being commemorated could be "reviewed" in a time-lapsed presentation. This made such streets more than pure transport routes. They became stages for the events of the day, symbols of success and power (see Sect. 4.6).

For the young American nation such an approach to urban planning seemed an obvious choice for the design of its new capital. Charles L'Enfant grew up in the park at Versailles, fought in the American War of Independence against the English, opened an architecture office after the war ended, and in 1790 presented the first president of United States,

Fig. 9.25 Charles L'Enfant, plan for Washington, the new capital, 1790

Fig. 9.26 **a** Canberra, Australia, built from 1913 onwards based on a design by Walter Burleigh Griffin, **b** Brasilia, Brazil, built from 1956 onwards based on a design by Lucio Costa and Oscar Niemeyer

George Washington, with a plan for the new national capital, Washington. The plan envisioned an orthogonal street grid crisscrossed by broad, diagonal avenues (Fig. 9.25).

Perhaps the most well-known case of "city remodeling" took place under Napoleon III in Paris. Up until the middle of the nineteenth century the city grew without being subject to any planning, which resulted in intolerable sanitary and traffic conditions. Baron Georges Haussmann, the new prefect of the city of Paris, developed a plan that was partly executed between 1853 and 1869. The city's tangle of narrow streets was penetrated by a new network of long, broad boulevards covering a total distance of 137 km. Lined with trees, these traffic conduits connected the city's prestigious public buildings, palaces and barracks. Here, too, the main reason for the execution of this plan was in fact of a power-political nature. Using the new street network, troops could quickly be moved around within the city, allowing for improved crowd control. The remodeling also brought other advantages. Sanitary conditions improved, the boulevards created open space, and the city's traffic problems were initially solved. This made Paris the first major city to adapt its traffic infrastructure to the new demands of the industrial age.

Broad, directive axes lost none of their importance in the twentieth century, a period in which all large-scale urban-planning projects, from Canberra to New Delhi to Brasilia (Fig. 9.26), drew on this model. All these places are intended to demonstrate power and magnitude, if not of an absolutist ruler then of a colonial power or an entire people.

References

Arnheim, Rudolf: Kunst und Sehen, Berlin, 1978 (original title: Art and Visual Perception, Berkeley, 1954)
Arnheim, Rudolf: Wahrnehmungsmässige und ästhetische Eigenschaften der Bewegungsantwort, Journal of Personality, 19/1951 (in: Zur Psychologie der Kunst, Frankfurt am Main, 1980)

Blum, Elisabeth: Le Corbusiers Wege, 1988, Braunschweig

Bollnow, Otto F.: Mensch und Raum, Stuttgart, 1980 (1963)

Botta, Mario: La signification de l'environnement construit et naturel, Vortrag in La Sarraz, 1978 (in: Werk, Bauen undWohnen, 1/1980, translation: J. Grütter)

Frampton, Kenneth: Die Architektur der Moderne, 1983, Stuttgart (original title: Modern Architecture, London, 1980)

Giaconia, Paola: Eric Owen Moss—The Uncertainty of Doing, Milan, 2006

Giedion, Sigfried: Raum, Zeit, Architektur, Zürich, 1978 (original title: Space, Time and Architecture, Cambridge, Mass., 1941)

Le Corbusier: Ausblick auf eine Architektur, Berlin, 1969 (original title: Vers une architecture, Paris, 1923)

Lee, Terence R.: Brauchen wir eine Theorie? In: Architekturpsychologie, Düsseldorf, 1973 (original title: Architectural Psychology, London, 1970)

Marinetti, Fillipo T.: Le Futurisme, (in: Le Figaro, 20.2.1909)

Mendelsohn, Erich: Dynamik und Funktion, 1923 (in: Programme und Manifeste zur Architektur des 20. Jahrhunderts, Braunschweig, 1981)

Metelli, Fabio: Zur Theorie der optischen Bewegungswahrnehmung (in: Bericht über den 24. Kongress der deutschen Gesellschaft für Psychologie, Göttingen, 1965)

Metzger, Wolfgang: Gesetze des Sehens, Frankfurt am Main, 1975 (1936)

Moholy-Nagy, Sibyl: Die Stadt als Schicksal, Munich, 1970 (original title: Matrix of Man—An Illustrated History of Urban Environment, New York, 1968)

Picard, Gilbert: Imperium Romanum, Fribourg, 1965

Rossi, Aldo: Die Architektur der Stadt, Düsseldorf, 1973 (original title: L'Architettura della Città, Padova, 1966)

Sant'Elia, Antonio und Marinetti, Fillipo: Futuristische Architektur, 1914 (in: Programme und Manifeste zur Architektur des 20. Jahrhunderts, Braunschweig, 1981)

Schmoll, J. A.: in: Malerei und Photographie im Dialog, Zürich, 1977

Schulz, C. N.: Genius Loci, Stuttgart, 1982 (1979)

Scully, Vincent: in: Arnheim, Rudolf, Die Dynamik der architektonischen Form, Cologne, 1980 (original title: The Dynamics of Architectural Form, Los Angeles, 1977)

Smith, Peter F.: Architektur und Ästhetik, Stuttgart, 1981 (original title: Architecture and the Human Dimension, London, 1979)

Snozzi, Luigi: Der Ort oder die Suche nach der Stille (in: Archithese 3/1984)

Stierlin, Henri: Architektur des Islam, Zürich, 1979

Van Doesburg, Theo: Auf dem Weg zu einer plastischen Architektur, 1924 (in: Programme und Manifeste zur Architektur des 20. Jahrhunderts, Braunschweig, 1981)

Venturi, Robert: Lernen von Las Vegas, Braunschweig, 1979 (original title: Learning from Las Vegas, Boston, 1978)

Zevi, Bruno: Erich Mendelsohn, Zürich, 1983 (original title: Erich Mendelsohn, Bologna, 1982)

Light and Colour 10

Contents

10.1 Light and Its Effects.. 301
10.2 Directed Light and Openings... 306
10.3 View and the Natural Illumination of Interior Space................... 308
10.4 Light Intensity... 315
10.5 Shadow.. 318
10.6 Colour.. 319
 10.6.1 Why Do We See in Colour?....................................... 321
 10.6.2 The Psychological Aspect of Colours 323
 10.6.3 Colour and Space... 324
 10.6.4 Colour in Architecture... 325
References.. 328

10.1 Light and Its Effects

Light is the prerequisite for optical perception. In complete darkness we can see neither space, form, nor colour. However, light is not merely a physical necessity; its psychological significance is one of the most important factors of human existence in general. The architect Morris Lapidus claimed that people are like moths, which instinctively throw themselves at a bright light; in a similar way, we are drawn to bright light without being aware of why) (Klotz and Cock 1974, p. 175). Light has always had a symbolic significance beyond its practical use. Over the centuries it has been regarded as the embodiment of life, and in many cultures throughout history the sun, as the source of light, was worshipped as a divinity.

 In ancient Egypt light was attributed a particular meaning. Due to Egypt's geographic location, natural light there is very intense as is the contrast between illuminated and

© Springer Fachmedien Wiesbaden GmbH, part of Springer Nature 2020
J. K. Grütter, *Basics of Perception in Architecture*,
https://doi.org/10.1007/978-3-658-31156-8_10

shaded surfaces. The clear geometric forms of Egyptian architecture with their shape edges generate a particular effect under strong light. Le Corbusier's statement about the connection between light and shadow has particular relevance in this context: "Architecture is the masterly, correct, and magnificent play of masses brought together in light. Our eyes are made to see forms in light: light and shade reveal these forms; cubes, cones, spheres or pyramids are the great primary forms which light reveals to advantage; their image is distinct and tangible within us and without ambiguity" (Le Corbusier 1969, p. 38). In Egypt the play between light and shadow is not limited to the great primary forms. The surfaces of buildings are often furnished with finely detailed reliefs cut into the stone (Fig. 10.1). Here, the light/shadow effect is continued on a smaller scale. For human beings divine being was unattainable, invisible, and therefore located in darkness. The path to this divine being, which led from light into darkness, was further elucidated by directed light (see Fig. 9.18). By positioning a building very precisely in relation to the sun natural light could be integrated into the structure such that at particular times rays of light would form axes and illuminate certain points and places while leaving others in darkness. The French Egyptologist Jean-Louis de Canival described the illumination of statues in the Temple of Khafre as follows: "The light fell through small windows between the wall and the ceiling; it was directed at every individual statue and reflected by a floor made of polished alabaster such that a highly diffuse light illuminated the space while the pillars and walls remained in darkness" (Canival 1964, p. 92). The statues represented different divinities. The indeterminacy of the darkness further strengthened the mystical character of the afterworld. Only a select few were permitted to enter the interior of the complex and experience this scene, which was not simply art in the contemporary sense but an attempt to give visual form to a spiritual-cultic constellation. The illumination was deliberately deployed to reinforce and materialize this idea.

Fig. 10.1 Temple, second century BCE, Kom Ombo, Egypt

10.1 Light and Its Effects

Greek temple buildings were sculptures whose effect radiated out into the space of their surroundings. The only task of the interior space was to house cult statues. Festivals and ceremonies took place in the open in a walled area in front of the temple, in the centre of which stood the altar. It is therefore not surprising that many of these interior spaces had only one opening, namely the door. In many temple complexes, such as the Temple of Khafre, the lighting of statues was improved by means of a pool of water that lay between the statue and the entrance. The incident light was reflected off the surface of the water and thus illuminated the cult statue. In buildings that required better lighting the Greeks often used skylights, increasing the height of a section of the roof to create a gap that allowed in light (Martin 1966, p. 91).

In early Christian and Byzantine architecture the interior space was spiritualized and distanced from reality. Here directed light played a central role. One example is the Hagia Sophia in Istanbul, where a series of openings perforate the base of the main dome, creating the impression that the dome-shaped church roof, which has a diameter of 30 m, is floating. The light that permeates through these openings and the windows in the lateral wall of the upper dome imbues the interior space with a sense of remoteness from the world (see Fig. 5.6).

The basic idea informing Gothic architecture of "building a part of heaven on earth" led to a dematerialization of interior space (see Sect. 5.1). Two factors made this possible: the transfer of the bearing structure to the outside of the church (see Fig. 5.10) and the specific way light was directed. The dimensions of the bearing sections were reduced to a minimum so that large areas of the walls could be glazed. In these churches the light penetrating the upper part of the central nave is so intensive that there are no dark zones at all in this area; the roof of the central nave seems to be literally hovering. By contrast, the lower part of the nave is in semi-darkness; the adjacent aisles and the required dimensions of the bearing structure in the lower part of the lateral facades prevent any more bright light from penetrating the space. At ground level the human being finds himself in a mundane semi-darkness and looks up to the brightly lit "heavens" as the site of the divine. The church roof forms the "floating firmament" (see Fig. 10.2, 3.1 and 5.10). The dark ceiling of the Sainte-Chapelle in Paris is accordingly painted with golden stars (Fig. 10.2b).

The reason why the Baroque space appears contradictory, why it deceives the senses, is described in Sect. 5.1. Directed light also plays a highly significant role here. By staggering bright, illuminated zones and dark, shadowed zones the illusion of depth is created, giving the observer the impression that the space extends into infinity. Indirect lighting is common in such spaces, and above all in late Baroque buildings the visitor can barely see the windows. Brightness in the interior space is thus created by reflections from the walls.

From the Baroque to the present the possibility of creating illusions by means of lighting effects has continued to be exploited. In sacral building special forms and lighting are often used to create optical effects that are not clearly definable in perceptual

Fig. 10.2 a The use of light in the Gothic church supports the spatial concept, **b** Pierre de Montereau, 1246–48, Sainte-Chapelle, Paris

terms, permit different interpretive possibilities, and, in addition, create mystical atmospheres (see Fig. 10.3 and 10.5).

There is a direct connection between the way light is directed and the complexity of a style (see Sect. 2.4). The more complex the arrangement a style involves, the more likely the use of light will play a role in the expression of the architectural idea. There are fundamental differences between natural light and artificial light. Naturallight changes continually, whereas in the interior space artificial light remains constant; neither the intensity nor the position of the light source is subject to temporal variations. Because the sun is so far away, the rays of natural light are parallel when they reach the earth. Artificiallight spreads out on all sides from a point source; the rays are not parallel. This difference results in two very different types of shadow and thus differences in lightness-darkness conditions between inside and outside spaces (see Fig. 10.4).

In general, interior spaces only rely on artificial light during the evening and night; during the day natural light illuminates the interior through openings in the walls.The extent to which natural light is necessary in the interior space depends on the respective demands placed on that space. Whether it is necessary for a work space or not is a matter of dispute between physiologists and lighting technicians. The architect Louis I. Kahn, for example, argued that a room was not really a room if it was illuminated artificially (Klotz and Cock 1974, p. 247).

Optical perception, the reception of visual messages, is determined by four factors: A) Time: At what point in time does the message reach the retina? B) The position of the perceived object. C) Light intensity: Both excessive darkness and excessive brightness

10.1 Light and Its Effects

Fig. 10.3 Sanaksenaho Architects, 2005, church, Hirvensalo, Finland

limit visual perception (Sect. 10.4). D) Colour: Colour is perceived only in a certain brightness range (Sect. 10.6).

Light intensity is the most important of these factors. Without light neither the position of an object nor its colour are discernible. Natural light is an extremely unstable factor. Its quality changes according to the season, time of day and weather conditions, and these changes alter our perception of our environment and thus of a building. The constant variation in natural lighting conditions ties human beings to natural rhythms, which can serve as a yardstick and provide a means of orientation. Here, too, we find a pronounced difference from artificial lighting. Today, physically optimal lighting intensity, colour and warmth etc. can be artificially generated, but the constant variation and resulting perceptual changes associated with natural lighting are difficult to copy with artificial lighting. The role of light as a natural clock is completely absent from artificial lighting. The position, size, form and material of a future house are precisely defined in the planning phase. Even the position of the sun, the source of natural light, can be calculated

Fig. 10.4 Differences in the way shadows are cast under **a** natural light and **b** artificial light

in advance for every time of day and year. However, the precise lighting conditions and influences such as cloud, rain, fog, etc. as well as the resulting socio-psychological components affecting the observer are difficult to predict and thus remain unknowns in the planning process.

10.2 Directed Light and Openings

There are many ways of designing openings that connect interior and exterior spaces (see Fig. 5.31). These differences result in light being directed in different ways. Originally a window was just a hole in a wall. In the interior such an opening appears as a luminous surface. There is a big difference in brightness between the window area and the surrounding wall: The window appears very bright while the surrounding wall area is the darkest part of the room; it is not directly lit and is only illuminated by light reflected off the other walls.

When the load-bearing system is a skeleton-frame system, i.e. consists of columns and beams (see Sect. 5.3.2), the wall no longer needs to function as a bearing element and larger openings such as horizontal and ribbon windows can be installed. As Le Corbusier wrote, "The entire history of architecture revolves exclusively around wall openings. Reinforced concrete suddenly makes it possible to achieve maximum illumination through the horizontal window" (Le Corbusier 1981, p. 94). If an opening is located at the end of a wall or forms a gap between wall and ceiling, the connecting wall or the ceiling will be illuminated by the light that enters through the opening (Fig. 10.5). These brightly lit surfaces in turn reflect light throughout the room, making the contrasts between light and dark much weaker. Such illumination can suggest spatial continuity and also function as a path indicator.

10.2 Directed Light and Openings

Fig. 10.5 **a** Zaha Hadid, 1993, former fire station, Weil am Rhein, Germany (see Fig. 7.4), **b** Le Corbusier, 1957, priory, La Tourette, France

The larger the openings the more the atmosphere of the interior space is influenced by external conditions. This dependence reaches its most extreme in the case of all-round glazing. Such spaces are highly exposed to changes in external conditions. The lighting conditions in the interior are similar to those in the surroundings. The more transparent the wall, the more difficult it will be to control the natural lighting conditions in the interior space (see Fig. 5.14). The degree of opening to the outside is also dependent on the prevailing understanding of space. It was only at the beginning of the twentieth century that the development of a strong relationship between interior and exterior came to be seen as something desirable in Western culture (see Sect. 5.1.1 and 4.5.3).

Even where it is seen as desirable to direct a lot of natural light into an interior, direct sunlight can be irritating. In order to avoid this, the position of openings can be selected such that the glazed surfaces are never directly exposed to sunlight and natural light thus penetrates the interior only indirectly. Mobile fixtures such as curtains and sheers can also be used to weaken or completely block natural light entering a space.

In certain geographic locations, the angle of incident sunlight is significantly steeper or flatter at different times of the year (Fig. 10.6). In such areas a canopy structure can be used to shield an interior from direct sunlight in the summer and to enable such sunlight to provide warmth in the winter. Le Corbusier is regarded as the inventor of the so-called brise-soleil: slats placed in front of a facade which hinder direct sunlight while, unlike

Fig. 10.6 Different angles of incident sunlight at different times of the year (in Central Europe): **a** in summer, **b** in winter

curtains and sheers, allowing a view into and out of the building. At the end of the 1930s Le Corbusier collaborated with the architect and urban planner Lúcio Costa and Oscar Niemeyer, who was at the time interning with Costa, on the planning of the Ministry of Education and Health Building (now the Gustavo Capanema Palace) in Rio de Janeiro. The facade of this building is equipped with brise-soleil to shield it from direct sunlight. Oscar Niemeyer later used a modified form of this system on several of his buildings (Fig. 10.7).

Mirrors intensify lighting and optically enlarge interior spaces. In the halls of mirrors that were built from the fifteenth century onwards in many palaces the reflecting surfaces functioned as lighting installations that also helped to multiply optically the splendour and opulence of the decor, an effect also utilized by Oscar Niemeyer in 1960 in the Palacio da Alvorada, the presidential palace in Brasilia (see Fig. 10.8).

In the headquarters of the "Hong Kong and Shanghai Banking Corporation" in Hong Kong by Norman Foster a bank of giant mirrors at the top of the atrium reflect natural sunlight down into the atrium and the plaza below (see Fig. 10.9).

10.3 View and the Natural Illumination of Interior Space

Apart from the type of opening used in walls, two other factors shape the optical relationship between interior and exterior: the type of natural lighting in the interior, i.e. the way natural light penetrates to the interior, and the degree of unrestricted view between the interior and exterior: the view from outside into the interior space and the view from inside out into the exterior space. An unrestricted view usually also means that light is

10.3 View and the Natural Illumination of Interior Space

Fig. 10.7 **a** Le Corbusier with Lúcio Costa, 1936–43, Ministry of Education and Health Building (now the Gustavo Capanema Palace), Rio de Janeiro, Brazil, **b** Niemeyer Oscar, 1955–60, residential building, Praca da Liberdade, Belo Horizonte, Brazil

Fig. 10.8 Niemeyer Oscar, 1960, Palacio da Alvorada, the presidential palace, Brasilia, Brazil

Fig. 10.9 Foster Norman, 1982–85, Hong Kong and Shanghai Banking Corporation, Hong Kong

able to penetrate an interior from outside. However, illumination from outside is not always associated with an unrestricted view. In principle there are three possibilities: a) the opening only permits light to enter but does not afford a view, b) light can enter and a view is afforded to the outside, or c) light can enter and a view is afforded in both directions. In most cases, where natural light is available designers will attempt to integrate it into the interior illumination. The illumination requirements of a space depend on the way it is utilized. However, in cases where they are not expressly required, pronounced contrasts between light and dark are to be avoided because they make excessive demands on our visual perceptual mechanism.

It has been experimentally proven that up to a certain point increasing brightness in a space is experienced as increasingly pleasant but that from a certain intensity onwards any further increase can be result in discomfort (Lau 1973, p. 105). The position, size

10.3 View and the Natural Illumination of Interior Space

and form of openings in an outer surface are often highly dependent on the type of construction of the building shell (see Sect. 5.3.2). The openings in vertical spatial enclosures, doors and windows often create a visual reference to the surroundings. Skylights, openings in the components that close off a space at the top, primarily function to conduct light into the interior. They do not provide much in the way of optical references to the surroundings; however, the illumination they create can generate particular moods (see Fig. 10.5).

The type of opening is seldom exclusively determined by the necessary amount of light: problems with ventilation, shielding, construction and appearance also play a role. The original task of the window was to conduct light into the interior while also separating the interior from the exterior climate. However, material restrictions meant that an opening could not climatically separate the interior and exterior while providing visual transparency at the same time. The materials used were thin stone plates, for example alabaster, and later opaque glass, which allowed light to enter the interior but did not permit a view in or out (Fig. 10.10a). Even today, visual transparency is not always an objective of window design. In the Arab world, traditional Islamic architecture often features meshed lattices positioned in front of widow openings, which allow people inside the building to

Fig. 10.10 a window, Greyerz Castle, Switzerland, b fort, fifteenth century onwards, Jodhpur, India

look out into the street without themselves being seen. With the spread of Islam to the east, this type of structure was also adopted in India, where it was constructed out of stone (Fig. 10.10b). Influenced by his travels in Turkey, Le Corbusier also used this idea in Villa Schwob, which was built in La Chaux-de-Fonds in 1916. Round openings in the walls of two rooms on the upper level allow a view down into the two-storey living area. Lattices in front of the openings prevent the person above from being seen (Fig. 10.11).

Reflecting glass can be seen as a later version of this idea: Views to the outside are possible but the exterior reflects the surroundings, thereby hindering a view into the interior. Tinted glass can be described as a variant of mirror glass, although the degree to which a view to the outside is possible depends on the type of colouring (Fig. 10.12).

In some cases it can still be desirable today to design openings that allow in light without permitting a view to the inside or outside. A good example is Yale University's Rare Book and Manuscript Library by Gordon Bunshaft (SOM). The building's outer walls consists of large, thin alabaster plates which allow in just enough light to ensure the interior space is not in darkness but prevent the kind of intensity that could do damage to the books (Fig. 10.13).

There are intermediate stages between transparent and merely translucent. The foyer around the main auditorium in the congress centre in San Sebastian, which was built by

Fig. 10.11 Le Corbusier, 1916, Villa Schwob, La Chaux-de-Fonds, Switzerland: **a** opening (above right in the picture) on the upper level with a view into the living area on the ground floor, **b** the same opening in the bedroom on the first upper level

10.3 View and the Natural Illumination of Interior Space

Fig. 10.12 Reflecting glass and tinted glass: **a** Herzog & de Meuron, 2004, Forum, Barcelona, Spain, **b** Frank Gehry, 2007, office building, New York, USA

Fig. 10.13 SOM, 1963, library, New Haven, USA

Rafael Moneo in 1999, is naturally lit by the translucent outer skin of the building. The façade is made of milk-glass elements that permit light to enter without affording a view to the outside, but such a view is possible in certain places where normal glazed openings have been installed (Fig. 10.14a).

The pyramid over the entrance to the Louvre extension built by I. M. Pei in 1989 uses completely transparent glass. The elaborate supporting structure for the large glass surfaces partly obscures the view of the older building before visitors lose sight of it completely when they descend into the subterranean foyer (Fig. 10.14b).

We find a similar situation in the case of the cathedral built in Brasilia in 1960 by Oscar Niemeyer. The translucent elements consist of double glazing, which permits enough light to create a pleasantly warm atmosphere in the interior (Fig. 10.15). The church is accessed via a ramp, which descends some four meters into the interior. A view

Fig. 10.14 a Rafael Moneo, 1999, congress centre, San Sebastian, Spain, **b** I. M. Pei, 1989, Louvre extension, Paris, France

Fig. 10.15 Niemeyer Oscar, 1960, cathedral, Brasilia, Brazil

from inside out into the immediate surroundings is therefore not possible, and only the outlines of several high-rise structures located further away can be made out.

10.4 Light Intensity

The intensity of light is one of four important factors affecting optical perception (see Sect. 10.1). The capacity of the eye to adapt to different light intensities is astounding: Optical perception is possible both in very weak light such as moonlight, which we already classify as darkness, and in light that can be 250,000 times as intense as moonlight (Rasmussen 1980, 189).

We distinguish between the natural light source provided by the sun and artificial light sources such as fire and electrical lamps. However, the illumination radiating from these natural and artificial sources is not the only type of light we can see. Apart from this direct light we also register indirect light reflected from illuminated objects. This reflected light lends a certain degree of brightness, or luminosity, to objects not directly struck by light rays, and it is this brightness that allows us to see these objects. It follows that two factors are important for the brightness we see: the illumination, which means the amount of light that strikes the object, and the reflectivity of the object, i.e. the ratio between the reflection and absorption of a certain amount of incident light. This means that the brightness we perceive is not directly proportional to the intensity of light. A smooth white surface that is only weakly lit can appear more luminous to us than black silk under strong light (Fig. 10.16). The eye can register brightness but it cannot determine which of the two factors, illumination or reflectivity, have contributed to this result. There are thus two possible ways of influencing the perceived brightness of

Fig. 10.16 The perceived brightness corresponds to the reflected light. This is dependent on the absorption capacity of the surface (2 possibilities)

an architectural element: by means of the intensity of illumination or by means of the surface qualities of the respective materials, i.e. their reflectivity.

The perception of brightness can thus be influenced with the help of light intensity and surface qualities. A certain level of illumination can be amplified or weakened by the choice of an appropriate surface structure. This possibility is seldom exploited in architecture but for stage designers it is an everyday tool (Arnheim 1978, p. 305). In order to avoid overly stark differences in the brightness of a space, for example, the wall that is directly lit can be covered with a more light-absorbent surface than the other walls.

In perceptual terms the brightness of an object is both relative and subjective. Our perception of brightness is influenced by our surroundings. The brightness of the surroundings in turn influences the perceived size of an object. An object in dark surroundings appears bigger to us than in bright surroundings, which is why objects appear larger to us by night than by day. This is one of the reasons why it is more difficult to estimate distance in the dark than in daylight.

The relative character of brightness perception is such that there are no certain criteria for assessing whether brightness arises directly from a light source or is a consequence of reflection. We see the moon as a round luminous disc. In purely perceptual terms we cannot ascertain whether it is a light source or is merely reflecting the incident sunlight. In most cases the perceived brightness values do not correspond to measured values. Socio-psychological aspects play an important role here. The psychological state of the beholder and his relationship to the object can influence his perception of brightness (see Sect. 1.4). Up to a certain point brightness perception is balanced out by the nervous system and the eyes. For example, our pupils expand automatically when brightness decreases, so that more light falls on the retina (Lau 1973, p. 87).

When we see different brightness values in our field of view as a result of different levels of illumination, then we tend to register a unitary value. The brightness of the surfaces in Fig. 10.17 varies from white to dark grey. Nevertheless, we register all surfaces as simply white (see Sect. 1.3.5). The question of how the brightness value of the object of the human perceptual mechanism is precisely determined remains without a clear answer (Arnheim 1978, p. 305).

The same applies to colour. If a building is a certain colour, for example red, we perceive an entire red scale, from light red to almost black but ascribe the building a particular red value (Fig. 10.18). This behaviour can also be explained in terms of information theory. If we had to consciously register every individual red tone (or all grey values in Fig. 10.17), the amount of information of would be far too great and would overload out brains.

In Sect. 1.3.6 we looked at depth perception. Depth, as the third dimension, is an important factor for spatial perception. One aspect of depth perception is the brightness gradient: a surface will appear lighter or darker depending on the size of the angle between incident light and the surface it strikes.

Different depths and thus shapes and space are perceived with the help of illumination and the differences in brightness it produces (see Fig. 1.33). However, for a shape to be

10.4 Light Intensity

Fig. 10.17 Registering a unitary brightness. Jörg Kurt Grütter, 2005, dwelling conversion, Zürich, Switzerland

Fig. 10.18 a Bolles-Wilson, 2001, Luxor Theater, Rotterdam, Holland, **b** 8 segments of the photo to the left. Colour constancy: despite the different colour tones we see a red house

correctly perceived, the beholder must know the location of the light source: he has to know from which side the object is being illuminated. For example, the red image to the

Fig. 10.19 Brightness differences indicate shape and thus space but do not unambiguously define them. In both the left and right examples the shapes above and below are both possible

right in Fig. 10.19 can be interpreted in different ways. If both the shape and the direction of lighting change (above and below), the perceived red image remains unchanged (red stripe to the right in the middle). Even when the position of the light source is known, the precise shape cannot be determined with any certainty. The red image to the left in Fig. 10.19 permits at least two interpretations, as seen above and below.

10.5 Shadow

Visual perception crucially relies not only on light but also on shadow.

Frank Lloyd Wright describes the interplay of light and shadow, their indivisibility, in vivid terms: "Man's faithful companion, the tree, lived by light. The building, man's own tree, lived by shadows" (Wright 1970). We distinguish between a body's own shadow and cast shadows. The former lies on the object itself. All surfaces of the body that are not directly illuminated lie in its own shadow. The cast shadow is thrown by

Fig. 10.20 The shadows provide us with information about the shapes of the different bodies and their positions

an object onto its surroundings. It can reveal information about the position of the light source but also about the shape of individual objects and their relationship to one another (Fig. 10.20).

The relationship of an object to its shadow is influenced by four factors: the position of the light source, the size and shape of the object, the size and shape of the cast shadow, and the position and shape of the surroundings onto which the shadow is cast. Three of these four factors need to be defined in order to precisely define the overall situation.

In the perception of architecture it is often the case that less than three of these factors are known, so that in spite of shadowing we cannot determine the precise spatial relationships involved (Fig. 10.21). For example, the perception of shadows can lead to an overestimation of the size of a set-off (Lauenstein 1938, p. 283).

10.6 Colour

The importance of colour is generally underestimated. But in fact, together with light intensity, colour vision is of prime importance for visual perception (Fig. 10.22).

Why do we see in colour? If we were only able to discern between light and dark, this would suffice for spatial orientation but our perceptual ability would be significantly restricted. We can check this by putting on a pair of dark-tinted sunglasses so that our vision is dominated by one basic colour. The absence of different colours deprives us of a fundamental distinguishing feature. In this situation, a red spot on a blue background is only discernible as a difference in brightness. If the brightness is omitted and there are no other reference points, then this spot is no longer discernible. However, if we are able to detect the colour difference, it becomes a distinguishing feature. Experiments have

Fig. 10.21 Shadows. Car park in Lugano, Switzerland

Fig. 10.22 Seeing in black and white and in colour, Nervi, Italy

shown that shape is more important than colour for spatial orientation and the identification of objects, although here, too, there are differences. For children in certain age groups colour is more important than shape. The character and psychological state of the test subject also have an influence. A cheerful disposition tends towards evaluation based on colour, whereas depressive people tend to assess using shape. Extroverts tend to favour colour, introverts shape (Arnheim 1978, p. 330).

Although subject to variations based on the connections between degree of complexity, type of information and the personality structure of the beholder (see Fig. 3.12), in the perception of a style with a predominantly complex arrangement colour will generally assume a higher status in relation to shape than it does in the perception of a style with a simple arrangement. A further implication is that in a message the coloured components tend to make up the aesthetic proportion of the information while the aspect of shape tends to correspond to the semantic proportion. This applies to only a limited extent, since it does not take into consideration the diversity of shapes and their emotional effects.

However, the perception of colour also alters in response to changes in illumination, time of day and weather conditions. Moreover, the hue that is perceived is influenced by the colour of the surroundings. A blue figure on a green background appears different to one on a red background. This explains, for the example, the difficulty we experience when choosing a colour for a house wall based on small colour samples, because the lighting conditions and the colour of the surroundings make the colour in the sample appear different from how it will appear on the object.

If an object with a certain colour is positioned in surroundings of a different colour, a tendency will emerge either to adapt the colours to one another or to emphasize their contrast. If the two colours are sufficiently similar or the object is sufficiently small in relation to its surroundings, there is a tendency to adaptation (Arnheim 1978, p. 360). The colour contrast between two surfaces is also the starting point for a definition of the concept of colour: "Colour is the visual sensation associated with a part of the field of vision that appears to the eye to be without structure, which is the only way that this part, viewed with one unmoving eye, can be distinguished from another area that is also without structure and seen at the same time" (DIN 5033). According to this definition white, black and all shades of grey are also colours, although in his theory of colour Johann Wolfgang von Goethe designated them as "non-colours" (Richter 1976, p. 10). Black and white have a particular status within the colour scale. As Theodor W. Adorno put it, "The ideal of blackness with regard to content is one of the deepest impulses of abstraction" (Adorno 1974, p. 65).

10.6.1 Why Do We See in Colour?

The eye registers light with a wavelength of between 380 and 780 nm (nanometer), and different colours are perceived at different wave lengths. The process of colour

perception begins with the retina, which contains light-sensitive receptors: 100 million rods responsible for black and white vision, i.e. the perception of brightness, and only 6 million cones responsible for colour vision. However, these cones only become active at a certain level of brightness; if the level is lower than this we humans see only black and white.

What we perceive as colour is made up of three components: the colour's hue, brightness and saturation (Arnheim 1978, p. 343). The perception of hue, or what is generally referred to as colour, is less differentiated than the perception of brightness; a human being can distinguish between around 200 brightness levels but only 160 different hues in a spectrum of pure colours (Arnheim 1978, p. 348). This colour differentiation is only possible when hues can be directly compared with one another. If we have to recall individual colours, the number of hues we can recognize easily and reliably is not much more than six (Arnheim 1978, p. 328). Because when differentiating colours brightness is more important that hue, a colour difference can be supported with the help of additional differences in brightness. As we saw above, the perceived brightness of an object depends on the intensity of illumination and the reflective capacity of the surface of the object (see Sect. 10.4). It is similar in the case of colour vision: The surface reflects not only a certain quantity of light but also light of a certain wavelength. Depending on the wavelength of the light falling on the retina, we perceive a certain colour. If all wavelengths are reflected at equal strength, we see white.

How do we see in colour? How are hues perceived? The attempt to answer this question has produced two theories: the trichromatic theory, also known as the Young-Helmholtz theory, and the opponent-process or Hering theory. The former was developed in the mid-nineteenth century by the German physicist Hermann von Helmholtz, who drew on the work of the English physicist and ophthalmologist Thomas Young. He observed that the three primary colours of blue, green and red could be used to mix all other hues and on this basis concluded that the human eye had to have three types of cone photoreceptors which reacted to light of different wavelengths corresponding to the three primary colours. These three fundamental stimuli formed the basis of all colour perception. The second theory, the opponent-process theory, was developed in the second half of the nineteenth century by the German physiologist Ewald Hering, who proceeded from what he categorized as the primary colours of red, yellow, blue and green, arguing that all other hues were perceived as mixtures of these primary colours. He also observed that when looking at a field made up of one of these primary colours, the observer will see the surroundings of the field in an opposing colour. The colour stimulus involves not only a certain field but also the neighbouring area, which appears in the opposing colour. In this model blue is the opposing colour of yellow, red the opposing colour of green, and vice versa (Nüchterlein 2004, p. 168).

However, colour perception is not only a reaction to electro-chemical stimuli. Socio-psychological factors such as the character and momentary psychological state of

10.6 Colour

the beholder can also have an influence of colour perception, as can cultural influences, associations and personal experiences. As indicated by expressions such as "see red" and "golden opportunity", colours also have a certain symbolic quality, which is based on a generalization of the emotional effect they elicit.

10.6.2 The Psychological Aspect of Colours

Different colours have different psychological effects on the beholder. These effects depend on three factors:

a) The location at which they are used. The deep blue of the sky over snow-covered mountains is pleasing to us, but the same colour on the walls of an apartment would make us shiver even in summer.
b) The culture, i.e. the norms, prevailing at the respective location. For example, the extreme colours black and white have a much higher status in Japan than in the Western world. In a number of cultures certain colours have a symbolic meaning. Whereas in the West the colour of mourning is black, in Japan it is white. In ancient Rome purple was the colour associated with the emperor, in ancient China the emperor's colour was yellow, which was thus a symbol of power.
c) Third, the psychological effect of colours also depends on socio-psychological aspects influencing the beholder. A surgeon and a wine dealer will very probably have different attitudes to the colour red.

Colours have a perceptual "weight". Although we know that normally the colour of an object has no influence on its physical weight, we perceive a white, yellow, green or light blue object as lighter than the same object coloured orange-red, dark blue or deep violet (Fig. 10.23). Black, as the darkest colour, is the exception: it conveys the impression of

Fig. 10.23 The perceptual "weight" of colours: **a** "heavy" roof, **b** "light" roof

emptiness. It is not only hue but also brightness and saturation that influenced the perceptual "weight" of colours: the brighter and paler, the "lighter" they appear. The precise reason for the differentiated perception of weight in the case of different colours is not known. It probably has to do with the fact that we are accustomed to seeing light, and thus brightness, above rather than below us. Correspondingly, we tend to perceive a lower element of a structure as heavier than a higher element (Frieling 1977, p. 23).

Colours also have a perceptual "temperature". We experience red and orange as warm, and blue and green blue as cold. Here, too, saturation plays a decisive role: the paler the colour, the "colder" it seems.

Colours can be used to influence and manipulate people's emotional states; they have a direct influence of the human organism. Blood pressure, pulse, breathing, irritability and the capacity to concentrate can all be influenced with colour. Here again, the level of saturation and the level of brightness play a role. Red can have a stimulating, exciting effect, while green tends to be calming and relaxing.

10.6.3 Colour and Space

A spatial concept can be supported with the help of colour. The illusion of depth can be created with black-white contrasts (see Sect. 1.3.4.3). The black-white contrasts in the stone facing on the facade of the Santa Maria Novella church (see Fig. 1.29) visually break up the large surface and create an impression of spatial depth.

Colours influence our perception of distance. Of the three colour-fields in Fig. 10.24a, the blue one appears closest and the yellow one furthest away. When we see these colours against a different background (Fig. 10.24b), the yellow field appears closest and the blue one furthest away.

Fig. 10.24 Colours influence our perception of distance: **a** blue rectangle appears closest, **b** yellow rectangle appears closest

10.6 Colour

Fig. 10.25 Influence of colour on spatial perception

As in the cases of perceived weight and distance, colours also have an influence on our sense of space, on the way space is perceived. They can support a spatial concept and influence the behaviour of people within that space (Fig. 10.25).

Figure 10.25 shows six identically shaped rooms with differently coloured enclosing surfaces. In spite of their identical dimensions, the six rooms appear different from one another. In room A the ceiling and back wall appear like one unit and thus as if they "flow" into one another. In room B the floor and the three walls seem "restrictive", the ceiling "freeing". In room C the dark ceiling also seems heavy and makes the space seem even smaller. Such a design does not invite the visitor to linger but compels him to keep moving. A foyer or a cloakroom area could be designed in this way. This contrasts with room D, which comes across as open and neutral. In room E the colouring breaks up the symmetry. The red wall to the left seems heavy and dominant, the wall to the right light and unrestrictive. Due to its orange back wall and blue side walls, room F seems less deep but broader. In perceptual terms, orange brings the back wall closer, while blue presses the side walls apart.

10.6.4 Colour in Architecture

Colour has almost always been an integral part of architecture. Materials used in building have their own colours (see Fig. 5.29). In ancient Egypt pillars were painted in different colours, like their models in nature, and ceilings were often rendered blue like the sky (Koepf 1979, p. 56). Also greek temples were originally at least partly painted, as

indicated by traces of colour found on excavated segments (Koepf 1979, p. 56). Some of the now bare surfaces were possible painted with ornamentation such as garlands etc. Larger surfaces were apparently not painted and harsh colour contrasts were avoided. The extent of this painting is not clear today. When assessing the question of colour in Greek antiquity the aspect of illumination should always be taken into consideration: Light in this part of the world is very intense, lines are sharp and clear, and shadows are succinct. Discussing the relationship between light and colour in Greek antiquity, Frank Lloyd Wright commented, "Of course I visited Athens – held up my hand in the clean Mediterranean air against the sun and saw the skeleton of my hand through its covering of pink flesh – saw the same translucence in the marble pillars of the aged Parthenon, and realized what "colour" must have been in such light" (Lauenstein 1938, p. 136). There is evidence that Gothic cathedrals were also partly painted (Der Spiegel 1984/29, p. 120). In the Baroque, painting was part of the architecture, supporting and indeed making possible the realization of the central spatial idea. The illusion of infinite space could only be achieved by painterly means (see Fig. 6.11b).

Over millennia, figurative paintings were done directly onto walls, which meant that their colour composition, brightness contrasts and content were influenced by their location. Indeed, one of their tasks was to emphasize the character of that location. Later, when pictures were painted onto autonomous surfaces, paintings were still often created for precisely predetermined locations. The artist knew in advance where his work would hang; he was familiar with the lighting conditions and the surroundings and could adapt his work to them. The idea of producing paintings in a studio, selling them in a gallery and finally hanging them on a random wall is relatively new and creates problems. Now the location has to be adapted to the picture, and in many cases there is no longer a relationship between painting and surroundings.

Modernist architecture was supposed to be above all functional, freed of everything decorative and "useless". Such "useless" aspects included colour, which led to the idea that architecture should be "white". In 1920, in their "Realist Manifesto", Naum Gabo and Antoine Pevsner wrote of the use of colour, "We reject decorative colour as a painterly element in three-dimensional construction. We demand that the concrete material be employed as a painterly element" (Gabo and Pevsner 1981, p. 53). In 1929, Mies van der Rohe accordingly used sanded plates made of travertine, red onyx, marble and other natural stone to clad both the floor and wall surfaces of the German pavilion for the World Expo in Barcelona (Fig. 10.26).

The impression that modernist architecture was exclusively white has also been influenced by the fact that photographs from the 1920s and 1930s are all in black and white. In 1919 Bruno Taut, in his "Call for Colourful Building", demanded more colour in architecture. The residential estate he built in western Berlin between 1926 and 1931 represents one of the early highpoints in this development. Rather than colour functioning here as a means of bringing the individual houses alive, it became an aspect of urban development. Taut commented, "The most important point is that colour should be

10.6 Colour

Fig. 10.26 Ludwig Mies van der Rohe, 1929, pavilion, Barcelona, Spain (see Fig. 2.7 and 6.15a)

used more to emphasise the spaciousness of the estate. The different effects of the colours and their luminosity allow the dimensions to be extended in some areas and compressed in others" (Hüter 1988, p. 207). The De Stijl movement, which was initiated by painters, architects and designers, also opposed the use of colour as a separate, purely decorative element in architecture. In its Manifesto Number V of 1923 the group wrote, "… 3. We have examined the laws of colour in space and time and have established that the mutual harmonization of these elements produces a new and positive unity. … 7. We have given colour its rightful place in architecture and we assert that painting separated from the architectonic construction (i.e. the picture) has no right to exist" (de Stijl 1981, p. 62). One year later a leading representative of the group, the painter and architect Theo van Doesburg wrote, "The new architecture has destroyed painting as a separate, imaginary expression of harmony, in its secondary form as representation and its primary form as colour planes. The new architecture permits colour organically as a direct means of expressing its relationships within space and time. Without colour these relationships are not real but invisible. The equilibrium of organic relationships first becomes visible through colour. The modern painter's task is to use colour to create not a two-dimensional plane but a harmonious whole in the new four-dimensional realm of space–time" (Van Doesburg 1981, p. 74). Like Bruno Taut he argued that colour should not be seen merely as an "addition" to architecture and that it was through colour that spatial relationships first really came into their own.

An important point to remember when considering the debate around colour in the 1920s is that many of the architects engaged in this debate were also painters, among them Le Corbusier, Theo van Doesburg, J. P. Oud and Bruno Taut. Le Corbusier, one of the most important figures in the discussion around the role of colour in modern architecture, used colour in his building designs very early in his career. In 1912, after travelling

for six months in the Orient, he began designing the "Maison Blanche" for his parents in La Chaux-de-Fonds, Switzerland. Obviously influenced by the impressions gathered on his journey, he employed a great deal of colour in his design of the interior (see Fig. 11.11). In January 1921, the journal "L'Esprit Nouveau", an avant-garde publication in which Le Corbusier was also involved that dealt with art, architecture and literature, published an article on colour. However, in his book "Vers une architecture", published in 1923, which focuses exclusively on architecture, there is no reference to colour in architecture. It was not until 1925, when he built the Villa La Roche in Paris, that Le Corbusier's interest in the use of colour seems to have been rekindled. Commenting on the project he said, "Were it completely white it would be a cream jug" ("Entièrement blanche la maison serait un pot à crème") (Le Corbusier 1926, p. 146). And in 1936, he wrote, "Colour in architecture, a tool as powerful as the floor plan and the section. Or better: polychromy, itself an integral part of the floor plan and the section" (Rüegg 1997, p. 7).

References

Adorno, Theodor W.: Ästhetische Theorie, Frankfurt am Main, 1974 (1970)
Arnheim, Rudolf : Kunst und Sehen, Berlin, 1978 (original title: Art and Visual Perception, Berkeley, 1954)
Rüegg, Arthur: Polychromie architecturale, Basel, 1997
Canival, Jean-Louis de: Aegypten, Fribourg, 1964
De Stijl: Manifest V, 1923 (in: Programme undManifeste zur Architektur des 20. Jahrhunderts, Braunschweig, 1981)
DIN 5033 (in: *Richter, Manfred:* Einführung in die Farbmetrik, Berlin, 1976)
Frieling, Heinrich: Mensch und Farbe, Munich, 1977
Gabo, Naum und Pevsner, Antoine: Grundprinzipien des Konstruktivismus, 1920 (in: Programme und Manifeste zur Architektur des 20. Jahrhunderts, Braunschweig, 1981)
Hüter, Karl-Heinz: Architektur in Berlin 1900–1933, Stuttgart, 1988
Klotz, Heinrich und Cock, John W.: Architektur im Widerspruch, Zürich, 1974 (original title: Conversations with Architects, New York, 1973)
Koepf, Hans: Struktur und Form, Stuttgart, 1979
Lau, J.: Zum Unterschied zwischen Modellräumen in natürlicher Größe und in maßstäblicher Verkleinerung bei der Beurteilung der Beleuchtungsqualität (in: Architekturpsychologie, Düsseldorf, 1973) (original title: Architectural Psychology, London, 1970)
Lauenstein, Lotte: Über räumliche Wirkung von Licht und Schatten (in: Psychologische Forschung, vol. 22/1938)
Le Corbusier: Fünf Punkte zu einer neuen Architektur, 1926 (in: Programme und Manifeste zur Architektur des 20. Jahrhunderts, Braunschweig, 1981)
Le Corbusier: Almanach, Paris, 1926
Le Corbusier: Ausblick auf eine Architektur, Berlin, 1969 (original title: Vers une architecture, Paris, 1923)
Martin, Roland: Griechenland, Fribourg, 1966

References

Nüchterlein, Petra: in Richter, Peter G. (ed.), Architekturpsychologie, Lengerich, 2004

Rasmussen, Steen E.: Architektur Erlebnis, Stuttgart, 1980 (Originaltitel: Omat opleve arkitektur, Kopenhagen, 1959) Unterschiedliches Blau (in: Der Spiegel, 29/1984)

Van Doesburg, Theo: Auf dem Weg zu einer plastischen Architektur, 1924 (in: Programme und Manifeste zur Architektur des 20. Jahrhunderts, Braunschweig, 1981)

Wright, Frank Lloyd.: The Future of Architecture, New York, 1970

Signs

Contents

11.1 Semiotics . 331
11.2 Semantics. 332
11.3 Adornment . 334
11.4 Symbols . 335
11.5 The Significance of the Sign in the History of Architecture . 343
References . 352

11.1 Semiotics

Every message, including the visual type, is conveyed with the help of signs. The study of signs is known as semiotics, which is based on the term semiology, which in turn derives from the Greek terms semeion, meaning sign, and logos. Every perceived sign has some sort of effect on the receiver. A basic distinction is made between two different groups of signs, although a sign can belong to both groups (Fig. 11.1).

The syntactic dimension of a sign tells us something about the sign as such: its shape, size, colour etc. The receiver can arrange several signs syntactically based on logical criteria.

The semantic dimension of a sign tells us something about its content, its meaning. Such content can often only be perceived and understood if the receiver has previously learned its meaning, i.e. if the sign is already part of the receiver's repertoire (see Fig. 1.6). Most signs have content beyond their syntactic meaning. A traffic sign remains merely a syntactic sign until we have learned what it is telling us, i.e. until we know what its semantic content is.

In nature, and particularly among animals, we find both syntactic and semantic signs. Markings and colours can be without "content" and serve merely as decoration, meaning that they have a purely syntactic function. However, such signs often also have a semantic function: They serve as camouflage or as a deterrent, as a means of protection or of triggering a stimulus.

The status of the sign in architecture is difficult to determine specifically since it varies from epoch to epoch, from architect to architect, and, finally, from building to building.

11.2 Semantics

Semantics describes the relationship of a sign to its meaning, its content. This relationship between sign and meaning can be multilayered (Fig. 11.1).

Take, for instance, the different levels of meaning of the circle as a sign. As a syntactic sign, the circle can be, for example, part of an ornament. This means that in this context the circle has no ideational content; it stands for itself as decoration.

Every shape has a certain dynamic. The circle is a non-directional shape with all points on its boundary equidistant from its centre (see Sect. 6.5.5). Its structural lines point radially outwards from the centre or inwards from its boundary. These qualities lend the circle a certain expressiveness which has been utilized in architecture. The first level of the circle's use as a semantic sign, its utilization as an architectural shape, has universal validity. It symbolizes certain qualities which can be understood without previous or special knowledge. The central-plan space, in contrast to the longitudinal space, does not suggest movement; it has a clearly defined centre, which projects an idea of calm and repose. Here, shape complies with "ideational substance", i.e. the round shape represents a particular attitude. In Sect. 6.5.5 we saw that, despite the constructional difficulties involved, the round shape was used in Greek temple design and in traditional Chinese architecture due to its representational function, its semantic content (see Fig. 6.22). The converse is also possible, namely that the round shape is chosen

Fig. 11.1 The different levels of meaning of a sign using the example of a circle

for purely structural reasons. Compared to other shapes, the ratio between circumference and surface area reaches its optimal value in the case of the circle. A circle's boundary is equidistant from its centre at all points, which makes the shape suited to structures bearing heavy loads. The round shape, i.e. the circle or the cylinder, needs the least surface area to enclose a certain space. It is a shape that permits construction that is identical on all sides. The qualities of the circle are so pronounced that the shape can also be used as an explicit sign or pictogram. A pictogram attempts to convey its content in a schematic image, the comprehension of which often requires prior knowledge. The explicit sign in Fig. 11.1 can mean not only "meeting point" but also "middle" or "central". The third level of meaning can be seen in a shape's metaphorical role. The circle awakens associations, i.e. we project our experiences into the shape, seeing it as a ring, a wheel, etc. The metaphor permits different interpretations and is thus dependent on the individual and his culture, i.e. it tends to be subjective. The former TWA Flight Center in New York designed by Eero Saarinen (see Fig. 5.17 and 6.19) can be compared with a bird taking flight. The metaphor gives visual expression to the function of the building, making it an advertisement for the airline. But the shape permits other interpretations as well. The curved shell could be interpreted as a reference to the shell of a tortoise, which would hardly suit the image an airline wants to project. Most shapes trigger certain memories in the beholder or lead to subjective comparisons. For example, a building might be described as an "ugly shoebox" or a "magnificent palace". Such descriptions give expression to a personal, generalized opinion. Gustav Theodor Fechner, the founder of perceptual psychology, already asserted in his association theory that most perceptions are connected with a preceding experience (Sörgel 1918, p. 26). In relation to architecture, he argued that the purpose or the use of a space was the most powerful experiential factor. The search for metaphors plays a role in most perceptions. Each newly registered sign is compared by the brain with a pre-existing repertoire and then classified (Arnheim 1980, p. 267). No perception is identical with what has already been experienced, and every comparison with what is stored in memory is a search for a metaphor. This process is not registered by the beholder to an equal extent in every case and often takes place automatically.

The image or depiction can be seen as an interim level between the pictogram and the metaphor. It is not supposed to trigger just any association but a very specific one. The depiction represents a very precisely defined content. In different epochs and cultural spheres, architecture is either illustrative or not. Modernist architecture is above all rational and functional and has no important task beyond this. By contrast, a Gothic cathedral was not only supposed to function as a space for assembly but also to provide an image of the firmament. Beyond its functional aspect it has the task of representing something.

Finally, the circle is an element of many symbols. The symbol is the highest level of semantic meaning of the sign. The formal qualities of the circle express an ideational content that goes far beyond its shape. In the Taoist yin-yang symbol the circle symbolizes the unity and perfection of the complementary oppositional pair. While the image

always stands for something "concrete", for example the vault of heaven, the symbol represents an intellectual, abstract context. Understanding a symbol requires a certain degree of prior knowledge and is culturally dependent. A symbol gives formal expression to an intellectual statement. Today the word "symbol" is used for all kinds of signs. For instance, numbers are often referred to as symbols, whereas in the normal case they are nothing more than explicit signs. This is not to say that a number cannot also have symbolic meaning, for example the number 52 as the unit of the Aztec cosmic cycle.

11.3 Adornment

Adornment in architecture can refer to different things: ornaments, embellishment, decoration, sculpture, pictures, frescos, stucco, etc. These variants all have in common the fact that they are all signs in perceptual terms and are not vital elements in physical terms. However, this does not mean that they are superfluous. The art psychologist Rudolf Arnheim argues that physical and psychological needs cannot be separated and that ultimately both are intellectual-spiritual needs (Arnheim 1980, p. 252). Every physical need felt by an individual, such as the need for warmth or nourishment, is also expressed as a psychological need. For example, a wall can be both a physical separation and an adornment. The wall panels clad in onyx in the Barcelona pavilion by Mies van der Rohe are both separating elements and adornment (see Fig. 2.7, 6.15a and 10.26).

Adornment can be more or less autonomous. A sculpture, at least today, can be erected just about anywhere. An ornament, on the other hand, is firmly tied to what it adorns. For the most part, Modernism consciously separates adornment and architecture. Adornment means an additional, but not absolutely necessary, enrichment. In other building styles, for example in the Baroque and Art Nouveau, the decorative and the structural were melded together. Structural elements were formed such that they on the one hand fulfilled their physical function, while on the other hand fulfilling an intentionally decorative role (see Fig. 11.2).

Certain types of adornment have a purely syntactic function. The ornament, for example, has no intellectual content; its primary task is to decorate. Originally the ornament replaced perishable plant adornments and was, accordingly, made up of flowers, leaves and garlands composed of durable material (Koepf 1979, p. 49). These forms were simplified, abstracted and ultimately rendered as pure geometric patterns.

Paintings and sculptures can fulfil a semantic task over and above their syntactic function; they can have an independent status and exist autonomously.

All types of adornment in architecture have the task of supporting a concept. An ornament, for example, can emphasize the dividing line between two elements or visually divide a large surface. A sculpture can serve to attract attention and thereby indicate a certain direction. A stucco ceiling creates different levels of brightness.

Fig. 11.2 **a** Doge's Palace, fourteenth century, Venice, Italy, **b** Hector Guimard, 1899–1904, metro station, Paris, France

11.4 Symbols

The symbol is a semantic sign, something that can be perceived by the senses and has a meaning that goes beyond its direct stimulus configuration. The symbol makes the ideational perceivable by the senses; it can give an abstract content concrete form. Even an adornment can have a semantic dimension: A picture can tell a story. However, once the content of a picture becomes more important than its effect as an adornment, we can speak of a symbol. The painting "Guernica" painted in 1937 by Pablo Picasso has become a symbol of protest against the horrors of war. According to Goethe, the symbol has the task of seeing the general in the particular and the particular in the general. Whereas the metaphor always involves a subjective, personal interpretation, a comparison of one object with another, the symbol stands for a specific ideational statement. Picasso's painting is still an adornment, but today its role as a symbol is more important. In most cases, a sign is not directly created as a symbol but becomes one later, over the course of time.

Not only whole objects but also simple shapes can have a symbolic value. In ancient China the circle and square symbolized the heavens and the earth. The circle expressed dynamism, the eternal cycle without beginning or end. The square was the optical stimulus configuration representing calmness and legality (Thilo 1978, p. 120) (see Fig. 3.11).

In ancient cultures there were places to which access was either banned or permitted for only a select few, such as religious and secular leaders: religious districts and localities, tombs etc. Adornments in such places therefore had a primarily symbolic function. Today the so-called Gate of the Sun stands in the Bolivian highlands, a remnant of what may have been a solar observatory built by members of the pre-Columbian Tiahuanaco culture. The gate itself, an opening in a large monolithic stone plate, must have had a symbolic significance and probably marked a district, an access point to a special place (Helfritz 1973, p. 135). The stone is adorned with a relief the central figure of which is thought to represent a sun god (Fig. 11.3). What appear to be sunrays radiate out from the figure's head, in some cases ending in the small head of a jaguar or puma: divinities of the moon and the night. Where the sunrays and thus the day end begins the night. They are linked to one another. The central figure is surrounded on both sides by smaller, similar figures, which are all oriented towards the central sun god. Did the depiction represent a kind of calendar or rather portray scenes from mythology? The figures were certainly symbols, conveying an idea that was more important than their role as adornment.

In ancient Egypt burial chambers were in most cases sealed shut following interment and thus no longer accessible. Nevertheless, the walls and ceilings are richly adorned with different imagery and written explanations, which constitute the record of an ideational statement. They are symbols; their function as adornment is inessential. The murals transformed the small chamber into a cosmic space in which the divinity and the ruler as the divinity's incarnation continued to exercise an influence on worldly affairs.

Fig. 11.3 Frieze on the Gate of the Sun, seventh/eighth century, Tiahuanaco, Bolivia

11.4 Symbols

Peter F. Smith argues that the human need for the symbolic emerged once human beings developed the capacity for objective consciousness. This capacity freed humans from the constraints of the immediate present. It gave them the possibility of predicting the future based on an objective analysis of the past. However, the gift of prediction brought with it a new type of fear. People's new intelligence enabled them to project all possible future catastrophes into the present, particularly the last of all catastrophes, death. Smith argues that the symbol was the solution to the problem of combining rational knowledge with emotional needs (Smith 1981, p. 140). The emotional aspect of the symbol is more important than its aesthetic aspect. Seeing a sign can be gratifying even in cases where the visual experience does not have an aesthetic aspect. However, usually the symbolic aspect of a sign enhances its aesthetic value by lending it a further dimension. The symbolic aspect lends the sign a degree of emotional expression when such expression is not imparted by the aesthetic aspect. The influence of the symbolic on aesthetic perception was also taken into consideration by George David Birkhoff in his attempt to calculate aesthetic measure (see Sect. 8.6). He concluded that, based on his formula, the aesthetic measure of an object with a symbolic character is either too high or too low (Gunzenhäuser 1975, p. 28).The computer scientist RulGunzenhäuser argued that Birkhoff's calculations treated each form as a purely syntactical sign, thereby disregarding socio-psychological elements and semantic interpretations. However, it is precisely these aspects that lend the sign its symbolic dimension (Gunzenhäuser 1975, p. 144). The expressive power of one and the same sign can vary according to the situation. For instance, a circle can be a purely geometric figure and thus have only syntactic value, or as a yin-yang sign, can take on a high degree of symbolic significance.

Symbolism is not restricted to visual perception; it plays a significant role in daily life and is one of the foundations of every human society (Norberg-Schulz 1975, p. 428). Every gesture, every word has a symbolic meaning in the widest sense if it conveys an idea (Norberg-Schulz 1975, p. 428). Shaking hands as a form of greeting has no syntactic significance; it is the expression of an idea and thus constitutes symbolic action. Indeed, most forms of social behaviour that have developed over time have a symbolic background.

The ideational content of a symbol can be expressed in architecture in different ways. Each colour is attributed a psychological effect. In accordance with these effects, the colours have often also acquired a symbolic meaning: red as the colour of love, blue for loyalty, etc. In ancient China yellow was the colour of the emperor; it was a sign of the supreme ruler, a symbol of power, law and order. Green was the colour of the imperial relatives. These colours could only be worn by the emperor and his relatives. It thus symbolized a particular social stratum and emphasized its hierarchical position (Thilo 1978, p. 67) (see Sect. 10.6.2).

Many building materials are also attributed a certain semantic character; they can therefore symbolize a particular quality and convey a particular idea: gold and marble are noble; they stand for wealth, durability and elegance. By contrast, wood has a natural and warm effect and thus represents quite different values.

Directed lighting can also illustrate an idea and thereby take on symbolic significance. The lighting of the baptismal font in St. Mary's Cathedral in Tokyo (Fig. 11.4) forges an optical link between the child being baptised and the divine. The rays of light falling from above can be understood as a symbol of the Holy Spirit, who descends from Heaven in order to receive the child being baptised into the Christian community. In the Bible, light is often equated with the divine and with truth (Arnheim 1978, p. 319). The light that shines into the upper part of the Gothic central nave therefore serves not only to illuminate but also to symbolize the divine and Heaven, thereby making the spatial concept of the Gothic cathedral clear (see Fig. 3.1 and 10.2).

Shape is probably the medium most commonly used to express symbolic content. The concave shape opens up to its surroundings and therefore has an inviting character. The concave entrance facades of Baroque churches thus became a symbol of God's house being permanently open to all (see Fig. 6.16 and 6.17).

A door is a functional element but can also be a very powerful symbol. By passing through it we enter a new space, a new realm, and in this sense it implies a change, a new beginning. This change can have both a concrete and symbolic character: heaven's gate, the gateway to the world, etc. In the case of the ancient triumphal arch, the gate was uncoupled from its actual function and used only symbolically. Passing through the arch in the wake of success in battle also represented a symbolic purification of the soldiers following the brutality of war. The false door, a simulated door that in reality is not one, is found in a range of cultures and symbolizes a passage that is impassable for human beings, for example the gateway to the beyond. The symbolic character of the gate is found everywhere. In ancient China one entered a group of buildings surrounded by a wall and housing an extended family through a gate. Passing through this gate brought one into the realm of a symbiotic community; the gate became a symbol of family par excellence (Thilo 1978, p. 225). In Japan the gate-like transit points known

Fig. 11.4 Kenzo Tange 1964, St. Mary's Cathedral, Tokyo, Japan

11.4 Symbols

as toriis signify the beginning of a holy Shinto district. They cannot be closed and thus form a purely symbolic partition. This motif is also found in many "primitive" cultures. For example, the Karen groups occupying the border areas between Thailand, Myanmar and Laos mark the points of access to their villages with a number of gate-like entrances. These gates also cannot be closed; they do not form a physical barrier. Their ideational content is additionally underscored by wooden figures, the gatekeepers (Fig. 11.5). The entire arrangement does not have any direct physical function; it is only their intended ideational content that makes them the bearers of this content.

In the Middle Ages the symbol had a significance quite different from what it has today. Apart from their role as mathematic signs, numerals were also seen as bearers of spiritual values and therefore often as symbols (Pevsner 1976, p. 113). The source of medieval number symbolism was above all the Bible. The number 12 can of course be divided into 3 times 4. 12 is the number of the apostles, 3 the number of the Holy Trinity and 4 symbolizes the worldly order. The combination of the three numbers can explain the task of the apostles to disseminate the doctrine of the Trinity of God throughout the world (Naredi-Rainer 1982, p. 42). This number symbolism found its formal expression above all in the sacral building.

The ideational statement of a symbol is usually conveyed via more than a single medium such as colour, material, light or form; as a rule these media exert a collective effect and supplement one another.

The Gothic cathedral is a total work of art with a symbolic significance that is barely imaginable today. The Gothic church attempts to represent the kingdom of God on Earth (see Sect. 3.1). Accordingly, the entrance portal, which is richly adorned with sculptures,

Fig. 11.5 Gate with a carved sentinel figure at the entrance to a Karen village, "Golden Triangle", Thailand

does not simply separate the internal and external space; it also symbolizes the transition from earthly to eternal life in the hereafter and thus represents the Last Judgement (Hofstätter 1968, p. 49). The side portals are dedicated to the Old Testament on the shadowed north side and the New Testament on the sunny south side. The round rosette window above the main portal permits a ray of light to penetrate the interior in such a way that it emphasizes the direction of movement towards the altar. At the same time the rosette represents the sun and the cosmos, or a rose, which is a common symbol of the Holy Mary. Since light can penetrate glass and gemstones without destroying them, in the Middle Ages it served as a symbol of the Holy Spirit (Hofstätter 1968, p. 51).

The symbol played a primary role in all architectural epochs well into the modern period. The design of space was based not only on functional, constructional or aesthetic criteria, as is often the case today, but also had a symbolic aspect. The symbol gives visual form to an ideational statement and can contribute to the illustration of an ideology. Sacral building in Europe reflected the Christian world view. Adolf Max Vogt's analysis of Russian revolutionary architecture shows how the political ideology prevailing at the time was expressed in architectural form. Different projects undertaken during this period, for example Lissitzky's speaker's tribune and Tatlin's Monument to the Third International, have an angle of inclination of 23.5 degrees, which corresponds exactly to the inclination of the Earth's axis (Vogt 1974, p. 211). In the view of ideologues of the time there were various connections between the working class and astronomy: The astronomer's knowledge of time and space meant that he could exert an influence on the organisation of work, which gave him power. In the original architectural drawings for Tatlin's tower, the diagonal runs from the lower right to the upper left, and this motif was employed in many drawings and posters produced at the time. Vogt interprets this as follows: "*Ascent* and *rebellion* are combined to create an overall impression of *progress in the face of the customary*—which corresponds precisely to what motivated this generation in Russia, what it wanted to communicate" (Vogt 1974, p. 212). In this sense the buildings were more than purely functional structures; they were the expression of a certain ideational position and became the symbol of a new world view.

Modernism rejected metaphors and symbols on the grounds that they were too vague and subjective (Jencks 1978, p. 50). Instead it concentrated on objective aspects such as function and economy. The modern sciences made almost everything measurable and explicable; the rational prevailed over the irrational. As a result, there was a steady decline in the influence of tradition, mysticism and religion, elements that constituted an important foundation of the symbolic. This did not prevent the formation of metaphors; however, the way they were interpreted was now completely up to the beholder, who now had no guidelines to draw on. The formation of metaphors now assumed an important role in the subjective evaluation of a building by the public. Modernist architects largely left the interpretation of their works and thus their evaluation to the beholder. Today a modern building can be an "ugly shoebox" or a "magnificent palace". Such widely divergent views were not possible in the Gothic period, for example, because the aesthetic aspect of a building was only one aspect of its appearance and thus of its

11.4 Symbols

evaluation. The metaphorical and symbolic content was a message that was deliberately manipulated and therefore understood in the same way by all visitors. This may be one of the reasons why formal originality was less in demand at this time. The ideational message to the church visitor was always the same, and it was conveyed with the help of symbolism. Modernism dispensed with this communicative possibility and limited itself to purely design aspects. Without the symbolic dimension, the forms defined more or less arbitrarily by architects were no longer understood by the wider public.

Postmodernism in turn increasingly attempted to take up extant sociological, psychological and ideological reference points and give formal expression to them.

With his design for the Civic Center in Beverly Hills (Fig. 11.6) Charles Moore attempted to create a particular atmosphere. In his view the dreams accompanying human action should be nourished by the character of the domicile (Moore 1979, p. 124). The designed location should inspire and awaken associations, promote the formation of metaphors and have symbolic content. The design of the facades of the civic centre and the vegetation, for example, recall Arab paradigms. The risk of such an approach is that it may result in a banal effect. Charles Moore argued that it was only by taking a design to the edge of catastrophe in the hope that it would not fail that one could build the ordinary in a way that people would notice it. His confidence that he could avoid such failure lay in what he saw as the handsome, cheerful character he invested in everything he carried out. His intent was to be humorous, a quality he saw as distinguishing his work from Venturi's (Klotz and Cook 1974, p. 297). According to Robert Venturi the architects of Modernism lost the ability to imbue form with a deeper ideational content, to work with symbols. He sees the main reason for this in the contemporary idolization of space (Venturi 1979, p. 174). In the case of his particular object of study, the Las Vegas Strip, he argues that this Modernist concept does not apply. Here the aspect of communication is more important than spatial qualities; the symbol dominates the

Fig. 11.6 Charles Moore, 1990, Beverly Hills Civic Center, Los Angeles

space. Venturi compares the Strip with the Forum in ancient Rome, where the statement, the wish to represent something, was also more important than the space (Venturi 1979, p. 138) (see Sect. 9.3).

Whether the buildings by Ricardo Bofill can be described as postmodernist or merely as what Kenneth Frampton called with reference to the "Walden 7" development "architecture of narcissism par excellence" (Frampton 1967, p. 253) remains to be seen. To be sure, Bofill is an architect who dares to approach the edge of catastrophe but substitutes the gigantic for the handsome and cheerful. In his large residential complex on the Places de Catalogne in Paris the apartments have no balconies, many have no direct sunlight, and the quality of the apartment floor plans does not exceed the average floor plan found in the average apartment (Fig. 11.7). Bofill describes his buildings as a "surrealistic world", one in which he consciously creates symbols (Schilling 1982, p. 20). The appearance of his buildings allows for different interpretations and awakens manifold associations. Compared with most of the residential estates in the greater Paris region and elsewhere, his projects do not project an anonymous architecture but rather constitute habitable monuments with which the residents can identify. The overall appearance, the communicative aspect, is more important here than the spatial qualities. The individual apartment as such, its spatial and formal qualities, are secondary. What is important is the possibility of identification, the ideational complexity of the composition.

The principle that Bofill applies is not new. In 1603 the Place Royal, now known as Place des Vosges, was built, the first enclosed and unitary square in Paris. Here, apartments for the upper middle class were arranged behind a unitary facade around a regular-shaped square (Fig. 11.8a). Here, too, the facades recall a palace more than a middle-class residential building. In 1630 Inigo Jones built the first terraced houses in Covent Garden in London based on the same principle. The apartments were integrated by means of a shared, unitary façade. The unified appearance of the complex is very

Fig. 11.7 Ricardo Bofill (Taller de Arquitectura), 1985, Places de Catalogne, Paris, France

Fig. 11.8 a Place Royal, today Place des Vosges, 1603, Paris, France, **b** John Nash, 1823, Cornwall Terrace, London, England

reminiscent of Renaissance palaces and was intended to create an impression of bigness. This model was subsequently adopted for terraced houses such as the residential complex Cornwall Terrace in London (Fig. 11.8b) built in 1823 by John Nash, who was later involved in the construction of Buckingham Palace.

11.5 The Significance of the Sign in the History of Architecture

The need for adornment is as old as the desire for physical protection. The first attempts at architecture were decorated and embellished, although in this case adornment was not used to beautify but referred to objects or persons and had a metaphorical and symbolic meaning. (Arnheim 1980, p. 253). The task of adornment was to continue the basic idea determining the architectural form in the non-constructional realm.

In ancient Egypt a temple was the domicile of a deity, a place where the Pharaoh as the representative of his people made contact with the divine. The temple symbolized the land of Egypt and thus the entire world (Canival 1964, p. 87). Ritualistic acts and decoration served to support this concept. Apart from the sarcophagus, the tomb held innumerable objects and pieces of the jewellery from the daily life of the king, and murals recalled episodes from his life. None of this was intended for viewing; very few people were even allowed to enter these spaces. The wall decorations illustrated the king's past, while the objects placed in the tomb were meant for his future life. All these additions and decorations were bearers of ideational content; they symbolized the sociological and ideological structure of the kingdom and were therefore not merely accessories but as important as the building itself (Fig. 11.9).

The relief depictions on the tympana in Greek temples were also not decorations in the modern sense. It was their task to tell a story about either the divinity to which the temple was dedicated or the temple builder (Martin 1966, p. 94).

Fig. 11.9 Tomb of Ramose, 18th Dynasty (ca. sixteenth century BCE), Western Thebes, Egypt

These depictions were part of the building, like the columns and beams, but communicated what the pure building structure could not express. The transplantation to museums all over the world has therefore also stripped them of their original purpose. Architecture was more than just a spatial shell; it helped clarify the basic values of the society.

Belief in a symbol can be so profound that it is invested with powers and capabilities that it in reality does not have. The ideational content becomes more important than visual perception. The ancient Greeks painted a pair of eyes on the bows of their ships which were supposed to keep guard during voyages (Arnheim 1980, p. 254). The "decoration" was a much a part of the voyage as the mast and sails. Their significance is comparable with modern radar facilities. Modified forms of these eyes are also found in other cultures; indeed, they persisted in the form of the figurehead into the modern period.

In the case of ancient Roman culture, too, adornment cannot be seen independently of its architectural environment but must be regarded as part of the overall composition. The large thermal baths were intended to enable the user to forget the profane world and all its problems for a while. They thus represented a kind of dream world. The vaults of these "pleasure centres" were adorned with gold or glass mosaics, which created very particular lighting conditions and an atmosphere that seemed remote from the world

11.5 The Significance of the Sign in the History of Architecture

(Picard 1965, p. 146). Adornment achieved what could not be achieved by structural means. Not only was the space placed in the foreground, as in the modern period, but also the ideational content. Any means could be used, not only structural ones, to give this content visual expression.

Today Romanesque churches give a false impression. What are now bare, unadorned walls were originally painted and furnished with costly cloths and works by goldsmiths, which shone in the light of numerous candles (Oursel 1966, p. 8). The Romanesque spatial concept was based on an attempt to build the house of God on Earth (see Fig. 3.1). The task of adornment was to lend grandiosity to this house of God, and adornment was therefore an important part of the overall concept. During the religious wars most churches were robbed of their adornments, which negated what they were originally intended to express. Here, adornment was also more than a beautifying addition. Without it the unity of the concept was destroyed. In their present condition the Romanesque churches convey a completely false image of what they originally were.

Up until the end of the Baroque age, buildings constituted total works of art. All the artists involved in a building project made an equal contribution and every represented art genre was important and indispensible. Today this attitude is difficult to imagine; it is alien to us. Often detached from their original location, decorations from other stylistic epochs often seem incomprehensible, even frivolous to us because we tend to see adornment as autonomous.

Today the idea of integrating art into building often refers to a sculpture or picture installed after the building has been completed. In earlier times a building constituted a unity that extended from the foundations to the smallest decorative detail and attempted to communicate an ideational concept.

Of course, at those times, too, the whole could also be divided into parts that were necessary in terms of statics and structure and those that did not have such a function. However, both types of component were responsible for the appearance of a style which was inconceivable without both of them. The respective parts they played varied from epoch to epoch and region to region. In the Early and High Gothic periods, the static-structural aspect took precedence over that of decor. In the thirteenth and the early fourteenth century this relationship changed, with the decorative now overlaying the structural. Still later we even see a tendency to detach the decorative from the structural. This approach reached its highpoint in the Renaissance. But even in this case, adornment never became completely detached from structure. Palladio wrote on the subject, "Adornment will suit the entire building if the individual elements correspond with the whole and large buildings are furnished with large elements, small buildings with small ones, and middle-sized buildings with middle-sized ones" (Palladio 1983, p. 113). In the Baroque the decorative aspects was again more closely fused with the structural and in part even took a dominant role. The primacy of adornment also allowed for the simulation of certain materials. No one took offence when valuable materials such as gold and marble were imitated merely for the sake of creating an illusion. Indeed, the optical-spatial illusions of this epoch would have been quite inconceivable without decorative means.

In the Rococo slowly ossifying ornamentation was reinvigorated once again (Pevsner 1976, p. 368). In the nineteenth century neo-styles adopted decoration and adornment from older styles, leading to an eclectic mix that in the latter half of the nineteenth century began in turn to generate widespread criticism (Giedion 1978, p. 206). In 1906, Hans Poelzig, who was at the time director of the art academy in Breslau, commented on the proliferation of styles as follows: "Yet it is just as evidently shown by both the good and inadequate solutions that a true architecture cannot be achieved with the tool of decoration, that a purely external means cannot be used to solve the problems of today's architecture. – The flight from all that is historically given is just as unable to bring salvation as the decorative recourse to forms of the past" (Poelzig 1981, p. 11).

Art Nouveau attempted once again to fuse the decorative with the static-structural (see Fig. 11.2b). Again the goal was to have both components supplement one another. This led to a renewal of handcrafts. In 1895 Henry van de Velde, a painter by profession, designed his own house, including all the fixtures and furnishings. He did not reject decoration but attempted to ensure that its utilization was formally and structurally appropriate: "And if you desire to beautify these forms and structures, give in to the longing for the refinement which your aesthetic sensibility or taste regarding ornamentation – whatever its type – inspires in you only to the extent that you can respect and maintain the law and the essential appearance of these forms and structures!" (Van de Velde 1981, p. 14) Both Poelzig and van de Velde did not oppose decoration as such; but they were of the opinion that it had to be an integral part of the whole.

In 1892, apparently largely independently of developments in Europe, Louis Sullivan published an essay in the USA titled "Ornament in Architecture" in which he criticized the incorrect use of decorative elements: "I should say that it would be greatly for our aesthetic good if we should refrain entirely from the use of ornament for a period of years, in order that our thought might concentrate acutely upon the production of buildings well formed and comely in the nude" (Frampton 1967, p. 46) (Fig. 11.10a). Sullivan was not completely unaware of developments in Europe, having studied for a short time at the Ecole des Beaux-arts in Paris in 1874. The decorations on his buildings often have a geometric effect, similar to a pure surface structure. Kenneth Frampton compares them to Islamic examples and interprets Sullivan's recourse to the aesthetic and symbolic values of the East at an attempt to bridge the gulf in Western culture between intellect and emotion (Frampton 1967, p. 48). Frank Lloyd Wright, one of Sullivan's students, used decorative elements in a similar way to his teacher. His adornments arose directly from the structure and were not subsequently added. He believed that much ornamentation, in the old sense of 'application', had no relevance for the contemporary world because we no longer understood their expressive power. He rejected the addition of embellishments for their own sake, arguing that they were undesirable unless, as details, they enhanced the expressive clarity of the architectural theme. People today, he argued, had little understanding of the term ornamentation, particularly architects. As he saw it, conceiving a construction in an organic way meant conceiving all ornamentation as part of the basic plan and therefore as belonging to the structure of the building itself (Lloyd Wright 1969, p. 80) (Fig. 11.10b).

11.5 The Significance of the Sign in the History of Architecture

Fig. 11.10 **a** Louis Sullivan, 1906, Carson Pirie Scott Building, Chicago, USA, **b** Frank Lloyd Wright, 1947, Unitarian Meeting House, Madison, Wisconsin, USA

In Europe the most vehement critique of all forms of decoration came from Adolf Loos. In 1900 he published a story titled "The Poor Little Rich Man", which tells of a man who has his house "beautified" by an architect, a house in which the man has hitherto lived contentedly. The architect decorates and adorns the entire house, leaving nothing untouched, even utilitarian objects. One day the poor little rich man receives a gift, which he enthusiastically shows his architect. The latter is indignant that his client has dared to display a new object in "his" house, when the house has already been completely designed by him, the architect (Loos 1981, p. 198). Loos opposed the decoration of utilitarian objects, the mingling of art and handcrafts, which was a primary focus of the German Werkbund movement and supporters of the total artwork. Indeed, he went further: "Ornamentation is squandered labour power and consequently squandered health" (Loos 1982, p. 83). Loos wrote "The Poor Little Rich Man" after reading the above-mentioned article by Sullivan, who he met during his three-year stay in America. In 1908 Loos wrote his famous article "Ornament and Crime", in which referred to decoration as amoral. Ornamentation, he stated, corresponded to a lower level of civilization, not that of the twentieth century: "the urge to ornament one's face and everything within reach is the very beginning of plastic art"—"The evolution of culture

is synonymous with the removal of ornamentation from utilitarian objects" (Loos 1982, p. 78). The story of the poor little rich man and the article criticizing ornamentation were separated by eight years, a period in which the situation changed. In the first article Loos criticized a powerful trend supporting the total work of art and Art Nouveau. By 1908 his statement of 1900 had already been borne out: the Art Nouveau trend was already on its way out and Loos was no longer alone in his opinion of ornamentation. Others soon expressed a similar opinion in equally direct terms, such as Antonio Sant'Elia and FilippoTommaso Marinetti in their "Manifesto of Futurist Architecture" in 1914: "The decorative must be abolished"—" ... decoration as an element superimposed on architecture is absurd ... the decorative value of Futurist architecture depends solely on the use and original arrangement of raw or bare or violently coloured materials" (Sant'Elia and Marinelli 1981, p. 34). Aesthetic value was thus no longer to be gauged with reference to adornment but solely in terms of the beauty of the material. This was also Adolf Loos' opinion (see Sect. 5.3.1), who also believed that the visible structure, the manner of assemblage, also contributed to the beauty of a building: "Pure structure should take the place of the fantastical forms from past centuries, the blooming ornamentation of past times" (Loos 1982, p. 134). In this sense Loos anticipated the general opinion of this theme prevalent in Modernism. In 1932 Henry-Russell Hitchcock und Philip Johnson wrote, "Architectural detail, which is required as much by modern structure as by the structure of the past, provides the decoration of contemporary architecture" (Hitchcock and Johnson 1985, p. 62). But even before Loos, rejection of the decorative was not fundamentally new. In the middle of the nineteenth century, for example, the philosopher Arthur Schopenhauer argued that embellishment belonged to sculpture rather than architecture, for which it was merely an extraneous ornament that could be dispensed with (Sörgel 1918, p. 158).

The rejection of adornment had two main causes. On the one hand, in the nineteenth century decoration was still regarded as a Classical, Gothic, Chinese, etc. accoutrement which was applied to a random architectural style and thus had nothing important to express, unlike adornment as it had been used over earlier millennia. On the other hand, industrialization shaped a new concept of beauty, the so-called "engineer's aesthetic" (see Sect. 8.2). A technical product was beautiful because it directly fulfilled its purpose, because each part of it had a precise function and nothing about it was superfluous. As August Perret put it, "When something is beautiful, it needs no decoration, since it is itself decorative" (Rykwert 1983, p. 168).Even Le Corbusier used decoration and ornamentation in his early work (Fig. 11.11), although he later excluded it altogether.

Developments in the nineteenth century brought an end to the total work of art. The different art forms of architecture, sculpture and painting became autonomous and subsequently remained independent of one another. Previously they had constituted a symbiosis in which each could not exist without the other. Either the decorative or the static-structural was dominant depending on the specific epoch but the different art forms remained unified in the total work of art. The end of this situation proved fateful for art per se. The ornament, the only artistic genre that was not autonomously

11.5 The Significance of the Sign in the History of Architecture

Fig. 11.11 Le Corbusier, 1912, La Maison Blanche, La Chaux-de-Fonds, Switzerland

viable, had found its place in the total work of art and therefore inevitably disappeared in Modernism.

In Modernism adornment is an independent architectural element; it has a new relationship to the building. The sculpture by Kolbe in Ludwig Mies van der Rohe's Barcelona Pavilion does not merge with the architecture. On the contrary, as the only organic form its effect is to create an antithesis to the structure's right-angled slabs and columns (see Fig. 10.26). This juxtaposition creates tension, which is increased by the strict geometry of the space.

The sign language of Modernism was limited to the purely formal statement and thereby became impoverished in terms of meaning. Within Modernism a current emerged that has been termed the "revolt against reason" (see Sect. 5.1). The strict geometry and perpendicularity of a space was fractured in favour of a free form. As a result the spectrum of the architectural sign language was expanded again, the scope for formal interpretations became greater, and the formation of metaphors became easier. This development ultimately led to Postmodernism. The dogmas of Modernism, for example the banning in the name of "purity" of elements that did not merely serve utility, were called into question. Ambiguity, compromise and contradiction were accepted again and absorbed into the architectural repertoire. As a result, adornment, as the bearer of a meaning or a message, again took on an important status within the range of design instruments. The sign as metaphor or symbol once again became important (see Fig. 3.4b).

One of the first advocates of this new conception was Robert Venturi, who already turned against the strict doctrines of Modernism in the 1960s. In his book "Complexity and Contradiction in Architecture" published in 1966—which Vincent Scully has called probably the most important book on architecture since Le Corbusier's "Vers une architecture"—he rejects the principles of Modernism, arguing that "the doctrine 'less is

more' bemoans complexity and justifies exclusion for expressive purposes" (Venturi 1978, p. 26). Venturi does not advocate for something fundamentally new; he is far more interested in reviving qualities which in earlier epochs were part of the language of an architectural style and lent it ideational content, and reintegrating them into architecture today "Ambiguity and tension are everywhere in an architecture of complexity and contradiction. Architecture is form and substance—abstract *and* concrete—and its meaning derives from its interior characteristics and its particular context. An architectural element is perceived as form *and* structure, texture *and* material. These oscillating relationships, complex and contradictory, are the source of the ambiguity and tension characteristic of the medium of architecture" (Venturi 1978, p. 33). In his second book, "Learning from Las Vegas", which he wrote with Denise Scott Brown und Steven Izenour in 1978, Venturi goes one step further in claiming that the perception of architecture is not limited to what is seen. The perception and design of architecture, he argues, rely on previous experience and the associations based on it, and these symbolic elements often contradict the form, structure and use with which they coincide in the same building (Venturi 1979, p. 104).

The authors see two possible ways of responding to this fact: the "duck" and the „decorated shed" (Fig. 11.12). The "duck" represents an attempt to give precedence to the meaning of a building over its spatial expression and structure. A fast-food outlet specializing in roast duck should directly express its content in formal terms by giving the structure the form of a duck. Because the form of a duck could make it difficult to construct a building economically and hamper easy use, the authors see a second possibility, that of the "decorated shed". Here a distinction is made between the building, a shell as economically built as possible and optimal for its intended use, and an added element designed to communicate the content and meaning of this shell. Both variations are not new. The authors take the Gothic cathedral as an example of a building that is both

Fig. 11.12 Two possible ways of visualizing the use of a building: **a** the "duck" and **b** the "decorated shed" (based on Robert Venturi)

11.5 The Significance of the Sign in the History of Architecture

a "duck" and a "decorated shed". The overall appearance of the church metaphorically presents its content, namely the kingdom of God on Earth (see Sect. 5.1). In Venturi's interpretation, the main facade, which contains the large portal facing the cathedral square, is a billboard, a display wall for religious propaganda (Venturi 1979, p. 124). The possibility of expressing the ideational content and meaning of a building with the help of the facade or a sign independent of the building leaves a great deal of scope for metaphors and symbols. The design of such signs is no longer a purely architectural task. Graphical, sculptural and painterly aspects can also be included, which generates the possibility again of creating a total work of art. The spectrum of stimulus configurations that can be deployed here is far more expansive than it is in Modernism. In Modernism the space takes centre stage, a fact that, according to Venturi, makes a symbolic form more difficult if not impossible to achieve. He argues that later modernist architecture, although rejecting form, led to an empty formalism, promoted an overwrought expressiveness while ignoring ornament, and deified space while rejecting symbols (Venturi 1979, p. 147). The architecture of Modernism avoided all types of decoration on its buildings. However, since space and thus its form were attributed a primary meaning, the buildings of Modernism are nothing other than large syntactic signs.

The ideology of Postmodernism arose in the USA. Its two most important European representatives are Aldo Rossi and Oswald Mathias Ungers (Klotz and Cook 1984, p. 10). Although their conceptions are not identical with the theory of Robert Venturi they also argue against the reduction of architecture to purely formal and spatial aspects. However, in contrast to Venturi they are of the opinion that the path of applied metaphorical and symbolic decoration is not the correct one to take. By "charging" geometric form with typological and historical references they attempt to again increase ideational content and thereby to more powerfully activate the metaphorical and symbolic level of meaning (Fig. 11.13).

Fig. 11.13 Aldo Rossi, 1990, theatre, Genoa, Italy

References

Arnheim, Rudolf: Die Dynamik der architektonischen Form, Cologne, 1980 (original title: The Dynamics of Architectural Form, Los Angeles, 1977)
Arnheim, Rudolf : Kunst und Sehen, Berlin, 1978 (original title: Art and Visual Perception, Berkeley, 1954)
Canival, Jean-Louis de: Aegypten, Fribourg, 1964
Frampton, Kenneth: Die Architektur der Moderne, Stuttgart, 1967 (original title: Modern Architecture, London, 1980)
Giedion, Sigfried: Raum, Zeit, Architektur, Zürich, 1978 (original title: Space, Time and Architecture, Cambridge, Mass., 1941)
Gunzenhäuser, Rul:Maß und Information als ästhetische Kategorien, Baden-Baden, 1975 (1962)
Helfritz, Hans: Südamerika: präkolumbianische Hochkulturen, Cologne, 1973
Hitchcock, Henry-Russell and Johnson, Philip: Der Internationale Stil, Braunschweig, 1985 (original title: The International Style, New York, 1932)
Hofstätter, Hans: Gotik, Fribourg, 1968
Jencks, Charles: Die Sprache der Postmodernen Architektur, Stuttgart, 1978 (original title: The Language of Postmodern Architecture, London, 1978)
Klotz, Heinrich and Cook, John W.: Architektur im Widerspruch, Zürich, 1974 (original title: Conversations with Architects, New York, 1973)
Klotz, Heinrich: Revision der Moderne, Munich, 1984
Koepf, Hans: Struktur und Form, Stuttgart, 1979
Loos, Adolf : Ins Leere gesprochen, Vienna, 1981 (1921)
Loos, Adolf : Trotzdem, Vienna, 1982 (1931)
Martin, Roland: Griechenland, Fribourg, 1966
Moore, Charles: The Place of Houses, New York, 1979 (1974
Naredi-Rainer, Paul von: Architektur und Harmonie, Cologne, 1982
Norberg-Schulz, Christian: Meaning in Western Architecture, London, 1975 (original title: Il significato nell'architettura occidentale, Milan, 1974)
Oursel, Raymond: Romanik, Fribourg, 1966
Palladio, Andrea: Die vier Bücher zur Architektur, Zürich, 1983 (1570)
Pevsner, Nikolaus: Europäische Architektur, Munich, 1976
Picard, Gilbert: Imperium Romanum, Fribourg, 1965
Poelzig, Hans: Gärung in der Architektur, 1906 (in: Programme und Manifeste zur Architektur des 20. Jahrhunderts, Braunschweig, 1981)
Rykwert, Joseph: Ornament ist kein Verbrechen, Cologne, 1983 (original title: The Necessity of Artifice, London, 1982)
Sant'Elia, Antonio and Marinelli, Fillipo: Futuristische Architektur, 1914 (in: Programme und Manifeste zur Architektur des 20. Jahrhunderts, Braunschweig, 1981)
Schilling, Rudolf : Ricardo Bofill (in: Tagesanzeiger Magazin, Zürich, 16/1982)
Smith, Peter F.: Architektur und Ästhetik, Stuttgart, 1981 (original title: Architecture and the Human Dimension, London, 1979)
Sörgel, Herman: Einführung in die Architektur-Ästhetik, Munich, 1918
Tange, Kenzo: Funktion, Struktur und Symbol, 1966 (in: Kultermann Udo, Kenzo Tange 1946–1969, Zürich, 1970)
Thilo,Thomas: Klassische chinesische Baukunst, Zürich, 1978 (1977)

References

Van de Velde, Henry: Credo, 1907 (in: Programme und Manifeste zur Architektur des 20. Jahrhunderts, Braunschweig, 1981)

Venturi, Robert: Komplexität und Widerspruch in der Architektur, Braunschweig, 1978 (original title: Complexity and Contradiction in Architecture, New York, 1966)

Venturi, Robert: Lernen von Las Vegas, Braunschweig, 1979 (original title: Learning from Las Vegas, Boston, 1978)

Vogt, Adolf Max: Revolutionsarchitektur, Cologne, 1974

Wright, Frank Lloyd: exhibition catalogue, Florence, 1951 (in: Humane Architektur, Berlin, 1969)

Name index

A
Aalto, Alvar, 124–126, 147, 231
Addison, Joseph, 115, 260
Adorno, Theodor W., 85, 86, 182, 190, 251, 260, 321
Alberti, Leon Battista, 27, 28, 251
al-Mansur, 50
Ando, Tadao, 156, 217, 225, 267
Aristotle, 133, 134, 147, 250
Arnheim, Rudolf, 102, 189, 279, 280, 334
Augustine of Hippo, 250

B
Bage, Charles, 169
Bagenal, Hope, 228
Baumgartner, Alexander Gottlieb, 251
Behnisch, Günther, 162
Behnisch, Peter, 94, 267
Bell, Alexander Graham, 213
Bense, Max, 89
Bernini, Gian Lorenzo, 61, 208, 283, 285, 287
Birkhoff, George David, 239, 261–263, 337
Blake, Peter, 186
Boccioni, Umberto, 254, 276
Bofill, Ricardo, 342
Bollnow, Otto Friedrich, 34, 122, 144, 150, 151, 286, 288
Bolzano, Bernard, 251
Boring, Edwin G., 4
Borromini, Francesco, 199, 200
Botta, Mario, 274
Boullée, Etienne-Louis, 98, 210
Bramante, Donato, 167, 294
Brown, Denise Scott, 350

Brunelleschi, Filippo, 114, 143
Bruner, J.S., 36
Bruno, Giordano, 134, 147, 154, 163
Bunshaft, Gordon, 312
Burt, Cyril, 255

C
Cardinet, Jean, 255
Choisy, Auguste, 184
Columbus, Christopher, 144
Constantine, 138
Costa, Lúcio, 299, 308, 309

D
Darwin, Charles, 107
da Vinci, Leonardo, 84
de Canival, Jean-Louis, 302
de Montereau, Pierre, 304
Descartes, René, 18
Drew, Philip, 181
Duchamp, Marcel, 276

E
Eiffel, Gustave, 71, 147
Eisenmann, Peter, 19, 24, 27, 28
Euclid, 226
Eysenck, Hans Jürgen, 255, 263

F
Fainsilber, Adrien, 43, 45
Fechner, Gustav Theodor, 251, 333

Foster, Norman, 32, 213, 308, 310
Fowler, Charles, 252
Frampton, Kenneth, 239, 342, 346
Freud, Sigmund, 80, 85, 254
Fuller, Buckminster, 75, 189, 210, 213

G
Gabo, Naum, 184, 326
Galilei, Galileo, 144
Gaudi, Antonio, 57, 59
Gehry, Frank O., 40, 75, 202, 222
Giedion, Siegfried, 82, 84, 148, 172, 192, 198, 199, 277
Goethe, Johann Wolfgang von, 161, 259, 321, 335
Goodman, C.C., 36
Graves, Michael, 260
Griffin, Walter Burleigh, 299
Gropius, Walter, 73, 74, 172, 173, 184
Grütter, Jörg Kurt, 21, 317
Gunzenhäuser, Rul, 337
Gutenberg, Johannes, 84

H
Hall, Edward, 37, 83, 153
Haussmann, Georges, 299
Hegel, Georg Friedrich Wilhelm, 251, 260
Helmholtz, Hermann von, 20, 322
Hennebique, François, 147, 148
Hering, Ewald, 322
Hertzberger, Hermann, 172, 173
Hitchcock, Henry-Russell, 148, 149, 171, 237, 348
Hollein, Hans, 80, 85
Hotz, Theo, 282

I
Izenour, Steven, 350

J
Jencks, Charles, 155, 240
Jenney, William le Baron, 148
Johnson, Philip, 26, 27, 88, 148, 171, 188, 212, 225, 237, 267, 348
Jones, Inigo, 342

Jung, Carl Gustav, 255
Justinian, 139, 140

K
Kahn, Louis I., 43, 44, 48, 50, 68, 85, 130, 134, 159, 161, 185, 187, 188, 190, 210, 304
Kandinsky, Wassily, 159, 279
Kant, Immanuel, 18, 232, 251
Kao Gong Ji, 53
Keppler, Johannes, 14
Klee, Paul, 195, 197
Krier, Rob und Léon, 186
Kris, Ernst, 85
Kurokawa, Kisho, 76

L
Lapidus, Morris, 260, 301
Le Corbusier, 25, 26, 43, 46, 54, 63. 65, 67, 68, 72, 73, 82, 88, 94, 100, 101, 148, 150, 158, 163, 167, 170, 185, 199–201, 210, 226–228, 240, 252, 253, 257, 277, 296, 297, 302, 306, 307, 309, 312, 327, 348, 349
Ledoux, Claude-Nicolas, 210
Lee, Terence R., 288
Léger, Fernand, 254
Leonidov, Ivan Ilich, 98
Lissitzky, El, 184, 192, 340
Loos, Adolf, 162, 253, 347, 348
Louis XIV, 114
Lovell, Philip, 107
L'Enfant, Charles, 298

M
Maderno, Carlo, 294
Magellan, Ferdinand, 144
Malevich, Kazimir, 254
Marcus Aurelius, 55, 58
Marinetti, Filippo Tommaso, 276, 278, 348
Meier, Richard, 25, 26
Mendelsohn, Erich, 228, 277
Metelli, Fabio, 270
Michelangelo, 17, 20, 90, 144, 145, 225
Mies van der Rohe, Ludwig, 43, 45, 124, 147, 149, 157, 160, 162, 170, 185, 186, 198, 199, 236, 237, 239, 277, 327, 334, 349

Name index

Moholy-Nagy, Sibyl, 119, 287
Moles, Abraham, 5, 6
Mondrian, Piet, 254
Moneo, Rafael, 312, 314
Moore, Charles, 159, 341
Moss, Eric Owen, 217, 275
Munro, Thomas, 90
Muthesius, Hermann, 79, 183

N

Nash, John, 115, 343
Nervi, Pier Luigi, 248
Neumann, Balthasar, 209
Neutra, Richard, 107
Newton, Isaac, 210
Niemeyer, Oscar, 121, 168, 184, 299, 308, 309, 313, 314
Norberg-Schulz, Christian, 108, 137, 152, 274
Nouvel, Jean, 43, 57, 60

O

Ortega y Gasset, José, 100
Otto, Frei, 114
Oud, J.P., 327

P

Palladio, Andrea, 98, 99, 126, 156, 157, 167, 206, 210, 227–229, 235, 241, 242, 251, 257, 345
Panofsky, Erwin, 82, 249
Paxton, Joseph, 72, 114, 146, 185
Pei, I.M., 60, 61, 167, 184, 211, 213, 215, 313, 314
Perret, August, 148, 170, 348
Pessina, Campi, 237, 238
Pevsner, Antoine, 184, 326
Pevsner, Nikolaus, 114, 126, 142, 144, 145, 149, 228
Piano, Renzo, 121, 171, 184, 188
Picasso, Pablo, 335
Piranesi, Giovanni Battista, 275
Plato, 208, 250, 252
Pliny the Elder, 14
Plotinus, 250
Poelzig, Hans, 346

Pólya, George, 233
Portmann, Adolf, 113, 123, 233
Prince Toshihito, 97
Prouvé, Jean, 72, 75, 76

R

Rasmussen, Steen, 228
Raverti, Matteo, 235, 236
Rogers, Richard, 121, 171, 188
Rossi, Aldo, 274, 297, 351
Rossi, Carlo, 214
Rousseau, Jean Jacques, 114
Rowe, Colin, 148, 158
Rucoba, Joaquín, 203
Rudofsky, Bernhard, 182
Rudolf, Paul, 237, 239

S

Saarinen, Eero, 201, 202, 333
Sant'Elia, Antonio, 276, 278, 348
Schiller, Friedrich von, 232
Schinkel, Karl Friedrich, 236, 237
Schopenhauer, Arthur, 193, 348
Scully, Vincent, 272, 349
Sedlmayr, Hans, 146, 193
Semper, Gottfried, 236
Shah Jahan, 258
Sirén, Jeikki, 117
Sirén, Kaija, 117
Sitte, Camillo, 130
Smith, Peter F., 90, 248, 256, 257, 337
Snozzi, Luigi, 54, 118, 296
Sullivan, Louis, 87, 184, 346, 347
Suomalainen, Timo, 120, 121

T

Tange, Kenzo, 162
Tatlin, Wladimir Jewgrafowitsch, 184, 340
Taut, Bruno, 19, 23, 326, 327
Theodosius, 176

U

Ungers, Oswald Mathias, 166, 351
Utzon, Jørn, 114, 121, 202, 210

V

Vacchini, Livio, 217, 244, 245
van de Velde, Henry, 182, 346
van Doesburg, Theo, 124, 148, 149, 170, 198, 236, 254, 276, 327
Vasari, Giorgio, 259
Venturi, Robert, 123, 150, 171, 217, 230, 273, 341, 349, 351
Vignon, Pierre, 98
Vitruv, 203, 228, 232, 250
Vogt, Adolf Max, 97, 340

W

Wagner, Otto, 145, 197, 236, 253
Washington, George, 298
Wesnin, Alexander und Viktor, 184
Weyl, Hermann, 233
Whorf, Benjamin Lee, 83
Witkin, Hermann, 34
Wölfflin, Heinrich, 47, 63, 197
Woodward, G., 172
Wren, Christopher, 297
Wright, Frank Lloyd, 110, 124–127, 147, 166, 168, 172, 184, 194, 199, 200, 202, 206, 207, 237, 253, 318, 326, 346, 347

Y

Young, Thomas, 322

Z

Zevi, Bruno, 144, 277
Zholtovsky, Ivan, 98

Subject index

A

Accommodation, 31
Acoustics, 163
Adornment, 334, 336, 343, 346
Aesthetics, aesthetic, 221, 247, 251
 gratification, 255
 information, 255
 measure, 261
 orders, 257
 values, 248, 263, 348
Ambiguity, 350
Animal, 13, 107, 113, 123, 130, 233
Antagonism to the present, 146
Arch, 205, 210
Architectonic culture, 80
Architecture
 and music, 228
 and nature, 127
 appearance, 40
 as a cultural medium, 79
 Christian, 138
 organic concept, 124
 perception, 105
 revolutionary, 97
 stagnation, 82
Arrangement, 92
 central system, 47
 free arrangement, 54
 linear system, 49
Art, 84, 254
 origins, 84
Artificial light, 304
Artist, artistic, 86
 production, 86
Art Nouveau, 334, 346, 348
Artwork, 86
Assemblage of parts, 68
Asymmetry, 233
Axis, 233, 297
 of symmetry, 233, 242

B

Balance, 144, 193, 222, 257
Baroque, 84, 91, 114, 126, 144, 145, 155, 156, 167, 195, 208, 212, 227, 228, 232, 292, 303, 326, 334, 345
Beam, 203
Beauty
 artistic, 251
 history, 250
 mathematical, 250
 measurability, 261
 natural, 251
 of geometry, 250
 of nature, 250
 of speed, 278
Beholder
 personality structure, 94
 space, 134
Binary
 decision, 7
 digit (bit), 7
Black-white contrast, 324
Blind spot, 19
Bridge-building system, 71
Brightness, 315, 322
 difference, 33
 stimulus, 33
Brise-soleil, 307

Building
 adaptation to the surroundings, 117
 and garden, 116
 appearance, 40
 components, 40
 confrontation of surroundings, 118
 construction, 68
 contrast to surroundings, 117
 historical background, 257
 industrially prefabricated, 72
 intellectual content, 68
 interior space, 122
 material-efficient, 75
 modernist period, 99
 monolithic, 89
 perceived weight, 121
 relationship to surroundings, 116
 relationship to the ground, 119
 styles, 88
 surroundings, 106, 112
 temporal dimension, 275
Built environment, 39, 75, 82, 116
Byzantine, 138, 303

C

Capacity for objective consciousness, 337
Cast shadow, 318
Cave, 119
Ceiling, 160
Centre, 297
Child drawing, 44
China, Chinese, 48, 51, 92, 93, 100, 108, 115, 119, 162, 164, 196, 204, 206, 241, 323, 332, 336–338
Choice of form, 182
Christianity, Christian, 138
 architecture, 303
 building, 201
 churches, 138
Church, 80
Circle, 92, 202, 208, 333, 336
City remodeling, 299
Cognition of our surroundings, 274
Cohabitation, 83
Colour, colouring, 32, 230, 305, 316, 319
 and space, 324
 differentiation, 322
 hue, 322

 in architecture, 325
 lightness constancy, 30
 perceptual temperature, 324
 perceptual weight, 323
 psychological effects, 323
 saturation, 324
 symbolic meaning, 337
Column, 160, 165, 203
Communication, 2
Complexity, 261, 264
 Components, 42Partsarrangement, 46
 self-contained, 42, 60
Composition, stroboscopic, 282
Computer program, 75
Concave form, 199
Concrete, 146
Cone, 14, 322
Constancy, 29
 colour and lightness constancy, 30
 shape constancy, 30
 size constancy, 30
Construction, constructional, 68
 changes, 274
 light-weight, 75
Constructivism, 184, 188, 192
Constructivist architecture, 68
Contradiction, contradictory, 217
 stimulus information, 11
Convex form, 199
Corner, 212
Courtyard, 206, 231
 house, 48, 128
Cube, 211
Cubism, 198, 275, 278
Cult object, 85
Culture, 82
 origins, 84
Curvature, 199, 210
Curve, 195, 199
 perceived dynamism, 282
Cylinder, 333

D

Daytime space, 151
Decision-making, 36
Decoration, 343, 346
Deduction theory, 20
Depiction, 333, 343

Subject index

Depth, 316
 dimension, 234
 perception, 31, 32
Design, 68, 190
 vernacular, 182
Dimension, 43
Directed lighting, 338
Direction, 297
Disequilibrium, 41
Distance, 151, 230
Diversity, 46
Dome, 204, 210
Door, 164, 311
 as a symbol, 338
Dwelling, 103, 152
 evaluation, 107
 Islamic, 129
Dynamism, 278, 280, 292

E
Effect of relative movement, 270
Ego, 83
Egypt, Egyptian, 55, 86, 110, 136, 162, 230, 232, 289, 301, 336, 343
Elemental form, 181
Elements of space, 159
Ellipse, 206, 294
Elongation
 horizontal, 34
 vertical, 34
Emotion, 94
Emphasis, 243
Emptiness, 157, 323
Engineer, 253
Engineer's aesthetic, 72, 252, 253, 348
English landscape garden, 114
Entrance, 199, 289
Environment, 105, 134
Equilibrium, 233
Escape distance, 107
Euclidean space, 30
Experienced space, 150, 152
Experience of beauty, 254
Expression of the whole, 39
Exterior, 122
 of the church, 141
Extrovert, 255

F
Falling/flowing water, 285
Far Eastern culture, 127
Fashion, 249, 259
Feeling, 84, 87, 251
Feng shui, 108
Figure-ground phenomenon, 26
Finland, 124
Flat surface, 197
Flexibility, 169
Floor, 160, 176
Form, 43
 and content, 189
 and culture, 181
 and shape, 190
 and structure, 190
 choice of, 182
 circular, 202
 contradiction, 216
 dynamic, 277
 follows function, 87, 184
 follows structure, 186
 irregular, 192, 216
 regular, 190, 193
 simplicity, 183
Formalism, 185, 189, 351
France, French, 98, 114, 115, 193, 298
Function, 185
 follows form, 186
Futurism, 276, 278

G
Gamma movement, 283
Garden city, 115
Gaussian curve, 264
Geographic space, 150
Geometry, geometrical, 250, 349
 operation, 226
Gestalt
 Gestalt laws, 223
 Gestalt psychology, 34
 Gestalt theory, 18, 19, 65
God, 5, 80, 113, 141, 291, 296, 339, 345
 goddess, 109, 111
Golden ratio, 212, 226, 228
Good architecture, 248
Good gestalt, 18

Subject index

Gothic, 70, 80, 141, 147, 182, 205, 232, 259, 290, 291, 303, 326, 339, 345
Gravity kinaesthetic perception, 34
Greece, Greek, 48, 86, 90, 111, 135, 147, 163, 165, 186, 195, 203, 285, 290, 303, 326, 344
Ground, 119

H

Hall of Light, 93
Hallucination, 11
Harmony, 82, 144, 221, 251, 257
Hearing, 13
Height dimension, 234
Hexagon, 214
Hierarchy, 41, 47, 240, 244
Horizontal line, 194
Housing
 biologically correct model, 107
 development, 103
Human being, relationship to nature, 114
Human perception. *See* Perception
Hypostyle mosque, 175

I

Ideology, 80
Idolization of space, 341
Illumination, 290, 302, 306, 315
 natural lighting, 310
Illusion, 11, 25, 345
 geometric-optical, 11
 optical, 30
 perceptual, 10
Image, 333
Imbalance, 222
India, 53, 67, 71, 258, 312
Industrial
 building, 186
 construction, 74
 mass production, 72
Industrialization, 71, 75, 103, 145
Information, 3
 aesthetic, 5, 86, 94, 188, 256
 amount of, 6
 content, 4
 repertoire, 8
 semantic, 6, 87, 188, 256

 storage, 17
 theory, 90, 255, 316
Intellect, intellectual, 87, 94
 content, 189
 product, 84
Interior, 122
 as holy area, 128
Intermediate space, 150, 154
International Style, 149
Introvert, 255
Irregularity, irregular, 235
 form, 192, 216
 order, 89
Islam, Islamic, 128, 130, 138, 174, 285

J

Japan, Japanese, 43, 53, 69, 76, 95, 98, 100, 109, 112, 126, 149, 158, 160, 173, 196, 294
 Metabolism, 252

K

Kinaesthetic
 perception, 271
 sensation, 33
Kitsch, 260

L

Landscape, 110, 114
Language, 85, 102
Law
 of closure, 19
 of geometry, 190, 254
 of good gestalt, 18, 227
 of invariant formation, 30
 of proximity, 19
 of similarity, 19
 of size constancy, 10
Light/shadow effect, 302
Light
 artificial, 304, 315
 effects, 301
 indirect, 315
 intensity, 304, 315
 natural, 304, 315
 wavelengths, 321

Subject index

Lighting, 287
 conditions, 307
 directed, 338
 effects, 303
 indirect, 303
Line, 194
 converging, 283
 curved, 195
 horizontal, 194
 straight, 195
 vertical, 194
Living space, 134, 150
Load-bearing system, 74
Load distribution, 244
Location, 108, 288
Luminosity, 315
Lying form, 194

M

Maison de l'homme, 73
Mandala, 53
Mannerism, 144
Material, 161
Mathematical space, 150
Memory
 long-term, 17
 short-term, 17
 storage, 16
Message, 2, 331
 active, 4
 disruption, 10
 originality, 5
 passive, 4
 receiver, 12
Metaphor, metaphorical, 333, 335, 349
 content, 341
 meaning, 201
Middle Ages, 167, 339
Mirror, 308
Misinterpretation, 19
Mobile home, 272
Modernism, 82, 87, 100, 102, 124, 146, 147, 193, 236, 340, 349
 sign language, 349
Monotonousness, 157
Monotony, 46
Monumentality, 232
Moonlight, 315

Moon viewing platform, 127
Movement, 269
 and time, 273
 forward/backward, 271
 horizontal/vertical, 271
 in architecture, 275
 in art, 275
 on a path, 288
Multiple messages, 4
Musical composition, 228

N

Nature, natural, 112, 184, 233, 250, 252, 253, 332
 and human beings, 113
 environment, 110, 116
 light, 308
Necker cube, 11
Neighbourhood, 107
Neo-Baroque, 145
Neoclassical period, 145
Neo-style, 182
Nerve tract, 33
Night-time space, 151
Nociception, 13
Noise, 10
Nomadism, 272
Norm, 87
Number
 of components, 40
 symbolism, 339
Numerals, 339

O

Occident, occidental, 86, 113, 291
Octagon, 216
Opening, 163, 190, 306, 311
Open space, 136, 155
Open system, 74
Opponent-process theory, 322
Optical illusion, 30
Order, 89, 224
Ordering principles, 261
Orientation, 194, 297
Originality, 5, 87, 255
Ornament, 334, 346
Orthogonal grid, 51, 112, 187, 203

P

Painting, 124, 198, 247, 275, 334
 conceptions of beauty, 254
Pantheon, 137
Parts
 assemblage, 68
 connection between type, number and relationship, 65
 non-self-contained, 65
 number of, 40
 prefabricated, 69
 relationship between number and arrangement system, 55
 relationship between type and arrangement system, 60
 relationship between type and number, 55
 rules for combining, 46
 self-contained, 42, 44, 55
 type of, 42
Path, 288
 entrance, 289
 of life, 291
 stages, 295
Pathway, 277
Perceived weight, 222
Perception, perceptual, 14
 illusion, 10
 kinaesthetic, 271
 of architecture, 105
 of brightness, 316
 of movement and speed, 271
 of speed, 35
 optical, 301
 orientation in space, 33
Perfection, 82
Periodicity, 240
Periods, 240
Permanence, 274
Personal
 reflection, 87
 territory, 107
Pictogram, 333
Picture, 335
Pillar, 196
Place, 297
Platform, 121
Plinth, 121, 230
Polygon, 214
Polyvalence, 171

Postmodernism, 82, 87, 150, 341, 349
Precedence, 241
Predictability, 7
Prefabrication, 69, 74
Principles of configuration, 236
Private space, 151
Proportion, 226, 230, 250
 arithmetic, 226
 geometric, 226
Psychology, 185, 264
Psychophysiology, 19
Public space, 151
Public square, 130
Pure form, 193
Pure surface, 197
Pyramid, 214

Q

Quotation, 25

R

Ramp, 167
Rationalization, 74
Receiver, 2, 12
Reception
 antenna, 12
 capacity, 16
Receptor cells, 32
Rectangle, rectangular, 208, 212
 proportion, 227
Recycling, 186
Redundancy, 7, 87, 90, 182, 238
Reflecting glass, 312
Reflection, 316
Reflexes, 10
Regular form, 190, 193
Regularity, 238
Religion, 80
Renaissance, 54, 86, 90, 142, 167, 189, 195, 197, 198, 206, 236, 249, 275, 292, 343, 345
Repertoire, 8
Retina, 15
Rhombus, 294
Rhythm, 237, 240, 286
Ritualistic act, 343
Rococo, 346

Subject index

Rod, 14, 322
Romanesque, 80, 141, 291, 345
Romanticism, 259
Rome, Roman, 48, 49, 80, 111, 136–138, 140, 163, 165, 176, 187, 204, 206, 212, 297, 344
Roof, 100, 160, 196
 flat roof, 101
 gable roof, 100
Room, 147
Ruins, 275
Russia, Russian, 97, 98, 184, 188, 193, 340

S

Sacral architecture, 138, 142, 144, 166, 204, 208, 272, 340
Sampling theory, 19, 65
Science, 84
Sculpture, 63, 135, 290, 334
Seeing process, 14
Sekishui, 75
Selection, 36
Semantics, 332
Semi-darkness, 303
Semiotics, 331
Sender, 2
Sensation, 4, 251
 of beauty, 254, 256
Sense
 of balance, 222
 of beauty, 259
 of touch, 163
Sensory organs, 12
Separation of emotions and intellect, 102
Shadow, 318
Shape, 190, 191, 321, 332, 338
 constancy, 30
 dynamic, 279
 emotional effects, 321
 perceived weight, 192
Shell, 333, 350
Ship-building industry, 75
Shrine, 294
Sight, 13
Sign, 8, 87, 331
 and meaning, 332
 semantic dimension, 331
 symbolic aspect, 337
 syntactic dimension, 331
Signal, 16
Signscultural-social content, 102
Site, 108
 symbolic meaning, 108
Size constancy, 30, 230, 234
Skeleton-frame structure, 148, 163, 169, 306
Skylights, 311
Smell, 13
Social value system, 249
Social zone, 153
Socio-psychology, 36, 255, 323
Solid structure, 163
Space, 108
 as surrounding, 134
 central-plan, 137
 differences, 165
 elements, 159
 experienced, 150, 152
 flexibility, 169
 geographic, 150
 hierarchy, 241
 history, 123, 133
 in ancient Egypt, 136
 in ancient Greek, 136
 in ancient Rome, 136
 interior and exterior, 122
 intermediate, 150, 154
 in Western culture, 135
 juxtaposition, 166
 longitudinal, 137
 mathematical, 150
 of a city, 134
 organisation, 165
 orientation, 175
 pluralistic conception, 146
 polyvalence, 169
 symbolic aspect, 340
 types, 150
Speed, 271, 278
Sphere, spherical, 208
Square, 92, 130, 211, 292
Stairs, 167
Stairway, 167
Standing form, 194
Steel, 146
Stimulus configuration, 280
Straight path, 288
Street, 130, 155, 298

Strict order, 90
Stroboscopic composition, 282
Structure, structural, 89
 engineer, 69
 framework, 191, 212
 properties, 274
Style, 43, 87, 249, 259, 345
 acceptance, 99
 architectural, 82
 atectonic (open), 47
 changes, 95
 complexity, 89, 304
 conservative, 97
 personality structure of the beholder, 94
 revolutionary, 97
 tectonic (closed), 47
Sunlight, 307
Superimposition, 199
Super-sign, 4, 16, 36, 87, 106, 188, 223
Surface, 161, 162, 195, 197, 248, 326
 curved, 199
Surroundings, 105, 116, 274
 types, 110
Symbol, symbolic, 334, 335, 344
 content, 341
 ideational content, 337
Symbolism, 337
Symmetry, 232, 241, 250
 axial, 233
 bilateral, 233
 in the depth dimension, 234
 in the width dimension, 234
 translational, 238

T
Taste, 13, 251, 260
Technology, 102, 252
Tension, 223, 245, 279, 350
Tetrahedron, 213
Texture gradient, 32
Theory
 of elementary design, 276
 of permanence, 274
Thermoception, 13
Time, 273, 304
Tinted glass, 312

Topography, 108, 111, 289
Touch, 13
Toyota Home, 75
Tradition, 93, 98
Traffic area. *See* Path
Translation, 238
Transparency, 311
Triangle, triangular, 212
Trichromatic theory, 322
Triumphal arch, 164, 204, 338

U
Unevenness, 282
Uniformity, 46
Urban
 planning, 298
 square, 155
Utilitarian object, 347
Utopian ideal cities, 48

V
Value system, 80, 82
Vertical line, 194
Visual
 balance, 222
 experience, 280
 reference system, 34

W
Walls, 160, 174
Wandering, 271
Weight, 192
Western culture, 92, 127
 conceptions of space, 135
Western dwelling, 129
Whole, wholeness, 61, 203, 257
Width dimension, 234
Window, 164, 306, 311

Y
Yin and yang, 110
Young-Helmholtz theory, 322

Made in the USA
Columbia, SC
10 January 2024